EDITING AND
SPECIAL/VISUAL EFFECTS

BEHIND
THE SILVER
SCREEN

BEHIND THE SILVER SCREEN

When we take a larger view of a film's "life" from development through exhibition, we find a variety of artists, technicians, and craftspeople in front of and behind the camera. Writers write. Actors, who are costumed and made-up, speak the words and perform the actions described in the script. Art directors and set designers develop the look of the film. The cinematographer decides upon a lighting scheme. Dialogue, sound effects, and music are recorded, mixed, and edited by sound engineers. The images, final sound mix, and special visual effects are assembled by editors to form a final cut. Moviemaking is the product of the efforts of these men and women, yet few film histories focus much on their labor.

Behind the Silver Screen calls attention to the work of filmmaking. When complete, the series will comprise ten volumes, one each on ten significant tasks in front of or behind the camera, on the set or in the postproduction studio. The goal is to examine closely the various collaborative aspects of film production, one at a time and one per volume, and then to offer a chronology that allows the editors and contributors to explore the changes in each of these endeavors during six eras in film history: the silent screen (1895–1927), classical Hollywood (1928–1946), postwar Hollywood (1947–1967), the Auteur Renaissance (1968–1980), the New Hollywood (1981–1999), and the Modern Entertainment

Marketplace (2000–present). *Behind the Silver Screen* promises a look at who does what in the making of a movie; it promises a history of filmmaking, not just a history of films.

Jon Lewis, Series Editor

1. ACTING (Claudia Springer and Julie Levinson, eds.)

2. ANIMATION (Scott Curtis, ed.)

3. CINEMATOGRAPHY (Patrick Keating, ed.)

4. COSTUME, MAKEUP, AND HAIR (Adrienne McLean, ed.)

5. DIRECTING (Virginia Wright Wexman, ed.)

6. EDITING AND SPECIAL/VISUAL EFFECTS (Charlie Keil and Kristen Whissel, eds.)

7. PRODUCING (Jon Lewis, ed.)

8. SCREENWRITING (Andrew Horton and Julian Hoxter, eds.)

9. ART DIRECTION AND PRODUCTION DESIGN (Lucy Fischer, ed.)

10. SOUND: DIALOGUE, MUSIC, AND EFFECTS (Kathryn Kalinak, ed.)

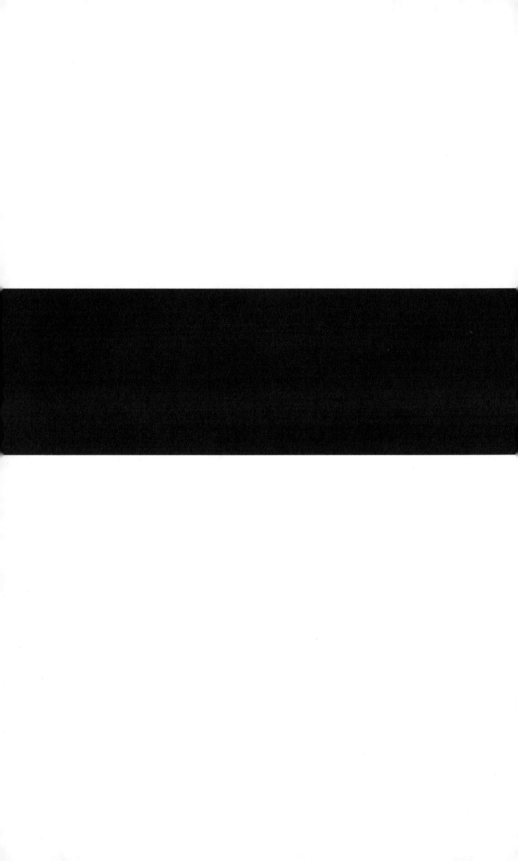

EDITING AND
SPECIAL/VISUAL EFFECTS

Edited by Charlie Keil and Kristen Whissel

RUTGERS
UNIVERSITY PRESS
New Brunswick, New Jersey

Library of Congress Cataloging-in-Publication Data
Names: Keil, Charlie. | Whissel, Kristen, 1969– editor.
Title: Editing and special/visual effects / edited by Charlie Keil and Kristen Whissel.
Description: New Brunswick, New Jersey : Rutgers University Press, 2016. | Series: Behind
the silver screen ; 6 | Includes bibliographical references and index.
Identifiers: LCCN 2015041069 (print) | LCCN 2015046275 (ebook) | ISBN 9780813570822
(hardback) | ISBN 9780813570815 (pbk.) | ISBN 9780813570839 (e-book (Web PDF)) | ISBN
9780813573571 (e-book (Epub))
Subjects: LCSH: Motion pictures—Editing. | Cinematography—Special effects. | BISAC:
PERFORMING ARTS / Film & Video / Direction & Production. | PHOTOGRAPHY /
Techniques / Cinematography & Videography. | SOCIAL SCIENCE / Media Studies. |
PERFORMING ARTS / Film & Video / History & Criticism.
Classification: LCC TR899 .E325 2016 (print) | LCC TR899 (ebook) | DDC 777/.55—dc23
LC record available at http://lccn.loc.gov/2015041069

A A British Cataloging-in-Publication record for this book is available from the British
Library.
Visit our website: http://rutgerspress.rutgers.edu
Manufactured in the United States of America

CONTENTS

Introduction Charlie Keil and Kristen Whissel 1

1. THE SILENT SCREEN, 1895–1927: Editing Scott Higgins 22
2. THE SILENT SCREEN, 1895–1927: Special/Visual Effects Dan North 37
3. CLASSICAL HOLLYWOOD, 1928–1946: Editing Paul Monticone 51
4. CLASSICAL HOLLYWOOD, 1928–1946: Special/Visual Effects Ariel Rogers 68
5. POSTWAR HOLLYWOOD, 1947–1967: Editing Dana Polan 78
6. POSTWAR HOLLYWOOD, 1947–1967: Special/Visual Effects Julie Turnock 91
7. THE AUTEUR RENAISSANCE, 1968–1980: Editing Benjamin Wright 103
8. THE AUTEUR RENAISSANCE, 1968–1980: Special/Visual Effects Julie Turnock 116
9. THE NEW HOLLYWOOD, 1981–1999: Editing Deron Overpeck 129
10. THE NEW HOLLYWOOD, 1981–1999: Special/Visual Effects Lisa Purse 142
11. THE MODERN ENTERTAINMENT MARKETPLACE, 2000–Present: Editing Meraj Dhir 156
12. THE MODERN ENTERTAINMENT MARKETPLACE, 2000–Present:
 Special/Visual Effects Tanine Allison 172

Academy Awards for Editing 187
Academy Awards for Special/Visual Effects 193
Notes 199
Glossary 229
Selected Bibliography 237
Notes on Contributors 243
Index 247

EDITING AND SPECIAL/VISUAL EFFECTS

INTRODUCTION Charlie Keil and Kristen Whissel

Both editing and special/visual effects have typically belonged to the province of postproduction, but their respective roles within the American filmmaking process have differed dramatically. While editing has often strived to hide itself, functioning as a craft designed to foster continuity and reinforce the effect of seamlessness that has long been the hallmark of Hollywood filmmaking, special/ visual effects have more readily lent themselves to the realm of the extraordinary and the spectacular. Even so, special/visual effects have been devised to produce a broad range of images and aesthetics, from the fantastical to the convincingly (photo)realistic. This volume focuses on the various special/visual effects artists and houses, processes, technologies, practices, and aesthetics that comprise the long and varied history of special/visual effects in the American cinema. At the same time, it offers a parallel examination of the manner in which editing has become integrated into Hollywood's moviemaking methods, giving equal attention to how editing has shaped the style of American films. To be sure, one can find numerous instances throughout film history when editing and special/ visual effects have been mutually supportive—from the stop-motion substitution used in *The Execution of Mary, Queen of Scots* (1895), where a well-placed cut creates the illusion of the monarch's beheading, to the combination of digital visual effects and concealed edits that produces the impression of an uninterrupted

1

and often hallucinogenic long take in *Birdman* (Alejandro G. Iñárittu, 2014). So while the increased departmentalization of labor involved in studio manufacture might have kept crafts distinct, and technology often distinguished the realm of visual manipulation from that of shot combination, editing and special/visual effects have shared the broad aim of transforming cinematic imagery throughout their history, even as each has been shaped in different ways by a broad range of influences. Operating in concert or singularly, editing and special/visual effects have emphatically transformed the American cinema, a rich and varied process of transformation that this volume traces in all its intricacies.

Editing

It is a truism of Hollywood cinema that style exists largely to go unnoticed. No aspect of style embodies that principle more consistently than editing, so much so that a common term for describing the system of cutting synonymous with best practices is "invisible editing." A history of editing in the American cinema must take into account how such an approach to piecing shots together took root in the first decades of the medium's existence, and how it became the linchpin of the classical style that dominated the studio era. Overviews of subsequent decades would devote equal attention to the challenges posed to so-called continuity editing, detailing how alternative approaches rendered the work of editors more noticeable. But studying editing as an important aspect of cinematic style only tells part of the story: we can also understand editing as a craft practice performed by trained and talented individuals invested in seeing their presence within the industry and contributions to the filmmaking process properly recognized. And while editing as a process may not seem as dependent on sophisticated equipment as the work of a cinematographer or sound technician, technology has also played an important role in both the workflow of the editor and the aesthetic effects of the editor's labor. Accordingly, this introduction takes into account technology's effect on editing, editing as a craft practice, and editing's relation to film style, reflecting the emphases evident in the volume's chapters. Weaving together some of the insights and observations of the chapters' authors—Scott Higgins, Paul Monticone, Dana Polan, Benjamin Wright, Deron Overpeck, and Meraj Dhir—can produce an initial portrait of editing as an integral part of Hollywood's moviemaking methods, a portrait extended and deepened by the full accounts provided in their chapters.

Editing and Film Style

The earliest films functioned without the apparent benefit of any kind of break in the duration of the filmed action. Whatever cuts existed in the first films were

typically hidden, to allow the removal or insertion of an element within the mise-en-scène without any evident alteration to all other elements: this approach to editing defines the so-called trick film. As numerous early film scholars have pointed out, these trick films are rife with hidden cuts; editing exists to effect a substitution akin to magical appearances and disappearances in stagecraft. By the early 1900s, editing became visible, with multi-shot films commonplace, and filmmakers experimented with different approaches to managing how editing might connect diverse shots.

Tom Gunning, following the Russian formalists, has suggested that we might think of the earliest "cine-genres" in "relation to the articulation between shots in terms of space and time." He goes on to identify four cine-genres, which occur in rough succession over the first fifteen years of cinema's existence:

> The first genre consists of narratives completed within a single shot. The second genre, which I term the genre of non-continuity, consists of a narrative in at least two shots, in which the disruption caused by the cut(s) between shots is used to express a disruption on the story level of the film. The third genre, which I refer to as the genre of continuity, consists of multi-shot narratives in which the discontinuity caused by cuts is de-emphasized by being bridged through a continuity of action on the story level. The fourth genre I call the genre of discontinuity, in which a multi-shot narrative conveys action which is continuous on the story level through a disruption caused by editing on the plot level.[1]

One notes in Gunning's typology two evident trends within this succession of cine-genres: the progressive reliance on a greater number of shots (provided by editing), and the aim of providing enhanced levels of narrative continuity even as, paradoxically, the operations of editing become more openly disruptive.

In the transitional period of American cinema (1907–1913), an era that overlaps with the timespan of Gunning's final cine-genre, the years after 1907 entailed a radical reconceptualization of the way in which space and time should be represented and managed.[2] That refashioning of time and space was prompted in part by changing market conditions. To meet growing demand for story films in a more orderly fashion, filmmakers sought to mass-produce narratives of a predictable length (1,000 feet), and in so doing looked for ways to craft stories on film that would prove both comprehensible and involving for audiences. Editing became a key element of style in this pursuit, because it afforded filmmakers a tool to manipulate time (by creating ellipses and reordering story time) and analyze space (through delineating spatial relationships tied to overlap, proximity, and alterity). These three spatial categories measure the relative distance that appears to separate one edited diegetic space from another, from negligible to substantial.

In his chapter on the silent period in this volume, Scott Higgins concentrates on the development of what he calls "analytical editing," focusing on how film-makers gradually came to feel comfortable dissecting a single space, which took longer to work out than articulating the movement from one distinct space to another. In effect, Higgins emphasizes the spatial categories of overlap and proximity, and highlights how editing makes the relationships among portions of a distinct space—or among spaces that are contiguous—clear to a film's viewers. Tracing the exploration of such spaces in a set of films made between 1909 and 1915, he demonstrates that the increased analysis of singular sets led to increased audience comprehension of potentially confusing spatial relationships. Even so, certain conventions would take several more years to solidify: for example, cutting on an angle remained a specialized technique in the early years of the feature film, but Barry Salt has calculated that by the early 1920s, about one-quarter of shot transitions were from a shot to its reverse angle.[3] By that time, cinematic space was being constructed in such a way that the camera seemed near-ubiquitous—the cut came to follow the scene's dramatic interest, or, as Higgins puts it, "editing shapes a scene's rhythm and leads viewers through its emotional arc."

The idea that analytical editing would aid in shaping story material continued throughout the formative years of the sound-era studio period, though the advent of sound strengthened the adherence to an increasingly stringent set of rules. Filmmakers adopted a multiple-camera system to adjust to the limitations imposed by sound recording. This meant that a menu of options was still available to the editor, who could choose among several setups, each performing a distinct function. As Paul Monticone points out in his chapter on classical Hollywood, the sound transition "reinforced classicism's dissection of narrative space" and led to standardization of the "practice of shooting entire scenes in 'master scene' or long shot, after which selected portions of the scene would be repeated from closer angles."

This approach to shooting came to be known as providing "coverage," and placed the editor at the center of the process of constructing a dramatically fluid presentation of space from distinct vantage points on the same set of actions. Shooting for coverage offered producers multiple advantages, not the least of which was the ability to choose from a varied array of perspectives, some of which might provide spatial clarity while others might highlight aspects of an actor's performance. The master scene functioned as a kind of baseline from which all other angles derived. Key to the entire procedure was the understanding that continuity would guide an editor's subsequent selection of appropriate aspects of the scene, so that the different parts could come together to produce a seamless whole.

If editing became more rule-bound during this period (for example, straight cuts invariably occurred between temporally continuous shots, while a dissolve signaled some kind of ellipsis and was typically deployed between scenes), Hollywood filmmaking used these rules to its narrational advantage. More overt forms

of transition, such as wipes, were used in a manner akin to punctuation marks, and, if momentarily held in place, a wipe or dissolve could help foreground a contrast, allowing for moments of overt narration that nonetheless aided in the viewer's overall understanding of the story. But the central logic of editing during this period was not re-creating strict spatio-temporal realism, but keeping viewers attuned to the psychological causality at the heart of the story; as editor Ralph Winters, a long-time MGM employee, puts it: "Any time a scene sustains itself you want to let it play, because the people in the audience have a chance to relate to whomever they want up on the screen. I can have my eye shift back and forth where it wants."[4]

Generally conceived of as unobtrusive and geared toward support of a story's dramatic logic, editing was rarely conceived of as "creative," but in rare instances the compression of time justified the judicious employment of more flamboyant techniques, as one finds in "montage sequences." These sequences, most famously exemplified by the work of Slavko Vorkapich (and Peter Balbusch), featured a degree of formal experimentation rarely seen in classical editing otherwise, combining, in Monticone's words, "graphic matches, staccato cutting rhythms, and even overt symbolism," but they also remained specialized aspects of studio films, exceptional bursts of editing self-consciousness. And, as MGM stalwart Jack Dunning recalled, the excesses of Vorkapich's sequences would still be tamed in an effort to fit them to the contours of classical filmmaking: "They'd make them elaborate and we'd cut them down to size."[5]

The 1940s witnessed a more noticeable preference for long takes, with filmmakers withholding the cut, often for a pronounced amount of time. While certain directors (such as John Stahl) had favored a longer average shot length (ASL) in the 1930s, the tendency gained momentum in the post–World War II period, only to give way to a reversion to shorter ASLs by the end of the 1950s. Moreover, as Dana Polan points out in his chapter on the postwar era, one begins to see the use of straight cuts for transitions from scene to scene by the 1960s, and even jarring cuts that feature aural continuity while playing up spatio-temporal discontinuity. He also notes more experimentation with dividing the screen into multiple sectors, doubtless a tendency prompted by the experimentation with expanded screen experiences at world's fairs and within the domain of the avant-garde.

Such experimentation with editing became increasingly prevalent by the close of the decade, with the use of straight cuts marking even more abrupt transitions between scenes, as the final shot of a scene, itself filmed at close scale, is replaced by a similarly close framing for the opening shot of the next scene, or when a scene opens with two close framings, the spatial relationship between them not immediately apparent. If the narrative situation allowed, editing could become excessively disjointed and diffuse. Donn Cambern, editor of the notoriously fragmented *Easy Rider* (Dennis Hopper, 1969), conceded that the film's quick cuts were novel, but still adhered to precepts of legibility: "We learned that it worked depending upon

the imagery, that it had to be clean, easily recognized. If it wasn't, it was simply a confusing blur of film. But if the imagery was clear and contained a certain emotional investment as well, then the audience accepted it."[6] Cambert's comments confirm that even innovative editors never lost sight of the governing principles of analytical editing; as Benjamin Wright points out in his chapter on the years dominated by the auteur resurgence, a celebrated filmic example of kinetic editing such as *Jaws* (Steven Spielberg, 1975) would still feature scenes of rapidly alternating action seemingly organized via the perspective of an observing character, keeping the arrangement of narrative action firmly anchored to the diegesis.

Nonetheless, an increasingly splintered editing style comes to characterize 1980s-era editing; as Deron Overpeck notes in his chapter on New Hollywood, music tie-ins affected the marketing of films while music videos influenced the editing. Films such as *Top Gun* (Tony Scott, 1986) and *Flashdance* (Adrian Lyne, 1983), fueled by propulsive rock music sound tracks, prioritized visual impact over continuity, and ASLs began to drop noticeably. Appearing in conjunction with these faster cutting rates is an increased reliance on multiple-camera shooting; now scenes are typically composed of a multitude of shots from a variety of perspectives, and it is not at all uncommon for shots to interrupt one another rather than build one on another.

As Meraj Dhir demonstrates in his chapter on contemporary practices, this disjunctive, jittery editing style has been further enhanced of late by the increased use of the moving camera. Oftentimes one moving shot (be it a track or a pan) will interrupt another, resulting in an action sequence operating as a blur of quickly cut moving shots with no apparent center. Even so, Dhir cautions against us believing that editing has undergone an epochal stylistic shift. While ASLs may have dropped, and editing become more noticeable in key genres, one can still find many examples of films that abide by longstanding continuity principles, and of editors who embrace the virtues of self-effacing storytelling. Evan Lottman, who worked on *The Exorcist* (William Friedkin, 1973) and *Apocalypse Now* (Francis Ford Coppola, 1979), and had long-term working relationships with directors Jerry Schatzberg and Alan Pakula, could be speaking for any number of editors when he claims that "editing should never call attention to itself. The experience of seeing a movie should be an experience that is divorced from its technique. Anything that suddenly pulls you out of the totality of the experience, a beautiful shot, a gorgeous piece of photography, even a *tour de force* performance, can hurt the overall effect. The dramatic experience should be the smooth, seamless integration of everybody's work on the film."[7]

Editing and Technology

Compared to such technology-intensive crafts as sound mixing or cinematography, editing has been relatively unaffected by major technological developments.

Nonetheless, particular machines or editing systems have altered the way in which editing has been executed, and this, in turn, can affect both workflow and style. Editors will often point to technological changes as altering their approach to their craft, and Richard Marks, a recent recipient of the Career Achievement Award from American Cinema Editors, believes that technology has played a role in changing industry perception of the editor's contribution to the filmmaking process. As he explains, "The difference in the editor's role reflected the change in filmmaking, and that probably came about when they started recording on mag stock rather than optical tracks. They started shooting more and coverage became different. More and more directors came to rely on the editing process to create scenes that at one time were created in one sweeping take, where they would rehearse something for three days, shoot it and get it right. As the shooting became more complicated, the need for relying on the editorial process became more apparent. Editors were no longer a pair of hands cutting off slates, they were people who had to think, have opinions, and have some feeling for the material."[8]

Because early editing tended to be fairly rudimentary, involving little more than making splices directly into the camera negative, the division of labor was not particularly involved. The shift to using positive workprints made the distinction between head editors and cutters and joiners not simply a material one (the latter workers carried out different tasks), but also a creative one (in that the head editor made the cutting decisions that determined all other editing-related labor). The introduction of the Moviola in 1924 was the first attempt at standardizing the process of editing: its viewfinder, which magnified the film image, and its electrified motor, which allowed film to run through at an even speed, promoted greater accuracy from editors. These attributes, in turn, would have allowed editors to cut more quickly if they so chose, now that enhanced precision was assured.

The Moviola enjoyed a long run as the machine of choice for Hollywood editors, but as Paul Monticone details, the adoption of sound complicated the process of editing by adding another track that required cutting. By 1930 the Moviola offered an attachment to handle sound reels and playback, which allowed editors to pinpoint where they wished to make their cuts in relation to the sound track. Other technological innovations further facilitated the cutting of sound and image, such as the multiple synchronizer, which allowed the image reel and the sound reel to be moved in unison so that both tracks would be cut at the same point. The stamping of numbers on the edge of frames at regular intervals of one foot, implemented by 1932, provided a way to ensure that image and sound still lined up without recourse to the multiple synchronizer. Both of these developments rendered the physical process of cutting more efficient while also allowing for faster cutting. In 1937, a supplemental viewing screen was added to the Moviola; this augmented the viewing lens of the original, permitting editors to see the details in longer-scaled shots more clearly. As Monticone suggests,

this development might have had the inverse effect of encouraging longer shot lengths, an evident trend in the latter part of the decade.

If the 1930s witnessed constant adjustments to the editor's central tool, the Moviola, subsequent decades saw other technological developments that had ripple effects on editing. Dana Polan points to four such developments; collectively, they indicate the diverse ways that technology could influence editing. The crab dolly, introduced in the late 1940s, permitted more intricate shots of longer duration and may have encouraged editors to slow their cutting pace. The proliferation of widescreen processes in the early to mid-1950s led filmmakers to reduce the number of edits in the belief that spectators would react negatively to the shift from one wide image to another. And the replacement of joining celluloid by cement (a liquid glue more like acetone) with tape splicing, a practice initiated in the postwar period, facilitated the process of experimentation with editing: the less permanent kind of join created by a strip of tape allowed editors to take apart their edits and redo them in another way. (As Carl Kress put it, "One of the greatest inventions ever made for the cutting room was the butt splicer which allows you not to lose frames and you can experiment. You can always fix any mistake.")[9] Perhaps most significantly, the rise of television exerted substantial influence over film editing, both in terms of training editors and priming audiences for comprehending different types of image flow. In interviews, many editors claim that one can attribute the demise of the dissolve to television's preference for the straight cut.[10]

As Benjamin Wright asserts, the most important technological shift in several decades occurred in the 1970s, when the flatbed editing machine (typically the Steenbeck or the KEM) came to displace the Moviola. Unlike the Moviola, which runs footage through a threading device with a screen that is vertically oriented, the flatbed, which features a larger viewing monitor, uses flat platters that move horizontally. Editors developed definite preferences, with many opting to stick with the Moviola because they favored the pronounced tactility of the editing process that it provided. The revered editor William Reynolds, whose career stretched from the 1930s to the 1990s, conceded that "even though there is a lot of taking film in and out of the Moviola mechanically, you're thinking about what your next step is while you're doing the mechanical things. I just found that wasn't true on the KEM, and after I did a couple of pictures that way I went back to the Moviola."[11]

Deron Overpeck charts an even more dramatic and lasting change to editing technology that occurred in the late 1980s, when competing electronic editing programs emerged, eventually displacing manual editing by the 1990s. As he explains, these video-assisted editing systems could be linear or nonlinear random access. In the former, footage was transferred to time-coded videotape; editors could then search for desired scenes on videotape and arrange them onto a master tape. Finally a computer-generated cut list detailing the time codes of

each edit would be the guide for cutting the negative. The latter system, abetted by early digital technology, entailed calling up scenes via keystrokes, rendering the search for multiple versions of a scene much quicker. As Overpeck demonstrates, the initial adoption of these systems was slow—the most popular system, the EdiFlex, had only succeeded in placing forty units in North America by 1987. But by the 1990s, digital nonlinear systems were gaining in popularity, with Avid emerging as the dominant brand. Editor Conrad Buff extolled the virtues of digital editing in 1994 by saying that "this system allows editors to experiment a lot more than we could ever have previously. . . . The technology allows you to get through the material much more quickly and produce a better product in the end."[12]

The pronounced ease and acceleration of workflow afforded by digital editing systems, in conjunction with other technological developments (such as video assist and more mobile lightweight digital cameras), have likely had a residual effect on the style of contemporary films. The increased experimentation that Buff described has translated into a proliferation of multiple takes of dynamic footage that produces an almost endless series of options for editors. The current state of affairs demonstrates that editing technology inevitably intersects with changing craft practices, themselves further influenced by industry conditions.

Editing as a Craft Practice

In the early years of film production, the role of the film editor was rather indistinct, and a film's director might well also function as its de facto editor. With the increased departmentalization of labor that attended the emergence of the studio system, editing, like other craft practices contributing to the making of motion pictures, became a specialized task with its own protocols. Even so, it appears that either the director or the producer would have been intimately involved with the editing of films in the silent period; certainly editors did not typically begin their work until principal photography was completed. As Monticone demonstrates, the transition to sound marked a discernible shift in how editors functioned, increasing their involvement while limiting their freedom. The introduction of a sound track, replete with dialogue, sound effects, and music, considerably complicated the postproduction process and brought the editor into the filmmaking timeline at an earlier stage. Because of the various sonic elements, the editing of the answer print, with the dialogue in sync, had to be completed in a timely fashion, so that the next phase of work could be started early enough to not delay the release of the distribution print. This meant that editing had to begin while production was still occurring so that a rough cut would be ready virtually as soon as filming was complete: one byproduct of this change in editing timelines was the elimination of the director as part of the editing process. Accordingly, as Monticone suggests, editors assumed more control over editing and progressively came

to work in a supervisory capacity, possessing a distinct role in the chain of tasks that defined a film's movement through a prescribed system. But at the same time, editors had to abide by the increasingly rigid rules concerning continuity and analytical editing.

Individual studio culture determined how editing tasks were meted out. According to William Reynolds, Paramount devised a system in the 1930s whereby an assistant editor executed a first cut while the film's editor stayed on the set with the director. The editor would only take over once filming was complete.[13] Other studios, such as MGM and Fox, created the position of a supervising editor, who oversaw all editing operations. At both studios, a woman occupied this crucial role: Margaret Booth served in such a capacity at MGM from 1936 to 1969, and Barbara McLean began her tenure as Fox's supervising editor in the 1940s, retaining the title until her retirement in 1969. But to read the ascendency of these female editors within the ranks of the profession as an indication that the craft was a haven for women within a largely male-dominated industry would be a mistake, according to Monticone. If anything, the ranks of editors held less opportunity for women as silent filmmaking gave way to sound. During this time, editing also began to organize itself along the lines of other crafts, forming the Society of Motion Picture Film Editors (SMPFE) in 1937. Despite this move, editors collectively demonstrated little interest in devising a distinct professional identity for themselves (unlike, say, cinematographers) (see figure 1). For example, the Academy of Motion Picture Arts and Sciences lagged in its recognition of the contribution of editors, with no Oscar bestowed for editing until 1935. It took until 1950 for a guild devoted to advancing the status of the editing profession to be formed.

The relative professional anonymity that editors endured during the studio era began to break apart much like the studio system itself by the late 1960s. As Wright puts it, "The decade that brought sweeping institutional changes to the American film industry also fostered a new collaborative role for picture editors as creative artists." By the end of the 1960s, most studios had moved to contracting out editorial work, resulting in short-term partnerships with filmmakers that Wright labels "flexible specialization." This means that editors had to exhibit flexibility in relation to both workflow and demonstrated skills. Walter Murch's efforts, for example, demonstrated how the aligned crafts of editing and sound editing could be blended if the work environment (in this case Francis Ford Coppola's Zoetrope Studios) allowed for the dissolution of traditional craft boundaries. Other editors had to be aided in embracing the new challenges brought about by rapid technological change, as when the advent of electronic editing systems signaled to editors that they would have to adapt to new technologies and possibly adopt new work methods. As Overpeck notes, to dispel editors' concerns about the potentially radical alterations to how they would do their work, some manufacturers tried to make their equipment look more like the machines that editors

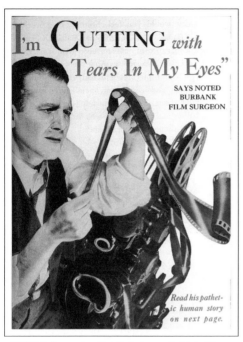

I'm CUTTING *with* Tears In My Eyes"

SAYS NOTED
BURBANK
FILM SURGEON

Read his pathetic human story on next page.

FIGURE 1: Early examples of how the trade press depicted editing tend to emphasize excision over craft. *Motion Picture Daily*, December 9, 1935, 3.

were familiar with; for example, the TouchVision had a graphical interface that was designed to resemble a flatbed.

Beyond proving their adaptability, it became equally important for editors to develop strong relationships with their filmmaker clients. Before, in the studio era, both director and editor performed circumscribed roles, but now the editor had to work closely with the director and demonstrate an ability to problem-solve; as Wright puts it, the new status of editors "locked them into a social contract with directors that was often dictated by formal uncertainty and creative compromise." Moreover, Wright argues, editors felt compelled to stress the distinctiveness of their craft and used "descriptive metaphors that crystallized their artistic contribution to a film and underlined the deeply intuitive nature of creative decision-making." Again, one can point to some prominent women, such as Dede Allen and Verna Fields, who exemplified the newly appreciated artistic dimension of editing, and who also developed strong working relationships with directors. Thelma Schoonmaker, who worked with Martin Scorsese on his first feature, *Who's That Knocking at My Door*, in 1967, went on to collaborate with the director on more than twenty films, including their most recent venture, *Silence* (2016). Similarly, Joel Cox started out with Clint Eastwood on *The Outlaw Josey Wales* (1976), Eastwood's fifth feature, and has worked with the director consistently for nearly forty years; Michael Kahn has been Steven Spielberg's editor since the making of *Close Encounters of the Third Kind* in 1977; and Ronald Sanders has performed the same role for David Cronenberg since 1979's *Fast Company*.

While these relationships speak to the possibility of stability for established editors, the post-studio era of short-term contracted labor has meant employment insecurity for most. When one couples a precarious labor market with the pressure to produce quick results because of the purported efficiencies that digital editing systems can provide, one sees many editors driven to what Meraj Dhir calls increased "niche specialization" in conjunction with demonstrating

"conspicuous virtuosity." These twinned attributes can lead to editors develop-
ing reputations as genre specialists, and consequently can help them secure jobs
when they display an aptitude for action films, musicals, or horror films. In this
way, editors have heightened their contribution to the overall aesthetic effective-
ness of a film, cementing editing's role in the creation of film style. At the same
time, the digital era has also promoted an increased porousness of the bound-
aries separating one craft from another: virtually any element in a film can be
created on a computer, which means that the domains of special/visual effects
and editing can now be subject to considerable overlap, depending on the project
and the filmmaking methods employed.

Special/Visual Effects

In popular culture, the term "special effects" often refers to a broad range of artis-
tic techniques and practices that, in fact, fall within the domain of three separate
types of effects work: optical effects, special effects, and visual effects. In addition
to serving as an umbrella category for all effects work, the term "special effects"
has often been used (especially by critics and journalists) chiefly to designate
spectacular, overwhelming visual effects sequences that appear in big-budget
blockbuster films. When used in this latter manner, "special effects" typically
functions as a kind of shorthand that incorrectly ties special and visual effects to
diminished narratives and a lack of character development associated with pop-
ular genres such as disaster, science fiction, and superhero films. In turn, in the
past fifteen years or so, one can detect in a broad range of discourses a tendency
not only to link special effects to ostentatious spectacle, but also the presumption
of a causal relationship between the latter and the proliferation of digital technol-
ogies and computer-generated images (CGI).

The chapters in this volume offer detailed analysis of the different types
of optical, special, and visual effects work accomplished by artists and tech-
nicians since the earliest years of the American film industry, whether such
work yielded elaborate spectacular effects or transparent effects intended to
go unnoticed by audiences. Moreover, they provide historical contextualiza-
tion for understanding various analog effects that have been used since the
late nineteenth century and throughout much of the twentieth century as well
as the digital visual effects that often dominate effects work today. Each chap-
ter offers insight into the numerous practices and technologies that have been
deployed over time to enable studios, directors, cinematographers, and produc-
tion companies to save time and money in their efforts to construct credible
and coherent fictional worlds; to represent otherwise "impossible" bodies,
movement, action, and spaces on film; and to minimize danger to actors, stunt
workers, and crews.[14]

It is always imperative to situate optical, special, and visual effects in the context of broader historical shifts and industrial change, from the rise and fall of the studio system (and, with it, the rise and fall of in-house effects departments) to the introduction of sound, widescreen formats, color, and digital technologies and workflows. The essays collected here do so, and in the process also provide an understanding of the relationship between spectacle and narrative that any discussion of special, visual, and optical effects must address. They also analyze the significant ways in which effects work has historically overlapped with other areas of specialization, including cinematography, lighting, editing, makeup, animation, and acting/performance.

The tendency of audiences, critics, and fans to combine different kinds of effects work under the rubric "special effects" may be attributed in part to the shifts in terminology used by the Academy of Motion Picture Arts and Sciences in its annual Academy Awards—an event that brings to the attention of the public those technical and artistic practices that are most successful when they are invisible and achieve their goals in a mode of transparency. As has been mentioned in recent studies that discuss the significance of prioritizing one term (visual effects) over another (special effects), the first award for special/visual effects was designated by the category of "Best Engineering Effects" and given to the first Best Picture winner, *Wings* (William Wellman, 1927). This category was renamed as "Best Special Effects" (and was given in conjunction with the award for best sound effects) in 1939 and the Oscar awarded to Fred Sersen for his photographic effects on *The Rains Came* (Clarence Brown). The Academy used this terminology until 1963. In 1964 the award category was dubbed "Best Special Visual Effects" and, finally, in 1972, it was changed to "Best Visual Effects"—the term that is still used today.[15] Given these overlapping and therefore somewhat confusing shifts in terminology, we should note the different terms practitioners have used and continue to use to designate and classify different types of effects work within the disciplines of special, optical, and visual effects.

The term "special effects" (also known as "physical effects") refers to those effects created on set or on location during live-action shooting. They include stunt work, makeup effects, miniatures, matte paintings, glass shots, models, puppetry, and animatronics, as well as explosions or crashes staged during principal photography and captured by the camera. In contrast, "visual effects" are created in postproduction following principal photography. Visual effects supervisor Michael Fink defines visual effects as "any imagery created, altered, or enhanced for a film ... that cannot be accomplished during live-action shooting, and further expanded to include virtual production—the process of capturing live images and compositing them or reinterpreting them into a scene in real time. This implies that much of the art of visual effects takes place in postproduction, after primary image capture is complete." However, Fink notes that "the process of designing, planning, executing, and completing visual effects requires

interaction and collaboration with nearly every department on a project."[16] As Richard Rickitt explains, "optical effects" refer to effects achieved with the camera that involve "using the properties of light, film, and lenses (such as front and rear projection)."[17] Rickitt notes that while effects artists use the term "opticals" to identify composites that have been created using the optical printer, the phrase "optical effects" is used to indicate processes such as double exposures and split-screen shots.[18]

Regardless of the means by which special and visual effects are accomplished and whether they are meant to be spectacular or to go unnoticed (as part of the background of a shot, for example), all have been produced with the goals of credibility and transparency in mind. That is, artists and technicians have historically worked to create effects with a degree of proficiency, precision, and seamlessness that effectively conceals both the manufactured nature of an effect (however stylized) and the technologies used to create it, thereby allowing audiences to engage in a (more or less) uninterrupted suspension of disbelief as they watch a film. Such transparency is the goal even in instances where a particularly elaborate effects sequence announces its status as the outcome of groundbreaking techniques and artistry that showcase the power of new technologies (such as, for example, the morphing sequences in *Terminator 2: Judgment Day* [James Cameron, 1991]). Seamlessness was the goal even in the very earliest examples of stop-motion substitution, an early optical effect that created the illusion that objects or bodies could instantaneously appear, disappear, or suddenly change position in space. To accomplish this, the camera operator stops the camera during filming, alters the set or the position of actors, and resumes filming. As Tom Gunning argues, in-camera edits (the point at which the camera was stopped) and the ensuing changes or substitutions made to the set were very carefully matched with the aid of splicing, so that audiences would see only the illusion created by effects artistry—magical appearances or disappearances—rather than the means by which it was accomplished.[19]

Effects artists and supervisors prioritized these objectives throughout the twentieth century and into the new millennium. Of course, one must keep in mind that the criteria audiences have used to judge an effect's transparency and credibility are themselves fully historical. For example, Ariel Rogers and Julie Turnock note in their respective chapters that in the 1930s, 1940s, and 1950s, audiences seem to have regarded rear projection (a process that allows a filmed moving background projected onto a transparent screen to be combined with live action during principal shooting on a soundstage) as offering an acceptable degree of credibility. However, rear projection often strikes contemporary audiences as far more noticeable, accustomed as we have become to digital forms of compositing that are considerably more seamless by comparison. For contemporary audiences, the differences in lighting, depth cues, and image quality of rear-projected backgrounds and those of the complementary foregrounded

live-action elements are too readily apparent, thereby revealing a shot's status as an assemblage.

Nonetheless, neither seamlessness nor a lack of transparency appears to dull curiosity about how special and visual effects are accomplished. From the beginning, as Dan North notes in his chapter, optical, special, and visual effects have provoked what Stephen Heath calls a "machine interest"—a desire to know the operations of the moving picture technologies that have made certain effects possible.[20] During the classical era, studios did their best to withhold from the public any information about the means by which filmmakers created various effects. However, for many years, *American Cinematographer* (first published in 1920) has made available information on how certain effects were accomplished; several of the volume's chapters cite this trade journal. More recently, periodicals such as *Cinefantastique, Cinefex,* and the annual SIGGRAPH publications describe the labor, artistry, techniques, and technologies (including software) used to produce special and visual effects. In turn, DVD and Blu-ray releases of films have often included more accessible "making of" featurettes that offer interviews with visual effects supervisors, artists, directors, and performers, thereby offering some insight into the creation of a film's visual effects. We can say, then, that from the beginning, special, optical, and visual effects have been caught up in a fascinating play of visibility and self-effacement, revelation and concealment.

Spectacle, Narrative, and the Integration of Effects

While the issues discussed above relate to whether or not the various elements and effects used to create a shot or sequence have been integrated into a (relatively) seamless whole, other scholarly debates have addressed the varying degrees to which effects have been integrated with narrative. This is particularly true of the silent era, during which time the relationship between spectacle and narrative changed considerably. At the beginning of this period, a typical film was composed of a single shot that directly addressed the spectator; by the end of this period, the typical film was a feature-length fictional narrative presented through the transparent system of continuity editing. In films made during the earliest years of motion pictures (1895–1903), storytelling was not a priority; rather, Gunning argues, films offered a relatively brief dose of spectacle that prevailed over narrative (which, if present, simply acted as a framework or support for a series of displays). Filmmakers often exploited optical and special effects in their development of what Gunning calls the "aesthetic of astonishment" that is the defining feature of the "cinema of attractions."[21]

As Gunning argues, the temporality of the cinema of attractions orients itself toward the present tense or the "now," and the images on display are presented in a mode of direct address to audiences.[22] This was especially the case with the

trick film, which might be organized around the elaboration of a particular effect, such as stop-motion substitution, in order to provoke shock, surprise, or laughter. After 1907, as the conventions for cinematic narration were developed and, in the 1910s, became standardized, special, optical, and visual effects were increasingly integrated with narrative and harnessed to the task of establishing a coherent and credible fictional world—whether the latter was fantastical or realistic. As the feature-length narrative film (five reels or more) and continuity editing became industry standards in the second half of the 1910s, special and visual effects gained in complexity and sophistication, enabling filmmakers to depict fictional worlds in a credible manner, to manipulate scale or perspective, to extend a set or a location, and to enhance an actor's performance.

As the film industry shifted from the East Coast to Los Angeles, and as production increasingly took place largely on studio lots, glass shots and in-camera mattes (pioneered by photographer and special effects artist Norman O. Dawn) became important means for creating credible fictional worlds without filming on location. In turn, techniques that joined or layered together elements filmed at different times into a single shot (through double exposures and split-screen techniques) improved over time as new technologies enabled more extensive and perfectly timed and matched illusions. For example, as North discusses, such illusions included well-known stars such as Mary Pickford playing different characters that seem to appear together in the same shot. Hence, as North makes clear, special and visual effects continued to offer moments of spectacle and astonishment that exceeded story, setting, or characterization, and provoked moments of fascination that foregrounded the capabilities of moving picture technologies and artistry, all the while ensuring that the tools and techniques that made them possible remained concealed.

In certain genres of the classical period and the New Hollywood, such as musicals of the 1930s or science fiction films of the 1970s and 1980s, we can understand spectacular effects to have functioned at some level as "attractions" of sorts—as moments of spectacular and even (in the case of science fiction) sublime displays that provoke affective responses (wonder, awe, astonishment).[23] However, as several scholars have argued, when it comes to feature-length narrative cinema, one has difficulty severing such moments entirely from a film's development of narrative, thematic concerns, or character development.[24] Moreover, one must keep in mind that special and visual effects range from ostentatious shots or sequences to those that are completely subordinate to the overall aesthetic of setting and mise-en-scène. Indeed, in her discussion of the modern entertainment marketplace, Tanine Allison discusses how the increased use of the Digital Intermediate (DI) and the development of new software programs expanded the domain of digital visual effects into new areas of production and postproduction. In the process, she explains, these technologies enabled a broad variety of effects work, ranging from elaborate spectacular

digital effects (as in *Avatar* [James Cameron, 2009]) to the creation of credibly (photo)realistic historical settings and locations (such as the depiction of 1920s Los Angeles in *The Changeling* [Clint Eastwood, 2008]) to invisible corrections and the elimination of unwanted elements from a shot.

Technology and Special/Visual Effects

Over the course of time, the technologies and techniques used by effects artists have become more refined and sophisticated, thereby facilitating a significant increase in the ability to manipulate the image (which artists can now accomplish at the level of the pixel) and to composite numerous elements of different origins into a single, cohesive image. To be sure, the availability of certain technologies and their affordances do not themselves determine how or when filmmakers will use them; rather, a broad range of influences comes to bear upon the implementation and exploitation of old and new technologies and practices, including industrial, economic, and cultural shifts (e.g., the rise of a genre or the movement of media texts across platforms), changes in film style and aesthetics, shifting labor practices and policies, and technological change in other areas, such as new developments in film stock, sound, and color.

The histories of rear projection and optical printing techniques are instructive here. As Ariel Rogers explains, the rise of synchronous sound in the late 1920s required shooting conditions that would allow sound technicians to maintain control over sound, with particular emphasis on ensuring the prioritization of dialogue on the sound track. Shooting on a soundstage created the optimal conditions for sound recording, which led to increased use of miniatures, matte paintings, glass shots, optical printing, and other techniques that allowed effects artists and cameramen to combine principal action with background footage shot on location or created, for example, with matte paintings. Chief among these was rear projection. This compositing technique was in widespread use in the 1930s and 1940s—so much so that Rogers argues that the increased use and expanding dimensions of the transparent screens used for rear projection, along with the other special effects, led to the construction and proliferation of diegetic spaces "increasingly mediated not only through the expansion and pervasion of screens but also through the layering of image planes receding into the depths of the diegesis."

However, during the 1950s and 1960s, the expanding dimensions of widescreen formats such as Cinemascope and VistaVision, along with an increased use of color processes such as Technicolor, gave the moving image greater clarity, which in turn made some effects—especially rear projection—appear less transparent once projected onscreen. Turnock explains that despite some technological improvements to rear projection in the 1960s (such as MGM's "Tri-Lace" system), in the 1970s optical printing (used widely since the 1920s to create wipes, fades,

split screens, and matte shots) became the favored technique for producing composite images. To be sure, each practice posed its own problems: while color rear projection could result in visible differences in the picture quality of the conjoined elements (creating what Turnock describes as a "planar effect"), composites created with the optical printer could result in visible "matte lines" (appearing as a fringing or a dark outline) that revealed where the different elements of a shot had been joined together. In the late 1970s, computer-controlled motion control rigs (developed at Industrial Light and Magic [ILM]) helped create "clean" traveling matte optical composites and greatly enhanced the complexity of composited images, allowing effects artists to combine and layer a greater number of elements deriving from different origins into a single, coherent mise-en-scène. In the 1990s, digital alternatives to the optical printer (discussed by Purse and Allison) eliminated visible traces of compositing techniques.

Most recently, the development of digital technologies has given rise to an increased reliance on visual effects in the construction of diegetic space and spectacular effects sequences. The use of CGI (images and even characters that are created entirely in the computer and later composited with live-action elements), in particular, has provoked concerns over the move away from cinema's photographic base and the loss of the indexicality of the film image (the material or physical connection between an object and its photographic sign, created by the camera's indifferent, chemical registration of the object's image). Scholars have noted that while this may be a significant problem for, say, documentary films that are making truth claims based on photographic evidence, the case is quite different for the use of special/visual effects in fictional narrative films, which have always been harnessed to the goals of fabrication, illusion, and even trickery.[25] As the chapters in this volume show, since the beginning of film history, filmmakers and effects artists have organized their work around the production of credible illusions and the synthesis of numerous different elements of a shot into a unified, integrated "whole" that seems to have existed materially as a continuous spatio-temporal formation before the camera during principal photography.

Whereas in the past such shots might have been composed of matte paintings, photography, miniatures, and live action combined via the optical printer, today they might be composed of numerous CG elements and live-action shot against a greenscreen and composited digitally. In each instance, effects artists use historically available tools to create the credible illusion of action taking place before the camera (or "camera") in a setting that never existed as such in space and time. Despite the ontological differences between analog and digital effects (between the material matte painting and the immaterial digital matte painting), the goals of effects artists have remained fairly consistent throughout film history, even if new digital tools have greatly increased the degree of control an artist has in creating and manipulating the various elements that compose an effects shot or

sequence. Hence, as Stephen Prince has argued, "Visual effects in the narrative film maintain a continuity of design structures and formal functions from the analog era to the digital one. Digital visual effects build on stylistic traditions established by filmmakers in earlier generations even while providing new and more powerful tools to accomplish these ends."[26]

To be sure, older analog effects—including the use of makeup effects, miniatures, animatronics, models, and mechanical effects—continued to be used throughout the final decades of the twentieth century and into the twenty-first century, often in conjunction with digital visual effects. Lisa Purse provides ample evidence to support a revision to recent histories that have overemphasized the use of digital visual effects in the 1980s and 1990s, and explains that the use of both analog and digital visual effects "depended upon the constantly shifting intersection of artistic, economic and technological imperatives." Numerous films, particularly science fiction films and horror films such as *The Terminator* (James Cameron, 1984), which featured facial prosthetics and robotics by Stan Winston, and *The Thing* (John Carpenter, 1982), continued to make extensive use of miniatures, makeup effects, puppetry, and animatronics. Purse notes that whereas lower-budget examples sometimes employed such effects in a manner that suggests nostalgia for effects work from past eras, others aimed for the smooth integration of analog and digital effects, as in *Jurassic Park* (Steven Spielberg, 1993), which featured both CG and animatronic dinosaurs. As render times shortened and computer technologies became more efficient and affordable, digital visual effects gave filmmakers ever more precise control over the image in postproduction. Purse argues that we should understand the final two decades of the twentieth century as a period during which a "diversity of practices," analog and digital, were developed, refined, and put to use.

Changes in Labor and Disciplinary Boundaries

The development and implementation of digital visual effects technologies and practices has significantly changed other practices and forms of artistry, much as the arrival of sound, widescreen, and color transformed special and visual effects in earlier eras. These include cinematography and editing as well as acting and performance. For example, Allison examines how motion-capture technologies have been developed for optically recording the bodily and (later) facial performances of actors. Effects artists can apply motion-capture data to key frame animation and new software programs to create fictional "hero" creatures such as Gollum in *The Lord of the Rings: The Two Towers* (Peter Jackson, 2002), Kong in *King Kong* (Peter Jackson, 2005), and the Na'vi in *Avatar*. Along with the development of technologies that allow an actor's facial performance to be composited with the live-action bodily performance of another (stand-in) actor, motion capture and other digital effects practices have led, Allison argues, to

an era in which "the line between visual effects and film performance—never totally clear—is rapidly breaking down." In turn, the increased reliance on the work done in computer-generated previsualization (the rendering of a film, shot by shot, in low-resolution animation prior to production) has, Allison explains, increasingly merged the separate crafts of cinematography and editing with visual effects, thanks to new digital workflows.

The various industrial, technological, cultural, and economic shifts that have shaped changes in the American cinema throughout the twentieth and twenty-first centuries have, of course, transformed the labor and culture of effects work over time. Whereas the classical era's thriving studio system fostered the growth of in-house effects departments and spurred many innovations (as discussed by North, Rogers, and Turnock), by the end of the postwar era, shrinking studios were often forced to eliminate their effects departments altogether, leading to the creation of independent effects houses beyond the confines of studio walls. And while innovation continued apace within independent effects houses, new workflows have created changing labor conditions for visual effects artists, particularly in recent years. Effects artists must contend with the highly competitive "project bid system" for securing contracts, which encourages companies to place fixed bids that are actually lower than the cost required to complete the work for a film—an industry practice that has resulted in the collapse of prominent, independent visual effects houses in recent years (discussed by Turnock, Purse, and Allison). This system has also led to narrowing areas of specialization, and the contracting of numerous small effects houses located around the world to complete the digital visual effects for a single film.

As this summary suggests, one can scarcely reduce the complex history of optical, special, and visual effects to the spectacular visual effects seen in recent superhero and science fiction films. Even so, the cinema's digital turn and the ensuing proliferation of CGI and digital visual effects have prompted theorists and historians to turn their attention to the long history of effects practices and technologies that have been marginalized in cinema and media studies. And while greater attention has been paid to editing, the close relationship and, at times, intertwined histories of editing and special/visual effects have received less attention, despite their shared origins in the trick film. As editing and effects work developed into separate disciplines that found themselves increasingly harnessed to the purposes of storytelling, they frequently aided each other in achieving their respective goals. While visual effects have helped to create certain types of transitions between scenes, such as overlapping dissolves and wipes, editing has, in turn, helped bolster the credibility and transparency of special and visual effects. For example, well-placed cuts in the transformation scenes in *Dr. Jekyll and Mr. Hyde* (Rouben Mamoulian, 1931) combine with the use of colored lenses, makeup, and other special and optical effects to enhance the illusion of Jekyll's continuous metamorphosis into Hyde over time.

In later years, rapid cutting (along with darker lighting) helped bolster the realism of fantastical creatures fabricated with the help of animatronics or CGI by reducing the amount of time effects shots appeared on screen and, therefore, the amount of scrutiny brought to bear upon them; one can find such examples in the action sequences featuring dinosaurs in *Jurassic Park*. In turn, digital transitions and blending techniques are often deployed to join separate shots and create the illusion of a single, uninterrupted long take—as in, for example, *Children of Men* (Alfonso Cuarón, 2006).[27] As Allison explains, since 2000, editing and visual effects have increasingly worked together to shape an actor's performance. Although editors have always had the capacity to modify an actor's performance by cutting between shots, that ability has been enhanced, as digital technologies now allow editors to edit *within* a shot to make minute changes to a performance. Whereas throughout much of the twentieth century, editing and visual effects most often took place only after production had been completed, both practices are now a routine part of the previsualization process that precedes production. Allison notes that "in a reversal of conventional practice, editing and visual effects therefore often precede the production phase, determining how the shots will be filmed/constructed beforehand rather than manipulating them afterwards. In the form of CG previsualization, visual effects now stand at the very origin of the editing process."

As the twelve chapters in this volume show, the complex and at times overlapping histories of editing and special/visual effects have been shaped over the course of the past 120 years or so by a broad range of artistic, technological, economic, cultural, and industrial forces. Together, they make the strong case that we must contextualize and understand more recent historical transformations in relation to the varied influences that have shaped both disciplines from the moment that the practices of editing and special/visual effects were engendered by that first "cut" in *The Execution of Mary, Queen of Scots*.

1

THE SILENT SCREEN, 1895-1927: Editing Scott Higgins

By the late 1920s, Hollywood filmmakers constructed time and space in the editing room, weaving it from flexible fragments held together by character psychology and story. Cinematic actions and geographies were determined not so much by the event occurring before the camera as by the ordering of shots. The path from the advent of projected films around 1895 to this fully functional system of narrative editing was an uneven one, traversed in fits and starts. Comparing the practices of film editors in cinema's early period (before 1906) and transitional period (1907–1913) affirms Thomas Elsaesser's observation that "change is not linear, but occurs in leaps: not on a single front, but in more jagged lines and waves."[1] Fundamentally different concepts underlie the editing in films from the early and late silent era, and yet most of the techniques we associate with storytelling appeared in some form before 1906. Once the film industry became organized around selling narrative experiences, roughly by 1905, filmmakers concentrated on solving problems of clarity. Editing was central to their efforts, and it was shaped by the twin demands of engaging viewers in the story and keeping them oriented in space.

This chapter considers the development of editing into a central means of articulating drama during the first two decades of commercial cinema, specifically analytical editing or scene dissection, the technique of cutting to different

camera angles in a continuous scene. A subtle means of controlling information and setting rhythm, analytical editing formed the backbone of scene construction during the studio era. It was a relatively late addition to the narrative filmmaker's toolbox, in part because staging and composition could adequately clarify most action played in a continuous shot. Filmmakers experimented with breaking the tableau cautiously and for specific reasons between about 1909 and 1917. Methods and motivations for changing angle accumulated until both audiences and filmmakers accepted that cinematic space should be fragmented and rebuilt according to dramatic needs.

Cutting in Early Cinema

Editing, conceived as joining two pieces of separately shot film, probably emerged in late 1896 with the advent of a loop that eased tension and allowed projectionists to assemble up to twelve single-shot movies on one reel. This practice had its roots in the magic lantern tradition of itinerant showmen who organized hand-drawn and photographic slides into thematic and narrative presentations.[2] Producers sold films on a shot-by-shot basis, but sometimes suggested they be grouped together into longer units. Queen Victoria's Jubilee procession in 1897 was a watershed event, as it yielded multiple views gathered by camera operators stationed along the route. Stephen Bottomore suggests that projectionists who assembled various shots onto single reels practiced an early form of contiguity editing, or following a single action through multiple, connected, spaces.[3] By the close of 1898, exhibitors were splicing together the rounds of boxing matches, tableaux depicting the stages of the cross in Passion Plays, actualities of fire brigades responding to alarms, and other thematically grouped shots into continuous presentations.[4] Editing was the province of projectionists who selected and arranged fragments of space and time into short programs.

Trick films, meanwhile, presented the earliest examples of editing ongoing action within a single space. Edison's *The Execution of Mary, Queen of Scots* (1895) features the substitution of a mannequin for an actress across a cut to create the impression of her decapitation. In 1896, when Georges Méliès used the technique in *The Vanishing Lady* to turn his assistant into a skeleton, he embarked on a career of miraculous transubstantiations. As Tom Gunning points out, the substitution edit was meant to be literally invisible, masked by the "continuity of framing."[5] This kind of continuity placed creative responsibility in the filmmaker's rather than the projectionist's hands, and required the strict control of space to create the illusion of unbroken time, a fundamental basis of scene dissection.

Generally, filmmakers before 1906 treated the continuous shot as an autonomous unit in which all action occurs within a given space from a single viewpoint.

Edwin S. Porter's 1903 Edison film *Life of an American Fireman* famously demonstrates this principle in the scene of firefighters rescuing a mother and child from a burning room. In one tableau, framed from within the room, a firefighter climbs through a window, carries the mother out, and then quickly returns to retrieve her baby. The next shot shows the action repeated from outside the house, as the rescuer climbs his ladder, enters the room, and reemerges to carry the woman to safety. She then begs him to return for her child, which he does. For Porter, simultaneous actions needed to be depicted in succession.[6] When filmmakers did break the tableau or interrupt continuous action, they did so for specific, spectacular effects, what Tom Gunning calls "attractions." For example, in *The Gay Shoe Clerk* (also 1903), Porter cuts from long shot to close-up to exhibit a young lady's lower leg as the eponymous clerk fondles her calf. Gunning views this close-up, and others like it, as a novelty used not "for narrative punctuation, but as an attraction in its own right."[7] Porter, in fact, was bringing together techniques from other attraction films.[8] The closer view is a one-off effect, a demonstration to the viewer of the camera's ability to magnify objects, a power readily displayed in earlier attraction films like *Grandpa's Reading Glass* (AMB, 1902). The fact that Porter would cut in to the customer's leg in *Gay Shoe Clerk* but not the suffering baby or the crying mother in *American Fireman* testifies to early cinema's priorities; spectacle, not narrative clarity, was a compelling reason to edit.

Telling Stories: Cutting between Spaces

Filmmakers first harnessed editing to the tasks of storytelling by cutting between spaces. Charles Musser notes that several factors, including rising audience demand and the threat of imports, led American producers to concentrate on story films between 1903 and 1905.[9] In 1904, Biograph was the first studio to consolidate editorial control of its films as part of its move toward fiction.[10] The shot was increasingly subordinated to narrative as the basic unit of production. A key genre in this transition was the chase film, which links successive spaces together through character movement. Biograph's *Personal* (1904), for instance, depicts a horde of women pursuing an eligible bachelor over fences and across rivers through eight shots. Each composition is sustained until all figures exit the foreground, and then in the next shot they enter the background and encounter another obstruction. The chase offered an easily comprehensible and extensible narrative framework, which could be packed with gags and attractions. Chase films remained popular until around 1908 and, according to Charlie Keil, the genre was "the most influential model of narrative construction" among early story films.[11] Their rudimentary structure instituted the principle of linearity: each successive space followed a continuous action that moved forward in time. Between 1907 and 1913 editors built on this basic linearity to construct

increasingly complex narratives. Characters exiting one shot and entering another became a common means for establishing contiguity. After 1909, filmmakers relied on contiguity cutting to unify spaces, and set designs that placed doors to adjoining rooms at the edges of the frame clearly marked an actor's movement from shot to shot.[12]

Once editors could depend on viewers to assume that shots were successive, they could create the impression of simultaneity by alternating between actions occurring in two or more spaces. Scenes of the hero's race to the rescue, rendered in chase-film contiguity, were intercut with scenes of a victim's imperilment, with both lines of action converging in the nick of time. Few sequences better illustrate the technique than the climax of D. W. Griffith's Biograph short *An Unseen Enemy* (1912). Dorothy and Lillian Gish play adolescent orphans, left alone in their country home with a large sum of money in the family safe while their older brother (Elmer Booth) bicycles to his office. The girls' "slattern maid" (Grace Henderson) and her criminal accomplice (Harry Carey) lock the girls in a sitting room while the villains attempt to bust the safe in the adjoining parlor. To prevent the girls from escaping and to conceal her identity, the maid holds a gun on them by reaching through a small hole in the wall between the rooms (an unused stove-pipe hookup). The maid, drinking heavily, becomes increasingly trigger-happy by the minute. Mad with fear and rage, the brother commandeers a passing auto and races to his sisters' aid.

Griffith directs viewer expectations with impeccable timing. From the moment that the older sister phones her brother, Griffith alternates among three lines of action: the sisters in the parlor, the villains in the front room, and the brother and his assistant in his office and then on the road as they race home. Action shifts among distinct locales at a blistering pace; Griffith alternates a full thirty-seven times (most often between the sisters and their brother) in about five minutes. Just as the younger sister (Dorothy Gish) approaches the gun, the brother's car becomes trapped on a swing-bridge, which is rotating to allow a boat to pass. The younger sister faints as the maid's gun turns to point directly at her head, and her older sister covers her body with her own. Time moves achingly slowly at the bridge but with tragic swiftness in the sisters' room. For the thirty-eighth shift, Griffith introduces a fourth line of action, the younger sister's rejected boyfriend moping about the estate. From this point, the lines of action quickly converge. Crosscutting allowed filmmakers to shape story time to precise dramatic needs. As soon as the solution to the dilemma becomes apparent, Griffith permits both brother and boyfriend to cover ground efficiently. In four more alternations the boy has arrived at the sisters' window, and, four more crosscuts after that, the brother's car arrives on the scene. In tracing the evolution of this schema, which began around 1908 in Pathé films, Gunning notes that Griffith pushes crosscutting to the center of his storytelling system and "makes the progression of time palpable through

its interruption, imposing a rhythm on the unfolding events."[13] Parallel editing intervenes in the flow of events, expands and compresses time, and orchestrates viewer expectations.

Analytical Editing: Breaking Tableaux and Building the Scenes

Crosscutting and contiguity editing juxtaposed actions filmed in different locations and on different pieces of film. The adoption of cutting on angle within a single space was surprisingly gradual, considering its eventual importance. According to Barry Salt, the angle change remained quite rare before 1913, "unless the camera was forced away from the standard move straight down the axis by the physical nature of the set or location."[14] Two practices, the insert shot and the emblematic shot, helped ease editing into the continuous scene. From around 1909 onward, inserts of notes and letters served to clarify narrative in a manner equivalent to an intertitle. Some inserts took on the quality of cut-ins as filmmakers began to integrate them into the ongoing action by including characters' hands or other elements of the surrounding mise-en-scène. Meanwhile, the practice of including closer shots of characters at the start or close of a film to help sum up its general identity gave way to character introductions anchored within the story world.[15] The practice became generalized in 1912, when American filmmakers were cutting directly in from a longer shot with some regularity.[16] Still, where editors were crafting dynamic stories by cutting between established locations from 1909 onward, they remained cautious about fragmenting a single space. Filmmakers appear to have required a specific and compelling reason to introduce a new perspective on a preexisting space.

The process by which changing the angle within a space, as opposed to directly cutting in, became a common tool reveals how filmmakers negotiated formal innovation. Moving the camera forward for a closer shot maintained obvious spatial orientation because visual information was repeated across the edit. Pointing the camera in a different direction, on the other hand, threatened to fracture the tableau beyond recognition. Perhaps the earliest example of cutting to a significantly different angle on a single space occurred in Bamforth and Co.'s comedy from 1900, *Ladies' Skirts Nailed to a Fence*. The film consists of three shots:

1. Two women stand before a small fence, conversing.
2. On the other side of the fence, two young men sneak up and nail the women's dresses to the fence.
3. In a return to shot 1, the women angrily thrash about, having discovered their plight.

As noted by Salt and Noel Burch, the film is remarkable for simulating the 180-degree cut by keeping the camera in place and moving the actors.[17] Across the edit, Bamforth has the ladies move to the other side of the fence and turn their backs, so that the young men can enter the foreground. The cut is necessary to explain the gag, but instead of reorienting the camera and revealing a new space, the filmmakers found a solution that maintained almost all visual cues. In fact, the restaging between shots preserves actors' positions across the cut: the woman in black remains on the right, and the woman in white on the left. *Ladies' Skirts Nailed to a Fence* exhibits a compromise between spatial and narrative clarity: a hesitation to alter camera angle that would continue into the transitional era.

Some films of the early period promoted the change in angle to the status of attraction, much like the close-up in *The Gay Shoe Clerk*. Biograph's 1904 *The Story the Biograph Told*, for example, makes the angle change the subject of the story. An office boy secretly films his boss's affair with his secretary. Later, the boss and his wife attend the cinema where the boy's film is screened and the illicit act revealed. The scene screened at the cinema presents the action previously shown in a frontal shot from an alternate angle, near the rear of the set. Keil suggests that the scenario points to film's ability to manipulate time and repeat the past.[18] It also showcases the angle change by concocting an explicit narrative rationale for it.

Changes of angle, which today appear routine, were occasioned by special circumstances. For instance, Eileen Bowser explains that a cut to a medium shot of Napoleon and a child in Vitagraph's *Napoleon, The Man of Destiny* (1909) followed the convention of framing children closer than adults.[19] Similarly, Keil notes two films from 1911 in which vehicles moving through the frame forced a cut.[20] The accumulation of circumstances accustomed editors to the tool, and analytical cutting emerged as the default system for transforming space into story.[21] We can trace the growth of analytical editing by considering three films from near the start, middle, and end of its development: D. W. Griffith's Biograph drama *A Drunkard's Reformation* (1909), Barry O'Neill's short comedy for Lubin, *Auntie's Affinity* (1913), and Cecil B. DeMille's Paramount feature *The Cheat* (1915). All of these productions are significant for dissecting scenes on interior sets into spatial fragments.

A Drunkard's Reformation: Spectator and Stage

Griffith's one-reel film features an extended sequence of 180-degree cutting on a set representing a theater. The drunkard of the title (Arthur Johnson) attends a production of Emile Zola's *L'Assommoir* with his daughter (Gladys Egan), where he recognizes his moral failings and reforms for the sake of his family. Griffith depicts this character change through eighteen alternations between the hero

and his daughter in the audience and the production onstage. These cuts break space down to an unusual degree, but several factors keep viewers oriented. An initial long shot from behind the audience establishes the setting and shows the father and daughter taking their seats. Once alternation is under way, the edge of the stage, a rope running along the bottom of the frame, and a curtain that opens at the start of each act clearly distinguish shots of the proscenium from those of the audience. There can be little confusion about which events take place in the play and how they relate to the story world. Since space does not overlap from shot to shot, there are no confusing reversals of screen direction when the camera faces audience or stage. Most important, the theater, an obviously familiar space for spectators, presented a special circumstance. Bowser and Salt note the importance of "spectator sequences" to the early use of reverse shots, and it makes sense that filmmakers could count on shared knowledge of architecture to insulate against confusion.[22] Theatrical situations also center on the act of watching, which motivates the analysis of space by binding camera reversal to character point of view. For Griffith in 1909, the theater setting helped naturalize editing, providing a rationale for formal experiment.

The narrative as a whole prepares the way for this scene dissection. Tom Gunning cites the sequence as an example of Griffith's psychological editing. Alternating between Johnson's reactions and the play conveys his internal development "from bored restlessness to increasing concern, to his final realization of the play's relevance to his life."[23] From its opening title that announces "The Most Powerful Temperance Lecture Ever Depicted," A Drunkard's Reformation primes the viewer to anticipate this scene of character change. Tableaux that show the father drinking while his wife (Marion Leonard) and child await him, and his abusive behavior upon returning home, clearly set out the problem that his trip to the theater must solve. If the parallels between the stage play and the earlier tableaux should prove too elusive for viewers, an intertitle clarifies: "A timely message! His own shortcomings mirrored in the stage play." Griffith grants the editing enormous narrative significance but limits it to the theatrical setting, and this typifies the caution with which transitional filmmakers first approached the analysis of space. Though far more complex than The Story the Biograph Told, A Drunkard's Reformation, like its 1903 predecessor, feels compelled to justify and explain angle change.

Auntie's Affinity: Lobby Talk

Four years later, Barry O'Neill's cutting in Auntie's Affinity appears comparatively fluid and confident. The one-reel romantic comedy takes place mainly in a hotel where Aunt Amanda (Mrs. George W. Walters) attempts to prevent her niece Marie (Marie Weirman) from consorting with the desk clerk (Clarence Elmer).

When she unwittingly falls in love with Pietro (Peter Lang), the hotel chef, Aunt Amanda is undone by her hypocrisy. To everyone's relief, Pietro reveals himself to actually be the Count of Montevideo and the desk clerk reveals himself to be the hotel proprietor's son, making both romances legitimate. Most of O'Neill's cutting follows trends of the period. He frames scenes from single camera positions broken by inserts of notes, announcements, and a small but important engagement ring. He cuts directly in for a scene of Marie on the telephone, a convention that Salt traces back to French films of 1908, and occasionally alters camera position upon returning to a space seen earlier, a practice that Keil notes emerged around 1909.[24]

On the set of the hotel lobby, however, O'Neill gets adventurous. The set offers a total of eight different camera setups to generate seventeen shots across the film. This degree of dissection is especially remarkable for an interior set. By 1912 reverse angle cutting had begun to proliferate for exterior shooting, where filmmakers were not limited by partial sets, were eager to display the landscape, and often staged large-scale action scenes.[25] In contradistinction to prevailing practice, O'Neill's set is never seen whole, but is divided roughly into two playing areas with eleven shots depicting the left and six the right. The leftmost wall of this three-sided set splays obliquely outward, a design that accommodates various perspectives without revealing the missing fourth wall. All camera positions can point toward the rear, but at widely diverging angles.

Comparison to a similarly divided kitchen set in D. W. Griffith's film *The Lady and the Mouse*, also produced in 1913, highlights the extent of O'Neill's experimentation. In this more famous example, Griffith offers an establishing shot depicting both halves of the kitchen set, followed by two closer parallel views that split the space into left and right playing areas. All three camera positions are frontal, with the two closer shots essentially functioning as axial cut-ins to contiguous spaces. *Auntie's Affinity*, by contrast, cuts between opposing angles and the left and right spaces do not overlap until quite late in the film (the forty-third of sixty-three total shots). Where Griffith dissects and linearizes a tableau, O'Neill implies a more fully three-dimensional space. The absence of a physical threshold to mark contiguity between shots, as well as the abandonment of strict frontality, more fully integrates viewers into cinematic space.

O'Neill relies on glances and a directional match on action to join the halves of his set. The left side of the lobby features a reception desk and switchboard along the left wall, and an elevator and bellhop bench at the rear. The door to the hotel restaurant dominates the far right wall, opposite the desk. These two spaces are first connected when Aunt Amanda exits frame right from a shot angled toward the reception desk and enters frame left into a medium shot facing the restaurant door. O'Neill then reinforces contiguity by alternating between the two halves as Aunt Amanda orders her niece away from the desk and berates the clerk for his flirtatious advances. Marie's subsequent entrance into Aunt

FIGURE 2: Screen direction and glance join the halves of the lobby set in *Auntie's Affinity* (1913).

Amanda's frame, and a series of sight links between Aunt Amanda, who glances off foreground left, and the desk clerk, who responds toward the right of his frame, stitch the lobby together (see figure 2). Indirect cues of action and glance rather than shared topography synthesize the whole. In this way, O'Neill's lobby calls on viewer inference in a way that *The Lady and the Mouse* does not. The angle changes center spectators in a dramatic architecture by positing already-seen spaces somewhere beyond, and nearly behind each camera position.

As in *A Drunkard's Reformation*, the scene dissection in *Auntie's Affinity* builds on a specific convention. As Ben Brewster notes, early instances of reverse cutting were centered on fights and acts of aggression.[26] One of the earliest examples of the technique, for example, occurs in Essanay's Western *The Loafer* (1912). Filming outside, director and star Arthur Mackley cuts back and forth between the hero and a belligerent tramp who berates him. The brief exchange quickly escalates into a chase and struggle between the men.[27] Mackley was perhaps adapting the type of reverse cutting typically used in exterior action scenes (as noted by Keil) to a personal confrontation. For his part, O'Neill moved the verbal altercation indoors and extended the exchange of shots. As Aunt Amanda and the desk clerk trade barbs, editing gives focus to each character and supports the rhythm of their argument (see figure 3). The combatants' glances and gestures toward the camera anticipate the shot/reverse-shot pattern that became

FIGURE 3: Glances and gestures anticipate shot/reverse-shot editing in *Auntie's Affinity* (1913)..

standard for depicting conversations around 1917, but which was not yet gener-
alized beyond special circumstances. The verbal altercation, like the spectating
sequence in *A Drunkard's Reformation*, supplies a specific motivation for analyt-
ical editing.

In the absence of a confrontation, with its strong directional cues and eye-
lines, O'Neill includes spatial overlap between his shots to more clearly connect
the parts to the whole. For example, when the film returns to the restaurant door
on the right half of the lobby later in the film, the camera is placed farther back
so that portions of the set's left side, such as the bellhop bench and a large leather
chair (which has been cheated), appear in the frame. In 1913, scene dissection
remained a cautious practice tied to a steadily accumulating but narrowly delim-
ited set of rationales.

The Cheat: Drama in Court

Several factors conspired to make scene dissection more common in 1915. Films
grew longer between 1914 and 1917, and editors turned to cut-ins as a means of
reducing tedium and adding variety to scenes.[28] At the same time, as Kristin
Thompson notes, film performance changed to a facial acting style that rewarded
closer framings.[29] The increase of dialogue titles in feature films further eroded
the integrity of the single-shot scene.[30] In addition to inserts, titles, and cut-ins,
changing angle within a continuous space became an established tactic in 1915,
though, according to Salt, as late as 1919 major directors still "tended to restrict
the device to one or two major climaxes."[31] *The Cheat* participates in and illus-
trates this formal trajectory. DeMille's high-budget production is best known for
its innovations in artificial lighting and low-key cinematography, but it also fea-
tures audacious scene dissection in its courtroom climax.[32] Businessman Richard
Hardy (Jack Dean) faces trial for allegedly shooting his neighbor, the wealthy and
mysterious Hishuru Tori (Sessue Hayakawa). In truth, Richard is taking the rap
for his wife, Edith (Fanny Ward), who gunned Tori down during an attempted
rape. When the jury finds Richard guilty, Edith dramatically reveals the scar that
Tori burned into her shoulder on the night of the shooting, thereby sacrificing her
reputation, setting off a courtroom riot, and clearing her husband of all charges.

For most of the film, with the notable exception of the altercation in Tori's
salon, DeMille, who also edited the film, refrains from changing angle, but
during this climax he ferociously splinters space. The sequence consists of
eighty-four shots (including titles), and many 180-degree reversals, gathered
from thirty-eight different camera positions. Like O'Neill, DeMille never brings
the space together into a coherent single view. The scene's establishing long shot,
taken from the very rear of the courtroom, consigns the central playing area to
the distant upper right-hand corner of the screen (see figure 4). Though we can

FIGURE 4: The courtroom establishing shot in *The Cheat* (1915).

identify the judge's bench and the audience, the scale and angle obscure our view of the main characters. Instead, we must construct the unified space from seventeen camera positions oriented in the direction of the bench, nineteen toward the audience, and two facing the jury. A certain reliance on spatial abstraction has been built into the space. DeMille uses a two-sided L-shaped set, with the bench and witness stand at the rear and the jury seated against a long wall on the left. This open design affords angles toward the bench, jury, or the audience, as long as the camera remains oriented toward the long wall. Though large, the minimally constructed set does not support grand views of the action.

Like Griffith's theater, DeMille's set mobilizes formal and narrative potentials inherent to spectating situations. Burch points out that courtroom sets in early and transitional cinema offered "a profilmic situation (that) reproduces a 'theatrical' one."[33] This allows DeMille to fragment space and use reverse angles after a rudimentary sketching out of the audience and performance areas. By 1915, this convention supports spatial breakdown far in excess of Griffith's singular views of stage and spectator. Fragmentation results in ambiguity, but it doesn't slow the story. For instance, it is impossible to establish a concrete relationship between the area that Richard and Edith occupy and the judge's bench, and shots of the defense are too tight to draw obvious contiguity between that area and the set as a whole. Remarkably, the scene withholds a frontal long shot of the judge's bench until after crowds have besieged it and obscured a clear view. The scene lacks redundant cues and spatial overlap such as O'Neill provides, and so viewers are never quite as firmly anchored in a total space. DeMille inscribes a rough sense of relations through the directions of glances and exits/entrances to and from the

frame. The courtroom grants greater fluidity than the hotel lobby, and DeMille appears less concerned with spatial clarity.

Instead, he prioritizes character reactions. Increased scene dissection coincided with mounting narrative complexity in feature films. Commenting on the history of editing in 1923, DeMille recalled that "the soul action, the reaction of the mentalities concerned . . . is something you can only get by a flash to a close-up or semi close-up."[34] *The Cheat*'s drama hinges on the conflicting goals and desires of four or five parties: Richard intends to sacrifice himself to spare Edith public humiliation; Tori, who resents and desires Edith, toys with revealing the truth; Edith, the social butterfly, values her standing among the elite but now feels guilt over her husband's predicament; Edith's scandal-obsessed social set relishes every detail from the court gallery, while the judge and jury strive to uncover the truth. To depict these various motivations and reactions, DeMille breaks down and assembles space according to "the reaction of the mentalities concerned."

For example, consider the depiction of Tori's answer to the question "Who fired that shot?" From a medium shot of the villain glancing slowly offscreen right, DeMille cuts to a high angle close-up of Edith from her right side, as she raises her head and widens her eyes. An iris cooperates with the high angle to eliminate her surroundings; the apex of spatial abstraction coincides with the height of narrative tension. When the film returns to Tori, he is also framed in a close-up. He subtly narrows his eyes, keeping them locked to the frame's right

FIGURE 5: Cutting between four closer shots articulates a dramatic turn in *The Cheat* (1915).

edge as a dialogue title intervenes: "Richard Hardy shot me." DeMille returns to Tori's close-up, and then cuts to a medium shot of Edith and Richard, clasping hands at their desk in front of the gallery (see figure 5). Shot scale continues to slacken with a cut to Tori, the judge, and the prosecutor framed in medium-long shot from over the defending lawyer's shoulder. The cut to Edith delays the dramatically charged answer, and Tori's close-up amplifies it. When the pressure momentarily eases, the camera backs away from its subjects, gives them room to breathe, and delivers more spatial information. Shot scale follows the moment-by-moment stakes of the story, allowing us to situate Edith and Richard only after the urgency has passed. The caution that marks our examples from 1909 and 1913 has largely disappeared: story determines space.

Scene Dissection, Storytelling, and Late Silent Hollywood

In its climax *The Cheat* approaches the flexibility and litheness of classical Hollywood editing, but scene dissection is not the default procedure. Limited to the courtroom and reserved for the only scene that brings all the parties together in a single space, cutting on angle remains a specialized tool, all the more powerful because it is not yet the norm. *The Cheat's* negotiation of spatial and narrative engagement seems distinctive of the transitional era. But the film is also on the cusp of analytical editing's massive expansion. According to Thompson, "Guiding spectator attention through frequent shifts in vantage point, analytical editing became a familiar schema that aided the easy comprehension of all classical films [by 1917]," while Salt observes that at the start of the 1920s "a point had been reached where 20 to 25 percent of shot transitions in many American films were from a shot to its reverse-angle."[35] The accumulation of circumstances that merited angle change reached a tipping point, after which American filmmakers tended to rely on editing for most dramatic scenes.

Intensified cutting influenced and was abetted by changes in production technology. Before the early teens, editors made splices directly into the camera negative, but as the complexity of cutting grew, producers standardized the use of positive workprints. As Thompson points out, the workprint gave editors a clearer view of the action, allowed for finer adjustments, and protected the quality of the original negative, which would be used to generate release prints.[36] The use of workprints coincided with a new division of labor. Head editors made creative decisions on the workprint, while cutters or editors conformed the negative to match that print, and joiners assembled reels for exhibition.[37] Editing developed into a specialized line of work, distinct from shooting and directing, and with its own hierarchies and protocols. Matching action from shot to shot, judging dramatic rhythm, and timing character's reactions required expert precision and adeptness. As early as 1916, some editors built special film viewers to help

them evaluate their cuts, but most made their decisions using a simple light box and magnifying glass.[38] It was not until 1924 that the profession benefited from a major new technology, with the introduction of the Moviola. Magnifying the image and running it smoothly at a constant rate using an electric motor and a shutter, the Moviola gave editors newfound accuracy.[39] It quickly became standard equipment, helping cutters more efficiently meet Hollywood's standards of elegance and fluidity.

Clarence Brown's 1926 MGM feature *The Flesh and the Devil* furnishes an example of the refinement of analytical editing in the late silent era. Midway through a short scene toward the start of the film, Leo (John Gilbert) catches sight of Felicitas (Greta Garbo) alighting from her train. The action begins with Leo playfully embracing Hertha (Barbara Kent), his friend's kid sister who obviously has a crush on him. Both are framed in a medium shot when Leo freezes, gazing offscreen right, and Hertha, rebuffed, exits the frame. Leo turns slightly toward the right and we cut to the scene's first point of view, a long shot down the platform toward Felicitas as she steps from her car and gestures off right, toward her waiting carriage. Loyd Nosler, MGM's editor, returns to Leo, now framed somewhat closer and frontally, lost in reverie. Another point-of-view shot of Felicitas follows, this time a medium shot as she tips the porter and glances toward her carriage. A quick cut back to Leo confirms that this vision in soft-focus is his alone.

Cinematic space surrounds the camera, its depiction governed by a character's desire. The first point of view shifts 90 degrees, using Leo's glance to bind the two shots. The second point of view presents a full 180-degree reversal, his eyeline now passing the camera and bringing Felicitas nearer to our gaze. Scene dissection appears to follow the viewer's interest. Leo's first glance raises an enigma, resolved by the shot of Felicitas. The return to him from a new camera position underlines his interest and magnifies our intrigue. Why is he dumbstruck? The closer view of Felicitas answers our question. Where the scene began with objective shots of multiple characters and regular dialogue titles, editing now offers subjective views of single figures, uninterrupted by words. Nosler cuts to a new camera position, a long shot framed from behind Leo that gently fills in the space between characters. As Felicitas crosses to her carriage, the camera pans left and Leo turns his head to follow. The shot's place in the decoupage loads it with functions: it concretely establishes the characters' spatial relations; emphasizes Leo's captivation; reveals a new playing area next to Felicitas's carriage, toward which Leo dashes; and aligns the viewer's access to the film world with Leo's actions on screen. Without hesitation, and likely without our noticing it, the camera leaps forward to the carriage where eight more shots detail the lovers' first conversation.

Flesh and the Devil constructs cinematic space with confidence and assured clarity. Editing shapes the scene's rhythm and leads viewers through its emotional

arc. We are oriented to the degree that the story requires it, and can easily infer the whole from the parts. In fact, cutting matches dramatic interest to such a degree that part and whole appear identical: the fragments are so compellingly arranged that we have no cause to doubt their unity. This fluidity of time and space may well have reached its peak in the 1920s. The coming of sound anchored cinema to more strict continuity. As David Bordwell puts it, the silent screen's plastic duration became "more fixed in the pace of recorded speech."[40] In his chapter on editing 1928–1946, Paul Monticone explains that the sound era gave editors more power in the production process, but also strengthened norms and encouraged predictable choices. Filmmakers' conception of space and time tangibly shifted with the innovation of the master shot, which had become standard by 1932.[41] The practice of filming a scene straight through from a single camera position (the master) and then repeating portions of the action in closer shots (coverage) gave sound-era editors a standard reference point for continuity. The principles and techniques of scene dissection remained in force, but editors could begin from a whole rather than construct from pieces.

2

THE SILENT SCREEN, 1895-1927: Special/Visual Effects
Dan North

Special and visual effects changed dramatically during the silent era of the American cinema, developing from simple in-camera edits to more technologically complex effects that would remain in use well after the arrival of the sound era. While the earliest effects (called "trick effects") served as spectacular displays, effects work in the 1910s and 1920s contributed to the star system, aided emerging studios in their efforts to differentiate their products, and provided moments of magnified sensation while supporting a developing narrative. Hence, special and visual effects must be analyzed within three broadly defined periods of the silent era. These include the *early* period, often called the "cinema of attractions"[1] (1895-1907), which was marked by experimentation and non-narrative spectacle; the *transitional* era (1908-1913), during which film production and exhibition began to cohere into something recognizable as an industry and effects increasingly served story;[2] and the *classical* period of the silent era (1914-1927), when the industrial infrastructure was standardized and effects techniques were refined, subordinated to narrative, and departmentalized in production workshops.[3]

 The era of the "cinema of attractions" was a time of eclectic experimentation with the new medium and heterogeneous exhibition practices prior to the

eventual standardization of technology, production practices, and narrative cinema.[4] According to Charles Musser, the distinctive modes of production and reception in the early period give the resulting films a pronounced "presentationalism," an aesthetic that encompassed the gesticulatory performances of the actors, frontal camera positioning, and a monstrative address outward toward the spectator.[5] For André Gaudreault, "an attractional view shows spectacular events that startle viewers, an action that suddenly grips them, or an effect that astonishes and amuses them more than it tells a story capable of moving or captivating them."[6] Trick films—a popular genre of the early period—were driven precisely by this need to surprise or startle audiences with a novel view or technique. It is in this mode of display that we find the first films using what could be termed special effects.

Frank Kessler defines a "trick" (analogous here to the more modern appellation "special effect") as

> any kind of intervention which manipulates the exact rendition of the visual impression that an actual scene would provide to an eye-witness. Such interventions can happen at the level of the profilmic (e.g. through the use of reduced scale models, fake body parts, etc.), at the level of cinematic devices (e.g. double exposure, stop motion splices, etc.), at the level of post-production (as is commonly the case today), or by combinations of these.[7]

In the early period, the extreme heterogeneity of film subjects saw actuality films exhibited alongside films featuring spectacular artifice in vaudeville houses, fairgrounds, and nickelodeons. Part of the appeal for early filmgoers was the marvel of the machinery itself, an invention that could manipulate images of reality as readily as it could capture them. However, early film's "machine interest," in Stephen Heath's phrase, gradually wore off as the subject of films began to settle into genres and styles, though it would continue in an enduring fascination with (special) photographic effects.[8]

During its first twenty years, American cinema developed a conventional syntax for the construction of narrative styles that were clear, marketable, and rationally suited to the imperatives of studios that needed to increase the rate of production at lower costs. Special effects might be residual of the early period's attractionist aesthetics, but they also include techniques that were (and still are) used to tell stories and carry out narrative tasks. Charlie Keil has observed that "the eventual crystallizing of the classical style doubtless occurs at the point where novelty ceases to figure as prominently as presumed diegetic expediency."[9] But even as storytelling became the primary mode for organizing film content, the spectacular impetus of special effects did not disappear, and they continued to provide startling moments of fascination that exceed their function as narrational devices.

Substitutions

In 1895, as part of his effort to stimulate a declining market for his peephole views, Thomas Edison cut the cost of his Kinetoscope and enlisted Alfred Clark to make a slate of new films. One of these films, *The Execution of Mary, Queen of Scots*, uses a substitution cut (a form of in-camera editing) to show Mary's decapitation. Robert Thomae, the Kinetoscope Company's secretary and treasurer, played Mary kneeling at the chopping block before the camera was stopped and he was replaced under the executioner's ax by a dummy.[10] Once the camera resumed filming, the executioner carried out the beheading. When projected, the action appears continuous, and the near-perfect match from the first shot to the second shows the execution as if one were a witness at the scene. Editing would later become the key device of storytelling, but in this early film, it was used as a novelty to toy with the convention of the uninterrupted flow of moving images within a fixed frame. And while this trick was used to spectacular ends, the technique used to accomplish it is transparent.

Edwin S. Porter's *Jack and the Beanstalk* (1903), a multi-shot story film made for the Edison Manufacturing Co. (influenced by the success of the French filmmaker Georges Méliès's fairy-tale films), used a range of effects. Substitutions allow a fairy to disappear or appear, and a dissolve makes the beanstalk appear magically to fade into view in Jack's bedroom.[11] Multiple exposure—whereby the film is run through the camera more than once, with different portions of the frame masked or exposed for each pass (discussed in more detail below)—is also used to depict Jack's vision of the giant's land. When Jack chops down the beanstalk, a dummy giant falls to the ground, following another substitution cut. Dummy substitutions were also used in *The Great Train Robbery* (Edwin S. Porter, 1903): a fight atop the moving carriage ends when an actor is substituted with a dummy, which is thrown from the moving train.[12] Notably, these substitutions, like the earlier *Execution of Mary, Queen of Scots*, create an illusion of continuity (i.e., to suggest that the actor and the dummy represent *the same body*), though the same trick can also be used to create abrupt, "magical" transformations or disappearances.

Effects in a film such as *Jack and the Beanstalk* still function as attractions or "the peak moments of the show" when "aggressive moments" punctuate the action, but they are organized around the structuring framework of an unfolding causal sequence.[13] Stop-motion substitution creates a jarring, abrupt effect, especially when the connecting shots are mismatched, giving them a powerful impact when used to show a sudden transformation. Early trick effects, then, were often explosive, disruptive, and ostentatious, and they did not immediately accord with the move toward integration of spectacle and narrative or toward invisible editing techniques. Effects were gradually put into the service of narrative and made to blend with the diegetic space.

Like stop-motion substitution, many of the first photographic trick effects arose from the affordances of the basic apparatus. Frederick S. Armitage, a cameraman at American Mutoscope and Biograph, toyed with accelerated and reverse motion and time-lapse photography (filming an event intermittently, so that the action in the resulting film unfolds at a fast pace). In *Demolishing and Building Up the Star Theatre* (1901), Armitage shot one frame every four minutes of the demolition of the Star Theatre across the street from the Biograph Studios in New York City.[14] Midway through exhibition, the film would be reversed, and the building would appear restored. Exhibitors could elect to show this palindromic movie the other way around, under the title *Building Up and Demolishing the Star Theatre*. Similarly, at the start of the chase in AM & B's *The Escaped Lunatic* (Wallace McCutcheon, 1904), a scene in which a deranged inmate leaps from the window of his third-story cell is shown in reverse at the end, creating the illusion that he has vaulted back into prison. Reversal was a fairly "simple matter," producing a "curious effect" at the point of exhibition; when the trick became more popular, new technology was developed to make it easier to accomplish.[15] To run a film in reverse through the camera, the operator had to crank the machine backward, an awkward action leading to variable cranking speeds. One solution was to invert the camera on the tripod, so some cameras were fitted with a second driving spindle precisely for the purpose of facilitating reversal effects.[16] While Armitage's film had used reverse motion to show the capabilities of the apparatus, *The Escaped Lunatic* "tamed" the effect in the service of a basic story of escape, flight, and pursuit; however, the lunatic's impossible jump shows off the prowess of the machine, not that of the human body.

Though "story films" based on well-known events, literature, or plays were popular in the early period, they did not feature the kinds of editing that created narrative or spatio-temporal continuity. Charlie Keil suggests that although after 1903 films could be characterized by an increased narrative *presentation* that displaced the monstrative aspects of the film attraction, only after 1908 was there more widespread narrative *integration*.[17] Acting became conventionalized into a clearer style;[18] editing became rationalized around the clarification of spatio-temporal continuity and the achievement of story tasks. By 1909, it was not uncommon to find films deftly incorporating a range of different special effects, whereas several years earlier the trick effect was itself a film's primary attraction. For example, over the course of about five minutes of screen time in *Princess Nicotine* (1909), a smoker vies with a pair of tiny tobacco fairies and the battle scene is created through an array of effects techniques. Most are created using forced perspective (shooting the miniaturized actors further away from the full-size actor, but staging the action to suggest they are the same distance from the camera), while others use miniatures or large-scale props.[19] There are several uses of stop-motion, not only to create instantaneous substitutions, but also to give an illusion of movement or transformation to an inanimate object by manipulating

and then shooting the object one frame at a time, as when a rose is animated to seemingly roll itself into the shape of a cigar. To create the illusion of smoke rushing into a bottle, a bottle was filmed with smoke pumped in from below. The footage was then reversed, and double exposure was used to show the fairy inside a bottle.[20] We can see, then, how even a simple premise for a film might necessitate a wide range of ad hoc special and optical effects to fulfill the required narrational tasks.

Compositing

The creation of seamlessly composited images has been a goal of special and visual effects artists since the earliest years of moving picture history. H. D. Hineline divides the history of "Composite Photographic Processes" into three main groups: masks, rear projection, and color separation. He uses the patent literature to follow the developments in techniques used to produce a composite image whereby "pictures in which the background and foreground are obtained from separate sources, and combined to produce the completed picture."[21] Frederick S. Armitage experimented with a number of compositing effects, including superimposition. For *Nymph of the Waves* (1900), Armitage superimposed elements from two existing films, *M'lle. Cathrina Barto* (1899) and *Upper Rapids, from Bridge* (1896), to create a sensual composition in which Barto dances in a range of styles against the backdrop of Niagara Falls. This was neither a realistic attempt to composite the dancer into the scene nor a fictional depiction of a translucent spirit floating above the waves. Instead, *Nymph* was something closer to a layered collage of imagery that points us to the affordances of the apparatus itself, its attractive effects resulting from the fortuitous interplay of two different films. This is precisely the kind of special effect (transplanting a performer to a new location) that would become rationalized in the service of story and, later, narrative.

For example, as early as 1903, Porter's *The Great Train Robbery* used special effects in the presentation of a story, including double exposure. In one interior shot (taken on a studio stage), a full-scale train can be seen rushing past outside a station window. This spatial illusion was achieved by shooting the interior action, masking the portion of the frame in the window, and then shooting the passing train separately, with the rest of the frame masked so that the composite image combined the two discrete shots into a single image.[22] The effect was not used as an "attraction," but for the construction of diegetic space; it is a narrational rather than a spectacular device.

Throughout the silent era, compositing was also used to present dreams, memories, or imagined images. In Edison's *Life of an American Fireman* (Edwin S. Porter, 1903), we see a sleeping fireman, while "a circular image representing his

premonitory dream" of the coming crisis occupies a large portion of the screen to the right of him.[23] In *Fireside Reminiscences* (Edwin S. Porter and J. Searle Dawley, 1908), "the characters' mental images are implanted in the fireplace or on the wall, in the same scene with them."[24] Eileen Bowser suggests that in the transitional period, this kind of "vision scene" was very common, a foundational device of narration rather than merely a novel trick effect.[25] Keil notes that in films made at Thanhouser Studios in the transitional period, "vision scenes often performed the crucial role of precipitating the moral conversion of characters tempted to pursue an ill-advised course of action in the plots."[26] Since vision scenes conventionally involved the use of double exposure, we can see a trick effect being closely aligned with a particular narrational function, or being coupled with moments of heightened narrative intensity.

Compositing was also used in stylized ways to aid narrative in communicating simultaneity and creating suspense. In the appropriately titled *Suspense* (Lois Weber and Phillips Smalley, 1913), the screen is split by three exposures to create multiple zones of action: one each for a husband and wife talking to each other on the telephone while the husband is away from home, and another showing a menacing vagrant working his way into the couple's isolated suburban house (see figure 6). The directors augment the simplicity of their film's suspenseful premise "by heightening tension and intensifying the film's psychological dimension through manipulation of style."[27] The split-screen technique is one such manipulation, allowing us to see the tramp entering the house while

FIGURE 6: Multiple exposures create three zones and intensify the action in *Suspense* (1913).

the panicked wife talks on the phone to her husband. This technique is used not only to display the medium's ability to collapse disparate spatio-temporal elements into a single frame, but also to unite those spaces in a constellation of causal relationships.

In addition to these kinds of in-frame composites, filmmakers often used multiple exposures to create ghostly apparitions. In Eva's death scene from *Uncle Tom's Cabin* (Edwin S. Porter, 1903), a double exposure creates the illusion of a translucent angel flying down from above to take Eva's spirit away. In the novel by Harriet Beecher Stowe (1852), Eva's dying vision of heaven is a crucial turning point at which those in attendance resolve to change their lives. Well-known stories adapted from literary works would often contain events that audiences would expect to see visualized, compelling filmmakers to seek a cinematic equivalent of a literary passage. For his death scene, Tom lies at the bottom left-hand corner of the screen while visions appear via multiple exposure in the empty frame above: he sees Eva return as an angel, followed by images of the Civil War and Abraham Lincoln's liberation of the slaves. E. E. Bennett suggests that by the early 1920s, it had become fashionable "to film death bed scenes in such a way that the spirit of the dying man or woman is seen to emerge from the body."[28] In the final scenes of *Beau Brummel* (1924), for example, which take place at the end of the eponymous dandy's life, Brummel (John Barrymore) hallucinates and imagines that he sees the translucent figure of his departed lifelong love, Margery (Mary Astor). By means of double exposure, she appears

FIGURE 7: John Barrymore is revisited by the apparition of his lost love in *Beau Brummel* (1924).

to him in ghostly form, but in an ingenious embellishment of the technique, she is able to hand him a keepsake that he gave her many years earlier. This effect is achieved by filming the two actors together, and then masking Barrymore's half of the set for the second exposure, so that Astor appears transparent in her half of the frame (see figure 7).

Multiple exposure also allowed actors to play dual roles, as in Edison's 1912 version of *The Corsican Brothers* (Oscar Apfel and J. Searle Dawley), where Frank Lessey plays both twin brothers, thanks to the masking of each half of the frame during a double exposure and the perfectly coordinated action of the two takes that was "so perfectly simulated as to make a complete illusion."[29] Technology, along with the timing of the performances, creates the illusion that one actor is two characters. Though E. E. Bennett claimed that a star would take on a dual role "simply to impress her own versatility on the public,"[30] the technique nevertheless carried the "machine interest" of a novel visual effect when two characters played by a single actor shared the frame.

Such tricks were no doubt helped by the release in 1912 of a new camera from Bell and Howell, which included a frame counter (invaluable in the refinement of perfectly matched multiple exposures).[31] An article in *Motion Picture News* from 1916 surveys some of the "ingenious devices" offered by the C. P. Gertz American Optical Company, recognizing that there was a market for purpose-built camera attachments. These included square and circular vignetters, a "mask box" that could hold a mask of any shape for creating composite images, and a double exposure device with movable blades that could mask successive portions of the frame while making separate shots for a double exposure sequence.[32] By 1918, the technique was refined to such a degree that Mary Pickford could play dual roles in *Stella Maris* (Marshall Neilan) as both a sickly aristocrat and the impoverished orphan who comes into her service. For the shots in which Pickford shares the screen with herself, the film was exposed twice, with one half of the frame masked each time. Pickford could suggest her two characters occupied the same room by giving the appropriate eyelines and timing their gestures to suggest interaction, but the characters could neither cross the central line of the frame nor could they touch each other.

The justification for casting Pickford in both roles, complicating the shooting of even simple dialogue scenes that could have been far more easily completed with two actors, is bound up with the commercial logic of a burgeoning star system, but also with the spectacular appeal of a technologically sophisticated illusion, one which showed off the studio's (Pickford Film) in-house technical prowess. By the time *Stella Maris* was released, Pickford was the most famous actress in the world, so the promise of seeing her play *two* roles in a single film must have made for an enticing marketing opportunity. To see a star multiplied onscreen confirmed that a technologically created illusion had made the previously impossible possible.

Pickford played another dual role (as young Cedric Errol and his mother) in *Little Lord Fauntleroy* (Alfred E. Green and Jack Pickford, 1921), and most reviews drew attention to the double exposures.[33] *Exhibitors Herald*, for instance, which presumably was intending to highlight the film's most marketable aspects, noted: "The double exposure is here perfected to the nth degree . . . with an accuracy at once amazing and uncanny. Even as the boy and his mother . . . stand talking to each other, their glances are so perfectly timed and placed that an expert could not detect a single flaw."[34] When the film opened on September 15, 1921, at New York's Apollo Theatre, Pickford was present to explain to the audience "very simply and in non-technical terms, how she had been enabled to play the dual role . . . and also wherein Mary, as 'Dearest,' kisses herself as 'Little Lord Fauntleroy.'"[35] This kiss is a small moment (a son wakes his sleeping mother with a kiss), transformed by an impressive photographic trick into a noteworthy set piece (see figure 8). Cedric pauses, moving his face slowly toward his mother's, and the camera lingers to allow the audience to anticipate and then enjoy the trick: the mechanisms of storytelling accentuate a spectacular attraction. The impact created by the achievement of such a difficult shot outweighs the narrative importance of a simple kiss. This is how special effects nestled into the narrational conventions of American cinema, not only to serve story but also to serve as moments of magnified sensation.

The Playhouse (Buster Keaton and Edward F. Kline, 1921) takes this effect much further in its prologue, in which Buster, a star of the theatrical stage, plays every member of a band and every member of the audience, transforming the theater into an entertainment circuit of the self, an excursus on the filmic body

FIGURE 8: A masterly double exposure in *Little Lord Fauntleroy* (1921) enables Mary Pickford, in a dual role, to kiss herself.

as malleable, reproducible, even indestructible. For the film's climax, Keaton performs as nine minstrels in synchronization. He worked to construct these sequences with cinematographer Elgin Lessley, who built a lightproof box over the camera and installed a series of shutters on the front. As each one was opened, a portion of the action could be shot, before the film was rewound and exposed again with a different shutter open. Keaton gives each version of himself a distinct set of individual characteristics even as he works in concert with the apparatus to time the interplay between the characters to perfection, exemplifying his taut mastery of physical comedy in lockstep with the camera.

Even today, the Visual Effects Society advises that effects techniques are mainly used when artists need to show something impossible, do something dangerous, or when the costs of staging the real thing would be prohibitive.[36] As production moved from the East Coast to California in the transitional era and Hollywood became more established, growing into a filmmaking community and industry, it made more commercial sense to keep effects work contained in-house, and to keep stars on or close to the studio lot. "Unusual effects" remained a key point of product differentiation for the studios, but from the transitional period onward special effects have been largely justified by their support of narrative, and their convincing portrayal of fictional locations.

Composites and Special Effects Set-Building

During the silent era, various techniques were developed for extending sets and creating the illusion of fantasy spaces, objects of gargantuan scale, or additional architecture under controlled conditions. Glass shots, for instance, involve shooting a scene through a pane of glass, onto which scenery could be painted to augment the profilmic view.[37] A variation using cut-out scenery mounted in front of the camera, devised by Walter Hall, the set designer on Griffith's *Intolerance* (1916), was patented as the Hall Process in 1921. The vast castle set designed by Wilfred Buckland for Douglas Fairbanks's *Robin Hood* (Alan Dwan, 1922) was embellished with even taller towers painted onto glass panes between the camera and the scene.[38]

"Hanging miniatures" could be used instead of glass paintings to extend buildings and reduce construction costs, or to block out unwanted parts of the location and conceal obtrusive production equipment. The seven-acre set built on the Universal lot in California for *The Hunchback of Notre Dame* (1923) was large enough that director Wallace Worsley had loudspeakers installed so that he could direct crowd scenes through a microphone.[39] As Carl Gregory recorded, although the reproduction of Notre Dame Cathedral appears full-sized, "the actual construction of the set was only to the top of the entrance doors, the upper portion being supplied with glass work and

miniature models."[40] The *Transactions of the Society of Motion Picture Engineers* (TSMPE) mentioned *Hunchback*'s impressive use of photographic effects: "This development is greatly enhancing the size and grandeur of studio sets and will probably be used to an even greater extent in the future."[41] Gregory noted in 1926 that the industry had changed to accommodate trick effects into their repertoire because of "the money savings that may be affected" through "the services of high salaried experts who are specialists in the business of artistic photographic trickery."[42] Earl Theisen reported that glass shots were "used in practically every picture" by the early 1930s.[43] A sprinkling of novel technical display, in the form of a few photographic trick effects, became an expected component of most major releases, but set extensions such as glass shots effaced, through illusions of limitless scale, the fact that film production was increasingly being confined to studios.

The late 1910s witnessed the development of several traveling matte processes, which enabled the compositing of moving foreground action with any background required. The Williams process was the most commercially viable and frequently adopted of these compositing techniques. It involved photographing foreground action against a black background using a Bi-Pack that gave a transparent negative along with the foreground action. The negative could then be used to create a "traveling matte," a mask that matches the outline of the foreground action frame-for-frame, and thus any background could be added without the transparencies that result during multiple exposures.[44]

Beyond the Rocks (Sam Wood, 1922), starring Gloria Swanson and Rudolph Valentino, was the first film to use the Williams process,[45] creating backdrops for the stars' performances and removing the need to export the cast to Versailles or the Alps. The process photography was done primarily for the convenience of the technique rather than for its spectacular potential. The opening sequence of Cecil B. DeMille's *Manslaughter* (1922) uses Williams shots to show Leatrice Joy racing her automobile alongside a speeding train. The traveling mattes use a dynamic interplay between foreground action and background plates to create an image of recklessly dangerous driving without placing the actress in peril. For *The Gold Rush* (Charles Chaplin, 1925), the same process was used to "insert" Charlie Chaplin and Mack Swain into the miniature set of a log cabin as it teeters on the edge of a precipice in a comic set piece far too dangerous to perform without resorting to special effects.

"Trick photography" had come to affect many aspects of filmmaking, and its technologies and techniques were becoming an integral part of regular production workflows. In 1927, Dick Hylan speculated that special effects might put stunt performers out of business, since "inventions in trick photography . . . are fast rendering it unnecessary to subject any man to the long chances of 'stunts.'"[46] Not all trick photography was adopted for safety reasons, but it did reduce the impact of those "long chances," whether physical or financial.

It is worth mentioning that miniature models have been used to stand in for full-scale constructions, or for real locations, objects, and creatures, since the earliest days of film. Albert Smith and James Stuart Blackton re-created a sea battle in a miniature set for Vitagraph's *The Battle of Santiago Bay* (1898).[47] They made the ships by pinning photographs to wooden bases drawn along on strings.[48] Miniatures of people and buildings can also be seen in another Vitagraph reconstruction, *The Windsor Hotel Fire*, released just a month after the New York blaze in March 1899.[49] Porter's *Uncle Tom's Cabin* (1903) includes a shot of a race between two boats played out in a single take with miniatures in front of painted backdrops, and in *The Birth of a Nation* (1915), the burning of Atlanta is depicted using split screen techniques to composite the wider action of people fleeing the blaze with a miniature set of the city aflame. For *The Lost World* (Harry O. Hoyt, 1925), a range of techniques (glass shots by First National's specialist Ralph Hamerass, matte shots, stop-motion animation by Willis O'Brien using miniature, armatured dinosaur models) were deployed to create the illusion of humans in danger of attack by dinosaurs; in that instance, there needed to be a sense of believable proximity between the live action and the animation.[50] These processes prevented physical contact between composited elements and kept the humans and dinosaurs in distinct zones of action.

Refinements to matte processes focused primarily on how to improve registration and minimize the black halo around foreground action that reveals the join between composited elements. This is caused by inaccurate printing of the composited elements, or by the slight shrinkage of the film and the negatives, creating fractional distortions of the image surfaces. The aim was to create a more convincing illusion of spatio-temporal wholeness, and as shooting became increasingly studio-bound, compositing offered technological, repeatable, reliable means to achieve the necessary control. The number of patents submitted for methods used to create composite images is evidence of a strong demand for refinements to compositing processes. In the sound era, when studios needed an efficient means for summoning foreign locations when recording was confined mostly to soundstages, these complex matte processes were largely replaced by rear projection.

Integrated Effects

Two final examples demonstrate the complexity and integration of special effects by the late silent period. Cecil B. DeMille's first version of *The Ten Commandments* (1923; remade in 1956 [see chapter 6]) features an extraordinary array of special effects, mostly in its first half, which tells the story of Moses and the Israelites' flight from Egypt; the second half is a modern drama asserting the continuing value of the commandments in daily life. To depict the Israelites'

escape from Egypt as they are pursued by the Pharaoh's army, Roy Pomeroy built a miniature model of the seabed and filmed it with two cameras, both over-cranked to produce slow motion, and one of them cranked in reverse as a torrent of water was poured in.[51] The reverse footage was used to show the waves parting to reveal the seabed, into which were composited a series of Williams shots of the Israelites crossing the dry bed of the Red Sea.[52] The forward shot of the water flooding the miniature set illustrates the sea closing over the Egyptians. Toward the end of the modern-day section of the film, Mary (Leatrice Joy) experiences paroxysms of grief after her philandering husband, Daniel (Rod LaRoque), flees for Mexico in a boat. Imagining her own suicide, she envisions herself superimposed against a body of water. The shot is similar to the composite image from *Nymph of the Waves*, but this time the effect functions as a narrational device. At the film's climax, Daniel's boat (depicted by a miniature model) is dashed against rocks that, with the help of a dissolve, transform into the stone tablets of the Ten Commandments, creating a blunt symbol of divine punishment as an infidel's ship founders on the laws he has violated.

F. W. Murnau's *Sunrise: A Song of Two Humans* (1927), one of Fox's last major studio productions of the silent era, is a resolutely human drama focused on the rupture and resolution of a young couple's marriage as they travel from their rural homestead to explore the teeming metropolis. In one particularly elegiac sequence, the reconciled lovers walk across a busy intersection, arm-in-arm, gazing into each other's eyes. The Williams process enabled Murnau and cine-matographer Karl Struss (Frank D. Williams worked on the optical effects for the film, uncredited) to shoot the couple against a blank background and then create a traveling matte to composite them against a transforming background; we see them first walking in heavy traffic, then the scene dissolves smoothly into an open summer meadow, then back to the shocking realization that they are standing in the road, blocking traffic. This is both the depiction of a story event, representing the couple's constancy as the world shifts around them, and a kind of subjective space imagined jointly by the characters in a fiction.

This sequence demonstrates not only how refined the matte processes had become by the late 1920s, but also how firmly integrated special effects were with the storytelling arsenal of Hollywood. By the end of the silent period, the mobile camera could nimbly follow actors through space or assume their floating per-spective. *Sunrise* used special effects photography not to showcase the medium, as had been the case during the attractions period, but to create visual correlates for abstract emotions and psychological states such as reverie, anguish, and terror.

In 1925, in an article calling for better storytelling at the movies, Cecil B. DeMille confidently announced: "We are near the limit of the great advance in the technical lines of trick photography, strange lighting, unique sets, and star-tling effects."[53] But as later years would show, special effects techniques did not hit a limit; they were constantly refined and adapted to new industrial changes

such as the coming of sound and the spread of widescreen and color processes: novelty effects could be important selling points, but they were just as likely to blend seamlessly with the rest of the narrative machinery that made stories legible and entertaining to audiences.

3

CLASSICAL HOLLYWOOD, 1928-1946: Editing Paul Monticone

*"A cutter"—even the phonetics of this name imply a rather menial laborer,
and there are even today a great number of studio employees who think
that all a cutter has to do, is clip the ends of the shots handed to him and
paste them together, according to the identification "slates" and scenario
numbers.*

 Criticus, "'Only a Cutter,'" International Photographer, *July 1930, 30*

The studio-era film editor was perhaps the consummate self-effacing craftsper-
son of the Hollywood cinema. While the term most frequently used to identify
this production task—"cutting"—accurately described the technical process of
splicing and cementing together lengths of celluloid, it did little to differentiate
between what we now understand as film editing—creating a finished film from
footage shot by directors and cinematographers—and negative-cutting and
patching, mechanical tasks carried out before and after prints are struck and
put into distribution. Moreover, while the work of cinematographers and art
directors was evidenced by what was on the screen, the "cutter's" job was often
understood by what was left out: faces on the cutting room floor or "unnec-
essary" footage excised.[1] And, indeed, much early academic film criticism,
especially that under sway of the auteur theory, valued filmmakers to the

degree they evaded editorial control or confounded studio attempts to insert gaudy close-ups of stars.[2]

While the *International Photographer* editorial does correctly point out that the editor's contribution to Hollywood cinema was unjustly overlooked in this era, the assumption that "Criticus" argues against manages to capture some of what has made the studio editor so elusive in film history. David Bordwell finds the term *découpage* most appropriate to characterize Hollywood editing's "parceling out of images in accordance with a script, the mapping of the narrative action onto the cinematic material."[3] As "in accordance with a script" implies, this "mapping" did not occur only in the editing room. Jean Mitry positions editing as one of three "operations" that comprise *découpage*. The continuity script, shooting "with a view to a certain editing," and editing itself are aspects of "the same creative process" that "differ only with respect to the craftsmen who carry them out."[4] Though part of an art practice that was always highly collaborative, the domain of the Hollywood editor was particularly crowded, as one Oscar-winning editor's typically modest description of her work suggests: "Film editing is telling the story with film. Good film editing is selecting the best of the film. Great film editing occurs when you begin with great pictures."[5]

Although this period's basic style of editing was in place before 1928 and continued after 1946, the studio era was a distinctive moment in the development of film editing. While studio editing departments were formed in the previous decade, the mature, sound-era oligopoly brought changes in technology and production practices that would uniquely situate the work of editors in the production process. In some ways, editors were never—and would never again be—more powerful, but, paradoxically, the so-called "rules" that governed the editor's work were never more assiduously followed. Editorial departments, among all production departments in the studio system, were also notable for the prominent positions held by women. Though generally content to remain invisible, this period's editors began to formulate a craft discourse that would distinguish them from mere "cutters," and through that discourse, as well as through oral history interviews, we can better understand how editors' efforts contributed to the style of classical-era film. Finally, minority practices within the studio system that bordered on, and sometimes supplanted, the work of the editor—pre-cutting and montages—suggested alternative work procedures and aesthetic functions, which augured later developments.

Sound Transition: Technology, Style, and Work Practices

The basic technology necessary to edit film remained remarkably stable from the silent era through to the advent of digital editing systems, but studio-era editors perceived a significant shift with the transition to sound. In the silent period,

editors could take their work home: they needed only a pair of geared rewinds, a light table, a splicer in order to cut, and film cement. With the transition to sound, several new technological innovations entered their workspace, and editors had to adapt the dominant stylistic devices of the late silent era to synchronous sound filmmaking. But the transition's most significant impact was in altering the place of editing in the overall production process, as well as the editor's relationship with other craftspeople.

After the transitional period of sound-on-disc and Movietone prints, editors became accustomed to working with separate reels of sound-on-film and image tracks, which doubled the amount of material they had previously handled and added the problem of synchronization. A rewind of multiple sprockets on the same shaft—the "gang sprocket" or multiple synchronizer—moved sound and image in unison and allowed editors to cut image and dialogue tracks at the same point.[6] Numbers stamped on frame edges at one-foot intervals became standard by 1932, and these freed the editor from the necessity of returning to the multiple synchronizer to ensure image and sound still lined up after making a cut.[7] These technologies increased efficiency of the physical process of cutting both image and dialogue, and edge numbering in particular has been credited with encouraging faster cutting. But these technologies did not simplify the process of choosing a precise cutting point.[8]

Viewing machines manufactured by the Moviola Company had been used in studios since 1925, replacing homemade viewers and jeweler's glasses and eliminating the need to screen work piecemeal as it was assembled. In 1930, the company offered an attachment to handle sound reels and playback, which enabled editors to cut words between syllables, though not all studios acquired this model immediately and many editors developed the ability to "read" sound track.[9] Further innovations to the Moviola followed throughout the decade. The Triplex model, which offered three sound reproducers, was introduced in 1933, though it found more use in re-recording departments than in editing departments.[10] The Moviola "Preview," released in 1937, supplemented the viewing lens with a small, ground-glass screen, thereby allowing editors to view details in longer-shot scales more clearly, which also might have contributed to increasing shot lengths later in the decade.[11]

The problems that came with obtaining adequate image and sound recording during production were met with an industry-wide effort, coordinated through the Academy of Motion Picture Arts and Sciences Research Council, to develop quieter lights and cameras.[12] No such institutionalized industry-wide coordination was necessary to meet the challenges that the sound transition presented to editors. Instead, trade papers occasionally reported on individual studios' ad hoc development of their own versions of each of the innovations described above, which preceded service firms such as Moviola creating models for industry-wide use.[13] These new technologies primarily served to streamline editing tasks, and

their effect on style was similar to that which Kristin Thompson attributed to the 1910s innovation of workprints: "Editing technology in general must have influenced film style in a minor but pervasive way, permitting existing stylistic devices to be better executed."[14]

The central importance of Hollywood editing's core stylistic device—analytical cutting—undergirded the adoption of multiple-camera filming from 1929 to 1931. Sound recording needs dictated that one full-set lighting scheme suffice for several camera setups to satisfy the demands of editing. This retention of the same lighting schema for different camera positions brought with it a resultant loss of control over the properties of the image. Still, this compromise ensured that classicism's aesthetic norms were preserved: "What made all this trouble worthwhile was the option of cutting, especially cutting to a variety of angles."[15] The underlying rationale for analytical editing's fluid movement from long shots to close-ups was to follow and highlight the personalized causal chain that constituted the classical narrative. Thus a dialogue scene in *Showgirl in Hollywood* (1929) is covered in such a way that the editor can choose among several setups: a long shot orients the viewer to characters' positions in a dressing room; a two-shot covers a conversation in the rear of the set; and single close-ups underline the dramatic climax of the scene (see figure 9).

This is not to say, however, that sound presented no significant aesthetic challenges to editors. Dialogue initially limited the editor's ability to control the

FIGURE 9: *Showgirl in Hollywood* (1929). Multiple-camera filming was adopted in order preserve classical editing's fluid movements between shot scales.

tempo of scenes. The difficulty in editing sound track on Vitaphone discs and Movietone prints meant that dialogue's pace led that of the image track.[16] An early scene in *Showgirl in Hollywood* displays this tendency. A quarrel between the Hollywood-bound heroine and her playwright boyfriend alternates images as the two exchange lines at a nightclub table; unable to speed the pace of scene by cutting to the listener and excising dialogue, the scene repetitively exchanges images of speakers and preserves gaps between lines of dialogue. Once the sound track was separately printed, it became easier for editors to coordinate the visual tempo and that of vocal performance and to speed the pace of performance in editing.[17] A convention governing when to cut the image in relation to dialogue—a few frames before a line finished, with the image shifting to the listener—became standardized by 1930, but varying this convention became a technique to manage tempo during dialogue scenes: cutting earlier would allow the editor to manipulate the speaker's lines and increase the tempo, while letting the dialogue finish before cutting to the reaction could create a moment's pause.[18]

On the whole, the sound transition reinforced classicism's dissection of narrative space. Multiple-camera shooting not only ensured that analytical editing remained the aesthetic norm during the sound transition, but it also functioned to standardize the practice of shooting entire sequences in the "master scene" or long shot, after which selected portions of the scene would be repeated from closer angles.[19] This new production convention, calculated overshooting, provided editors standardized coverage of scenes and a predictable set of choices to make in assembling sequences. Sound thus brought about an alteration in production practices that increased efficiency in the editor's aesthetic function—distinct from the mechanical task of cutting film—which was necessitated by the most important change in editing affected by the transition.

If picture editing itself underwent no major technological or aesthetic transformation, the broader postproduction process, of which editing was part, certainly did. Those who worked in cutting rooms during the late silent era recalled a lengthy editing phase that often did not begin until after principal photography concluded and was overseen, and often carried out, by the director.[20] After the sound transition, the postproduction phase involved not only assembling the image track but also adding sound effects and music, dubbing dialogue, and creating a final sound mix. As a result, the editor's completed working print, with dialogue in sync, was expected a week after shooting finished, so that a "feeler print" could be made and sent to the relevant departments.[21] The editor's involvement in postproduction after this point differed somewhat among studios. But what was true at all studios is that additional postproduction steps were accompanied by a further subdivision of labor among postproduction departments.

In order for the production schedule to accommodate the additional steps necessary to produce an answer print, editors began working on pictures shortly after production began. Films were not only shot out of sequence but, in their

first cut, assembled out of sequence. Each morning the director would screen the previous day's footage with the editor, and select which takes—or portions of takes—he thought best. After screening dailies, the director would return to the set to begin the day's photography, and the assistant editor would break down reels, file away takes not chosen by the director, and deliver the rest to the cutting room, where the editor would assemble the sequence. Directors would view the edited sequence and recommend revisions, and this process of batch editing would continue such that an editor had a rough or first cut within days of photography's completion.[22] Since editing proceeded alongside shooting, directors were no longer able to do their own cutting, and increased responsibility for a first cut devolved to editors. Moreover, editors increasingly functioned in a supervisory capacity during production, assessing whether the scene was adequately covered to cut together, and, when it wasn't, they would often request that the director or second unit supply retakes, cutaways, or inserts. Editors might also order frame enlargements or reversals from the lab, and in some cases even shoot this material themselves.[23] After the final scene was edited, all the completed sequences were combined; subsequent additional changes necessitated by the film's overall pace, and identified in conjunction with the director, would be made at that point. Only then would the first cut be submitted to the producer for approval.[24]

The sound transition served simultaneously to remove the director from the editing room, increasing the editor's control over the image track, and to shorten the production time available for this process, increasing his reliance on the aesthetic norms of continuity and analytical editing. These work practices became so entrenched that editors beginning their careers in the late 1930s would view the director's post-studio-era return to the cutting room an unwanted intrusion.[25] In 1973, Grant Whytock, whose career spanned the 1910s through the 1960s, reflected that "the editorial department was," in the studio era, "more powerful than it is today. It was almost the last word. . . . You see, the first thing they had to do was make that schedule and you couldn't carry on like they do today where a director goes in and stays with the picture for a year in the cutting room."[26] These basic, industry-wide work practices uniquely placed the editor in a distinct position within the film production process. But studio-era departments did not operate uniformly, nor did the day-to-day work practices of sound cinema fix occupational paths for editors or constitute a professional identity.

Studio Variation, Women's Work, and Professional Identities

Despite the standardization of practices discussed above, there were nevertheless notable differences between one studio and the next. At most studios, editors were only present on set to oversee first-time directors.[27] Paramount's practice of having the assigned editor stay on set to assist the director in getting adequate

coverage was unique, as was its penchant for allowing assistant editors to make the first cut, after which the head editor would tighten the rough cut to running length while maintaining smooth continuity.[28] At some studios, such as Warner Bros., the editor's work concluded promptly after the first cut received producer approval: "With this working print approved, I can sit back and draw a deep breath of relief and await the first appearance of the next production—which usually comes the next day."[29] Where previews were customary (notably at MGM and with comedies), the editor would remain assigned to the picture to make further revisions and would thus participate in later stages of postproduction. At MGM and Twentieth Century–Fox, the supervising editor would take over from the assigned editor and guide the film through the final phases of postproduction, overseeing the addition of music, sound effects, and, later, the rerecording of dialogue.

The position of supervising editor was the most distinctive organizational variation in studios' editorial departments. While all departments had administrators who were responsible for managing personnel and assignments, MGM was the first sound-era studio to create a supervisory position to oversee rough cuts and to monitor productions. Margaret Booth worked on Irving Thalberg's productions until his death in 1936, at which time she was promoted to the new position (see figure 10). From then until 1969, she cut no film, but from her personal projection room she screened and monitored the studio's output and

FIGURE 10: Margaret Booth, supervising editor at MGM from 1936 to 1969, perhaps the most powerful of Hollywood's notable women editors.

reported directly to the studio chief, Louis B. Mayer, during his tenure, and to his successors for decades thereafter. Ralph Winters recalled: "'Miss Booth,' as she was called . . . was a tough taskmaster and used to drag me over the coals every day—but I learned. . . . Time and again, editors were sent back to their cutting rooms to adjust their work to her liking."[30] While she wielded much power at MGM, Booth used her position to maintain the invisibility of editing: she believed "a perfect film ought to give the illusion that it was all done exactly as seen on the screen, that there never was any person such as a cutter."[31]

Although women have been notoriously underrepresented in film production, several in addition to Booth rose to such prominence in editorial departments that behind-the-scenes interest pieces rarely failed to take note. "Film editing," observed the *New York Times* in 1936, "is one of the few important functions in a studio in which women play a substantial part."[32] Viola Lawrence began her career in 1913 at Vitagraph in New York, came to Hollywood in 1917, and by the 1930s was Columbia's top editor, assigned to prestigious films such as *A Man's Castle* (1933) and *Only Angels Have Wings* (1939). Blanche Sewell, like Booth, worked on prestige productions at MGM, including *Queen Christina* (1933) and *The Wizard of Oz* (1939). Dorothy Spencer worked with independent producer Walter Wanger on *Stagecoach* (1939) and *Foreign Correspondent* (1940) before moving to Twentieth Century–Fox in 1943, where she would remain through the 1950s. Lasting over forty years, Anne Bauchens's collaboration with Cecil B. DeMille is among the longest filmmaker-editor partnerships in film history, from 1915 until his death in 1959. Barbara "Bobby" McLean moved with Darryl F. Zanuck to Fox in 1935 and remained after his departure, becoming the studio's supervising editor in the late 1940s.

McLean was regularly assigned to Henry King's films—twenty-nine in all, including *Wilson* (1945), for which she won an Oscar—but she is most closely associated with Zanuck, at whose side she sat through years of dailies and rough cuts. She attributed at least part of her success to providing a "woman's perspective" among Zanuck's trusted male collaborators. Such statements can fuel essentialist assumptions about female patience and organization, often enlisted to explain the success of women within this profession.[33] Of particular note was the purported ability of women to manage the egos of directors and producers, which often clashed in the editing process, though this assumption likely reveals less about women editors than the competing demands all editors needed to negotiate. In the end, the editor was the producer's representative, and it is no coincidence that the most enduring studio-era collaborative relationships involving editors were not actually with directors but with executives like Mayer and Zanuck, producers like Wanger, and producer-director hyphenates like DeMille. This pattern of professional affiliation was not to change until the rise of independent production, at which point editors were selected by directors, who became more directly involved in cutting.

Despite the presence of women among the ranks of the industry's top edi-
tors, the profession was still overwhelmingly male throughout the studio era and
became increasingly "masculinized" through the 1930s, as Karen Ward Mahar
has observed.[34] As a result, women who had already begun to ascend the ranks
or had established reputations before the sound transition continued to do so, but
few new women editors entered the profession during this period.[35] Three factors
seem to have brought a temporary halt to women's advancement. Nearly all the
major female editors of the period started their careers in the silent era, working in
joining rooms and as negative cutters. The transferability of these negative-cutting
skills to positive-print editing was relatively direct. With the transition to sound,
editing became a more technologically intensive task, and several women retired
to the negative-cutting room or were dismissed by heads of editing departments,
who believed these women to be less technologically savvy than their male peers.[36]

In addition, silent-era editors often saw their responsibility limited to assist-
ing the director, who did his own editing. Most women editors began in this
fashion and were eventually entrusted with more responsibility, putting together
first cuts. Here, the silent era's flexibility of work roles enabled women to rapidly
ascend from negative cutting, to assisting in editing, to becoming full editors—
and to move into still other occupational areas.[37] With the increasing importance
of the assistant editor, and the attendant course of systematic training for full
editors, women's paths into the job were narrowed. These assistants were typi-
cally recruited from the ranks of librarians and projectionists—members of the
editorial department whose responsibilities involved hauling cans of film to and
from screening rooms.[38] Finally, the formation of the Society of Motion Picture
Film Editors (SMPFE) in 1937 supported this more formalized system of training
that required editors to begin as assistants and, like many unions, pursued the
interests of its male members. A 1940 *Los Angeles Times* article declared "Lady
Film Cutters: A Vanishing Profession" and quoted the secretary of the society as
saying that "women cutters are 'resented' by their male co-workers."[39]

That the editors' industry-wide association focused on such labor issues is not
surprising—in order to improve their working conditions, most crafts formed
guilds and unions in the late 1930s—but it is telling how little attention the
editors' society paid to the task of crafting a shared professional identity and pro-
moting this through industry-wide organizations. In contrast to the American
Society of Cinematographers, the SMPFE had no publication of its own in which
to fashion an occupational identity, promulgate notions of "good artistry," or ally
itself with other, established crafts in order to stake its claim to a distinct self-
image within the studio-era production system. Indeed, the only craft discourse
that editors generated appeared in articles in other unions' and guilds' publi-
cations, and these were often overviews written for amateur filmmakers, not
for their peers or other craftspeople.[40] Editors did not organize a section within
the technicians' branch of the Academy until late 1932, and no Academy Award

honored editing until 1935.[41] The DGA offered to make full editors members, a proposal that appealed to editors interested in increased prestige, but the editors' membership—80 percent of whom were assistants, stock-footage librarians, negative cutters, and studio projectionists—voted the resolution down.[42] In 1944, the SMPFE's membership voted to affiliate with IATSE, after which it became the Motion Picture Film Editors, Local 776. A guild devoted to advancing the profession's status was not formed until 1950.

Still, there are signs editors were dissatisfied with being viewed as anonymous craftspeople or mechanics who culled the director and photographer's best footage. A booklet produced by the society on the occasion of its first annual ball included "Facts About the Society," and several anonymous editors used the space to recommend that the society "impress the producer that our work is as important as [that of] the director, writer, and camera man" and "take away the theory that editing is mechanical."[43] The booklet also included brief notes of praise from notable directors who had started in cutting rooms—among them Frank Capra, Norman Taurog, and Dorothy Arzner—and an essay by producer Sam Zimbalist on the distinction between "cutters" and "editors." While the former merely assembled shots into their script continuity, the latter imbued them with a tempo and rhythm such that stars, directors, and producers would be "so interested in the story the sequence tells that they're [*sic*] forgotten all about their pet scenes, their likes and dislikes."[44]

Studio-Era Continuity Editing

In 1934, speaking at an Academy Symposium on scene transitions, Cecil B. DeMille stressed that self-effacement was the hallmark of a technician whose artistry distinguished him from the mere mechanic: "[The] technician who is an artist wants to play in perfect harmony with the picture. The minute an audience becomes conscious of the effect, the picture is over as far as drama and story go."[45] Such sentiments found themselves echoed in oral histories and interviews with studio-era editors. DeMille's editor Anne Bauchens elaborated: "It takes away from the reality. If you want the audience to believe the story, you should keep away from anything tricky."[46] Somewhat counterintuitively, devices that called attention to themselves—mixing types of wipes or elaborate dissolves—were *not* recognized as signs of artistry, but mere technical ability. The aesthetic criterion recognized is the subordination of technical ability to the "unity" of the work—its dramatic effects—and invisibility. The dominant devices used to cue transitions between scenes, as well as to manage space and time within scenes, function, in the first instance, compositionally; they are efficient means of delivering narrative information. The "rules" editors followed accomplished this basic task, but, within these rules, editors varied devices to heighten dramatic effects.

The task of scene transitions is to signal the elision of story time and a change in location. This task was, in the first place, accomplished in the writer's construction of the scene: exposition clarifies what time has passed and dialogue hooks at the end of the scene cue viewers to expect the next scene's action. Editing devices were codified "punctuation marks" that supported these scripted cues. The optical printer moved the creation of transitions from the set, where they were created in camera, to the laboratory, from which editors would request dissolves, wipes, and fades.[47] The function of each of these devices was highly conventionalized: a lap-dissolve indicated a brief, indeterminate, and—from the perspective of the narrative—inconsequential passage of time, either within a scene or to a scene that shortly followed, while a fade to black signaled the end of an "act" and presaged a lengthier temporal gap. Editors' reluctance to use straight cuts between scenes—or for short temporal gaps within scenes—was, in part, to avoid potential viewer confusion.[48] But dissolves additionally functioned to "soften spatial, graphic, and even temporal discontinuities,"[49] and, in the major studios, became markers of quality. Gene Fowler recalls McLean dogmatically enforcing the convention at Twentieth Century–Fox and dismissing straight cuts as "cheap Republic tricks."[50]

With respect to narration, wipes were the functional equivalents of dissolves, denoting brief ellipses, but they better maintained a fast pace and were thus thought appropriate for comedies and action films. In these cases, graphic smoothness was accomplished by matching figure movement within the shot to the direction of the wipe, as in *Libeled Lady* (1936) when a wipe follows a harried newspaperman across the frame. The affective dimension of scene transitions could also motivate a fade to black for relatively brief temporal ellipses. Although the temporal gaps in *Phantom Lady*'s (1944) trial sequence called for dissolves, several fades to black slow the scene's tempo, creating a disjunctive contrast with the offscreen voice of the prosecutor, who rapidly and assertively makes his case. The entire trial episode thus becomes somewhat disjunctive, matching the experience of the accused's secretary, whose subjective response to the trial—confusion and concern—structures the sequence. Thus editing devices offered a menu—albeit limited—of options that could perform the necessary function of clear narration while also subtly modulating tempo and pace.

Some scene transitions could more forcefully announce the process of narration. In *Dr. Jekyll and Mr. Hyde* (1931), a diagonal wipe is held, thus bisecting the screen and contrasting Jekyll's bedridden patient with the fiancée he ignores (see figure 11). Similarly, dissolves are extended to allow the final shot of one scene to become superimposed over the first shot of the following scene. For example, after Jekyll's near-liaison with a prostitute is interrupted, the image of her swinging leg continues over the first thirty seconds of the next scene, during which he discusses, in clinical terms, the nature of impulses with his colleague. Since neither dialogue, performance, nor framing cues the viewer

FIGURE 11: In *Dr. Jekyll and Mr. Hyde* (1931), a diagonal wipe and extended dissolve renders narration overt by pointing up ironies and foreshadowing later events.

to read this as subjectively motivated by the character's lingering interest, the editing device here makes narration overt in foreshadowing later events. More intrusive, though diegetically motivated, is *Our Town* (1940), in which the narrator appears to grab the camera by its lens and turn it toward himself—in a different space—in order to relate the details of a courtship that have preceded the wedding we are about to see.

The devices that governed intra-scene editing aided not just temporal legibility, but also the impression of continuous duration. Moreover, editing devices oriented viewers to the fictional space and characters' relative positions within it. As discussed in the previous chapter, the principles of scene dissection were established by the early 1920s, and, as already noted, the sound transition accommodated and reinforced these principles. Historians of film style have demonstrated that violations of the conventional deployment of continuity editing devices are exceedingly rare; accordingly, it is "no wonder that, of all Hollywood stylistic practices, continuity editing has been considered a firm set of rules."[51] Though the conventions of intra-scene editing sought to create the impression of continuous time and coherent space, editors would sacrifice strict "realism" to other considerations. The most emphatic device for signaling temporal continuity was the precise match-on-action cut, in which an action begun in one shot was continued, with neither repetition not elision, in the next shot. Throughout this period, however, editors instead relied on continuous diegetic sound and eyeline matches to *imply* durational continuity, and dismissed the perfect graphic demonstration of it as distracting showboating or "a hangover from the old silent days."[52] Similarly, the practice of "cheating" the positions of actors between shots, creating better-balanced compositions within individual shots but also continuity errors between shots, did not bother editors.[53] The infrequent reliance on devices that most rigorously enforced continuous space and time illustrates the logic that undergirded continuity editing devices: not "realistic" spatial and temporal representation for its own sake, but in order to unobtrusively guide viewers' attention to the

"character-centered—i.e., personal or psychological causality—[that] is the armature of the classical story."[54]

Despite the rather strict paradigm of intra-scene cutting, editors understood their work here to possess a subtle artistry that exceeded mere adherence to "rules." Ted Kent, editor for James Whale's films in the early 1930s, recalled that the director gave precise instructions as to which shot scale to use for each line of dialogue. Whale's instructions followed the basic principles of analytical editing, but Kent still thought his understanding of editing "elementary": "every cut that he would come in on would be on dialogue," which resulted in undesirable "jumping around." Better, Kent and his colleagues believed, were gradual changes in shot scale in order to "ease into" close-ups.[55] Evincing their commitment to classicism's aesthetic norms, Ralph Winters cites the ordinary scene of character interaction as that which editors took the most pride in and looked to when assessing their peers' abilities:

> The editing of the sequence that takes place between and among people, is really the most important. . . . Some of the chases and action sequences are difficult to edit. But the real, I think the real—what's the word I'm searching for? The *art* is centered around people, what you can do with people. To keep your editing smooth, to glide in and out of close-ups and medium shots, and letting the audiences' eyes be exactly where they want to be.[56]

The rapid alternation of tight close-ups or extreme changes in shot scale—from long shot to tight close-up—were shunned as shortcuts to "keep it alive" that blunted the force of editors' most reliable device for emphasizing an important narrative development—the judicious cut to the close-up. Moreover, "keeping it alive" was a shabby substitute for the subtle quality editors most often claimed was their contribution to the film: a smooth "rhythm" that absorbed viewers in the unfolding narrative.

This rhythm was not, however, the only quality editors viewed as an inviolable ideal. As Patrick Keating has extensively documented in his study of this period's cinematography, Hollywood stylistic conventions accommodated generic variation that admitted more expressive displays of style, and, to some extent, this was also true of editing.[57] As indicated above, certain transitions were thought appropriate to some genres, and musicals in particular could tolerate a variety of wipes that might be thought gaudy or distracting in drama. More common, as the Winters quote indicates, were variations *within* a film, with certain sequences—"chases and action sequences," for example—calling for certain "moods." Notwithstanding his dislike of Whale's approach to editing dialogue, Kent advised "the more cuts the merrier" when the monster comes alive in a horror film.[58] Similarly, action sequences could be cut more rapidly. Much of *Dead End*

(1937) demonstrates a tendency toward long takes and ensemble staging (overall average shot length, or ASL, of 9 seconds), but its climactic alley fight and rooftop shootout comprises fifty shots in 3:14 of screen time (ASL of 3.8 seconds). In such scenes, editors not only cut more frequently but also cut between more setups than would be used to cover dialogue sequences. As a result, genre-scene conventions could motivate sacrificing the editing ideal of smoothness and invisibility, but only if these sacrifices were motivated by narrative action.

Despite the acceptability of more assertive cutting in different genres, historians of style have found overall average shot lengths varied little between films of different genres.[59] Generically marked scenes, such as musical numbers and action sequences, offer many of the studio-era cinema's most conspicuous passages of editing, but these are rendered statistically insignificant by the preponderance of the era's basic unit of narrative construction, the dialogue scene. Studio-era editing departments most frequently worked with these scenes, and thus editors developed a nascent practitioner discourse that privileged modest aesthetic values such as "smoothness" and narrative support.

Alternative Editing Practices in the Studio System

The work processes and aesthetic ideals of the studio-era sound cinema subtended an ongoing stabilization of formal conventions established in the preceding decade. Editing departments were the location where classicism's aesthetic norms were most forcefully sustained. This mandate—containing stylistic excesses that risked undermining narrative comprehension—was accompanied by the corresponding production function of maintaining producer control over directors. However, editing was not uniformly an extension of the studio system's mode of production and commitment to invisible storytelling. Ironically, such exceptions are most evident when editing took place outside of its dedicated studio department.

"Pre-editing" was a process that eschewed "master scene" coverage for a precise visual design in advance of shooting. A 1932 article describes this practice as necessary for complex sequences, such as the ballroom scene in *One Hour with You* (1932), in which images needed to follow a previously recorded sound track.[60] But the practice could be used in a more thoroughgoing fashion. For *Gone with the Wind* (1939), David O. Selznick sought greater control over production and engaged art director William Cameron Menzies as a "production designer" so that "we might be able to cut a picture eighty percent on paper before we grind the cameras."[61] Selznick's habit of rewriting to the last minute ultimately forced him to abandon Menzies's elaborate designs, and directors were instructed instead to "substitute simple angles" that could be assembled by editor Hal Kern. Although Selznick's ambitions went unrealized, Menzies's subsequent films with

Sam Wood more fully incorporate the designer's ideas about the harmonization of set design, cinematography, and shot sequence. While the results did not fully overturn continuity principles, Menzies's pre-cutting led to some variation in the execution of these principles and departed from the ideal of invisibility. Extreme shifts in shot scale—long shots to very tight close-ups—and the eccentric shot reverse/shot patterns in *Our Town* draw more attention to editing than more conventionally shot and edited sequences.[62]

Orson Welles's *Citizen Kane* (1941), among the most stylistically baroque films of the classical era, was similarly pre-cut. Robert Carringer's book-length study of the film details how many scenes were edited in camera by Welles and cinematographer Gregg Toland and dispenses with the editor in a line: "Few films can have left an editor with a narrower range of choices."[63] The most celebrated passage of editing in *Citizen Kane* (1941), the breakfast table montage that charts the collapse of Kane's first marriage, was conceived and executed by Welles, and editor Robert Wise's contribution was limited to fine-tuning the rhythm and pace of the sequence. Treating narrative material that would typically be developed through a series of ordinary scenes as a flamboyant montage—conceived and executed during principal photography—is itself notable. Montage sequences were used throughout this period, particularly in the 1930s and in adaptations of lengthy novels, but these transitional sequences were more typically assigned to a specialized department or unit within the special effects department and segregated from principal photography.

Since Hollywood's montages comprised rapid editing, inserts, photographic effects, and optical printing, special effects departments (discussed in Ariel Rogers's chapter in this volume) housed units dedicated to their production. From Bungalow 9 on the MGM lot, Slavko Vorkapich headed a montage unit consisting of a cameraman and an editor, and established himself as the industry's leading montage specialist. His influence is registered in the informal labeling of these montage sequences as "Vorkapich shots." Other studios followed suit and established their own units. Warner Bros.'s special effects department, for example, promoted Don Siegel, a former assistant editor, from shooting inserts requested by editors to designing and directing montage sequences. The fact that these sequences incorporated effects and were made by effects departments is the result of their mixed lineage. The vogue for montages began in the 1920s, when filmmakers such as Ernst Lubitsch and F. W. Murnau brought to Hollywood superimpositions used in Germany to summarize narrative events or depict subjective states.[64] Soviet montage cinema provided additional devices that would be absorbed by the classical system.

When the montage theories of Soviet filmmakers reached America's filmmaking center in the mid-1930s, they were viewed suspiciously as the "devious mysticisms of the 'cinema art form' fraternity."[65] Some Hollywood technicians rejected the notion that "montage" was anything new, and none understood it

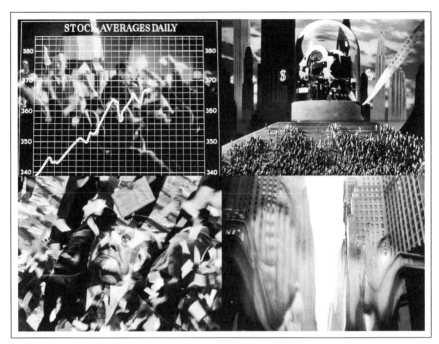

FIGURE 12: Events that exceeded the grasp of classicism's personalized causality were often depicted in montage sequences, such as Don Siegel's montage representing the stock market crash of 1929 in *The Roaring Twenties* (1939).

as a global theory of filmic construction.[66] Instead of a constructive "building up" of meaning through the juxtaposition of shots unrelated in their content, Hollywood's language posited a profilmic whole. That narrative world preceded and existed apart from the work of the editor, whose job was to hone the replete profilmic reality and extract the essential dramatic material. As a result, Soviet "montage" came to be understood as particular applications of "creative editing," as opposed to "simple continuity" editing.[67]

Passages of "creative editing" were thought useful for two purposes. First, a montage sequence could compress the passage of time and indicate what narrative developments had been elided. For example, the rise of stars in *What Price Hollywood?* (1932) and *Maytime* (1937) is condensed in montage sequences. Such sequences could also economically depict narrative events that would be prohibitively expensive to film more conventionally, as in *Cleopatra* (1934), when the Battle of Actium is rendered in a four-minute montage combining miniature work, inserts, and footage from DeMille's earlier *The Ten Commandments* (1923). Complex scenes such as stock market crashes, riots, police bulletins, and so on also depicted supraindividual narrative developments, which the classical style's prioritization of personalized causality was ill equipped to handle (see figure 12).

While the narrative function of the montage was quickly conventionalized, the sequence's narrative condensation and abstraction did permit more formal

experimentation. If the narrative "point" of the montage was simple—time passes, the stock market crashes, news travels—within these sequences filmmakers were given free rein to explore graphic matches, staccato cutting rhythms, and overt symbolism—all devices typically eschewed by studio-era filmmakers. In the many talks and interviews he gave promoting his own theories of montage, Vorkapich predicted that in the near future, perhaps by 1945, montage would be liberated from their narrow narrative functions and its devices would come to dominate the entire film.[68]

Studio-era work practices and norms would prove more durable, and these alternatives remained minority practices. Pre-cutting as explored by Welles and Menzies was an infrequently employed approach to editing within the studio era, where production and postproduction practices overwhelmingly favored master-scene shooting and continuity editing. Similarly, montage sequences were specialized units of film, segregated from the larger work; they related narrative information that classicism's dominant aesthetic practices were not designed to convey. The studio-era film was predominantly composed of scenes of character interaction that adhered to the invisible art of continuity editing, carried out by the cutter. Although rare exceptions within a stable system, both alternatives suggest possibilities abandoned by the establishment of classical norms and left to be explored by later generations of editors.

4

CLASSICAL HOLLYWOOD, 1928-1946: Special/Visual Effects
Ariel Rogers

Special effects played an important role in the sound-era studio system, the province of newly formed specialized departments. A pervasive presence in even run-of-the-mill Hollywood productions, effects often served the practical purpose of replacing location shooting with the creation of composite images that combined principal action shot on studio grounds with background scenery, whether photographed or painted.[1] The ability to film dialogue in the controlled environment of the studio was particularly useful on the heels of the coming of sync sound; however, this practice accorded generally with Hollywood's rationalized business model, offering the most economical and convenient means of producing imagery that nevertheless displayed a form of "production value" associated with exotic land-, sea-, and cityscapes.[2] Paramount technician Farciot Edouart reflected this attitude toward effects in contending that rear projection conformed "to the industry's ideal of getting the best possible picture under the most completely controllable conditions, and with a minimum of time, expense, and danger."[3]

By 1928 technicians regarded the term "trick photography" and their own designation as "trick men" outdated; as Carroll Dunning put it in 1929, "The

misnomer, 'trick men,' still sticks, but they are the true 'photographic effects' technicians of the industry."[4] Throughout this period technicians strove to distinguish between "tricks" and the more quotidian special effects that, as *American Cinematographer* put it in 1947, were not "designed to surprise, mystify, or amuse the audience" but were rather "devices which the cinematographer uses to save time, expense, or effort in presenting an illusion of reality on screen."[5] A corollary to the latter emphasis is the lack of attention devoted to effects, despite their pervasiveness, in studio publicity, reportedly "lest the 'secrets' broadcast to the world might take the glamour from the screen."[6]

The emphasis on integrating component parts into unified images—so that, as Fox effects head Fred M. Sersen put it, "in the finished scene all the parts will fit together like a jig-saw puzzle"—renders the special effects of this period part-and-parcel of the classical Hollywood style, which encourages viewers, in David Bordwell's words, to "construct a spatial whole out of bits."[7] As Bordwell and Kristin Thompson contend, production practices adopted with the coming of sound, including the use of rear projection as well as multiple-camera shooting, shifted the way in which Hollywood synthesized such bits, minimizing "the blending together of images in the camera" and making film "more of an assemblage of separate images (and sound tracks) shot and combined by specialists."[8]

Much discussion of contemporary visual effects rests on assumptions about the cohesiveness and alterity of the classical Hollywood cinema. When these effects are associated with spectacle and related affects such as awe and wonder, they are often aligned with early cinema (with its emphasis on presentation) and tacitly distinguished from classical Hollywood (and its focus on representation).[9] When they are associated with a notion of realism, there is also a tendency to distinguish contemporary illusions—thanks to the capacity of computer-generated imagery and digital image synthesis to render fantastic images photorealistically—from earlier forms of Hollywood realism, in this case downplaying the ubiquity of effects in earlier, supposedly more authentic filmmaking.[10] Cinematic images in the classical era, however, were subject to heavy manipulation—and even construction—as well.[11]

Scholarly work prompted by the increasing presence of digital technologies in cinema (and the disciplinary crises accompanying it) illuminates the effects of this earlier era, however, by encouraging a questioning of the relationships among technologies and media.[12] Discourses on and applications of effects in the classical era show that these effects functioned in tandem with other contemporaneous techniques and technologies—including sync sound, widescreen, three-strip Technicolor, deep-focus cinematography, stereoscopic 3D, and the multiplane camera—to shape particular forms of mediated experience. Moreover, experimentation with the combination of spaces and temporalities facilitated by techniques such as rear projection and optical printing also put cinematic effects work into dialogue with elements of the media landscape outside the realm of

film production, ranging from the rethinking of theater and screen design to the development of television.[13]

Techniques and Technologies

Several older approaches to special effects carried over into this period. In addition to full-scale mechanical effects—as used, for instance, for the earthquake in *San Francisco* (W. S. Van Dyke, 1936)—effects artists continued to call upon techniques such as miniatures, glass shots, and both still and traveling mattes.[14] Technicians employed miniatures for the creation of settings as well as the staging of action. With regard to the former, miniatures offered an economical means for completing sets. As Paramount art director Hans Dreier explained, "If a given part of a set is duplicated on a smaller scale and the replica is placed between the camera lens and the original set, preserving the original lines of sight emanating from the camera, the photograph of the portion in miniature will coincide exactly with that of the original set, and it will not be necessary to use the large set at all."[15] In their function in completing sets, miniatures played a similar role to the matte paintings that became more ubiquitous with the rise in optical printing. However, as production designer Vincent Korda argued in 1941, set-miniatures had certain advantages over matte paintings, including three-dimensionality and the flexibility to accommodate camera movement as well as multiple camera angles and focal lengths.[16] *The Jungle Book* (Zoltan Korda, 1942), for instance, features a miniature (placed in the middle ground, rather than the foreground as was conventional) to create the upper portion of the lost city.[17]

With regard to their better-known role in staging action, miniatures were employed to render events—including, often, calamities such as explosions or natural disasters—that, in the words of Don Jahraus, head of the department at RKO responsible for miniatures, "would be impossible or impractical in actuality."[18] For instance, they facilitated the depiction of earthquakes toppling large buildings in *The Last Days of Pompeii* (Ernest B. Schoedsack, 1935) and *The Rains Came* (Clarence Brown, 1939).[19] Miniatures became especially important to the war films of the 1940s, for which the subject of aviation was of particular interest even as the war made the use of actual planes less feasible.[20] A. Arnold Gillespie's department at MGM, for example, used miniature planes and boats for the sequences in which characters set out for combat in *Mrs. Miniver* (William Wyler, 1942) and *Thirty Seconds over Tokyo* (Mervyn LeRoy, 1944).[21] For the staging of such action in miniature, it was necessary to calibrate carefully the scale and detail of the miniatures, as well as the perspective and speed of the camera, in order to simulate the look and movement of life-sized objects.[22]

A subcategory of the set-miniature, glass shots entailed the use of a partially painted pane of glass positioned in the foreground in front of the action to be

filmed. The camera would capture both the image painted on the glass and the action unfolding behind the transparent area.[23] This technique thus also facilitated the creation of composite imagery at the time of shooting, and it was popular into the early 1930s. *King Kong* (Merian C. Cooper and Ernest B. Schoedsack, 1933)—a film that also deployed miniatures, model animation, rear projection, optical printing, and both the Williams and Dunning traveling-matte processes (described below)—used glass painting to create the background in the long shot of the crew's arrival at Skull Island, with the faraway images of the great wall and Skull Mountain painted on a sheet of glass that was actually positioned a few feet away from the camera.[24] By 1932, however, matte painting began replacing glass shots, and by 1937 glass shots were reportedly "seldom used."[25] As one cinematographer put it in 1934, matte shots didn't interfere with production to the degree that glass shots did, and they allowed "the director and cinematographer much greater freedom in their choice of set-ups."[26]

Traveling mattes—also innovated in the silent era—played a prominent role in the early 1930s. Techniques such as the Williams and Dunning processes made it possible for the matted area to shift from frame to frame, so that a moving figure could be composited with a separate background. The Williams process took footage of the primary action to create a matte that made it possible to composite that action with separately photographed background imagery during printing, while the Dunning process used color separation to "self-matte" the action footage onto pre-filmed background footage at the time of shooting.[27] For *The Invisible Man* (James Whale, 1933), John P. Fulton employed the Williams process to enable background imagery to show behind the portions of the protagonist's body that were supposed to be invisible.[28]

By the mid-1930s, however, these traveling-matte techniques were largely supplanted by rear projection (designated at the time by terms such as "process projection," "background projection," and "transparency process"). Simpler than the Williams and Dunning processes, it entailed the projection of previously photographed background imagery through a translucent screen on the set. Actors performed in front of the screen, so that the composite camera could capture their action and the projected background simultaneously.[29] This concept was not new in the 1930s either, but several developments made it newly feasible, including adequate means for synchronizing the background projector with the composite camera in order to avoid flicker (achieved with electrical hook-ups developed for sync sound), faster and more sensitive negative emulsions to photograph the rear-projected image (achieved with the introduction of supersensitive panchromatic film stock), and more powerful light sources, paired with improved optics, to make the rear-projected image brighter (developed to accommodate larger theaters and widescreen projection).[30] Problems with the rear-projection process included the loss of detail and definition in the projected background, the challenge of keeping both the actors and the projected background in focus,

the difficulty of rendering the projected background image completely steady, the variation of light across rear-projection screens including the presence of "hot spots," and limitations on marshaling sufficient light for large rear-projection screens. Technicians worked to address these challenges, particularly through innovations in screen construction and rear-projector design.[31]

Probably the most familiar technique of this era, rear projection became ubiquitous, providing the moving backgrounds for countless images of actors who, from the safety and comfort of Hollywood soundstages, would pretend to be touring far-flung locations or speeding along in moving vehicles. As early as 1932 Farciot Edouart contended that rear projection had "come into general use in practically all of the major studios" and that "scarcely a picture is released by any such major producer which does not include at least two or three such scenes—and some productions have used this process to make 75 or 80% of their total foot-age."[32] In a report on the process department "at one of the major studios"—likely Edouart's department at Paramount—American Cinematographer compared that studio's creation of composite shots in 1930 (when such shots were achieved with the color-separation process), 1931 (the year the studio adopted rear projection), 1932, and 1933.[33] While the number of such shots rose from 146 to 340 to 503 to 658, the average cost per shot dropped from $314.95 to $184.61 to $140.59 to $116—a reduction in cost attributed to both volume and the reuse of background film from the library amassed by the studio in those years.[34] By 1942 Paramount was reportedly making between 1,600 and 2,000 rear-projection shots per year.[35]

One of the foci of the engineering discourse on rear projection in the 1930s was the issue of screen size. Early in the decade, rear projection entailed relatively small screens of around six to eight feet wide, a limitation attributed in large part to the amount of illumination needed for larger screens.[36] Technicians worked to increase the size of rear-projection screens over the decade, with redesigned projector optics and new cellulose surfaces facilitating the use of larger screens (such as the twenty-foot-wide screen used in King Kong) in 1932.[37] By 1938, with the use of triple-head rear projectors, which superimposed three separate background images onto a single screen and thus supplied more light, it was possible to use thirty-six-foot screens for black-and-white work.[38] Paramount employed such a screen for Spawn of the North (Henry Hathaway, 1938), even though production had begun with a much smaller, twenty-four-foot screen.[39]

The revamped Technicolor process popularized in mid-decade necessitated more illumination and thus posed greater difficulties for large rear-projection screens. Prior to the introduction of triple-head projectors in 1938 the maximum size for a rear-projected color image was ten to twelve feet wide; the triple-head projectors made it possible to use fifteen- to eighteen-foot-wide screens for color work.[40] Technicolor films such as The Adventures of Robin Hood (Michael Curtiz and William Keighley, 1938) and Dr. Cyclops (Ernest B. Schoedsack, 1940) made use of these projectors.[41] In 1942 new rear-projection equipment, built to

industry-wide standards that had been adopted in 1939, was put into service. This new equipment had single-head projectors with equivalent power to the earlier triple-head models. Further, three of the new units could be combined to create an even more powerful new triple-head projector.[42] Paramount used two such projectors, with dual screens, to achieve a forty-eight-foot-wide Technicolor background image of a forest fire for *The Forest Rangers* (George Marshall, 1942).[43] At the same time as this experimentation with color rear projection, a traveling-matte system suitable for three-strip Technicolor was developed in the United Kingdom. Utilizing a blue background screen, this process made possible the fantastic airborne horse and genie in *The Thief of Bagdad* (Ludwig Berger, Michael Powell, and Tim Whelan, 1940).[44]

Nearly simultaneous with the rise in rear projection, an increased reliance on optical printing facilitated the creation of composite shots in postproduction. Optical printing involves the re-photography of carefully controlled portions of footage projected within the device.[45] Like rear projection, optical printing was not a new technique, but it became newly plausible with the popularization after 1926 and refinement in the early 1930s of duplicating negative and positive film stocks that mitigated the loss of quality in re-photographed images.[46] As Carl Louis Gregory put it in 1928, optical printers could be applied to "dissecting the component parts from various pictured realities and then recreating an imaginative result from the dissected parts."[47] Optical printers took over effects previously achieved in the camera—ranging from transitions such as fades and dissolves to matte shots and split-screen effects—and contributed to the vogue for wipes in the 1930s (the latter exemplified by *Flying Down to Rio*, Thornton Freeland, 1933). The traveling mattes, split-screens, and dissolves enabling characters to appear and disappear in *Topper* (Norman McLeod, 1937), for example, were achieved through optical printing.[48] Moreover, optical printers could be used to modify otherwise unusable footage; RKO optical printing pioneer Linwood Dunn, for instance, deployed the device to remove offending lettering from the side of a truck in *Flaming Gold* (Ralph Ince, 1933) and to change the timing of a plane bursting into flames to correspond with the action in another part of the frame in *Ace of Aces* (J. Walter Ruben, 1933).[49] In 1932 Warner Bros. technician Fred Jackman contended that all fades and dissolves were being made on optical printers, and by 1936 Dunn could observe that "during the past four or five years hardly a single production has been released that did not utilize the services of the optical printer to some extent."[50]

Applications and Resonances

The effects technicians working in Hollywood saw it as their duty to employ such techniques and technologies, in A. Arnold Gillespie's words, "to achieve

the illusion of live-action reality."[51] And it can be tempting to judge effects of this period according to whether they do—or, often, don't—appear convincing to contemporary eyes.[52] Whatever the verdict, though, studios used effects to help construct a historically specific version of cinematic "reality" that merits close analysis. In particular, rear projection and optical printing worked with other technologies and practices to produce heavily mediated cinematic spaces; film space was increasingly constructed through proliferating screens (in production as well as exhibition) and stacked image planes (constituted by these screens, together with paintings, miniatures, and expanses of glass) receding into the depth of the image.

The interest in expanding the size of the rear-projection screen links this effects technique with discourses on theater design, which also emphasized the prospect that screens could dominate a cinematic space. The standard sizes for rear-projection screens proposed in 1939, ranging from seven feet to thirty-six feet wide, closely matched contemporaneous theatrical screen-size averages, which ranged from ten feet to thirty-four feet wide.[53] There had been experiments with large-screen exhibition in the 1920s, and discourses on theater design in the late 1920s and 1930s emphasized efforts, aligned with the prospect of larger screens, to move away from the ornamented décor of picture palaces and toward a less obtrusive theatrical space subordinated to a dynamic screen spectacle.[54] As theater architect Benjamin Schlanger put it in 1931, "The very art of the theater should demand more intangible surroundings than those which are obtained by garden walls and other finite unchangeable forms. The larger screen will to a great extent determine the treatment of the interior, its very size making it an integral part of the auditorium."[55]

The interest in larger cinematic screens occurred in a context in which the prospect of a new kind of domestic screen was also widely discussed. Film industry personnel deployed the issue of screen size in the attempt to distinguish cinema from television, but concern about screen size also infiltrated discussions of the new medium. As of 1928 television screens had a relatively small picture of seven by eight inches, and the prospect of larger television screens for both home and theatrical exhibition was of keen interest in the ensuing years.[56] Despite rhetoric of intermedial competition, the engineering discourse not only troubles the distinction between cinema and television in its emphasis on theatrical television but also joins them in a media landscape marked by the proliferation of screens. Moreover, thanks to rear projection, screens pervaded the movie set itself. As Cecil B. DeMille describes it, his 1936 Paramount production of *The Plainsman* entailed a stage in the foreground upon which were arranged "not one screen, but two, behind [the] set." For reverse-angle shots, the production team "simply turned our set around . . . re-aligned the screens, and carried on with different backgrounds."[57] The picture DeMille paints here is thus one in which production also occurs in a space surrounded by screens.

The notion that screens could and should structure cinematic space illumi-
nates the special effects in the era's biggest commercial success, *Gone with the
Wind* (Victor Fleming, 1939). While this film also makes heavy use of matte
painting (a feat for Technicolor), producer David O. Selznick and the technicians
working for him conceived the film's centerpiece burning of Atlanta sequence,
in particular, as an experiment in the use of screens to construct both diegetic
and theatrical space.[58] That sequence makes use of rear projection (both full-
sized and miniature), as well as optical printing, to composite the actors with
the fire footage that was famously shot before the role of Scarlett had even been
cast (color plate 1).[59] Such rear-projected Technicolor footage was a point of pride
for Selznick, who boasted to William S. Paley of CBS—in a letter urging him to
utilize rear projection for television productions—that *Gone with the Wind* "did
many things with transparency work in color that had not hitherto been thought
possible."[60] Selznick's plans for implementing a three-screen setup for the exhi-
bition of *Gone with the Wind* also originated with that scene.[61] In short, the fire
sequence was imbricated through and through with the use (or prospect) of cut-
ting-edge screens in both production and exhibition. The threat of engulfment
posed by the massive fire in the diegesis would, according to Selznick's plan for
triple-screen projection, apply to viewers in the theater as well. Although the idea
of triple-screen projection was eventually abandoned, the film's exhibition strat-
egy emphasized a multi-pronged approach to ensuring spectatorial immersion
in other ways, including explicit directives to exhibitors about the elimination of
house lighting and the need for ushers to keep aisle curtains and doors shut.[62] Not
only does such an approach to exhibition accord with the engineering discourse
on the use of screens in theater design, its link with rear-projection screens also
makes it clear that this diegetic space was constructed according to a similar logic
of pervasive and engulfing mediation.

The discourses on rear-projection screens also indicate a focus on the rela-
tionships among image planes that aligns them with the interest in image
depth evident in discourses on other techniques and technologies in the 1930s
and 1940s. Like the optical printing that famously facilitated the deep-focus
aesthetic of *Citizen Kane* (Orson Welles) in 1941, rear projection was heralded
as making possible sharper focus in background as well as foreground planes,
since it could bring together elements shot with different focusing distances (as
long as the actor and screen were positioned sufficiently close together that the
composite camera could keep them both in focus).[63] At the same time, devel-
opments in rear projection, such as the triple-head projector that enabled the
use of larger rear-projection screens, both facilitated and demanded an increased
depth of focus for the composite camera: facilitated because the increased image
brightness supplied by that projector made it possible to stop down the lens of
the camera; demanded because the ability to use larger rear-projection screens
meant a concomitant ability to increase the distance between actor and screen.[64]

The movement toward larger rear-projection screens also expanded the camera-distance options for process shots. Whereas small rear-projection screens meant that actors had to be photographed at fairly close range in order for the projected image to constitute their background, larger screens facilitated longer shots fully backed by rear projection.

These effects often relied on the stacking of image planes. *King Kong* featured miniature jungle sets arranged in several planes, separated from one another by partially painted sheets of glass and including small screens utilized for miniature rear projection.[65] *Gone with the Wind* also stacked glass-mounted matte paintings and miniature-projection screens (with paint scraped off the former in places to provide a view of the latter), particularly for the burning of Atlanta sequence where miniature rear projection supplied some of the background images of the fire.[66] Vernon Walker, head of the camera effects department at RKO, advocated the nesting of rear-projected images within rear-projected images.[67] Considering that the theatrical screen displaying such multiply processed shots itself acted as yet another image plane, it is clear that cinematic space had become increasingly mediated not only through the expansion and pervasion of screens but also through the layering of image planes receding into the depth of the diegesis. In this sense these approaches to special effects resonate with discourses on other contemporaneous technologies including stereoscopic 3D, which was reputed to render depth "as if given by a series of thin cardboard models placed in different planes," and the multiplane camera, which enhanced the illusion of

FIGURE 13: A representation of the use of stacked planes to construct cinematic space from *Notorious* (1946).

depth for animation by enabling foreground and background elements painted on glass to be illuminated and moved separately and shot at different distances from the camera.[68] A 1938 article on the multiplane camera mentions the possibility of utilizing process backgrounds in the device.[69] Filmmakers using rear projection sometimes attempted to bridge the gap between foreground and background planes by positioning objects in the middle ground. For *Gone with the Wind* Selznick advocated placing "some actors and action between the plate and our principals—such things as actual troops going in front of the wagon when it is stopped."[70] *Dr. Cyclops*, drawing on an approach from *King Kong*, bridges a rear-projected medium close-up of Dr. Alexander Thorkel (Albert Dekker) with a live-action long shot of one of the scientists he is supposed to have shrunk by using a large prosthetic hand to extend Thorkel's body into the live-action foreground (color plate 2).[71]

A particular shot in *Notorious* (Alfred Hitchcock, 1946) provides a representation of this kind of mediated space constituted by stacked planes (see figure 13). The film heavily features rear-projected images of Rio de Janeiro, but here the still painting of a seascape creates the background. The window frame, together with the curtains flanking it, makes this painted surface a figure for the various film screens used in the production and exhibition of the film, particularly since the shape of the window approximates a widescreen aspect ratio and the aperture left by the curtains approximates the Academy ratio.[72] If Cary Grant occupies the position of a film viewer, the movie puts the actual viewer into the familiar position of apprehending a series of stacked planar images, starting with the theatrical screen itself. This film—like many others, ranging from the fantastic to the naturalistic—thus marshals effects techniques including rear projection, together with other elements of production such as set design, to construct a diegetic space that both reflects and extends the increasingly mediated viewing space within which it was experienced.

5

POSTWAR HOLLYWOOD, 1947-1967: Editing Dana Polan

1947 . . . Imagine, suggest the coauthors of *Pictorial Continuity*, a filmmaking manual for the amateur, scenes from anodyne American life—buying a used car, attending a picnic, mowing a lawn, and so on. Then see how the experts would film these charming bits of Americana. With dedication, you can do it too.

Arthur Gaskill and David Englander's *Pictorial Continuity* radiates cheerful faith in postwar culture as built up from ordinary yet almost folkloric rituals. Subjects drawn from quaint everydayness have a seemingly inevitable, logical, naturalized air to them. Accordingly, their filmic treatment should likewise be rendered in logical and natural form. Proper storytelling technique, the authors explain, is "essential to every production, whether Hollywood epic, newsreel, documentary, cartoon, or homemade movie of the baby in her crib."[1]

This technique, as their title asserts, is that of "continuity." In their words, continuity helps tell a "story smoothly, coherently, logically"; it is "the proper development and connection of motion-picture sequences to create a smoothly joined, coherent motion-picture story." Like other such amateur moviemaker manuals, *Pictorial Continuity* promotes proper continuity as both flexible (there should be no dogma here) *and* rule-bound (there may not be one right way to film a scene but there are certainly demonstrably wrong ways). Take, for instance, a recurrent example from the book of a common action from American life,

"something ordinary and everyday, such as one person's visiting another." Since we are in the postwar moment of salesmanship, why not imagine "a salesman's call on a prospective customer"? Pictorial continuity for this routine activity would entail establishing the scene by a long shot that captures the whole of the office of "Mr. Prospect" (as Gaskill and Englander name him) and ending with a close-up, "the heart of your picture." But since a punctual shift from long shot to close-up would jar, add an intermediate view: "This great jump will not do. It is too abrupt. There must be a midway or transition shot—a *medium* shot."[2] Moreover, to avoid jumpiness, you will want each shot to take a somewhat different angle on Mr. Prospect. Then, you can expand the scene by returning every so often to the establishing shot or by inserting logically motivated cutaways (for example, to Mr. Prospect's dutiful secretary).

For contrast, let's take another example of a businessman, another "Mr. Prospect," waiting in a room. This time, though, the example is not hypothetical, à la Gaskill and Englander's 1947 manual, but from an actual film. 1966 . . . In John Frankenheimer's *Seconds* (David Newhouse and Ferris Webster, editors), a businessman, Arthur Hamilton (John Randolph), alienated from work, family, and suburban lifestyle, waits by the phone for a call that could send him toward the rebirth promised by a mysterious organization. No establishing shot here, no smooth dissolve from the previous scene. Instead, we have a jarring cut from a long shot outdoors in early evening as Hamilton arrives home to an extreme close-up of the telephone in the shadows of late, late night. Cut to an extreme close-up of the anxious Hamilton that blocks off his forehead and chin. Cut, *without a change in angle*, to a slightly longer view that now shows a bit more of Hamilton from just below his chin to almost the top of his head and, with another cut at the same angle, a bit more. Then to two additionally distant shots, the first revealing Hamilton at his desk and the next in the inky dark of the room overall. And suddenly the phone rings with unsettling loudness and we cut back to a closer view (but from a new low angle) of Hamilton apprehensively grabbing the receiver.

Needless to say, this all seems a direct inversion of what Gaskill and Englander had offered. Instead of an establishing shot that leads smoothly into closer views of the subject, the *Seconds* sequence starts close and then proceeds outward. And the maintenance of the same angle after each cut violates the rule, expounded in so many manuals like *Pictorial Continuity*, that continuity cutting requires some variation in angle to avoid discord: instead, we notice the axial cuts in *Seconds*, which are quite palpable.

Stylistically, thematically, we are no longer in the optimistic space of the well-functioning Americana that undergirds Gaskill and Englander's book: two years after *Pictorial Continuity*, Arthur Miller's play *Death of a Salesman* would offer a devastating depiction of salesmanship's futility, and through the years, the alienation of the white- collar drone, the ubiquitous "man in the gray flannel

suit," would become a common trope in popular culture. *Seconds* comes from this tradition, and it matters that the film tries to find stylistic equivalents for lives not going as smoothly as the American dream had promised. Editing in the 1960s could itself become a tool in the representation of alienation and emptiness. For instance, in 1967's *Divorce, American Style* (Ferris Webster, editor), a marriage's breakdown receives dramatic form when the increasingly estranged husband and wife (Dick Van Dyke and Debbie Reynolds) retreat to their bathroom after one more empty suburban cocktail party to separately prepare for bed: in a veritably choreographed whirlwind, the two pass each other imperviously, sharply opening and closing drawers and sliding doors, all of this cut to the slamming of each door and the shutting of each drawer. Cinema of the 1960s seems and feels different, from the overall narratives of the films down to the ways individual shots are put together.

As Paul Monticone's chapter on studio era–editing well captures, continuity editing had been established early on and endured through the decades of the studio system, finding supple ways to turn challenges (such as the coming of sound) into resilient extensions of the original paradigm. That a postwar book for amateur filmmakers, such as Gaskill and Englander's, can insist that the same model applies in the realm of hobby culture suggests just how far the ideology of continuity editing had been disseminated. As Gaskill and Englander wryly note, one needs to master the procedures to tell the story coherently, but not engage in too much experiment and innovation, since "this is just a simple homemade movie, not a psychological drama by Orson Welles."[3]

Of course, the Hollywood system allowed for degrees of flexibility; thus, in his breakthrough study of cinematography, Patrick Keating has argued that each film represented complex negotiations (between producers and makers, for instance) over goals of realism and glamour, narrative and the need to show off stars, plausibility and genre conventions, and so on.[4] In editing, likewise, the procedures of filming that gave editors material from which to build continuity—for instance, shooting master shots of an entire sequence and then capturing closer views of individuals within the scene, and going back right away to the set if more coverage was needed—were not about binding editing into one particular structure, but creating options. For every producer who (in)famously railed against directors who provided mainly long-take master shots (and thereby, in the producer's view, abrogated the producer's ultimate say over the whole creative process), there were other producers who expressed concern that too much coverage could encourage "cuttiness" (the term is David O. Selznick's, employed in one of his legendary memos, to suggest that two-shots—i.e., longer takes of both figures in a conversation uninterrupted by cutting—might work as well as shot/reverse shot).[5] After all, for the producer, while there might well be a need for editing to offer visual diversity in addition to moving the story forward, there was also recognition that Hollywood films were designed to highlight star acting

and that this might sometimes best be served by longer takes and longer distance shots that showed two star figures playing off each other.

Yet, even if the Hollywood system has always offered a (bounded) range of options for filming, there were preferred approaches that tended to dominate in this or that historical moment. This is why one can construct a *history* of film style and even suggest, as Barry Salt has done in his pioneering work, a statistical quality to variabilities and regularities. Importantly for the beginning of the period that concerns us here, Salt notes a concerted increase in average shot length (ASL): in the early to late 1930s, shot lengths had started to decline ("Particular advantage of the possibility of speeding up the cutting rate was taken at the Warner Bros. studio," asserts Salt in a statistical confirmation of what has long been common intuition about pacing in Warner films), but then began to rise from about 1939 on.[6]

By the late 1940s, longer takes filled Hollywood films. In Salt's words, "The net result of this was that the mean A.S.L. for a large sample of Hollywood production went up from 8.5 seconds in the late 'thirties to 9.5 seconds in the period 1940–1945, and finally to 10.5 seconds in the period 1946–1950."[7] Into the 1950s, long sections of films could ensue with little or no editing: most pronounced is Alfred Hitchcock's 1948 experiment of filming *Rope* (William H. Ziegler, editor) with a moving camera and daringly minimal use of cuts. At a more local level, long-take filming could create alternatives to classical analytic editing. A striking example occurs in Fritz Lang's *Clash by Night* (1952), shot by cinematographer Nick Musuraca and edited by George Amy. The protagonist (Robert Ryan) tries to endure the marriage of the woman he loves to another man but, anguished, he storms out of the wedding party. In long shot, we see him descend a side staircase and walk all the way up to the camera: rather than cutting in for a close-up, the movement here offers a clever way to create a close-up within the long take (especially clever since the more typical way to create a close-up would be to move the camera *in*).

It has often been assumed that deeper-focus cinematography (as in 1941's *Citizen Kane*, shot by Gregg Toland and edited by Robert Wise) led to shots of longer duration, although seemingly there is nothing inherent in a deeply focused shot that requires it to remain onscreen for a long time. Still, if one has gone to the trouble to set up a shot that exploits the resources of deep focus, it is worth letting it be seen for a while. Additionally, since being able to see into the recesses of a deep focus shot expands the potential for visibility, just as it might take longer to scan a long shot versus a close-up, it would take longer to take in what is shown in a deep-focus shot versus a shallow one, and this might also encourage keeping shots on the screen longer. Yet just as significant a factor in the vogue for longer takes was widespread interest in moving the camera, an option made all the easier by new devices for gliding the camera effortlessly through filmic space. Key here were the various iterations of the "crab dolly," so called because it could

scuttle in any direction around the set (and even through the set, as when walls slide up to enable *Rope*'s camera to explore all parts of the apartment where the film takes place).[8]

And no doubt there were intermedial reasons as well for the interest in long-take cinematography. For instance, Tennessee Williams-esque psychodrama could encourage actors to work through psychological issues in a long take—for instance, the opening of Sidney Lumet's *The Fugitive Kind* (1960; Carl Lerner, editor) offers over four minutes of uncut soliloquy by Marlon Brando. Method acting worked from the assumption that actors needed time to unveil their tapping into the deepest recesses of the mind. Thus, in 1954's *On the Waterfront* (Gene Milford, editor), when Terry (Brando again) and Edie (Eva Marie Saint) wander through a playground early in the film and get to know each other (and he famously tries on her glove, which she has dropped) one long take is used: it lets us see Terry's groping attempts at the articulation of tenderness. In contrast, when Terry confesses his role in her brother's death, Edie's reaction, punctual more than psychological, is handled through montage: cutaways to boat whistles, fast shifts between Edie and Terry that increasingly move closer to them, offscreen sounds of machinery, abrupt cuts (and at several angles) to the priest (Karl Malden) who is hoping some good will come out of all of this.

To witness just how much Method acting and fast editing could seem inimical, one can cite a symposium on editing and acting that the American Cinema Editors (ACE) sponsored in 1965 in which one invitee, actor Guy Stockwell, argues how the actor's needs might conflict with the editor's. The question that the Method raises, in Stockwell's words, is "how do you develop a role and get some kind of continuity on stage? Well, it becomes compounded tremendously when you are doing it on film because, as you know, we do it in fits and snatches. ... When this [the director's filming of the bits] is all done, it then goes in those cans to the editor. ... What I want to know is this—*how does the editor go about determining for himself what that actor was trying to do? What the line through the actor's performance was? And in what ways—if it does—in what way does it determine where those scissors go?*"[9]

Another factor that slowed down cutting rates, for a time, was the emergence of large-screen formats—CinemaScope, Cinerama, and so on—that the studios promoted as spectacular alternatives to the small screen of film's rival, television. Negatively, it was felt that fast editing wouldn't work well with large-screen processes (one assumption was that cutting from shot to shot in widescreen would be jarring to spectators who might well have trouble ingesting so much of an expanse of new visual material with each view that came up on the screen); positively, some cinematographers argued that large-screen formats might minimize the need for editing and put more creative control into their hands. (Famously, cinematographer Arthur Clarke argued for the superiority of CinemaScope long takes over analytic editing by declaring, "I believe that it is more interesting and

natural to the spectator if scenes are sustained and a minimum number of cuts are made.")[10]

But as recent scholarship has clarified, more rapid rates of cutting quickly became acceptable to filmmakers working with widescreen formats. For instance, Lisa Dombrowski analyzes how black-and-white Scope films from 1956 on, such as the cheesy *Kronos: Ravager of Planets* (1957; Jodie Copelan, editor) or Samuel Fuller's *Forty Guns* (1957; Gene Fowler Jr., editor) are replete with fast cuts that abruptly change the scale of the image, while Ariel Rogers finds in Elia Kazan's 1955 *East of Eden* (Owen Marks, editor) a tactilely engaging investment in canted angles and, more important, impactful cuts to close-up (especially in the film's climax). To take a somewhat more staid example, the 1956 adaptation of the Broadway musical *Carousel* (William Reynolds, editor) shows how length of shot and editing patterns became open aesthetic choices more than mechanical adherence to format constraints: each of the first three songs, which move from solo to duet to group effort, exhibits a different editing style and shot length ("Mr. Snow" is one long take with extensive camera movement; "If I Loved You" alternates one-shots and two-shots; "June Is Busting Out All Over" cuts dynamically all around a 360-degree space to show revelers whose enthusiasm for summer fun seems boundless), and an even earlier non-vocal musical number includes quick cutaways and shot/reverse shots of Billy Bigelow and Julie riding the carousel. (The shot/reverse shots on the carousel—camera on Billy, camera on Julie—can almost seem to comment playfully on narrative continuity's reliance on over-the-shoulder shots: Julie is positioned on a rising-and-descending carousel horse, so each view of Billy shows him over her endlessly shifting shoulder)[11] (see color plate 3).

Yet a decline in ASL, predictable when filmmakers came progressively to master editing in widescreen, actually turned out to be a longer-term and consistent drop that endured over the following decades. As Barry Salt puts it, "A new trend now appeared in the cutting rate of Hollywood films: a trend towards scene dissection into shorter shots which was the reverse of the long take trend of the nineteen-forties. Although, as always, some long established Hollywood directors moved with the trend, the change was primarily associated with new, younger directors who started making films at the end of the 'forties or the beginning of the 'fifties."[12] (Salt cites Robert Aldrich as one key example here.) In a later essay, Salt even offers a graph that shows ASLs progressing upward to a plateau in the early to mid-fifties, followed by a constant and dramatic fall over the ensuing decades.[13] No doubt a variety of factors were at work here: for example, the increasing visibility of European art-cinema experimentation with editing; and the influence of television, including an influx of personnel from that medium to film, which encouraged dynamic cutting, both to emulate the seemingly fast shifts between cameras that distinguished some live television drama, and to attempt to outdo it as a rival visual medium.

Technological change within the specific domain of editing made only a relatively minor contribution to this story of changes in patterns of postwar editing, at least up to the end of the period that concerns us here. As craftsmen who worked with gadgets to which they were devoted, film editors tended to be technologically conservative: thus, as late as 1963, ACE member Frederick Y. Smith could observe, "In the past twenty-five years or more there have been few innovations invented or developed which pertain specifically to the handling of film by the Film Editor."[14] Nonetheless, there were two innovations worth describing, one of which began to have an impact only at the end of the period under consideration in this chapter.

One innovation, apparent throughout the immediate postwar period into the 1950s, was the attempt to find alternatives to the standard method of physically combining shots, which typically used glues or fluid cements. There were two drawbacks to the traditional procedure. First, these adhesives worked only when emulsion was scraped away and the ends of the two pieces of film then overlapped; this meant losing some portion of two contiguous frames (with, as a consequence, a slight modification of the intended rhythm of the edit). When screening rough cuts, editors would often insert blank or black film (termed "slugs") to indicate where frames were missing: one can only imagine that this would negatively affect the experience of watching even these preliminary versions, distorting tempo or dramatic effect. Second, the cementing gave an aura of finality to the edit, though one might only be at the stage of rough cut.

Often the first problem could be solved by what came to be termed a butt-cut or butt-edit (a term from welding, where butt-welds put two pieces of material end-to-end and join them there rather than overlapping them). One early system for butt-cutting involved heating the ends of the film and adhering them through acetate applied on the base of the strips, not the emulsion side. Yet this still gave the splices a permanence akin to that produced by cementing.[15] Increasingly, the preferred solution came to be *tape* splicing, wherein some sort of splicer lined up the two strips of film "butt to butt" and then pressed a strip of tape over them to make the join. (Tape splicing, of course, would not be used on final prints for distribution, only for rough cuts.) Tape encouraged experimentation since it was now easier to take an edit apart and redo it in another fashion. Revealingly, in a boundless ode to tape splicing in *Cinemeditor*, Irving Lerner (who had experience in producing and directing as well as editing) declared that tape's impact was aesthetic more than mechanical. Lerner saw tape-splicing as opening up new worlds of editing creativity: "The butt splice, held together by transparent tape with the built-in possibility of adding and subtracting frames and manifold choices of other shots without marrying up the workprint makes all this possible and easy.... If there are rules, they are there to be broken.... The only way to such discovery is experimentation, trial and error. The butt splicer makes this process simpler; and possibly cheaper. It provides us with the freedom to try."[16]

The other technical development—which came to America after the period covered in this chapter but which started to be spoken of early and to exert an influence—was the rise of flatbed viewing machines, such as the Steenbeck or the KEM, both manufactured in Germany. While many editors, adhering to that fetish of craft traditions that distinguished the profession, stuck to their upright Moviolas, the flatbeds offered several attractions: using a combination of sprocket gears and rollers, these new machines could run film at much more rapid and variable speeds than Moviolas, thus hastening the editing process (and they didn't risk tearing the film, a constant danger with the upright Moviola); the flatbeds could accommodate bigger spools of film (thus allowing more of a film's construction to be viewed in one sitting); and they had a much bigger screen than the Moviolas did, which could encourage shared viewing of footage. (The latter feature encouraged the increasing interaction—sometimes felicitous, sometimes fractious—between editors and would-be auteurs that Benjamin Wright outlines in his chapter on editing in the subsequent decades.) Perhaps most important, flatbeds could accommodate three or more reels of film, each with its own picture head, so that editors could switch from one reel to another, checking out alternative versions in an anticipation of the nonlinear editing that would characterize the digital age.[17]

While the first U.S. feature to be edited on a flatbed, by Barry Malkin, wouldn't be released until 1969 (Francis Ford Coppola's *The Rain People*), American editors knew of the device—and in many cases lusted after it. Some had encountered flatbeds during European shoots (issues of the ACE's *Cinemeditor* from the 1960s are filled with articles about what to expect during foreign shoots), and some learned about them from auteurs coming to America from abroad. Even without hands-on contact with the machine itself, editors became ever more aware of the values of speed, of rhythm for longer sections of film, and of seeing editing as part of a collaborative process in which editor and director alike worked to render cinema an expressive form.

Technology aside, changed technique imparted a new sense of dynamism to shot-to-shot rhythm as American film made the transition to the 1960s: above all, the new decade saw an increased use of straight cuts between scenes. In the straight cut, one moves directly from one scene to the next, rather than by means of dissolves or fades or other such smoothing devices. In his chapter, Benjamin Wright shows how one such case, Dede Allen's scene-to-scene cutting for 1967's *Bonnie and Clyde*, so seemed to violate classical continuity (in part because the straight cuts often led not into establishing shots but smaller details of the new scene) that studio boss Jack Warner felt virtually assaulted and insulted by the new process.

In his statistical analyses, Barry Salt found such cuts still to be rare in the 1950s—for instance, in a sample from 1959, he declared nineteen out of twenty films to have "all the transitions between shots done with the traditional fades,

dissolves, and wipes"[18]—but quite widespread by the 1960s. There was clearly a learning curve—both for filmmakers and viewers—to the technique. For instance, Nunnally Johnson's 1956 *Man in the Gray Flannel Suit* (Dorothy Spencer, editor) has two long flashbacks when businessman Tom Rath (Gregory Peck) sees things that trigger recollections of the war: in the first, Rath looks at a man in winter dress and conventionally *a dissolve* takes us back to Rath's killing of a young German for his coat; in the second, Rath looks up at planes flying by and *a straight cut* brings us back to wartime parachute jumps. To see how far things would soon develop, one has only to contrast this to the way Sidney Lumet's *The Pawnbroker*, from 1965 (Ralph Rosenblum, editor), deals with the intrusions of memory: *The Pawnbroker*'s flashbacks start sometimes as mere flashes almost subliminal in duration and not always sporting visual matches or other transitional devices to smooth them over. (This approach stands in contradistinction to *The Man in the Gray Flannel Suit*, where both series of flashbacks, whether executed by dissolve *or* straight cut, are preceded by Rath looking at something that triggers them.)[19]

While there are isolated examples of straight cuts throughout the 1950s, some seem quite awkward as markers of transition. Take, for instance, another Nunnally Johnson film, *The Black Widow*, from 1954 (also Dorothy Spencer, editor). On the one hand, while the film's first scene transition (from an airport where the protagonist sees his wife off on a trip, to a cocktail party he then attends) is handled by a dissolve, the transition out of the party occurs with a straight cut, to cars in daytime going up a New York avenue: the viewer likely interprets this new image as "later" (maybe the next day) until a voiceover abruptly indicates this new scene is actually a few months earlier. The transition is quite confusing. (Later, as *The Black Widow* turns into a murder investigation, the flashbacks accompanying each witness giving his or her account of what led up to the crime are presaged by straight cuts. At least one flashback lies, and one can wonder if using flashbacks to offer multiple, not necessarily reliable accounts of a crime

FIGURES 14-15: Editing contributes to a false sense of continuous action in *The Graduate* (1967), as Benjamin Braddock jumps from a pool into Mrs. Robinson's bed.

had some inspiration from Akira Kurosawa's *Rashomon*, which had received an honorary Academy Award the previous year.)

Some of the straight cuts in the 1950s, especially later in the decade, have an ostentatious quality as if the filmmakers know they are onto something bold and distinctive. For instance, in George Abbott and Stanley Donen's *The Pajama Game* from 1957 (William Ziegler, editor), a climactic speech has the boss speaking conciliatorily in close-up at his employees' union rally; suddenly there is a jump to the same framing but with the boss now in pajamas, with the camera craning back to reveal him at an employee party taking place later than the rally and elsewhere. Just a few years later, in the penultimate scene of Disney's 1961 *The Absent-Minded Professor* (Cotton Warburton, editor), the film's title character goes to Washington to offer the government his levitational invention, Flubber. At a White House press conference, he is asked if he has further scientific plans in mind, and there is a cut to an extreme close-up as he says, "I do." But then another cut to long shot shows him no longer at the White House but in his own home giving his assent to his long-delayed marriage (hence the "I do"). Films of the 1960s come to be filled with jarring cuts of this sort—seeming aural continuity linked to spatial and temporal discontinuity. Yet to find such a technique in the seemingly conservative world of Disney family entertainment suggests how far the hip, new editing style could infiltrate even the most staid and conventional of storytelling worlds. And while, as with *The Pajama Game*, the ironically matched cut in *The Absent-Minded Professor* can strike us as a way of jazzing up classical storytelling, later films use matched straight cuts to make meaningful points: for instance, the notorious cut from bone to spaceship in *2001: A Space Odyssey* (1968; Ray Lovejoy, editor) to comment on man's fraught evolution across the vastness of time, or the famed cuts in *The Graduate* (1967; Ralph Rosenblum, editor) from Benjamin jumping from a pool raft onto Mrs. Robinson in bed, the edit suggesting how the emptiness of his sexual relationship reiterates his empty slothfulness at home (see figures 14 and 15).

At the same time, as the example of *Bonnie and Clyde* suggests, abrupt straight cuts without any matching (ironic, thematic, ostentatious, or whatever) would also become a common practice in 1960s cinema. At the extreme (and the flashes in *The Pawnbroker* already hinted at this), the straight cut to a new reality can move beyond the function of simple inter-scenic connection: in Roger Corman's *The Trip* from 1967 (Ronald Sinclair, editor), an LSD trip is represented by flashes that intrude into the consciousness of a commercials director who has taken the drug. And while 1969's *Easy Rider*—analyzed at length by Benjamin Wright—does use straight cuts to move from scene to scene, it does so in a highly unconventional manner: flashes from an upcoming scene break into the current scene, becoming progressively longer until they replace it.

Beyond the way straight cuts increasingly influenced how scene transitions were structured in the 1960s, they also contributed to a type of explosive editing *within* the frame during the decade. Specifically, there was a vogue from the mid-1960s on for splitting the image into ever more multiple frames within the overall frame, as one sees in *Grand Prix* (Henry Berman, Stu Linder, and Frank Santillo, editors) from 1966, and *The Boston Strangler* (Marion Rothman, editor), *Charly* (Fredric Steinkamp, editor), and *The Thomas Crown Affair* (John Wright, editor), all from 1968 (see figure 16).[20]

In the case of *Grand Prix*, the split screens (along with some of the fast montages in the film) were created by legendary designer Saul Bass. Film historian Jan-Christopher Horak has shown how Bass's interest in montage had led him earlier to think of the acclaimed title sequences he had designed as veritable montage within the frame (consider, for instance, Bass's credits for 1960's *Psycho*—lines frenetically shooting past one another or violently colliding). Horak sees the experimentation in *Grand Prix* as the next step in conceiving of the image as a space of visual explosion. As critic Bosley Crowther, quoted by Horak,

FIGURE 16: A multiple-screen effect creates intoxicating imagery in *Grand Prix* (1966).

wrote at the time of the film's release, "Triple and quadruple panels and even screen-filling checkerboards full of appropriate and expressive racing-world images hit the viewer with stimulations that optically generate a sort of intoxication with racing."[21]

There were direct influences on this new styling of the filmic image from experimental cinema and from expanded screen experiences at various world's fairs (Grand Prix director John Frankenheimer had been much taken with a multi-screen slide experiment at the 1964 Fair by architect/designers Ray and Charles Eames) and expositions, such as Canada's Expo 67, but a deeper inspiration might be a general assumption in 1960s psychedelic culture that everyday perception underutilized human capacity for sensory intake. In this respect, the "intoxication" that Crowther found in Grand Prix is not that far from the drugginess that seems to inspire the visual feel of a number of sixties films. ("Take the ultimate trip," as the ads for 2001: A Space Odyssey put it.)

Across media, frenetic sensory overload became a goal: to take one example from an allied medium, ACE member Stanley Frazen describes his experience editing the television series The Monkees: this was, he recounts, "a series that would literally be constructed in the editing room. . . . We too were challenged to find new ways, new methods, new rhythms for film construction. . . . This 'no rules' is probably the greatest opportunity that can befall an editor if he digs its significance. It's like a new world—it's the LSD of film."[22]

But as the case of 2001 suggests, not everything is frenetic in the visual style of trippy 1960s films. True, space traveler Dave Bowman's voyage "beyond the stars" is represented as a fast, psychedelic experience of sensory overload, but elsewhere the film is distinguished by deliberate longueurs, and in the context of the 1960s this could be intoxicating in its own way. Indeed, drugginess could also be associated with a seeming slowing down of time, producing a contemplative rhythm divorced from the pace of the 9-to-5 work ethic. Take, for instance, 1969's Easy Rider: certainly editor Donn Cambern exercised freedom in fashioning a fast-paced LSD sequence, but the film is also marked by the decidedly slower pot sequences where joints are proffered, people slowly move into stoned mode, and then they make long, often comical speeches replete with fantastic imaginings.

To return to the example of Seconds, it is worth noting that if fast, abrupt editing (as in the aforementioned telephone sequence) is often foregrounded, other sequences are heavily invested in the long take. For instance, when the head of the mysterious organization that promises rebirth asks a vacillating Arthur Hamilton what aspects of his current life are meaningful, there is a long take of around six minutes in which Hamilton enumerates what he finds rewarding (his marriage, his family, his boat, a promised promotion, socializing with friends, and so on), only to end in tearful silence at accepting the emptiness of it all. This long take is experimental in its own way and achieves a corollary to the experience of white-collar alienation.

Or take another example from *The Graduate*: early in the film, an unclothed Mrs. Robinson traps Benjamin in a room of her palatial house. A rapid montage captures the panic Benjamin feels at this attempt at seduction: first, he is shown whipping his head around three times in three cuts and, second, shots of his dismay-filled face alternate with almost subliminal glimpses of Mrs. Robinson's naked flesh. The direction of Benjamin's reluctant glances only partially lines up with Mrs. Robinson's body so, at this frantic level of editing, there is also insistence on not matching the shot and its reverse shot.[23] But when the offscreen sound of Mr. Robinson's car coming into the driveway is heard and Benjamin flees the room, the film cuts to an almost minute-and-a-half long shot in which Benjamin comes downstairs, Mr. Robinson comes in, and the two begin a conversation about Benjamin's future. If the fast editing in the scene with Mrs. Robinson finds one extreme way to play out Benjamin's sense of entrapment, so does the downstairs interaction with Mr. Robinson, where the lack of a cut amplifies Benjamin's "capture." Later, in this film, which is a compendium of bold filmic techniques, there is even a sequence that metaphorically manages to combine the long take and "cutting": in bed with Mrs. Robinson at a point when their affair has been going on for some time, Benjamin asks her if, for once, they could talk a bit before having sex. For the first two minutes of the scene the action plays out in one long take, but at key moments in their conversation, Benjamin or Mrs. Robinson flicks the lights in the room on or off so that the single take is interrupted—cut up, in a way. Again, the creative impulse is to investigate options and, in this case, to engage in two (the long take, visual interruption) at the same time.

We might then characterize many sixties films via the title of a short film from 1959 that director Richard Lester shot and edited, *The Running, Jumping, and Standing Still Film*, and that led the Beatles to hire him for their first two features, *A Hard Day's Night* (1964; John Jympson, editor) and *Help!* (1965; John Victor-Smith, editor). Lester's short has lots of running and jumping but also calmly surreal scenes like one in which a character far in the background comes slowly to a beckoning figure standing still in the foreground, only to be punched out once he gets there. In myriad ways, many sixties films push at the limits of time—the too fast, the too slow—and can create experiences quite unlike the graceful, flowing, mainstream narratives of the classical Hollywood system.

6

POSTWAR HOLLYWOOD, 1947–1967: Special/Visual Effects

Julie Turnock

Prior to World War II, the day-to-day work of the effects team in the "Classical Hollywood" era had been fairly straightforward. Effects teams in most cases were expected unobtrusively to match the (mostly) studio-bound principal photography: all elements had to appear in the proper perspective in the picture plane and blend as seamlessly as possible with the live-action cinematography and mise-en-scène. Such work might, for example, add ceilings to sets, fill in the upper stories of buildings, or add clouds to the sky. In the postwar era, the use of special effects was still driven primarily by the same practical considerations of novelty, cost, efficiency, and safety. Effects technology tended to utilize or expand upon the techniques used in films like *King Kong* (Merian C. Cooper and Ernest B. Schoedsack, 1933) and *Gone with the Wind* (Victor Fleming, 1939). It might be tempting, therefore, to imagine that once the studios set up their effects departments there is little to say about special effects work until the changes brought by *Star Wars* (George Lucas, 1977) and other groundbreaking films of the late 1970s. However, the increased use of color cinematography, widescreen, and large-format film in the immediate postwar era prompted a number of shifts in many areas of production, such as shooting on location (often in far-flung places) and a

trend toward formal expressivity in both color effects and staging.[1] As larger and higher-resolution images brought more intensive scrutiny to their work, special effects teams had to refine and rethink a number of their working methods.

Sizable Hollywood studio effects units could indeed choose from a great diversity of special effects techniques, discussed in the previous chapters. These include detailed miniatures, matte paintings, physical and mechanical effects, rear projection, and optical printing. Such techniques continued to be used in the spectacular climaxes of impressive road show productions that include *The Ten Commandments* (Cecil B. DeMille, 1956) and *Mutiny on the Bounty* (Lewis Milestone, 1962), as well as in science fiction films such as *War of the Worlds* (Byron Haskins, 1953) and *Earth vs. the Flying Saucers* (Fred F. Sears, 1956). Also, a few directors, most notably Alfred Hitchcock, used special effects in unexpected ways in films such as *Vertigo* (1958) and *Marnie* (1964) by infusing the mise-en-scène with emotionally and psychologically dramatic effects. At the same time, in the wake of the Paramount Decree forbidding studio monopolies, effects departments (along with many others) began to break apart and disperse as studios found it more cost-effective to outsource effects to independent effects houses.

Crisis #1: Color Rear Projection

In the postwar era, the mainstream of the special effects industry focused their research on a technology contemporary viewers often consider mundane at best and embarrassing at worst: color rear projection. Although viewers in the post–*Star Wars* era and the age of digital compositing often find rear projection somewhat awkward—or even incredibly obtrusive—evidence suggests that viewers and critics in the classical and postwar eras accepted or tolerated the technique.[2] Rear projection is generally organized around a set of projection technologies that were called "process" when the projected images were moving, and "transparencies" when the projected image was still.[3] Black-and-white (panchromatic stock) rear projection came into common use in the early 1930s and was favored over color separation techniques and traveling mattes such as the Dunning process or the Williams process (developed through the late 1910s and 1920s).[4] While its main compositing alternative, color separation techniques (such as bluescreen compositing accomplished with the optical printer), including various traveling matte techniques, were still in use—and, in the opinion of many, such as director George Stevens, achieved a superior result—by the postwar era they were considered to be specialty techniques reserved for circumstances where rear projection was not feasible.[5]

From an industrial standpoint, rear projection still suited production schedules, creative hierarchies, and personnel staffing much better than optical printing. By the 1950s, black-and-white rear projection had become so

commonplace and standard it was rarely mentioned in the professional literature except when directors or cinematographers wanted to brag about eschewing it in favor of location shooting.[6] However, two technological developments in the 1950s and 1960s threw this previously stable technique into turmoil among practitioners: the increasing use of color film, which tended to distort color values when rear projected; and the increasing use of location shooting, which forced rear projection footage to be edited together (frequently in the same sequence) with location shooting and backlot footage, causing visual mismatching and inconsistency. Potential problems with color rear projection's ability to attain the accepted professional image quality had been expressed in professional literature as early as 1939.[7] But as widescreen color films became more and more common through the 1950s, color rear projection provoked a crisis in the process and transparency personnel of effects departments.[8] These departments came under pressure to counter the appearance of color distortion and better match foreground and background image quality. Until the late 1960s, effects artists (at MGM and Paramount, especially) began aggressively researching and developing color rear projection techniques.

In the early 1960s, MGM debuted what they called their "Tri-Lace" rear projection system, a triple projector, blended composite, ultra widescreen method which they touted as the "first and only radical departure from the previously standard center-line method of rear-projection to be made in the last 30 years."[9] As an *American Cinematographer* article explains:

Some progress was [previously] made in correcting the color distortion of background and prints to improve the final composite. This had been a constant and serious problem, because the background, when rephotographed, becomes a dupe, while the foreground action is, of course, originally negative; the resulting contrast makes the final composite, if not competently handled in the many steps of this medium, barely acceptable, according to established standards of technical quality.[10]

In frank terms, this article delineates the technical headaches and professional dissatisfaction involved with color rear projection that had bedeviled practitioners over the years. The contrast between foreground and background described by this technician reveals diverging perspectives on color rear projection: for producers and the general public, rear projection remained visually acceptable; however, from the point of view of effects artists and technicians, the quality of the composites resulting from color rear projection had declined to the point that it was no longer acceptable. Hence, this technician's analysis reveals a conflict between the professional image quality standards of the effects artists and the studio's economic industrial efficiency requirements.

Hitchcock's *To Catch a Thief* (1955) can serve as a somewhat lavish but

nevertheless typical example of color rear projection in the prestige picture. It also demonstrates the problems involved in editing together rear projection and location footage as well as the resulting color distortion. The effects team's goal was typical of high-budget films of the 1950s: to unobtrusively cut together the lush VistaVision location images of the French Riviera with backlot and rear projection shots of the actors made in the studio in Hollywood.[11] According to industry discourse, the goal of matching location shooting and rear projection was central, but perhaps more important was "achieving the amount of technical finish one expects from Hollywood major studio cinematography."[12] Challenges to accomplishing this "technical finish" faced by second unit location photographers in coordinating footage included matching the source of light and weather conditions among shots, despite shorter schedules in location shooting and the lack of "technical refinements" available at the studio.[13] Production records for *To Catch a Thief* indicate that more transparencies and plates (over location shooting) were used than originally planned, due to unfavorable weather conditions.[14]

A particularly striking example of such problems is visible in the scene when John (Cary Grant) and Francie (Grace Kelly) drive along the Riviera coastline through hairpin turns, sparring verbally with one another while being tailed by police (color plate 4). This scene is composed of Riviera location principal photography edited together with location second unit photography and Hollywood studio rear projection. The sequence begins with an establishing (second unit location) helicopter shot of the car on the road. The shot cuts to rear projection studio footage of the foreground actors, sitting in a glossy, bluish green car, in very sharp focus, modeled with rather hard, shiny lighting effects that sculpt the figures of the actors in relief against the background. There is a cut to a traveling matte shot of John looking in the rearview mirror at the following police car (second unit), and back to a two-shot in the car, alternated with second unit photography through the car's windshield. The difference in quality of the Hollywood-shot footage of the foreground actors in richly colored VistaVision Technicolor is especially noticeable thanks to Francie's shimmering highlighted blond hair, bright salmon pink dress, and John's deeply tanned and somewhat leathery skin.

Although the movement of Francie's car dodging buses and pedestrians as it speeds down the road is expertly coordinated for suspenseful effect between the second unit and rear projection plates, the image quality of the background plates is noticeably degraded. The background plates are not only smeary looking (different from simply being out of focus) but also have a markedly muddier hue and cooler blue tone than the foreground elements. Also, as is typical with rear projection, there is a subtle difference in the way the eye perceives the speed of the car and the speed of the background. These problems are visible despite the fact that at the time, the large format VistaVision system (used to film both the foreground and background plates) was promoted as providing the most saturated

color possible. Problematically, the intense VistaVision color only makes the distinction between foreground and background more evident. The combined effect of this contrast, common in such scenes (and not solely attributable to Hitchcock's intention), is like a shallow stereoscopic effect, and calls attention to itself as a composite, however subtly. In other words, the foreground appears as one flat plane, and the background as another flat plane, and the two are not fully synthesized into the convincing illusion of an integrated whole—a problem the later Tri-Lace method was unable to solve. And although a 1955 VistaVision production like *To Catch a Thief* vividly demonstrated the added production value of color location photography as well as the splendor of the VistaVision process, it also conversely intensified the contrast with the rear projection plates, which had previously been less evident.

Examples provided by films made around the same time, such as *Written on the Wind* (Douglas Sirk, 1956) and other less canonical films such as *The Cobweb* (Vincente Minnelli, 1955), *3:10 to Yuma* (Delmer Daves, 1957), *Designing Woman* (Vincente Minnelli, 1957), *Sayonara* (Joshua Logan, 1957), and *Gidget* (Paul Wendkos, 1959), establish the baseline practice; indeed, rear projection sequences in Hitchcock films look largely the same as those made by less prominent directors such as Wendkos. In all cases, one sees a planar effect where the foreground and background planes of action visually grate on one another, subtly out of sync. The lighting and coloration of the foreground is markedly harder, brighter and shinier than the muddied, grainy background. To sum up, the example from *To Catch a Thief* demonstrates that rear projection had particular technical specifications that were not often, if ever, significantly altered for directorial manipulation. In order to film dialogue scenes and properly record the sound in "moving" vehicles, all filmmakers were locked in to the technique's particular specifications. Although several directors (including Hitchcock) occasionally made expressionistic use of special effects, most directors and studios tended to adhere to a fairly standard look for rear projection in this era.

Crisis #2: "Road Show" Spectacle Effects and Location Shooting

The pride of the studios in the postwar era was the lavish production known as the "road show," which included films such as *Ben Hur* (William Wyler, 1959) and *Lawrence of Arabia* (David Lean, 1962). Road shows were the highest budget studio productions (exhibited with the live theater model, including reserved seating, higher ticket prices, and an intermission), released initially with great fanfare and publicity in major cities, and eventually shown in smaller markets. Road show spectacles amply displayed the studio effects departments' capabilities and often served to spur technological research and development in those departments. As with rear projection, color location shooting caused problems

for effects teams, who had new sets of standards to conform to and problems to solve in order to live up to increased expectations. Those standards included richer color palettes, higher-definition images, and the need to compose larger image areas. Problems encountered by effects teams included a lack of control over environments and shooting locations and unstable location weather conditions for technicians to match. The greater scrutiny of special effects on expanded screens and larger film formats led the technicians to begin to downplay rear projection in favor of larger scale miniatures, and to start to explore older but more expensive traveling matte techniques.[15]

Generally speaking, the effects strategy was to go big. Paramount's 1956 production of *The Ten Commandments* (Cecil B. DeMille) provides a particularly extravagant example of a mid-century road show production, with a proverbial cast of thousands, months of location shooting in Egypt, and more than two years of shooting altogether.[16] Filmed as much as possible on the actual biblical locales "in order to give the picture authenticity and the utmost religious significance,"[17] the film's special effects program was also well funded. Over the course of three years, armies of effects workers produced matte paintings, miniatures, and practical effects for the production, climaxing in the famous sequence depicting the parting of the Red Sea. DeMille had previously worked closely with longtime Paramount effects head Gordon Jennings on large-scale epics such as *Samson and Delilah* (1949) and *The Greatest Show on Earth* (1952). However, Jennings died of a heart attack shortly before filming was to begin. This disruption in Paramount's effects department brought effects legend John Fulton—best known for his optical effects work on *The Invisible Man* (James Whale, 1933) and *The Mummy* (Karl Freund, 1932) as head of Universal's effects department—to the studio. Fulton worked at Paramount as head of special effects for another decade, also contributing to many Paramount productions directed by Hitchcock, including *Rear Window* (1954), *To Catch a Thief*, and *Vertigo* (1958).

DeMille conferred an unusually high status on Fulton for the shoot. Fulton traveled to Egypt for six months to help DeMille and cinematographer Loyal Griggs scout locations to accommodate the effects footage and to assist in the staging of principal photography, including staging for the Exodus sequence.[18] Back in Hollywood, Fulton inherited the longstanding Jennings team (which included Ivyl Burks in miniatures, Jan Domela in matte paintings, and Paul Lerpae in optical printing) and had the colossal task of organizing and executing the parting of the Red Sea sequence. The wall of water "miniature" for the sequence was so large that Paramount had to lease part of RKO's backlots to build it.[19] The massive physical water effect was created with split screen photography, reverse motion, physical smoke effects, matte paintings, storm cloud animation, and hand-animated rotoscoping, combined with Sinai Peninsula location footage and live-action actors performing against a bluescreen. The parting of the Red Sea resulted in one of the most complex effects sequences yet made, and one that

could only be accomplished with the full economic power of the studios backing a prestige road show production.[20]

Although the lush large format and widescreen color photography of the 1950s and 1960s and the location shooting typically used in road show films like the *Ten Commandments* added to the stature and prestige of the effects team, they also caused considerable problems for effects artists. The largely set-bound cinematography of the period from the 1920s through the 1940s had meshed well with the studio workshop special effects of the same era. However, the effects teams of the later road shows were pushed to match the higher image quality of postwar cinematography. Their approach was to escalate the scale of their effects work correspondingly. The enlarged image size and resolution of the principal photography meant that when cut together and projected on giant screens alongside higher resolution location footage, details in miniatures, mattes, and rear projection (previously well suited to the lower resolution and the smaller scale of the Academy aspect ratio) were magnified as well. The parting of the Red Sea sequence sidestepped these problems through scale and movement, not to mention the latitude granted by the supernatural status of the event. In the long shot of the parting sea, the frame is jam-packed at the edges with the movement of the gaping crowd in the foreground, the rumbling sky overhead, and Moses' performative gesture (color plate 5). However, the shot is carefully composed to direct the spectator's eye to the road that parts the water, thereby discouraging the spectator from scrutinizing the composited mise-en-scène. Moreover, the entire sequence includes very little location work, so the shots do not alternate with location footage but remain consistently within the "magical" effects aesthetic. The overall effect is so overwhelming with detail and action that its "apartness" from the rest of the film seems appropriately climactic, rather than jarring.

MGM's *Mutiny on the Bounty* (1963) also serves as a "go big" index of mid-century studio resources. The film made use of a great variety of effects techniques such as demonstrating the "success" of its Tri-Lace color rear projection method described above. However, *Mutiny* also demonstrates the physical extremes and mechanical scales studio road show pictures were willing to attempt in order to create a sense of "authenticity" or "reality." For example, the production built *four* full-scale models of the *Bounty* ship.[21] First, for the storm sequence that climaxes the first part of the film, a full-scale model complete with sails and set up on rockers was built inside one of the largest MGM soundstages and positioned against a huge gray cyclorama. Two others were constructed as full-scale cutaways—one with full deck gear and sails, the other a cutaway model of the below decks interiors and built on rockers on the MGM backlot. The fourth and most remarkable was the full-scale practical sailing model of the *Bounty*. In order to facilitate location shooting on the seas around Tahiti and Bora Bora, the model was to be, in effect, a floating motion picture studio, designed and built to "provide the most complete and spectacular camera coverage of the story action."[22]

Other films that required extensive location shooting, like *Gigi* (Vincente Minnelli, 1958), were filmed in renowned "authentic" locations (such as Maxim's nightclub and the Bois de Boulogne in Paris), while *Sayonara* was shot on location in Japan in the famous Takarazuka Theater near Osaka and at the emperor's summer palace in Kyoto. *Strategic Air Command* (Anthony Mann, 1955) put VistaVision cameras into aerial photography interactions with the U.S. Air Force's B-36s. Eventually, Stanley Kubrick followed the road show's example by building enormous "miniatures" of spaceships for *2001: A Space Odyssey* (Stanley Kubrick, 1968). The road show gave the impression that Hollywood's grandeur (and the special and visual effects it required) was unlimited by monetary concerns. However, in the late 1960s, this escalation in production backfired. Road shows lavished too much money on productions that bombed financially and critically, precipitating a downscaling in producing, financing, and staffing big-budget films, and the eventual trimming or elimination of in-house effects departments.

Crisis #3: "Expressive" Uses of Effects and Alfred Hitchcock

> *I think the secret of successful color photography is not to shoot a scene to make it look as it looks to the eye. . . . Straight, ordinary cinematography is for newsreels. . . . As a painting, well done, can stir you emotionally, so also do scenes painted with light have a similar emotional impact on audiences.*[23]
>
> —Leon Shamroy, ASC

One of Hollywood's mid-century alternatives to the production value and "authenticity" promised by extensive location shooting was to embrace a more frankly artificial style, and special effects played an important role in realizing these stylized visions. For example, in a discussion of cinematography, Leon Shamroy describes the purposeful use of non-naturalistic color filters he used to "tint scenes in delicate, pervasive hues complimentary to story mood and action for increased emotional impact," for the musical *South Pacific* (Joshua Logan, 1958).[24] Shamroy's choice had the blessing of (former theatrical) director Joshua Logan, but not that of the producers, who were spending a great deal of money to shoot "authentic" Polynesian locations in Hawaii.[25]

These more expressive trends in filmmaking (associated most often with Alfred Hitchcock, but also with Logan, Vincente Minnelli, and Douglas Sirk) had an important impact on special effects practices as well. The special and visual effects assignments for the vast majority of postwar era films remained the seamless matching of principal photography and the creation of unobtrusive backdrops for the main actors. However, the mid-century saw a minor but

nevertheless significant use of effects for expressive purposes, which included those designed to match a non-naturalistic mood, atmosphere, or psychological state, in contrast to those designed to create a plausible environment. As filmmakers experimented with potentially expressive elements of the mise-en-scène, including lighting, costuming, and set design, special effects crews were likewise expected to redeploy their traditionally unobtrusive effects toward less naturalistic and more visibly expressionistic ends. In some cases, this meant returning to the by-then less familiar color separation traveling mattes.

Due to his historical prominence, Hitchcock is a particularly intriguing and troubling figure in tracking this trajectory. While he often used effects conventionally, as with the use of rear projection to create a location backdrop in *To Catch a Thief*, Hitchcock also loved playing with new special effects processes, and was not at all hesitant to talk to interviewers about the "secrets" and motivations behind various optical effects.[26] He bragged to François Truffaut about being the first in the British studios to use the Schufftan composite process in *Blackmail* (1929) (in the British Museum sequences), and openly discussed the optically montaged Salvador Dali dream sequence for *Spellbound* (1945), the matte paintings used for the nonexistent bell tower in *Vertigo*, as well as the complex hand-drawn traveling mattes for *The Birds* (1963).[27]

However, when placed within the context of the trend for expressive effects in cinematography, color film, and art direction, effects that seem idiosyncratic when considered in isolation become more situated when considered as part of a historical shift in effects practices. For example, the many optical effects in *Vertigo* follow a mid-century trend when visually expressing the inner state of the main character, Scottie (James Stewart), along various trajectories. For example, Scottie's nightmare sequence (designed by artist John Ferran and executed by Paramount's Fulton and his effects team) features fluctuating and pulsating lurid color filters that accentuate Scottie's distress. Animation (of Carlotta's bouquet) depicts Scottie's spiraling mental disintegration. The traveling matte process used in this sequence helps thematize Scottie's mental state as he walks against a black background that is optically filled in with a cemetery, then as his disembodied head is printed over a swirling vortex, and finally as his black cut-out figure falls onto the tile roof of the mission (see figure 17).

In *Vertigo*, Hitchcock uses effects techniques such as traveling mattes both in their conventional "realistic" manner (as when Scottie witnesses Madeleine fall from the tower) and expressively (when Scottie dreams that he is the one falling). By showing rather than concealing the composites with black cut-out areas, these sequences dramatize and visualize Scottie's mental dislocation, his psychological fragmentation, and the lack of a full narrative picture. Studio records document Hitchcock's considerable correspondence with Fulton on directing or executing the many composites, matte paintings, and montage sequences needed for this sequence and others, and there is an unusually high number of effects shots used

FIGURE 17: In the dream sequence in *Vertigo* (1958), traveling matte cut-outs indicate Scottie's deteriorating mental state.

in the film to represent Scottie's mental state.[28] While this approach is appropriate in a film featuring themes that are so intertwined with its protagonist's mental state, the dream sequence is nevertheless unusually protracted (lasting two minutes) and elaborate, even in an era that relished symbolic Freudian montage sequences (see, for example, *Crack-Up* [Irving Reis, 1946] or *The Father of the Bride* [Vincente Minnelli, 1950]).

Although Hitchcock was somewhat unusual in his creative use of effects, his films used them realistically and conventionally far more often than expressively. For example, the production files for *Vertigo* have many specific and directed notes to John Fulton about the film's optical effects. Although *Vertigo* features several rear projection sequences, all are conventionally conceived, as in the sequence when Scottie and Judy drive to the mission shortly after Scottie realizes Judy's role in his deception. Certainly, Hitchcock had motivation to engineer an emotionally charged atmosphere through the unconventional use of rear projection. However, visually there is no evidence of manipulation in color, angle, or distance, and the production files do not include any reference to the rear projection beyond the shooting of the plates, all of which are described conventionally in the production record.[29] Unlike the many notes to Fulton, there are no special notes to Paramount's head of rear projection, Farciot Edouart (who Fulton did not directly supervise), in the production files. Instead, the ominous nature of the occasion is indicated visually, through editing (such as a shot indicating Judy's POV of the trees), and aurally, by the score.

In other words, one should exercise caution against overstating or overgeneralizing Hitchcock's expressive use of effects techniques. Although he loved to discuss his showier effects sequences, neither he nor his collaborators, in any evidence I have found, discuss manipulating rear projection for expressive

purposes.[30] Instead, the lack of discourse around rear projection suggests that as a compositing technique, it was visually conventional and commonplace. In contrast, bluescreen traveling matte techniques, because rarer at that time, were visually less familiar and more appropriate for the kind of disconcerting effects that occur in a film such as *Vertigo*.

In summary, Hitchcock was indeed unusual in the studio era for paying such attention to the cutting edge of special effects technology.[31] However, we can understand *Vertigo*'s unusual effects as a more flamboyant use of expressive effects in the mise-en-scène that was typical in this era, as seen in Douglas Sirk's color-filtered and fraught interiors in *All That Heaven Allows* (1955) and *Imitation of Life* (1959), or in Vincente Minnelli's dream and fantasy sequences in the musicals *An American in Paris* (1951) and *The Band Wagon* (1953) and in his dramas *The Cobweb* (1955) and *The Four Horsemen of the Apocalypse* (1962). Effects crews working on Hitchcock's films often created conventional effects; however, like the artists who deployed color filters in *South Pacific* to distort Hawaiian location footage for emotional effect, these crews were also charged with matching a character's psychological interiority with setting and narrative.

Moving somewhat down market to the independent sector, the well-known 1950s cycle of science fiction films—particularly space exploration and alien encounter films—might be understood as providing lower budget examples of the trend toward using effects for visual stylization and psychological metaphor and analogy. The science fiction films of the 1950s, such as *Earth vs. the Flying Saucers* (Fred F. Sears, 1956), *Invasion of the Body Snatchers* (Don Siegel, 1956), and *20 Million Miles to Earth* (Nathan Juran, 1957), displayed—rather than concealed—elaborate, albeit cheap, effects programs. Along with their higher-budgeted studio-produced counterparts, such as *War of the Worlds* (Byron Haskin, 1953), *Conquest of Space* (Byron Haskin, 1955), and *Forbidden Planet* (Fred M. Wilcox, 1956), these films are generally understood as visual manifestations of various Cold War geopolitical anxieties.[32]

Lower budgets mandated a less precious attitude toward the precise matching of effects elements to live-action footage, and these films tapped into the strangeness of their alien crafts and creatures to transform this potential drawback into a distinct aesthetic. In *Earth vs. the Flying Saucers*, for example, as the rotating discs hover over Washington, D.C., landmarks, their hard, smooth, metallic surfaces and mesmerizing gyrations (stop-motion animated by Ray Harryhausen) contrast with the more "organic" marble and limestone of the stable, neo-classical buildings.[33] The simple, streamlined design gives the impression of impenetrability, unknowability, and inhumanity. Likewise, the alien spacecraft in *War of the Worlds* help accentuate the visitor's otherworldly strangeness to prompt maximum discomfort in audiences. The so-called "Tripod" design (executed by Gene Warren Sr. and his team) also emphasizes the ship's sleek impermeability, but adds to it a green glowing abdomen and, most

disturbingly, a long ostrich-like "neck" with a laser-blasting "eye" on top. These design choices evoke both a perversion of familiar organic forms and imply hostile forms of alien surveillance. The fact that the alien creatures and crafts are not seamlessly incorporated into the mise-en-scène exaggerates their unearthly and distinctly inhuman designs and foregrounds the aliens as expressions of viewers' unconscious fears and beliefs.

Finally, a brief mention should be made about studio outsourcing and independent effects houses. Historians have attributed the success and stability of the Hollywood studio system to Fordist efficiency methods.[34] However, the history of special effects provides an instructive example for understanding postwar changes to the industry, and especially changes to the studios in the wake of studio workers' labor actions of 1945 and the Paramount Decree in 1948. As the studios began to dismantle aspects of their distribution and exhibition branches, they also slowly began to cut or spin off elements of their production units. Special effects departments were among the earliest targets for cuts for a number of reasons. Studio heads suspected that the mystery that cloaked special effects work was, in fact, a cover for inefficiency, making these departments an easy target in cost-saving efforts. More important, though, were viable outsourcing alternatives in the independent sector, which had existed since the 1910s.[35]

By the late 1940s, artists and technicians in studio effects departments found it more lucrative and professionally advantageous to set up independent houses in Hollywood outside of the studio gates. RKO's famed optical expert Linwood Dunn (*King Kong*) formed Film Effects Hollywood in 1946. Other houses led by former studio effects workers, including Joseph Westheimer, Frank Van der Veer, and Howard Anderson, all saw steady business from studios, independent production houses, and commercial (advertising) production houses throughout the postwar era and into the 1970s and 1980s, where they completed effects work for features, shorts, advertisements, and eventually television. The slow dismantling of the major studios' effects teams led to the entire sector becoming independent from the mid-1960s on, when the auteur special effects boom initiated by blockbusters such as *Star Wars* and *Close Encounters of the Third Kind* required both a new special effects aesthetic as well as a different workforce and business model.

Despite its somewhat moribund reputation, the postwar era in special effects from 1947 until 1967 included a number of important technological and economic shifts and upheavals that would continue to resonate into the so-called "Auteur Renaissance" of the late 1960s and 1970s. Although effects artists in postwar studios largely worked within the same aesthetic paradigm and technologically refined and repurposed techniques developed in earlier eras, they nevertheless demonstrated their flexibility by reworking those methods in order to match new production contexts around color film and cinematography, widescreen formats, location shooting, and dramatic expressivity.

7

THE AUTEUR RENAISSANCE, 1968–1980: Editing Benjamin Wright

The history of American cinema in the 1970s has been roundly characterized as a cultural schism between, on the one hand, a spiritually rebellious and socially conscious cinema and, on the other, an outwardly commercial one. The "Hollywood Renaissance," as it has been called, represented a pivotal moment in the American film industry when major studios, faced with crippling financial losses and a staggering unemployment rate among Los Angeles–based filmmakers, climbed out of a deep recession by diversifying risk, consolidating holdings through corporate conglomeration, and recruiting a younger generation of filmmakers to tap into the expanding youth market with aesthetically experimental narratives inspired by European art cinema and more commercial "high-concept" projects billed as "event" films. The emergence of star directors like Francis Ford Coppola, George Lucas, and Steven Spielberg, who were credited for resuscitating the ailing movie business with a mixture of technical expertise and stylistic flair, largely overshadowed the network of professional relationships that blossomed between these filmmakers and their sound and picture editors, cinematographers, composers, production designers, and visual effects personnel. The auteur renaissance, which elevated the creative authority of American film directors during the 1960s and 1970s, also served to strengthen the professional status of picture editors, whose reputation in Hollywood as mechanical

technicians had limited their position as creative decision makers. The decade that brought sweeping institutional changes to the American film industry also fostered a new collaborative role for editors as creative artists.

While cutting film had always been considered a technical craft by major Hollywood studios and labor guilds and remained wed to the basic tenets of the classical style, the period ushered in broader changes in the ways editors conceived, talked about, and organized their work. Embedded within this shift in practice was a desire among editors to develop their professional identities beyond their jobs as splicers, cutters, and knob turners. As editors sought to experiment with editorial conventions and narrative form, their experiments gradually changed how popular films were cut, transforming the status of their work from technical to artistic. What follows is a brief examination of how this occupational shift took place and transformed film editing from a skilled trade to an expressive craft.

The constitutive relationship between the social organization of an artistic community and the cooperative decisions that shape the production of an artwork has been examined by Howard S. Becker, whose sociological studies of "art worlds" suggest that such occupational transitions are commonplace in art history when there are changes in the status of the artistic medium among critics, audiences, and practitioners.[1] In describing the networks of cooperative action and artistic conventions in the production of popular art—including painting, music performance, clothing design, and furniture making—Becker outlines a theory of artistic practice that applies equally well to the professional identities of editors in the film industry. A strong parallel can also be found in Robert R. Faulkner's ethnographic studies of contemporary Hollywood studio musicians and composers. He argues that the "composer-artist" works for a "client-employer," resulting in a work (the composition) that is highly negotiated and subject to external contingencies.[2] In a commercial craft like filmmaking, clients do not always treat below-the-line practitioners as experts the way they would a physician who provides a diagnosis; in most cases, decisions arise out of complex creative negotiations. In other words, as Faulkner notes, "Only the craft really belongs to the craftsman. The product belongs to someone else."[3] Ultimately, these sociological approaches help to clarify the social processes of picture editing, particularly in the 1970s when the status of cutting film—and those who cut film—was elevated to the level of expressive craft.

As the public profiles of editors expanded in the New Hollywood, so too did the need for editors to speak about their work in concrete terms. Anthropologist Thomas Porcello has shown that technical professions such as sound mixing regularly use linguistic resources such as metaphorical description as the basis for community membership, perpetuation, and occupational expression.[4] Indeed, metaphorical description becomes a vital resource for editors to illustrate the highly esoteric aspects of their work. Editors often describe themselves as jazz

musicians who perform "visual rhythms that are not easily defined," while others refer to "that other consciousness" to convey the intuitive properties of cutting film.[5] Some describe their work as assembling a "patchwork quilt" or finding "balance" among sound, music, narration, and a director's personal statement. Still others emphasize the relationship to sculpture and the plastic arts: "Like metal, you can bend it in different positions."[6] The insights gained from speech about professional practice reveal a set of discursive conventions based on how editors manage careers, build recurring client relationships, and make sense of their creative work. These conventions, which derive from the general tasks of film editing, are evenly split between the rote mechanical labor of operating equipment and the expressive practices that account for the aesthetic qualities of the work. With this in mind, we can distinguish three basic occupational tasks of film editors in the New Hollywood: technical skill, client management, and footage assembly.

At some level, the relationship between technical skill and professional style is reflected in the editor's task of cutting on machines. Notwithstanding the large-scale changes to distribution and exhibition throughout the period, editing of the image track in the 1970s remained largely tethered to studio-era technology, particularly the Moviola. Generations of Hollywood filmmakers learned to cut on Iwan Serrurier's upright machine, which was developed in 1917 and dominated the industry until a pair of German-made flatbed systems—the KEM (Keller-Elektro-Mechanik) and Steenbeck—were introduced to American filmmakers in the late 1960s. Serrurier's Moviola runs footage through a threading device not unlike a sewing machine with a vertically oriented viewing screen that magnifies the film as it passes across the lens, while flatbeds feature a larger viewing monitor and accommodate more sound and picture reels on flat platters that run footage horizontally through the editing mechanism.

Walter Murch, an early adopter of flatbed technology, describes the differences between the upright and flatbed systems in metaphorical terms: "The Moviola is sculptural in the sense of a clay sculpture that you're building up from bits, whereas the KEM is sculptural in the sense that there is a block of marble and you're removing bits."[7] Similarly, Dede Allen assesses editing technology of the period in this way: "When people are working on an eight plate KEM, they're in effect working with two Moviolas but they don't get their hands on the bits and pieces of film."[8] Allen's preference for cutting on the Moviola was motivated by the comfort she felt standing over the machine, her eyes and hands mere inches from where the film passed through the gate, whereas flatbeds were designed to be used from a seated position, further away from the workprint. Interestingly, as Allen liked to joke, the smaller viewing screen and upright position of the Moviola made it that much more difficult for clients to stand over editors and suggest where to cut.[9]

These approaches also reveal that editing technology was neither deterministic nor mandated, but instead related to the technical demands and preferences of

the editor. Although a small number of picture editors were experimenting with flatbeds at the time, most practitioners who were trained during the studio era continued to choose the Moviola over newer devices. Film editor Donn Cambern recalls a moment during the production of Paul Mazursky's *Blume in Love* (1973) when he invited other editors to watch him work on the KEM machine and try it out: "Nobody came in! It's one thing when a man who has been on the Moviola for forty years is not interested, but I didn't understand when someone my age or younger wouldn't even give it the time of day."[10] Perhaps not surprisingly, the proliferation of independent productions, negative pick-ups, and package-unit deals created an uncertain environment for technological innovation and adoption within the industry. And while breakthroughs in nonlinear, video-based editing systems occurred in the early 1970s, it would be two decades before the majority of freelance picture editors made the transition from Moviolas and flatbeds to computer-based systems.[11]

The ongoing experimentation with compacted shot lengths and rapid-fire cuts in the late 1960s and early 1970s demonstrates that editors did not require any machine beyond the labor-intensive Moviola to engage in innovative cutting. The car chases in films like *Bullitt* (1968; Frank P. Keller, editor), *The French Connection* (1971; Jerry Greenberg, editor), *The Seven-Ups* (1973; Greenberg, editor), and *Gone in 60 Seconds* (1974; Warner E. Leighton, editor) all feature compressed action intercut with point-of-view shots, driver reactions, and stunt shots delivered at a rapid pace. Jerry Greenberg, who cut both *The French Connection* and *The Seven-Ups*, recalls, "I cut [the car chases] on a Moviola in a huge room. We tended to take big bites and make each section as developed as possible." Although the sequences featured shortened shot lengths, Greenberg looked to develop a sense of continuous action (even if there was none) by intercutting between cars and what they were chasing.

What is important to note in this context, however, is that the way task arrangement functioned for picture editors in the 1970s was largely motivated by the emergent freelance employment structure of below-the-line practitioners. By 1969, most major studios had divested themselves of on-the-lot postproduction services and began contracting out sound and picture editorial work to independent facilities and freelance workers. In economic terms, the short-term partnerships that developed between craft professionals, filmmakers, and studio management in the 1970s constituted a form of industrial organization that Susan Christopherson and Michael Storper call "flexible specialization."[12] Flexibly specialized workers provide subcontracted services to producers and directors but remain open to changes in workflow, professional relationships, and technical skills. As picture editorial made the transition from full-time, salaried staff positions to single-film contracts, editors negotiated their professional status within the industry by developing strong relationships with filmmaker clients that could lead to recurring work and the prospect of a stable career.

The major difference between editing practice in the studio system and the post-divestment period was the working relationship between editor and director. During the height of studio filmmaking in the 1930s and 1940s, most film directors had little involvement in pre- and postproduction decisions, which were routinely handled by editorial supervisors and unit-producers. In a clear illustration of the serialized mode of production, studio directors moved on to other projects after the completion of principal photography and turned over their footage to the editorial department, where creative decisions were largely supervised by producers and studio executives like David O. Selznick at MGM and Darryl F. Zanuck at Twentieth Century–Fox. As Don Fairservice has argued, studio management mandated a strict timeline for film production, which was measured by the amount of "cut footage" that could be produced in a single day's filming, and anything that fell short of two and a half minutes would be judged unacceptable.[13] In other words, neither director nor editor had the time to explore creative possibilities and editorial options.

Alternatively, while the freelance system afforded editors greater creative flexibility, it also introduced a managerial element to the task structure that was largely absent in the 1940s. In addition to performing a set of administrative tasks—hiring assistant editors, setting editorial budgets, managing schedules, and organizing footage—editors in the New Hollywood also managed client directors. As Robert R. Faulkner explains, "What a worker does about the problems of inappropriate demands and different definitions of the situation depends upon a number of factors, including the alternatives at his or her disposal, his or her power to define and control the actions of clients, and his or her power to select a clientele to work with."[14] When a director is unsure about the right approach to a particular sequence, the editor may be given the creative latitude to solve the problem his or her own way. In other situations, the editor may struggle for creative control with a client over the appropriate solution to an editorial problem. In both cases, the editor's professional identity as a problem solver is tied to both artistic and social aspects of client management that ultimately contribute to career advancement and reputation within the industry.

Donn Cambern's work on *Easy Rider* (1969) offers another way to think about how client management influences aspects of editorial style. The acid trip sequence, which was shot on 16mm and blown up to 35mm for release prints, presented Cambern with a thorny problem: how to create narrative structure out of hours of hand-held, off-the-cuff footage of the film's main characters tripping out on LSD in a New Orleans cemetery. The Mardi Gras footage was deliberately rough and untethered to classical Hollywood continuity, aiming to represent the psychedelic sensations experienced by the characters, but it lacked narrative focus. Cambern explains the problem by confessing "for the longest time, I had no ideas. . . . I had to realize the storyline myself. It was like writing with film. Everyone left me to my own devices and once I showed it, we made suggestions to shorten it."[15]

The final version, which clocks in at five and a half minutes, retains the raw energy of director Dennis Hopper's original footage but focuses on Captain America's (Peter Fonda) emotional soliloquy about death, effectively turning the rest of the sequence into an extension of the character's point of view (see color plate 6). Working without an editorial roadmap, Cambern faced a second challenge: how to convey the psychedelic effect of the acid trip through his cutting style. The solution, as he saw it, was in the nature of the transitions:

> It was all straight cut. I had never done acid, but I thought that it was very impressionistic and that individual moments would be clearly defined. They didn't gradually go from one to another as you might in a dissolve. They would be just a series of emotional impressions. That's the reason for the straight cut, to create the sensibility of capturing an image for a moment and going on to the next image. It would be like writing in very short sentences, in bursts.[16]

The descriptive metaphor about "writing with film" underlines Cambern's solitary process but speaks as well to the ways in which editors communicate with clients. Cambern also served as the picture editor on other "BBS" youth-oriented films produced by Bob Rafelson, Bert Schneider, and Steve Blauner, including *Drive, He Said* (1971) and *The Last Picture Show* (1971), which balanced counter-cultural looseness with editorial concision.

Anne V. Coates, who cut *Lawrence of Arabia* (1962) for David Lean and *Murder on the Orient Express* (1974) for Sidney Lumet, also edited *The Elephant Man* (1980) for David Lynch. One of Coates's more difficult tasks on that film was interpreting Lynch's ideas for the opening montage featuring fragmented images of John Merrick's mother being attacked by an elephant. The nightmarish sequence features high-contrast black-and-white photography, different camera speeds, and the slowed-down roar of an elephant. The effect is striking and represented one of Coates's biggest challenges on the film: "It was difficult for him to get over to me what he wanted to do there. We did a lot of experimentation because we had to go through him, through me, then through my assistant who would order from the laboratories. We tried a hundred different speeds with the woman's head turning and the elephant roars."[17] Coates describes her role as an editor-counselor: "I like having a little edge with the director—you know, discussions and arguments. I think that's what editors are partly there for, like a sounding board."[18] Discussions and arguments, in Coates's view, can push the material in new directions or alert the client to choices that might otherwise be ignored.

When director Bob Fosse and his editor, Alan Heim, discussed how the musical numbers in *All That Jazz* (1979) would be cut, Heim initially bristled at Fosse's suggestion that he cut off the beat of the music. Fosse had chosen to shoot most of the dance sequences in close-up, avoiding any wide shots of dancers' bodies.

Having cut *Godspell* (1973) and *Hair* (1979) in more conventional fashion using longer takes and full-body framings during musical numbers, Heim clung to a principle of continuity. Ultimately, he and Fosse decided on a technique of cutting "between" beats that created a rhythmic effect that was unpredictable but also retained a clear sense of continuity among Fosse's tightly composed framings.[19]

In a more extreme case, editor Louis Lombardo experienced combative relationships with his directors, Robert Altman and Sam Peckinpah. While Altman was experimenting with overlapping sound, longer takes, and zoom lensing on films like *M*A*S*H* (1970), *McCabe and Mrs. Miller* (1971), and *California Split* (1974), Lombardo wasn't given much choice when it came to the footage. As Peter Biskind explains, Altman stormed out of a meeting when Lombardo criticized the "muddy," barely audible sound track on *McCabe*, but everyone, including Lombardo, was helpless to change anything "before the new power of the Auteur."[20] On *The Wild Bunch* (1969), Lombardo learned how to communicate with Peckinpah by reading his body language: "He used to grunt and I knew what he meant. You get to be in tune with a guy; if he starts to squirm, you know he's not pleased."[21] In cutting the film's climactic gunfight, Lombardo sought to rein in Peckinpah's footage by creating a greater sense of unity among the shots. Peckinpah shot the street fight from multiple angles but gave Lombardo a "one-sided fight" with little or no coverage of the Mexican army firing at the wild bunch:

> I had people being hit and nobody shooting at [the wild bunch]. I told Sam that my concept in that street fight was to involve the audience. I wanted them to think they were in the middle of an explosion that went off around them. The street fight was 21 minutes long when I first cut it; that is three reels. It went on and on. I went the standard route, I had everything make sense. It went out at four and a half minutes.[22]

Lombardo shortened most of Peckinpah's shots and created continuity using bits and pieces of footage, resulting in what is now considered to be one of the most kinetic action sequences of the New Hollywood.

In this sense, editors in the New Hollywood began to function as psychologists, coaches, mothers, fathers, pragmatists, diplomats, and arbiters of taste. Flexible specialization may have spurred the growth of semi-independent filmmaking in Hollywood and freed below-the-line talent from studio hierarchies, but it also locked picture editors into a social contract with directors that was often dictated by formal uncertainty and creative compromise.

The third basic task of picture editing is also the most difficult aspect for editors to describe. The assembly of thousands of feet of raw footage into a coherent whole represents the totality of a picture editor's managerial and creative role in the filmmaking process. Not surprisingly, editors in the auteur renaissance

began describing their creative choices using descriptive metaphors that crystallized their artistic contribution to a film and underlined the deeply intuitive nature of creative decision making. The relationship between convention and innovation in editing style is evident in the language editors use to describe the appropriateness of a choice. Interviews with editors of the period reveal a common descriptive vocabulary: editing picture is about "feel," "rhythm," "instinct."[23] These linguistic resources and the different meanings they convey are part of the discursive strategies that help freelance editors explain, clarify, and illuminate the underlying artistic value of their work. They are expressions of tactility and tacit knowledge—the physical *feel* of film passing through hands on a Moviola; the intuitive *feel* of knowing what is an appropriate cut. What these terms can tell us about the style of editing in this period is reflected in the diverse creative choices made by editors and directors.

Between 1968 and 1980, the realities of freelance, short-term, single-project contracting undoubtedly shaped the material conditions of editing practice, especially within the editor-director relationship. There are several notable partnerships during this period—Lombardo with Altman (*McCabe and Mrs. Miller*; *California Split*), Heim with Fosse (1974's *Lenny*; *All That Jazz*), Sam O'Steen with both Mike Nichols (1967's *The Graduate*; 1971's *Carnal Knowledge*) and Roman Polanski (1968's *Rosemary's Baby*; 1974's *Chinatown*), and Thelma Schoonmaker with Martin Scorsese (1980's *Raging Bull*)—but three others stand out as paradigmatic examples of how expressive editing practices were borne out of the complex task structure of New Hollywood editors: Dede Allen with Arthur Penn (*Bonnie and Clyde*; 1971's *Little Big Man*), Verna Fields with Steven Spielberg (1974's *The Sugarland Express*; 1975's *Jaws*), and Walter Murch with Francis Ford Coppola (1974's *The Conversation*; 1979's *Apocalypse Now*).

In 1967, *Time* magazine declared films like *Bonnie and Clyde* to be part of a "New Cinema," possessing "a poetry and rhythm all its own," where "chronological sequence is not so much a necessity as a luxury. The slow, logical flashback has given way to the abrupt shift in scene. Time can be jumbled on screen."[24] These observations speak directly to the expressive and unconventional editing choices made by Penn and Allen. What is most striking about the editing of *Bonnie and Clyde* is its brisk pace, highlighted by Allen's decision to cut for speed. As Penn reviewed Allen's cuts from her New York office, he pushed her and her assistants to be more aggressive and cut with more "energy." As Allen recalls, "He kept saying, 'Look at the film again and make it go faster.'"[25]

One solution Allen devised was to replace fade-ups from black with straight cuts, effectively smashing into a scene instead of easing into one. The practice irked studio chief Jack L. Warner, striking him as too unconventional. Penn also used close-ups to establish new settings instead of using more conventional establishing shots, as when Clyde Barrow (Warren Beatty) and Bonnie Parker (Faye Dunaway) prepare for their first robbery together. The scene begins close

on Clyde drinking a soda, then cuts to Bonnie admiring the revolver at his hip, and then a tight shot on the pistol. The first time Allen reveals the setting is in a medium two-shot when Clyde walks away from Bonnie to enter the general store. These aggressive framing and editing strategies worked to amplify the speed at which the plot moved but were antithetical to Allen's tacit knowledge of classical editing structure. And while the film has been compared to films of the French New Wave that pushed the boundaries of Hollywood classicism, Allen's work is best described as a negotiation between her own editorial rhythm and Penn's penchant for blunt force cutting.

Likewise, the film's climactic ambush, which comprises sixty individual shots over sixty-three seconds, features tight close-ups, various camera speeds, and some of the era's fastest cutting (slightly more than one second per shot). It also manages to retain a clear sense of spatial continuity through eyeline matches and consistent left-to-right movement. Perhaps not surprisingly, authorship of this sequence has been debated, with Arthur Penn taking credit for inventing it and Allen giving credit to assistant Jerry Greenberg for actually cutting it. In a 1993 interview with *Cineaste* magazine, Penn states:

> I just had this vision. I knew what it would look like and, when I got into the editing room, it turned out to be true. Dede Allen edited the film but Jerry Greenberg, one of her assistants, edited that scene, and he was just shaking his head. I came in and I said, "Here's how it goes—this shot, to this shot, then to that shot." It was as if I was reading it out of some other perception. I knew exactly what it would look like.[26]

The internal pressures and dynamics of the editor-client relationship are exemplified in Penn's description of Allen and Greenberg functioning as conduits, positioned to receive Penn's original "vision." Still, in a bid to protect her own

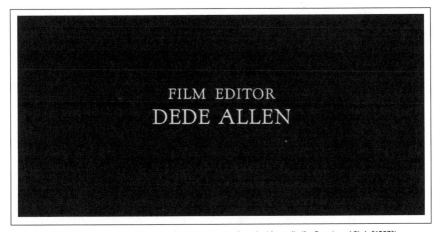

FILM EDITOR
DEDE ALLEN

FIGURE 18: Dede Allen became the first picture editor to receive a solo main title credit (for B*onnie and Clyde* [1967]).

creative identity, Allen acknowledged Penn's involvement but also insisted, "He never told me where to cut."[27] At the same time, at Penn's insistence, Allen received a solo editing credit in the film's main titles, the first time an editor was ever given one (see figure 18). Allen's 2010 obituary in the *Los Angeles Times* credited her work on *Bonnie and Clyde* for raising "the level of her craft to an art form that was as seriously discussed as cinematography or even directing."[28]

As Dede Allen was cutting film in New York, another female film editor in Los Angeles was teaching a new generation of directors the expressive power of film editing in the cinema school at the University of Southern California. Verna Fields began her career as an editing apprentice working for Fritz Lang in the 1950s, and after cutting sound for producer Walter Mirisch she formed her own production company and began to produce, direct, and edit socially conscious documentaries for the Johnson administration's Office of Economic Opportunity, the National Film Board of Canada, and the United States Information Agency. Around the same time, Fields edited several independent films by first-time directors, including Peter Bogdanovich's *Targets* (1968) and Haskell Wexler's *Medium Cool* (1968) that brought a *vérité* texture to these features. *Medium Cool* tells the story of a jaded news cameraman and a young war widow who get caught up in the political and social chaos that erupts during the 1968 Democratic National Convention in Chicago. Fields's approach to the film was greatly informed by her documentary work, where footage didn't always match and the best angle wasn't always available.

Fields imparted the same rough-and-ready approach to her students at USC, many of whom would go on to become part of the "Movie Brats" generation: George Lucas, Walter Murch, John Milius, Matthew Robbins, Marcia Griffin, William Huyck, and Gloria Katz. According to producer Frank Marshall, Fields was a "den mother" who provided editorial assistance and supervision on her students' early works outside the university. Most notably, she supervised picture editorial on George Lucas's first studio film, *American Graffiti* (1973).[29] The commercial success of *Graffiti* led to her being hired to work on Steven Spielberg's first feature film, *The Sugarland Express*, in which Fields balanced the stylistic interplay between inventive long takes and short, staccato cutting. More than anything else, however, these young filmmakers relied on Fields's experience to shape their projects. Ironically, the close collaborative environment Fields nurtured among her students and young client directors caught the attention of the Editors Guild, which sent her a notice decrying her working style. The Guild's position was based on the outdated studio model that separated the workflow between directors and picture editorial. Fields dismissed the memo and told an interviewer in 1976:

> I want to know what the director is thinking. I like to know what he's trying to get on film and how he visualized it, so I can try and put it together that way. I enjoy being involved in the production—the making

of a movie on location—because when I know the problems that emerged in shooting and the compromises the director had to make, then maybe I can get back to what he wanted in the editing.[30]

This working style was tested on Spielberg's follow-up project for Universal: *Jaws*.

In the spring of 1974, Fields accompanied Spielberg to the Martha's Vineyard location, and by the end of filming the pair had completed work on cutting the first two acts of the film. Although she was informally affiliated with Universal Studios, Fields was never a studio employee and did most of her editing in the converted pool house of her Van Nuys, California, home. Spielberg called Fields "Mother Cutter," a nickname that spoke to her relaxed and informal working style but also to the lessons she imparted to the young director. It was Fields's opinion that the problematic mechanical shark did not look scary, so she opted to show less of the beast than Spielberg originally envisioned. As Spielberg recalls: "The sad fact was that the shark would only look real in 36 frames and not 38 frames. And that 2 frame difference was the difference between something really scary, and something that looked like a great white floating turd."[31]

Fields's sense of rhythm imbued the film's action scenes with the same driving beat that she brought to the car chases in *American Graffiti* and *The Sugarland Express*. On *Jaws*, she realized early on that continuity was less important to follow than the dramatic feel of the moment: "What is most important is not to lose the emotional impact. If clouds don't match or the water isn't exactly the same color, people won't notice if you keep the rhythm. In a film like *Jaws* where people are so caught up in the suspense we were able to get by with a lot."[32] The metronomic cutting pace is evident in the beach attack sequence when she establishes three possible victims—an obese woman, a teenager and his dog, and a boy on a yellow raft—and repeatedly builds tension, then releases it as she cuts between them and Chief Brody (Roy Scheider) keeping watch (see figure 19).

When *Jaws* was released in the summer of 1975, producers David Brown and Richard Zanuck arranged for several members of the cast and crew to participate in a nationwide press junket. Verna Fields was asked to lend her voice to the promotional tour in part because industry reports pegged her as being the figure that "saved" the film from disaster. Fields routinely dismissed the reports as hyperbole but used the platform to call attention to her roles as creative decision maker and sounding board: "I think they feel that *Jaws* wouldn't have been as good a picture without me. And to a certain extent they're right. . . . [Spielberg] does not have the kind of ego that doesn't want feedback. He likes to be able to call me and get my reaction to a scene he is working on, and he can take criticism."[33] The immense popularity of the film certainly spotlighted Fields's stylistic choices, but her recollections of the discussions with Spielberg reveal much more about how editing in the auteur renaissance was linked to the expressive relationship between editor and director. As "Mother Cutter," Fields taught editorial

FIGURE 19: Building tension through rhythmic cutting, with Chief Brody as the visual pivot, in *Jaws* (1975).

concision and deemphasized the need to maintain strict continuity among shots. Most of all, she trained a group of young filmmakers to understand the complexities and compromises of editorial collaboration.

In many ways, the occupational transition from craft to art crystallizes with the editorial workflow devised by Walter Murch for Francis Ford Coppola's *Apocalypse Now*. Working at the Northern California headquarters of Coppola's American Zoetrope filmmaking collective, Murch had been cutting sound and picture for several of Coppola's films, including *The Godfather* (1972), *The Godfather Part II* (1974), and *The Conversation*. The Zoetrope philosophy, inspired by Coppola's own exposure to contemporary European film practices, placed a premium on craft experimentation, including the adoption of KEM flatbeds and cutting-edge non-linear, video-based editing platforms. What this meant for a sound and picture editor like Murch was an opportunity to blur the occupational divide between what he and Coppola thought were arbitrary craft distinctions. Since Zoetrope was located in San Francisco, Murch and his team of editors and mixers remained outside the jurisdiction of the Editors Guild and the sound mixers' union, IATSE Local 695, which at the time prohibited picture editors from cutting or mixing sound. By skirting Guild regulations, Murch was able to combine the technical, administrative, and creative aspects of sound and picture editorial under one all-encompassing philosophy. As Murch recalls, "Most

people in Hollywood thought what we were doing was crazy. But it was the late sixties, it was San Francisco, it was all part of what we saw then as the beginnings of the technical democratization of the filmmaking process."[34]

What Murch and the other Zoetrope filmmakers envisioned as a radical reconceptualization of Hollywood filmmaking practices also represented a bookend to the most significant shift in occupational identity and organization among picture editors. That Murch was able to reconfigure the occupational boundaries of below-the-line work exemplifies the period's experimental treatment of craft and practice. In many ways, the hallucinatory opening from *Apocalypse Now*, featuring a series of layered superimpositions and dissolves set against the rhythmic pulse of Huey helicopters and the music of The Doors, offers a highly complex but still lucid audiovisual statement of picture editing in the New Hollywood (see color plate 7).

As the industry itself made the transition to a freelance marketplace, editors were beholden to the economic logics of flexible specialization, where career advancement was tied to the technical, social, and aesthetic aspects of the way editors worked. The occupational transition from craft to art among picture editors in the auteur renaissance was part of a larger institutional and cultural shift that changed the way popular American films were produced, distributed, and exhibited. Changes to aspects in film style are partly responsible for the "poetry and rhythm" of editing in the New Hollywood, but creative versatility remained fitted to the technical skills, linguistic resources, artistic sensibility, and managerial acumen common to editing practices of the period. The adventurous experiments of the decade created a newfound curiosity about the craft, evident in print media reaction to editing: throughout the 1970s, reviews in trade magazines such as *Variety* began to regularly feature brief assessments of below-the-line contributions; and, in 1981, the Motion Picture Editors Guild, which represented nearly two thousand sound and picture editors in Los Angeles and New York, relaunched the Editors Guild Newsletter, featuring stories about picture editors and their current projects. Ultimately, editing choices in the auteur renaissance possessed a playful, expressive quality that continued to emphasize the "invisible" qualities of classical continuity, but also called attention to the skill of the artist making the cut.

8

THE AUTEUR RENAISSANCE, 1968-1980: Special/Visual Effects

Julie Turnock

2001: A Space Odyssey (Stanley Kubrick, 1968), *Star Wars* (George Lucas, 1977), and *Close Encounters of the Third Kind* (Steven Spielberg, 1977) were among the films that initiated a 1970s cinematic trend in believable fantasy accomplished through intensified special and visual effects production, giving rise to significant changes in effects technology and economics.[1] The so-called "Auteur Renaissance" filmmakers' emphasis in the 1960s and 1970s on *vérité* styles, location shooting, and gritty naturalism inspired in large part by American documentary and European art house trends would seem to sound the death knell for the set-bound artificiality of the big-budget Hollywood productions discussed in the previous chapter.[2] In fact, the science fiction blockbusters of the mid- to late 1970s reinvigorated special effects production, through self-styled American auteurs led by directors such as Stanley Kubrick, George Lucas, and Steven Spielberg, paradoxically attempting to realize their "vision" with a special effects aesthetic that was designed to be simultaneously more realistic and fantastic.[3] Moreover, I argue that the significant changes in special effects production in the 1970s grew directly out of the American auteur movement, not as a replacement of it as many have conjectured.[4]

Flamboyant special effects became a prominent way that several of the 1970s auteurs, most distinctly Lucas and Spielberg, but also Ridley Scott and David Lynch, designed their elaborate diegetic environments to get their individual auteurist "visions" on the screen. While "Auteur Renaissance" may be a loaded term arising out of a triumphalist baby boomer discourse, the American Auteur movement can be understood as a distinct historical movement rather than an evaluative category that judges some directors' films successful and others less so.[5] Instead, we can think of this movement as an ethos adopted by filmmakers, with an edge of professional necessity. In the late 1960s and early 1970s, auteurism was a movement that many filmmakers believed themselves and their peers to be a part of that differentiated them from workaday mainstream filmmakers, while at the same time aligning themselves with the established "great" directors of the Hollywood studio era and world art cinema.[6] These filmmakers used the auteur label to create for themselves a recognizable commodity identity. Some, like Francis Ford Coppola or Robert Altman, cultivated a larger-than-life personality. Additionally, these filmmakers and others, including Terrence Malick and Brian De Palma, developed a signature visual style. Special effects played an important role in this self-branding enterprise.

The strategy of presenting oneself as an auteur was not just limited to directors. The 1970s was also the era of "auteur specialists" in, for example, sound design (Ben Burtt), editing (Walter Murch), makeup and prosthetics (Stan Winston), and cinematography (Vilmos Zsigmond). Many specialists, including those recently let go by the studios and those in the independent sector, used similar career strategies as the directors to promote their work. The field of special effects was no exception. A number of effects artists, including Douglas Trumbull, John Dykstra, Robert Blalack, Robert Abel, and Richard Edlund insisted on more professional and popular recognition for their work. Rather than understand themselves as compliant "team players," low in the production hierarchy, many—due to their 1960s art school backgrounds or parallel careers as experimental artists—believed special effects supervisors should be "above the title" and that in promotional materials their names should be as important as (or more important than) the actors and directors.[7]

2001: A Space Odyssey

Before *Star Wars* and *Close Encounters,* Stanley Kubrick's *2001: A Space Odyssey* set the paradigm for the auteurist special effects movie. *2001* was enormously influential to the later science fiction films of the 1970s. It provided the model for an immaculately realized, plausible "science fact" environment created out of composite techniques that were considered unfeasible in previous productions. Kubrick's aesthetic goal for the effects, inspired by satellite and NASA images

from space appearing in the media in the early 1960s, was to visualize a believable future for viewers to contemplate the interrelation of humans and technology.[8] For Kubrick, cinema played an important role in that evolution and encouraged a particularly "photorealistic" approach to the special effects aesthetic that aimed to simulate the *look* of spaceships captured by a single Panavision live-action camera and lenses.[9]

Thanks to the nearly carte-blanche support of MGM, the production of *2001* was unusually long (nearly three years) and enjoyed an unusually high budget, estimated at $10–12 million. The luxury of time and money meant Kubrick could keep a highly trained staff (largely from the UK) on the payroll for four years (including pre-production) and also insist upon retakes and re-dos whenever he was not 100 percent satisfied with the results.[10]

Early on, Kubrick knew that neither traditional rear projection nor bluescreen composites would provide the "first-generation" image quality he needed for creating the illusion that film cameras were shooting in space. Instead, for the ships, he used labor-intensive contact printing that would lose as little image quality as possible over the course of the printing process, as well as unusually large-scale miniatures shot with 65mm film stock.[11] Shooting at the Borehamwoods Studios in the UK, Kubrick assembled a primarily UK-based staff, including Wally Veevers and Tom Howard (both special effects artists on the *Thief of Baghdad* [Ludwig Berger, Michael Powell, and Tim Whelan, 1940]), Hammer regular Les Bowie, and many others trained on Rank, Korda, and Hammer films. He also hired a few Americans—Douglas Trumbull and Con Pederson—on the strength of *To the Moon and Beyond,* an educational film they had produced for the 1964 World's Fair while working at a small independent effects house, Graphic Films.[12]

For the "Star Gate" (color plate 8) sequence—the stylized and graphic portion that appears at the end of the film—Trumbull was inspired by a demonstration given by experimental filmmaker John Whitney while working for Graphic Films.[13] As Trumbull put it, Kubrick had said vaguely that he wanted the camera "to go through something," and that it was up to him to develop a technique to make it happen.[14] In the technique, an animation camera tracked slowly toward sheets of glass, one of which held transparent, backlit art work, while the other was masked in black material apart from a small vertical or horizontal slit—hence the technique's name, "slit scan." The shutter on the camera was then opened to expose a single frame of film to the image. At the same time, the artwork itself was moved horizontally or vertically across the slit to provide streak distortion. Next the film was rewound and the process repeated with the blur of light traveling from the opposite frame toward the center. The result was the effect of traveling through a tunnel of light. A particularly memorable effect, slit scan was also used by others (such as the title company R/Greenberg Associates) to create streaking title effects for films like *Superman* (Richard Donner, 1978) and the wormhole sequence in *Star Trek: The Motion Picture* (Robert Wise, 1979).[15]

1: The culminating extreme long shot of the building collapse in the burning of Atlanta sequence in *Gone with the Wind* (1939) was achieved through optical printing.

2: In *Dr. Cyclops* (1940), a large prosthetic hand bridges the rear-projected background with the live-action foreground.

3: A treatment of shot/reverse shot in widescreen produces over-the-(shifting)-shoulder continuity in *Carousel* (1956).

4: A rear projection sequence in the widescreen VistaVision and Technicolor production of *To Catch a Thief* (1955).

5: Composition of the effects elements directs the eye toward the parting of the Red Sea in the lavish road show production *The Ten Commandments* (1956).

6: Loosely shot but tightly edited 16mm footage from the "acid trip" sequence in *Easy Rider* (1969).

7: Highly complex and layered superimpositions punctuate *Apocalypse Now* (1979).

8: The famous "Star Gate" sequence, a psychedelic effect from the "slit-scan" technique, in *2001: A Space Odyssey* (1968).

9: In *Close Encounters of the Third Kind* (1977), intense neon lights shot in a smoky environment illuminate the mundane Earth environment.

11: The rapid cuts in *JFK* (1991) connect black-and-white and color shots of the alleged conspiracy with frames from the famous Zapruder film of the actual assassination.

12: In *Raiders of the Lost Ark* (1981), footage of an actress, wire-animated silk ghosts, and optically animated

13: In *The Thing* (1982), the expressions of the detached, alien-possessed Norris head are manipulated using radio- and cable-controlled mechanisms.

5: Cutting between multiple camera positions during a musical number in *Chicago* (2002) results in a variety of perspectives on the action but also produces continuity errors and a loss of compositional focus.

Kubrick had no plans to use this highly skilled team or these techniques in future science fiction projects, or to found a permanent independent effects house. *2001*'s effects were designed as one-offs, to serve the particular purposes and requirements of the film. This is one of the primary reasons that the *2001* legacy loomed large over science fiction film, but proved too laborious and expensive to provide a workable model for future special effects-heavy productions. The goal of later filmmakers working in the genre would be to approach *2001*'s level of photorealism, but on a reproducible scale, both in terms of money and labor.

Technological Change in 1977

Although the 1960s and 1970s did not introduce many altogether new technologies to special effects (with a few major exceptions), the era did witness a significant increase in the intensity, density, and visibility of effects in the overall film. While optical compositing, matte painting, miniatures, and stop-motion animation had all been in use in feature film production since the 1910s, many of these techniques were revived and recontextualized by effects artists in the 1960s and 1970s in ways that enabled them to be intensely layered together in the same shot and distributed throughout a film in a higher percentage of the overall shot count. For example, *2001* had a previously unthinkable 200 effects shots (out of a total 602 shots), while *Star Wars* nearly doubled that amount to 365 (out of 2,089 shots).[16]

As discussed in previous chapters, projection techniques, such as rear projection, had been the primary compositing technique in the studio era, one that was favored chiefly because it was completed during principal photography and therefore did not require lengthy postproduction techniques or a highly specialized crew.[17] Most prominently, however, special effects artists such as Douglas Trumbull and those on the Industrial Light and Magic (ILM) team at this time—including John Dykstra, Richard Edlund, and Dennis Muren—revived the use of optical printing techniques developed through the 1920s and early 1930s (but generally deemphasized from the mid-1930s on) in order to build elaborately composited sequences that were woven into the film as a whole, rather than reserved for climactic moments. However, the optical printing technology brought back and refined in the 1970s involved an increased reliance on postproduction effects techniques, completed after main-unit photography and by a different workforce than principal photography. This change in technological emphasis led to both a shift in production timelines and the prioritization of skills favoring artists and technicians with animation and optical printing training.

It is difficult to underestimate the importance of the introduction of motion control camera technology in the 1970s within the history of special effects in American cinema. Motion control is a kind of computer-assisted camera

technology in which a programed camera rig could perform precisely repeat-able camera movements.[18] First and most importantly, this technique freed the so-called "locked down" camera previously needed to make clean traveling matte optical composites, allowing for the look of a moving camera shot during effects sequences. For example, instead of a single miniature starship moving horizontally across a star field (as in 1950s science fiction, for example, *Forbidden Planet* [Fred M. Wilcox, 1956]), motion control allowed the compositing of multiple moving images originating as still photography (for example, a planet), animation (laser beams), and moving images (a model starship) to be composited together to appear in motion and as if captured by a single live-action camera. Motion control also allowed more moving elements, along more directional axes, making more intensive layering of elements and motion effects possible. This technology, along with the intensified compositing it allowed (and paired with fast-paced editing), largely created the illusion of kinesis that helped accelerate the storytelling filmmakers hoped would absorb viewers into their complex and expandable imaginary worlds.

Motion control has been most closely associated with John Dykstra's computer-assisted camera system named the "Dykstraflex" developed for *Star Wars*. However, the technology predates the 1977 production. The independent effects company Robert Abel and Associates beat Lucas's team to the punch with computerized motion control on their famous "Bubbles" 7-Up television ad of 1975.[19] Also, although Douglas Trumbull admits his protégé Dykstra initially expanded the idea, Trumbull was almost simultaneously developing the technology for use on *Close Encounters*.[20]

Star Wars (and Its Sequels)

2001 was not designed to be a repeatable model for future feature productions. Nevertheless, the production did serve as a kind of research and development lab for techniques that would later be developed and streamlined for many kinds of special effects films. George Lucas's many statements about *2001* suggest it served as a model for a "shot in space" photorealistic look enhanced by stylized animation effects.[21] However, Lucas also strongly suggests that rather than *2001*'s slow contemplation of technology and progress, he intended *Star Wars* to move at a zippier pace, both visually and narratively.[22] In the 1970s Lucas consistently described the original *Star Wars* in pulp and comic book terms, his most common reference points being the "Flash Gordon" serials and the "John Carter from Mars" comics. Lucas often used the term "documentary fantasy" to describe the look of *Star Wars* (in contrast to Kubrick's "science speculation"), which was meant to suggest a style in which fantastic impossible events take place, and characters and objects appear, in a perfectly credible "used future."[23] Instead of

Kubrick's pristine glossy spaceships waltzing majestically across the Cinema-scope screen, *Star Wars*' multiple battle-worn spaceships would zip, flash, and explode in aerial dogfight action with rapid editing, kinetic movement, and animated laser beams crisscrossing the tall VistaVision aspect ratio.

The effects program for the film was both an artistic and creative strategy as well as a financial one. Unlike Kubrick, Lucas planned to develop a rationalized process for producing special effects on a grand scale, and he wanted them to conform to his particular, and historically specific, brand of realism. He also understood that financial freedom meant artistic freedom. Economically, Lucas wanted to remain independent of the Hollywood studios and to maintain greater control over his product. The more work that could be completed "in house" at Lucasfilm, the less the studios could interfere with the film (as had been the case with his earlier movies *THX-1138* [1971] and *American Graffiti* [1973]). Lucas intended to build something like a personal parallel studio system in Northern California that he would control, and an in-house special effects team was an important part of that scheme. Moreover, Lucas also kept more control over an expandable *Star Wars* universe. This not only meant sequels, but also ancillary products—something with which few filmmakers, especially of the New Hollywood group, had concerned themselves.[24]

Aesthetically, Lucas wanted the effects to match the style of 1970s "New Hollywood" cinematography pioneered by cinematographers such as Laszlo Kovacs (on *Easy Rider* [Dennis Hopper, 1969]), Vilmos Zsigmond (on films such as *The Sugarland Express* [Steven Spielberg, 1974]), and Nestor Almendros (on *Cockfighter* [Monte Hellman, 1974]). It was a special effects look that conformed to the live-action cinematography favored by his New Hollywood peer group: naturalistic lighting, location shooting, a handheld camera, rack focus, and lens artifacts such as flares.[25] Filmmakers favored these techniques primarily in opposition to slick Hollywood studio "artifice" and in emulation of lower-budgeted world New Waves. Live-action shooting in, for example, a Maysles documentary or a Monte Hellman film, was *not* meant to conceal the act of filming but instead call attention to it. The unpolished, rough look of the "mistakes" in the camera work suggested immediacy and authenticity. In other words, Lucas wanted *Star Wars* to look as if it were a 1970s road film or documentary, but shot in space.

The special effects for *Star Wars*, and even more so for its sequels, were designed to take a pulpy, graphic, and nostalgic subject matter—namely fantastic 1940s and 1950s science fiction action serials—and shoot them as a documentary. This was the "credible fantastic" aesthetic Lucas had in mind. In addition to the kinetic energy given to the space battles aided by the motion-control camera, this aesthetic required that special effects artists pay particular attention to multilayered compositing. The "credibility" of this aesthetic demanded that many elements of different origins (still photography, rotoscope animation, motion

photography) be combined into a single, composite mise-en-scène. Importantly, effects artists did not want to lose image quality as film elements were duplicated over the composite process, and they did not want the seams (matte lines) to show. They shot effects footage on higher format VistaVision film to keep color richness (especially in the blacks and whites) and maintain image thickness and sharpness, and refined bluescreen techniques to minimize matte lines. Moreover, special effects sequences, for example in the battle on the Ice Planet Hoth in *The Empire Strikes Back* (Irvin Kershner, 1980), were shot to emphasize photographic "mistakes," as if captured by a harried battle cameraman, such as camera wobble suggesting handheld cameras, or rack focus and lens flares.

In addition to the extensive on-set effects techniques such as makeup, puppetry, and costuming, the "fantastic" side of the coin was primarily achieved by animation techniques, carefully designed and composed for graphic impact. Light sabers, planet explosions, laser blasts, electrical fields, and other zap or flash effects were hand-animated through rotoscoping in bright pulsating colors and coordinated with practical pyrotechnics to enliven the frame and also distract from compositing seams.

Two famous examples demonstrate the "documentary fantastic" style in *Star Wars*. In the famous opening flyover, as a rebel ship makes a daring escape from an Imperial cruiser, the various techniques meld together to situate the viewer in both a plausible outer space setting as in *2001*, but then jolt them into a kinetic aerial battle. First the virtual camera "tilts" down over the flat still artwork of the horizontal planet surface below and the moons and star field above. Then, the highly detailed miniature model work shot with a motion-control camera starts the action unexpectedly "over the head" of the viewer as the two craft glide across a diagonal axis from the top right into the deep central space of the frame. This "z-axis" movement, facilitated by the motion control rig, is combined with rotoscope animation of the laser blasts, which are followed by a strobing of the screen as they fire. Through these combinations of techniques, the viewer not only understands visually the power relations involved in this battle between good and evil, but also that the unexpected and fantastic science fiction elements promised by the title will be substantiated in a contemporary and familiar style of photographic realism. In another example, the Millennium Falcon's famous jump to light speed (see figure 20) demonstrates how animation is deployed in the *Star Wars* original trilogy. After leaving Mos Eisley spaceport, the hastily assembled band of Luke, Obi-Wan Kenobi, Chewbacca, and Han Solo race to evade an Imperial Cruiser to heed Princess Leia's call to the join the rebels in the Alderaan system. As Han Solo pushes the lever forward, the glimmering "stars" in the star field in front of them begin to streak and converge precipitously toward a central point on the z-axis, providing both a narrative moment of escape and a powerful visual experience of forward bodily momentum.

FIGURE 20: A kinetic animation effect for the Millennium Falcon's jump to light speed in *Star Wars* (1977).

While most of these techniques had been used before and throughout cinema history in one form or another, they had not been deployed at such a high concentration. The combined and seemingly contradictory goal of perfect seamlessness and artificially created, stylized "cinematography" served as a house style for ILM since its early days, and has proven extraordinarily influential to styles of realism in special and visual effects.[26] Lucas's goal to use effects techniques to expand the diegesis beyond the edges of the screen, to galaxies far, far away, has been equally influential for the later digital blockbuster's multi-platform entertainment tent poles.

Close Encounters of the Third Kind

After *2001*, Douglas Trumbull returned to the United States and, in 1970, formed his own independent effects company while he developed directorial projects for himself, including 1972's *Silent Running*.[27] Meanwhile, his American colleague, Con Pederson, helped found the important ad production company Robert Abel and Associates. Trumbull's many ambitions to rethink cinematic spectacle, inspired largely by his work on *2001,* ran into many financial hurdles.[28] The equipment he wanted to build for 70mm production required considerable capital investment. Fortuitously, Spielberg, tired from his effects struggles on *Jaws*, gladly handed over effects duties to Trumbull for *Close Encounters*, with a more or less free hand.[29] Trumbull could use the studio's money to build his equipment, and Spielberg could leave the considerable challenges of effects work to someone else.

Nevertheless, Trumbull was hired with a production design concept already in place. While *2001* and *Star Wars* took place in alternate timelines and in impossible off-Earth locations, *Close Encounters* had the challenge of bringing impossible effects objects "down to earth" into the banal Midwestern life of electrical linesman Roy Neary (Richard Dreyfus), providing a transcendent

experience that would make him, and the viewer, contemplate the limits of the possible and believable. In other words, *Close Encounters'* challenge was to put UFOs into direct contact (as the title promises) with humans in a recognizable earthly context, *as if* happening today, right in front of us.

Spielberg, his cinematographer Vilmos Zsigmond, and production designer Joe Alves had already discussed and storyboarded their concept for the look of the UFOs, which Spielberg described as "an oil refinery at night" with soft glowing lights in a steamy atmosphere.[30] Nevertheless, Trumbull and his team had a great deal of freedom in executing that plan. Rather than follow the example of earlier movie UFOs, especially in 1950s science fiction films such as *War of the Worlds* (Byron Haskins, 1953) or *Earth vs. the Flying Saucers* (Fred F. Sears, 1956) with their hard edges and shiny surfaces, the UFOs in *Close Encounters* were characterized by their soft, nebulous outlines lit by vivid neon and casting defined beams of light over the landscape. Trumbull, aided by Dennis Muren and many others, constructed miniatures with multi-pointed lights, neon tubes, and irregular protrusions, and then shot them using motion control in a smoky room to increase the impression of a hazy shape that the eye cannot quite define as solid or not, but definitely beyond the Earth's known technologies. When composited with a blurred edge into the ordinary naturalistic Earth location, the UFOs seem to travel in their own environment, and appear simultaneously fascinating and other, beautiful and strange.

In fact, before the promised "third kind" (direct physical contact) of the film's final act, the UFOs are represented as only loosely physical, and often as pure, sentient light. In the sequence where Barry (Cary Guffey) is abducted from his home by aliens, the brightly colored light penetrating the house (such as the concentrated orange beam piercing the keyhole) is experienced by Jillian (Melinda Dillon) as an alarming, invading force, while Barry models the childlike wonder we are supposed to experience, as the index of playful, curious visitors. The dazzling intensity, especially in the incandescent-lit domestic interior, as it pushes into openings and turns on the electronics, compels their attention as it plays across their alternately terrified and delighted faces. Barry's tiny silhouette against the overwhelming radiance streaming through the open door across the threshold creates a potent (nearly effects-free) image of the awesome potential the aliens possess. This powerful visual impact of the light *as* light is compounded when connected to a UFO. In the first physical appearance of the UFOs in the film (color plate 9), as Roy Neary, Jillian, her son, and a few others gather on a ridge above the city, a series of four UFOs pass them following the road around a bend. As the brightly colored neon lights of the UFOs play across the humans' amazed faces, the varying-sized UFOs' lights emit both a radiant, self-contained glow effect that seems bound within its own alien atmosphere, as well as piercing beams that scan the landscape and characters as they whoosh past. In contrast, the headlights of the ensuing police appear dim and "earthly."

While undoubtedly creating the appropriate look for the UFOs (contrasting alluring and friendly with awe-inspiring and frightening) and staging humanity's first contact with alien life, these techniques were also useful for disguising the composite work. Like *Star Wars*, a number of strategies were devised to conceal such artifice. In *Close Encounters*, the nighttime appearance of the UFOs not only enhanced the intensity of their light effects, but also allowed the on-set lighting to seem to extend from the UFOs and "blow out" the principal photography. Moreover, backlighting, a technique exploited both by ILM and Spielberg throughout their long partnership, helps give the eye the impression of a solid special effects object, while obscuring it at the same time.

Finally, Trumbull's work, first on the "Star Gate" in *2001* and then in *Close Encounters* and later *Star Trek: The Motion Picture* and *Blade Runner* (Ridley Scott, 1982), developed the idea of the special effect environment as an experience that one feels physically, sensuously, and even intellectually: removing "realistic" touchstones forces the audience to contemplate its relationship to the environment presented, whether we are transcending human understanding, being exposed to aliens from another world, or contemplating a dystopian future.

The Disaster Cycle

While the hits of 1977 receive the (deserved) bulk of the credit for initiating the special effects heavy blockbuster, it is worth noting a related trend, the disaster cycle, which contributed to the intensification of the special effects marketplace before the late 1970s. Started largely by *Airport* (George Seaton, 1970) and continued by *The Poseidon Adventure* (Ronald Neame, 1972), *The Towering Inferno* (John Guillerman, 1974), and *Earthquake* (Mark Robson, 1974), and tapering off around 1975, the star-studded disaster cycle of the early 1970s favored traditional studio-style effects rather than the intensified optical printing used in later 1970s films. Because by the late 1960s most studios had eliminated their effects departments, such productions had to hire independent companies or rehire recently fired employees in order to accomplish these elaborate disaster scenarios.[31]

The immense popularity of the disaster cycle in the early 1970s troubles the critical perception that audiences preferred "sophisticated" *Easy Rider*–style "authenticity" over big-budget spectacles—a movement that *Star Wars* obliterated.[32] However, before *Star Wars* and *Close Encounters*, the disaster cycle demonstrated that some forms of large-scale effects work, especially physical effects as well as miniature and model work, were already experiencing a strong revival. Apart from disaster films, we can also see this most evidently in *Jaws* in 1975 and in the 1976 remake of *King Kong* (John Guillerman). The rehiring of traditional studio personnel these films necessitated not only kept traditional methods in practice through the 1970s, but also put experienced studio

personnel in touch with the newer generation of filmmakers.[33] In this way, after the financial bombs of late 1960s road shows such as *Dr. Dolittle* (Richard Fleischer, 1967) and *Star!* (Robert Wise, 1968)—flops that caused producers to cast around for youth-oriented, lower-budget independent productions such as *Easy Rider*—disaster films represent the revival of blockbuster-scale Hollywood productions.

Importantly, elaborate and complex special and visual effects sequences play a central role in helping create a new subject matter for major productions. While the reliance on numerous effects-driven sequences on this scale was novel, disaster films are definitively based more in traditional approaches than the *Star Wars* model of later 1970s special effects. Not surprisingly, disaster films emphasized on-set stunts and mechanical effects. Moreover, disaster films can be seen as the apex of stunt work. Combining the late 1960s taste for gritty realism and the studio's desire for on-set techniques, stunts with fire, explosions, and cars in particular were in great demand. Resorting to the older techniques and approaches described in the previous chapter, these productions preferred first unit principal photography to extended postproduction work. Simply put, disaster films intensified *on-set* physical effects and mechanical effects (such as fires and explosions) rather than extending or elaborating the trend toward *postproduction* photographic effects begun with *2001*.

Changes in the Economy of Special Effects

The 1970s also experienced an important change in special effects production in the independent sector. Although there had been a vigorous independent effects sector parallel to the studio workshops since the 1910s, the post–*Star Wars* era, led primarily by the Lucas-assembled ILM, transformed the independent effects shop and the way feature films contracted effects teams.

ILM grew out of the rather informally assembled crew for the first *Star Wars* film, which upon that film's success immediately incorporated into an independent effects house (bankrolled by Lucasfilm) and geared up for the sequels *The Empire Strikes Back* and *Return of the Jedi* (Richard Marquand, 1983). The original *Star Wars* team also split in two. The Lucasfilm team, now officially renamed Industrial Light and Magic, moved from Van Nuys to northern California's Marin County for the sequels, leaving behind a sizable team in the San Fernando Valley to help John Dykstra, *Star Wars*' special photographic effects supervisor, who had founded his own independent house, Apogee. *Star Wars* animation head Robert Blalack started his own firm, Praxis. Meanwhile, Douglas Trumbull had already formed Future General, which was hired to produce effects on *Close Encounters*, as well as *Star Trek: The Motion Picture*. In the 1970s, these new houses would compete with longstanding independents such as Van der Veer

Photo Effects and Robert Abel and Associates for feature film work, along with many more new start-ups during the 1980s.

While the independent houses had historically completed a few shots at a time assigned by the studios, they also worked on independent films, TV shows, and TV commercials, and completed other simple optical title work for industrials or other nontheatrical films. Now, many independent houses aspired to do effects exclusively on feature films, and to be the primary supplier of effects on a feature film. Rather than being contracted for a few shots at a time, now independent houses bid against one another to do all the effects work on a particular film. This long-existing "project bid" economic model intensified as an economic necessity as too many firms chased too little feature work. Though considered the top of the line, on the downside, ILM was much more expensive than other houses, which meant they were often underbid. Profit margins for effects houses were therefore razor thin. The project bid system (which also locked in the prices at the time of bid acceptance, much to the feature production's advantage) led to a quick thinning of the pack by the mid- to late 1980s, a trend exacerbated by the transition to digital visual effects in the 1990s. ILM was able to remain at the top of the special effects field for so long in large part due to the financial stability of their Lucasfilm backers, bolstered by the huge popularity of their films such as *Raiders of the Lost Ark* (Steven Spielberg, 1981) and *E.T.: The Extraterrestrial* (Steven Spielberg, 1982), and later by *Terminator 2: Judgment Day* (James Cameron, 1991) and *Jurassic Park* (Steven Spielberg, 1993), for which ILM produced the special effects.

Conclusion

Although *Star Wars'* and *Close Encounters'* enormous financial success meant their style of effects dominated later productions, there were other approaches to special effects through the 1970s and early 1980s. The popularity of films like *Star Wars* and *Close Encounters* encouraged a brief diversity of special effects styles and approaches, most of which were eventually absorbed into a more streamlined approach pioneered by ILM. For example, rather than try to emulate *Star Wars* and *Close Encounters'* (expensive) optical effects, many instead looked to the practical and mechanical effects of *Jaws* and its large-scale animatronics. Amalgamating the trends for creature effects (in *Star Wars*) and the slasher film's gore effects, the four years encompassing the release of *Halloween* (John Carpenter, 1978), *Alien* (Ridley Scott, 1979), and *The Thing* (John Carpenter, 1982) constitute a high point in the use of elaborate makeup prosthetics and on-set live-action effects sequences—including the famous "chest burster" sequence in *Alien*. Also in the late 1970s and early 1980s, stop-motion animation, which had been a longstanding special effect technique in such films as *The Lost World*

(Harry O. Hoyt, 1925) and *King Kong* (Merian C. Cooper and Ernest B. Schoedsack, 1933), transitioned into a specialty animation technique, after its last gasp in *Clash of the Titans* (Desmond Davis, 1981) and *Caveman* (Carl Gottlieb, 1981). Finally, Frank Oz and Jim Henson's puppetry also enjoyed a brief vogue with *The Muppet Movie* (James Frawley, 1979) and *The Dark Crystal* (Jim Henson and Frank Oz, 1982).

If *2001* set the bar for a new style of special effects, then *Star Wars* and its sequels made them repeatable, and *Close Encounters* brought them down to earth. These approaches proved powerfully influential in the coming decades, most especially in the digital age, as effects artists both continued to adapt existing procedures to new technologies, and also looked to this era as a model for making an environment from the ground up look "photographic" even when there was no photography in the image capture.

9

THE NEW HOLLYWOOD, 1981–1999: Editing Deron Overpeck

The American cinema of the 1960s and 1970s broke with many of its long-held conventions and reinvented itself by looking to earlier European art film movements for inspiration, adapting jump cuts, freeze frames, elliptical narratives, and more to American film tastes. The legacy of a style fueled by art cinema, fused with traditional Hollywood genres, persisted into the 1980s and 1990s, especially in the form of American independent cinema. But that tendency was counterbalanced by a more kinetic approach to filmmaking influenced by other media, such as advertising, television, and, particularly, music videos.

Beginning in the early 1980s, a number of films made striking use of montage as much for visceral impact and marketability as for spatial and temporal coherence. Concurrent industrial shifts in Hollywood put a premium on synergy, providing further support for a style that reinforced a film's connection to a range of related media products. David Bordwell has described the music video–inspired montage of these years as an integral component of the "intensified continuity" that developed over the course of this period: the basic rules of editing persisted, but the number of shots in a film rose as the average length of those shots decreased.[1]

Bordwell does not view the decades of the 1980s and 1990s as making a radical break with those that preceded them, choosing the term "intensified continuity"

to signal in part a perpetuation of core principles. Certainly at the level of key personnel, one can see a carryover effect: many of the artists (particularly editors) who had entered the film industry during the Hollywood renaissance of the 1960s and 1970s contributed to the montage-driven films of the 1980s. But the legacy of that renaissance also registered in the rise of independent cinema, as directors who began their careers in the 1990s looked to the achievements of mavericks such as Robert Altman and Martin Scorsese as a touchstone for their own editing innovations. These parallel if divergent developments in American editing began with the advent of music video–influenced cutting patterns in the early 1980s before their antithesis, the intellectual montage that resurfaced in independent filmmaking, emerged at the end of the decade and continued into the 1990s.

These antithetical approaches to editing were subtended by a technological shift that occurred at the same time: the introduction of multiple competing electronic editing programs. Although their use would not become common until the 1990s, the industrial discourse that supported their eventual prevalence in postproduction occurred in the 1980s. Electronic editing systems, which were also referred to as video-assisted editing, can generally be divided into two models: linear and nonlinear random access. Linear models transferred film footage to high-quality videotape; time codes would be added to the videotapes so that each frame had a numeric sequence with which to identify it. Editors could then select and arrange specific shots into sequences, recording these sequences onto a master tape for later review. Once a final edit of the film had been determined, the editing system's computer would generate a cut list with the time codes of each edit; the film editor would use such a list to cut the negative from which the master film print would be made. Although the process could save time and money, it had significant drawbacks. Because the footage was stored sequentially—or linearly—on videotape, editors would have to fast forward or rewind to get to a particular shot that they wanted. Each variation on a scene had to be recorded onto a separate videotape and viewed individually. The introduction of videodisc—and thus digital—technology later in the 1980s allowed for the development of nonlinear random-access video editing. Shots could now be called up via keystrokes, and the increased computing power allowed for multiple variations on a scene to be viewed quickly and easily. Digital nonlinear systems would ultimately be adopted by the film industry in the 1990s.

By and large, the discourse surrounding the adoption of video-assisted editing systems emphasized their budgetary benefits and technical specifications, with less attention paid to any resistance to that adoption. One producer of sports documentaries noted that video-assist editing reduced the need for multiple workprints, which had become expensive due to the cost of silver.[2] Francis Ford Coppola was one of the earliest adopters of video-assist filmmaking programs, using them at all stages of production on *One from the Heart* (1981; Rudi Fehr,

Anne Goursaud, and Randy Roberts, editors), *The Outsiders* (1983; Goursaud, editor), and *Rumble Fish* (1983; Barry Malkin, editor). Video storyboards were created before principal production began and were displayed on television monitors during filming. The footage was then transferred to Sony Beta videotapes for editing, but because so much planning had gone into the pre-production phase, the film had essentially been "pre-edited" before shooting began, reducing the amount of work the editor needed to do.[3] The primary benefit for Coppola was cost: video-assist editing "radically reduc[ed] post-production editing time, thus significantly diminishing interest charges on investment capital."[4] For a filmmaker tired of working for "studio executives who don't have my background and my experience,"[5] the creative freedom suggested by the economy of electronic cinema seemed heady. Indeed, Coppola's larger industrial goal for electronic cinema was to wrest control of filmmaking from the studios and allow individual filmmakers to make more "personal" works inexpensively.[6]

Coppola saw video-assist editing as facilitating greater artistic independence via cost-efficiency and reduced postproduction time; nearly all advocates for such editing systems cited these benefits, regardless of the perceived end goal. However, another important argument invoked technological determinism—the adoption of electronic editing signaled a glorious "new age" of film editing. "Will those whirling wheels and whirring motors [of film editing machines] be silent after nearly 50 years of making Hollywood pictures? Have advances in telecine transfers from negatives come so far as to allow electronic editing to displace conventional film editing machines?" asked one writer for *American Cinematographer*. "The answer is yes. A new age *is* dawning, spurred by the cross pollination between film and video technologies."[7]

According to an article about the Montage electronic editing system published in *Millimeter*, "The integration of film and videotape technologies is not only inevitable, but desirable."[8] The Montage was an exciting tool because it offered editors "a different direction" in which to take their craft.[9] In an *SMPTE Journal* article detailing the release of the Alba editing system, company owner Joseph Rooney connected the development and expected spread of video-assist editing systems to the industrial shifts that occurred after the fall of the studio system, which saw many editors lose their staff positions and migrate from film work to the television industry.[10] Rooney's essay plays on a double meaning of "conformation"—the development of video editing systems that would meet the needs of film professionals and the requirement that those professionals would accept the proliferation of those systems. "There exists a large and incredibly talented pool of film editors who must make the transition to video because of the changing market, becoming more and more involved in the video tape process," he wrote. "As the manufacturers begin to design equipment that is human engineered . . . the infusion of this talent will be more rapid, and the technology will become more adaptable to film use."[11]

The possibilities of video-assist systems were met with ambivalence from some established editors. In 1981, Paul Hirsch, whose credits included *Obsession* (1976) and the original *Star Wars* (1977), acknowledged that the systems would be commonplace "in the not too distant future," but indicated that he would continue to prefer to work with celluloid in order to maintain a "tactile relationship" with his craft.[12] As late as 1994, Tom Rolf, who cut *Taxi Driver* (1976) and *The Right Stuff* (1983), would muse about working with "the film in my hands, around my neck, in my mouth."[13] On the other hand, Dede Allen and Richard Marks were more enthusiastic about the potential of new technologies. Although Allen had already used a form of video-assist editing—devised by Stanley Kubrick for *The Shining* (1980; Ray Lovejoy, editor)—to catalogue the 700,000 feet of footage shot for *Reds* (1981; Allen and Craig McKay, editors),[14] she rued the slow development of editing technologies in a 1985 interview with *American Film*.[15] Allen also asserted that editing was more intellectual than physical: "I have had people say, 'Oh it is so marvelous to watch those hands work,' and I keep saying 'It is not in the hands, guys, it is up in the head.' The frustration is that the hands can't do it quite as fast."[16] However, Marks, the editor of *The Godfather Part II* (1974) and *Pennies from Heaven* (1981), suggested that the new systems would not necessarily save editors any time because they would be so busy "exploring all the new options" offered by video-assist.[17]

By and large, however, the industrial discourse about the coming of video-assist editing downplayed the attitudes of editors, particularly those who were suspicious of the new technology. Any discussion of dissent tended to focus on more general complaints, such as film editors' lack of familiarity with the video industry ("film people are very leery of video people," noted one video executive), the daunting prospect of having to learn new systems and techniques, and an alleged "simple and common fear of computers."[18] Much of the discourse sought to dispel any concerns about the transition by emphasizing the ease with which the systems could be used. The EditDroid was developed by LucasFilms and Convergence Corp. to add a "human" touch to editing, and the TouchVision had a graphical interface that was designed to look like a flatbed editing machine, while the Montage promised to "combine the flexibility enjoyed by film editors for the last half century with the speed and economy of electronic editing." Coppola's electronic system strove to be "as personal and non-technical as possible . . . more like an instrument than a machine."[19]

Despite such assurances, the adoption of electronic editing systems was slow over the course of the 1980s. By 1987, the most popular system, the Edi-Flex, could boast only forty units in use across the United States and Canada. Both technological and financial reasons explain this slow growth.[20] The Edit-Droid's hardware often crashed, limiting its impact and allowing random access competitor Cinedco to market its Ediflex system as more reliable. Additionally, Lucasfilm tried to sell the EditDroid system at a steep cost of $75,000, at a time

when most companies rented their systems to producers. As a result, only twenty systems were actually built. Embarrassed by the failure, Lucasfilm pulled the system from the market in 1987; a new version was introduced to the market in 1989 but with little impact.[21] Similarly, the Montage's market influence dwindled when the company that developed it was forced into bankruptcy proceedings in 1986.[22] Such software and financial glitches impeded the film industry's adoption of video-assist systems; for much of the 1980s they were used primarily for television programs.

Avid Film Composers would become the primary digital nonlinear system in the 1990s. Conrad Buff, Mark Goldblatt, and Richard Harris, the three editors of *True Lies* (1994), used the system to corral the million feet of footage shot. Buff had earlier used the system on *The Getaway* (1994) and had become an acolyte of digital editing. "I personally wouldn't go back to traditional editing methods after doing it this way," Buff told *American Cinematographer*. "With digital editing, the finished product is creatively superior, because this system allows editors to experiment a lot more than we ever could have previously.... The bottom line, whether you're working on a small picture or something with a lot of effects, is that this technology allows you to get through the material much more quickly and produce a better product in the end. And both directors I've worked with using this system have fallen in love with it."[23]

By 1997, more than fifty films had been at least partially edited using the Avid, including *Rambling Rose* (1991; Steven Cohen, editor), *The Fugitive* (1993; Don Bronchu, David Finfer, Dean Goodhill, Dov Hoenig, Richard Nord, and Dennis Virkler, editors), and *The English Patient* (1996; Walter Murch, editor), which was the first digitally edited film to win the Academy Award for Best Editing.[24] At the end of the 1990s, George Lucas used the Avid to make possible the electronic cinema that Francis Coppola had envisioned at the beginning of the 1980s. For *Star Wars Episode I—The Phantom Menace* (1999), Lucas and editors Ben Burtt and Paul Martin Smith "used extensive storyboards and full-motion animatics" to edit together a rough cut of the film before going into production with live actors.[25]

Larger industrial trends beyond technological developments would also have an impact on montage. At the beginning of the 1980s, Hollywood embarked on a new wave of conglomeration and consolidation. The possibilities of media convergence offered by the growth of cable television encouraged the second wave; this time, media companies began to target one another in order to create entertainment empires—for example, News Corporation's investment in Fox in 1981, followed by its outright purchase in 1984, and National Amusements' procurement of Viacom in 1984—while existing media conglomerates used their subsidiaries to develop new revenue streams—for example, Warner Communications' ownership of MTV through Warner-AmEx Satellite Entertainment. These industrial developments provided the economic context for

the decade's aesthetic shifts. Alerted to the potential of merchandising by the massive success of *Star Wars*, Hollywood began to incorporate into its business strategies potential sales from ancillary items such as video games, T-shirts, and, most pertinent here, sound track albums. Justin Wyatt argues that these marketing expectations shaped cinematic aesthetics in what came to be known as "high-concept" filmmaking.[26] High-concept films drew their stylistic influences from the world of advertising, minimizing narrative in favor of flashy visuals that were easily featured in marketing campaigns and could aid in the branding of other merchandise.

Wyatt notes that music tie-ins were particularly important because "frequently a major portion of these films is composed of extended montages which are, in effect, music video sequences."[27] These extended montages were then repurposed for use as advertisements for songs and sound track albums. Perhaps because of this reuse, films from this period were often described as being influenced by MTV, the cable channel that almost exclusively programmed music video clips beginning in 1981. For example, *Variety* described *Flashdance* (1983) as "pretty much like watching MTV for 96 minutes."[28] However, Marco Calavita has persuasively argued that such assertions of MTV's influence are problematic—and not least of all because MTV wasn't yet available in Los Angeles or New York when *Flashdance* was in production.[29] Calavita demonstrates that the montage-driven style of the 1980s was a continuation of trends in film style that began in the 1960s. "Several prominent films by these filmmakers and their contemporaries show the influence of what might be generically described as the European New Wave," Calavita writes, "and their work through the early 1980s exhibits some of the same qualities critics have identified as MTV aesthetics."[30] Calavita focuses his argument on directors, but it applies equally to editors whose careers extend from the 1960s to the 1980s. *Footloose* was edited by Paul Hirsch, who, as noted above, had worked with Brian De Palma, including the director's countercultural comedy *Hi, Mom!* (1970). Similarly, one of the editors on Tony Scott's *Top Gun* (1986), Billy Weber, had cut Terrence Malick's elliptical *Days of Heaven* (1978) and the action film *The Warriors* (1979). *Flashdance* coeditor Bud Smith had nearly twenty years of experience under his belt: on television documentaries, Robert Downey Sr.'s *Putney Swope* (1969), and *Sorcerer* (1977), William Friedkin's remake of Henri Clouzot's French classic *Wages of Fear / La Salaire de la peur* (1955). Their credits demonstrate the editors' experience in adapting more experimental techniques to mainstream fare.

All the same, it would be a mistake to downplay music videos as an inspiration for some of the stylistic trends in film editing that began in the 1980s. The quick cuts, emphasis on movement over narrative continuity, and rock music sound tracks of many films clearly fit the pattern established by such promotional clips. MTV may not have made it to many cable systems before 1983, but—like the careers of the aforementioned directors and editors—the history of the music

promo film extends back to the 1960s, when the Rolling Stones and the Beatles, among other acts, made promotional films for a number of their songs. Arena rock acts like Queen and New Wave bands like Devo continued this tradition in the 1970s and 1980s.[31] Additionally, videos for disco songs were played in dance clubs. As such, the music video format had more than enough time for its aesthetic sensibilities to influence filmmakers by the early 1980s.[32] The growing importance of the sound track album would have further encouraged the influence of music videos on films. MTV and montage-driven, music-oriented films were parallel developments, parts of a broader industrial shift in which films and music videos were elements in extensive synergistic campaigns that sold goods across a conglomerate's line of companies.

Among the films that demonstrate the influence of music videos are *Footloose* (1983; Bud Smith, editor), *Eddie and the Cruisers* (1984; Patricia Nedd, editor), *Streets of Fire* (1984; Jim Coblentz, Freeman Davies, and Michael Ripps, editors), and *Purple Rain* (1984; Albert Magnoli and Ken Robinson, editors). A closer examination of *Flashdance* illuminates how these films deviated from traditional editing patterns. Although MTV had not developed enough of a reach to influence its production, the film was marketed with the cable channel in mind.[33] Its simple story minimizes the need for editing to keep spatial and temporal relationships cohesive and thus allows more overtly stylized montage. Although it has no characters who sing, *Flashdance* falls within the musical genre. In his seminal study of the American film musical, Rick Altman argues that visual and audio dissolves—he uses "dissolve" to describe any transition, not just the overlapping of images or sounds—serve as transitions between the "real" world of the film narrative and the "ideal" world in which the song and dance routines can be performed.[34] In *Flashdance*, however, the distinction between reality and fantasy is erased; all of the music its characters listen to is defined by its diegetic grounding rather than the orchestral swell typical of American movie musicals.[35] Montage is used not to smooth out the lines between reality and fantasy but rather to convey the energy and emotional centrality of music and dance to the characters' lives.

Flashdance follows Alex, a young woman who works as a steel welder by day and performs at a blue-collar bar/avant-garde dance venue at night. Her dreams of becoming a professional dancer would seem to introduce an element of fantasy into the film, but all her dance sequences are rooted in the reality of her life. The editing reflects her emotional state at a given moment. In order to screw up the courage to apply to a ballet school, Alex dances while listening to "Maniac" by Michael Sembello. The sequence begins with a close-up of Alex taping up her toes, and continues with a series of rapid cuts of Alex's various body parts: her feet hopping in place, her writhing hips and buttocks, her determined face as she spins around. Long shots of her stretching her muscles are inserted briefly at various points, but the majority of the sequence comprises these disconnected shots

of her body. Practically, this was necessary to hide the fact that the star (Jennifer Beals) did not perform her own dancing.[36] Thematically, this fracturing of Alex into various body parts reflects the disconnect between the lofty goals she has and the low self-esteem that keeps her from pursuing them. The pace of the cuts in this sequence is erratic—some shots last less than two seconds, while others are held for nearly ten, with no clear pattern of how these shots are compiled, further reinforcing the sense of imbalance.

Conversely, Alex's audition emphasizes her wholeness. Rather than beginning with a close-up of her bandaged feet, the scene begins with a long shot of Alex tying her shoes outside the audition room. This sets the pattern for the rest of the sequence, which is composed almost entirely of long shots of Alex dancing around the room to the film's theme song, "Flashdance...What a Feeling," which she plays on a phonograph. Other than two inserts of her legs moving through her routine, all of the shots of Alex are from a distance. This emphasizes her confidence: she easily commands the attention of the admissions committee, who clap, tap their toes, and even blow their noses in time with her moves. The pace of the cuts is more consistent: the beginning of the sequence is dominated by several shots lasting as long as twenty seconds, but as the tempo of the song increases, so does that of the cuts. By the end of the sequence, the length of the shots has fallen to three or four seconds, capped by a series of four one-second shots of Alex, from different angles, as she launches herself into the air. Alex's audition concludes abruptly; the audience is left to assume that she has won admission based on her broad smile as she rushes out to meet her boyfriend. Indeed, it is a testament to the film's emphasis on visual appeal over narrative coherence that any sense of closure it provides has to be assumed from montage and not dialogue.

The influence of music videos extended to other popular genres, even as music itself remained central to editing's effects. Tony Scott's upscale horror film *The Hunger* (1983; Pamela Power, editor) begins with the Goth rock band Bauhaus performing "Bela Lugosi's Dead" as stylish vampires (Catherine Deneuve and David Bowie) prowl a nightclub looking for fresh blood. The musical performance features medium close-ups of singer Peter Murphy's gaunt body behind a cage, occasionally locking his contorted body into freeze frames. The two vampires are introduced through tight close-ups of her glistening red lips and his cool demeanor as they glide toward their chosen victims. As the credits cease, a series of smash cuts of the undead driving the soon-to-be-dead to their lush brownstone is intercut with the final moments of the musical performance, serving as a kind of punctuation for it. Because of Murphy's presence, the stylized visuals, and edits to the song itself—it is a three-minute segment of a nine-and-a-half minute song, much like a single that has been edited for radio airplay—the opening has the hallmarks of the music video format.

The appeal of the montage sequence tied to a popular song is evident in its wide usage beyond the musical; such sequences efficiently condensed narrative

information into a few minutes of screen time, hastening their broad adoption. Although montage sequences of this nature certainly existed before this period, they would become commonplace in the 1980s and 1990s: films as diverse as *Ghostbusters* (1984; David E. Blewitt and Sheldon Kahn, editors), *Teen Wolf* (1985; Lois Freeman-Fox, editor), *The Breakfast Club* (1985; Dede Allen, editor), *Dirty Dancing* (1987; Peter C. Frank, editor), *Goodfellas* (1990; James Y. Kwei and Thelma Schoonmaker, editors), *Forrest Gump* (1994; Arthur Schmidt, editor), *Clueless* (1995; Debra Chiate, editor), and *Rushmore* (1998; David Moritz, editor) all feature them. Usually, these sequences shortened the amount of time needed to present narrative information by compressing anywhere from twenty minutes (the climactic basketball game in *Teen Wolf*) to unspecified months (*Forrest Gump*'s cross-continental jog). Temporal compression could also be applied to the depiction of blossoming love, as seen in montage sequences from *Valley Girl* (1983; Eva Gardos, editor), *Better Off Dead . . .* (1985; Alan Balsam, editor), and, with tongue in cheek, *The Naked Gun: From the Files of Police Squad!* (1988; Michael Jablow, editor).

Music-video style montage was used for more than temporal compression; it could also be used in the spatial reorganization that became common in the action film, one of the decade's most popular genres. *Top Gun* (Chris Lebenzon and Billy Weber, editors) serves as a shining example here. Like *Flashdance, Top Gun* and its sound track album were marketed on MTV with videos featuring scenes of aerial dogfights, heterosexual coupling, and homoerotic bonding. The editing prioritizes visual impact over continuity. The flight scenes frequently break the 180-degree rule, which is intended to maintain spatial continuity across shots so that viewers have a clear understanding of the action. To capture the chaotic nature of aerial combat, the montage mixes the direction of the planes, quickly cutting from one shot to the next. The climactic dogfight with foreign jet fighters best demonstrates these patterns. In the ultimate sequence of this scene, Maverick (Tom Cruise) is pursued by an enemy plane. A shot of three jets silhouetted by the sun and flying toward the camera is succeeded by a shot from behind the planes, establishing a flat path to the action; these shots mirror the frontal shots of Maverick and the enemy pilots within the planes as they deliver necessary expository dialogue. Once the planes start firing at one another, though, the frontal shots are replaced by action moving horizontally—right to left or left to right—across the screen: missiles racing toward targets, bullets spurting out of guns. Soon the planes are also moving in these directions, but none of the directions is consistent; Maverick is shown flying screen left to right, but the missile he fires to win the engagement travels in three different directions before destroying its target (see color plate 10). It's a thrilling but also jarring scene, due to its rejection of continuity editing principles.

Top Gun typifies the action film's reliance on quickly cut sequences that privilege sensation over spatial logic, a trend identified by David Bordwell in his

account of intensified continuity. Bordwell notes that in the 1980s the average shot length (ASL) in American films dropped to between 3 and 7 seconds, down from the average of 5 to 8 seconds in the preceding decade; he attributes this development at least partially to the influence of music videos.[37] This tendency continued into the 1990s, as the ASL for many films dropped to the 2-second range, and the total number of shots sometimes climbed past 2,000. Bordwell identifies the increased use of digital editing systems, which made it easier to cut individual frames from shots, as one of the reasons for this shift.[38] This development was particularly notable in action films; beyond *Top Gun*, one can cite another Tony Scott film, *The Last Boy Scout* (1991; Tony Baird, Mark Goldblatt, and Mark Helfrich, editors), as well as *Point Break* (1991; Howard Smith, editor), *The Last Action Hero* (1993; Richard A. Harris and John Wright, editors), and *Bad Boys* (1995; Christian Wagner, editor).

However, one of the most striking examples of intense montage is Oliver Stone's *JFK* (1991; Joe Hutshing and Pietro Scalia, editors), a film containing more than 2,000 shots.[39] Stone used multiple film gauges, speeds, and colors to dramatize James Garrison's investigation of the assassination of President John F. Kennedy. To keep track of such diverse footage, *JFK* editor Scalia used a Sony video editing system and credited it with the film's striking editing schemes. "I think it's safe to say that had we not used that system, the film would have been cut differently," he told *Post-Script*. "We could experiment and try a lot of things because it was so fast. The tools can influence the cutting methods. The equipment does influence the form the movie takes."[40]

JFK uses its innovative cinematography to effectively rewrite history, frequently (but not exclusively) using black-and-white footage to present what "really" happened during the purported conspiracy to kill the president and its aftermath. In the climactic courtroom sequence, Stone blends segments from the widely known Zapruder film from 1963 with staged footage of Kennedy's motorcade and a team of government and military sharpshooters taking aim at the president (see color plate 11). In the frames in question, a tight close-up of the assassin's eyes is followed by a point-of-view shot as he fires his rifle, both of which are in black and white; the third shot is a jittery color shot of the president's limousine, linking the enacted footage to the color Zapruder frames that graphically present the fatal head shot. Together, the four frames take up approximately two seconds of screen time. Depending on one's perspective, the frenetic cinematography and montage either solidify Stone's "counter-myth" to the Warren Commission or establish "political paranoia as a cinematic motif."[41]

JFK may have set a new standard of rapid, disjunctive cutting, but the decade saw additional examples of frenetic editing, especially in high-concept action films like *Batman Forever* (1995; Mark Stevens and Dennis Virkler, editors), *Con Air* (1996; Chris Lebenzon, Steve Mirkovich, and Glen Scantlebury, editors), and *Armageddon* (1998; Lebenzon, Mirkovich, and Scantlebury, editors)

that continued to prioritize visual impact over narrative or spatial coherence. However, it would be a mistake to suggest that the entirety of American montage during these decades was as intense as that found in *Flashdance* or *JFK*. The resurgence of American independent filmmaking at the end of the 1980s provided a counter to these trends by drawing inspiration from the cinematic traditions of the 1970s.

To be sure, examples of this strand of American filmmaking, which used montage for intellectual rather than kinaesthetic goals, could be found even in the early 1980s—for example, in the historical epics *Reds* and *The Right Stuff* (Glenn Farr, Lisa Fruchtman, Tom Rolf, Stephen A. Rotter, and Douglas Stewart, editors). Both films use montage to demonstrate what the former's director, Warren Beatty, would describe as the "irony of history," the gap between a historical event and the imperfect human narratives constructed about it.[42] In *Reds*, Beatty and coeditor and co-executive producer Dede Allen conducted documentary interviews with Will Durant, Henry Miller, Rebecca West, and prominent leftists of the 1910s and 1920s; this footage was designed to provide commentary on the real John Reed and Louise Bryant, the historical events surrounding them, or cultural mores of the period. *The Right Stuff* examines the distance between the political and personal realities of America's first manned space program and the mythologies that were already accruing to the astronauts. Several montage sequences reveal the occasionally absurd experiences of the Mercury Seven. In one sequence, as the Mercury program's chief scientist explains in voiceover that the prospective astronauts—including a group of chimpanzees—are undergoing tests designed to desensitize them, test pilots and simians perform identical tasks, such as riding stationary bikes; any one of the pilots is interchangeable with another, but also with nonhumans as well.

This ironic engagement with the past came in various flavors of irreverence. The makers of *The Atomic Café* (1982; Jayne Loader and Kevin Rafferty, editors) combine government films, newsreels, television programs, and advertisements into a darkly humorous account of how nuclear war was presented during the 1950s. Woody Allen's *Zelig* (1983; Susan E. Morse, editor) tells the story of a man so neurotically obsessed with fitting in that he develops the ability to take on the physical appearance of those around him. In a parody of the interviews with famous intellectuals in *Reds*, the film intersperses footage of Susan Sontag, Saul Bellow, and Bruno Bettelheim with "archival" footage of Allen as Zelig and Mia Farrow as his psychiatrist and lover.

These forays into using editing conceptually were a prelude to more extensive late-decade developments, as films such as Steven Soderbergh's *sex, lies and videotape* (1989; Soderbergh, editor) would more clearly connect with the editing tendencies evident in the early part of Hollywood's 1970s renaissance. Soderbergh eschews the spatial ruptures and rapid cuts that had become increasingly common in big-budget films in the 1980s. Even in scenes where Soderbergh

appears to violate the 180-degree rule, he does so to connect the worlds of Ann, a housewife struggling with infidelity, and Graham, her husband's emotionally unavailable friend. For example, in the scene where Ann breaks through Graham's emotional walls to achieve intimacy with him, this reversal is visualized by subtle intercutting between two tracking shots so that the character's original positions in the set have been reversed. In other scenes, audio is used to bridge disparate spaces, although not for the purpose of selling sound track albums. At the beginning of the film, shots of Graham shaving in a gas station bathroom are intercut with Ann's therapy session, where she discusses her concerns about social problems she cannot control, such as excess garbage. Her voice connects the spaces, with Graham's act of cleanliness juxtaposed against her fears about filth and her therapist's concerns about her obsession with what she cannot control, suggesting that Graham may prove to be someone she struggles with as well.

Sex, lies and videotape presaged the resurgence of American independent filmmaking that eschewed flashy montage sequences in favor of characterization and more metaphoric editing. Also released in 1989, Gus Van Sant's *Drugstore Cowboy* (Mary Bauer and Curtiss Clayton, editors) further exemplifies this late-decade trend in editing. For example, in one montage sequence, interspersed among images of drugs, syringes, and other related items is a shot of a statue of the Virgin Mary, drawing a link between chemical addiction and religion. The sequence hearkens back to the Soviet montage period, particularly Sergei Eisenstein's *October, or Ten Days That Shook the World* (1928; Esfir Tobak, editor).

In the 1990s, auteur-identified independent films like Quentin Tarantino's *Reservoir Dogs* (1992; Sally Menke, editor), Allison Anders's *Gas, Food, Lodging* (1992; Tracy S. Granger, editor), and Richard Linklater's *Before Sunrise* (1995; Sandra Adair, editor) would follow in the footsteps of Soderbergh and Van Sant. Reminiscent of early Martin Scorsese films, the opening scene of *Reservoir Dogs* uses loose editing rhythms while maintaining basic continuity principles. It is composed of a series of tracking shots that circle the table at which a band of thieves eat breakfast and crassly discuss Madonna songs. The pace of the camera movements is fairly languid; the shots range from four to thirty seconds. This cuts against the rapid pace of the dialogue, creating a disorienting effect that suggests the fragility of trust that will be a major theme of the film. However, the shots also establish where each thief is at the table, providing the viewer a clear understanding of the physical space in which the scene unfolds.

Later in the decade, Paul Thomas Anderson would more openly rely on the films of the 1970s to break with the increased number of shots and decreasing ASLs of mainstream action cinema. *Boogie Nights* (1997) and *Magnolia* (1999), both edited by Dylan Tichenor, are self-consciously patterned on Scorsese and Robert Altman, respectively, and both incorporate long takes into their editing schemes. *Boogie Nights* begins with a nearly three-minute-long tracking shot that starts in front of a movie theater and concludes inside a busy disco. In *Magnolia*,

Anderson replicates Altman's trademark use of a zoom lens through repeated tracking movements, often match-cutting from one shot of these movements to another to transition between scenes. It concludes with a two-minute slow zoom-in on the face of Melora Waters as she shyly accepts love into her life.

The American independent cinema of the 1990s continues to influence film-makers, as seen in the mumblecore movement and the minimalist films of Kelly Reichardt and Ty West. Yet so does the more conglomeration-inspired, synergy-driven style of the 1980s and 1990s. When MTV cut back on its music video programming, music-oriented montage sequences became less common in American film. And yet such moments still persist: all of the Sam Raimi–directed and Bob Murawski–edited *Spider-Man* films feature interludes that could be used as music videos were they not so deliberately ludicrous; perhaps the most noteworthy example is the sequence of Peter Parker dancing down the street to the strains of "People Get Up and Drive Your Funky Soul" in *Spider-Man 3* (2007). Animated films also employ such sequences—for example, the touching "Married Life" montage in *Up* (2009; Kevin Nolting, editor). In any event, such a scene is no longer as common a storytelling or marketing device as was the case a few decades ago.

At the same time, the action montage pioneered in *Top Gun* is evident in the comic book adaptations that today provide the film studios with the best oppor-tunities for synergy. It has clearly influenced Michael Bay's style of frantic cutting across shots full of chaos, honed in the 1990s on *Bad Boys* (1995; Christian Wag-ner, editor) and *Armageddon* (1998; Mark Goldblatt, Chris Lebenzon, and Glen Scantlebury, editors) and perfected (if that's the correct word) in the *Transform-ers* series. Similarly, Christopher Nolan's Batman trilogy disregards principles of spatial and temporal continuity in several of the films' action sequences—such as Batman's pursuit of Bane after the stock heist in *The Dark Knight Rises* (2012; Lee Smith, editor). Thus, just as traditional editing styles were modified to fit the studios' expectations for synergistic sound tracks in the 1980s and 1990s, so are the editing styles of these later decades being modified to enhance the superhero adaptations of the 2000s.

10

THE NEW HOLLYWOOD, 1981–1999: Special/Visual Effects Lisa Purse

It's a long road from imagination to the screen, and plenty of routes work.
—David Heuring, American Cinematographer

It is tempting to define visual effects in the 1980s and 1990s by what was already under way in the late 1970s, such as the motion-control camerawork and sophisticated traveling mattes of *Star Wars* (George Lucas, 1977), the careworn future-tech production design of that film and *Alien* (Ridley Scott, 1979), or the emergence of George Lucas and John Dykstra's influential effects house Industrial Light and Magic (ILM), assembled for *Star Wars* but subsequently involved in key blockbuster effects pictures of this period. It is equally tempting to define the period by how it ends, with bravura displays of vividly spatialized, seamlessly photorealistic digital visual effects in films such as *Dark City* (Alex Proyas, 1998), *The Matrix* (the Wachowskis, 1999), and *Fight Club* (David Fincher, 1999). From the standpoint of the contemporary ubiquity of digital visual effects, the emergence and development of digital imaging technologies in mainstream filmmaking is perhaps the most familiar special effects narrative we now associate with the years 1981–1999, not least because key digital milestones appear in this period, including the computer-generated (CG) sequences of *TRON* (Steven Lisberger, 1982), digital morphing in *The Abyss* (James Cameron, 1989) and

Terminator 2: Judgment Day (James Cameron, 1991), computer animation in *Jurassic Park* (Steven Spielberg, 1993) and *Toy Story* (John Lasseter, 1995), digital extras in *Titanic* (James Cameron, 1997), and "bullet time" in *The Matrix*. One could, therefore, characterize 1981–1999 as a "transitional period" in which digital imaging processes grow in prominence and technical sophistication, and nondigital effects disciplines become correspondingly less common. But doing so may retroactively suppress the extent to which particular effects practices and workflows persisted and were combined in this period. As the epigraph for this chapter suggests, as in other decades, multiple paths could be taken to realize the director's vision, and decisions about which combinations of effects disciplines would be called upon depended upon a constantly shifting intersection of artistic, economic, and technological imperatives, producing a diversity of practices not always acknowledged in existing histories.

Advances in Optical Compositing and Motion Control

In a 1981 article for *Cinefex* magazine, Jordan Fox asserts: "Toss the catch-all phrase 'special effects' at the average filmgoer, and chances are his or her first mental image will fall within the realm of special *photographic* effects."[1] This was in no small part due to *Star Wars'* innovations in motion control, optical effects, and optical printing, brought to filmgoers' awareness by the film's massive success. *Star Wars* spawned a series of blockbuster fantasy films that replicated its strategy of generating large-scale, dynamic action spectacles through the expert optical compositing of matte paintings, miniatures, and stop-motion, live-action, and bluescreen elements, foreground and background plates, and rotoscoped animation (that is, painting animated elements into the photographic frame) in films such as *The Empire Strikes Back* (Irvin Kershner, 1980) and *Return of the Jedi* (Richard Marquand, 1983), the *Raiders of the Lost Ark* films (Steven Spielberg, 1981, 1984, 1989), and the *Star Trek* sequels (1982, 1984, 1986, 1989).[2] Thus emerged a key strand of 1980s effects practice: the strategy of continuous refinement of the optical composite and its constitutive photographic elements.

In the main, these refinements were undertaken by well-funded, large effects houses such as ILM, John Dykstra's Apogee, Inc. (1978–1992), and Richard Edlund's Boss Film Studios (1983–1997) that could afford the research and development time and costs necessary to produce new generations of optical printers, higher frame rate cameras, bluescreen processes, and motion-control cameras. For example, while at ILM for *The Empire Strikes Back*, Richard Edlund oversaw the development of a modified high-speed "Empire" VistaVision camera, a motion-control system that could precisely replicate movements recorded in the field on a stage or miniature set, subsequently used on films including *Raiders* and *Poltergeist* (Tobe Hooper, 1982),[3] and a four-headed "Quad" optical printer

"that could combine four separate elements in one pass, saving considerable time when creating complex multi-element composites,"[4] both innovations that won Motion Picture Academy Scientific and Technical Awards.

Such advances minimized matte lines—the "fringing" that becomes visible when different passes in an optical composite are not lined up correctly—while accommodating the compositing of many more objects in the frame, and, thanks to motion control, more dynamic movement of the camera and onscreen objects. The number of composited elements in the *Star Wars* sequels, for example, proliferated so that by *Return of the Jedi* hundreds of ships featured in the key battle scenes.[5] For the *Raiders of the Lost Ark* scene in which the Ark of the Covenant is opened releasing hundreds of spirits, the Quad printer combined animated apparitions, footage of wire-armatured silk ghosts manipulated in a water tank, and live-action plates to produce the final sequence (color plate 12),[6] moving Edlund to celebrate its "positionable repeatability" and accuracy of "one and two-tenths of a thousandth of an inch."[7] These new optical printers also reduced the number of duplications an optical element would need to go through in the compositing process (thus limiting the extent of image degradation common with "dupe" elements). At Boss Film Studios, Edlund would later be responsible for further advances in this area, building the Super Printer for *Ghostbusters* (Ivan Reitman, 1984) and the Zoom Aerial Image Optical Printer (ZAP) for *Poltergeist II: The Other Side* (Brian Gibson, 1986), another Motion Picture Academy Scientific and Technical Award winner.

These technologies were attractive not just because of the fantastic visions they enabled, but because of the fine-grained control over the final image they permitted. Bruce Nicholson, optical photography supervisor on *Star Trek II: The Wrath of Khan* (Nicholas Meyer, 1982), gives a sense of this precision in his description of optical compositors as "the last road in the process," explaining, "We see to it that the elements are color-balanced to each other, that they're positioned correctly in the frame and are the proper relative size, and that they don't have any noticeable flaws like grain or soft focus. If there are any mistakes, we try to correct them or make them look less noticeable."[8] But the aim was less a flawless image than an integrated one. On *Empire*, effects director of photography Dennis Muren deployed heavy diffusion on the miniature spaceships in order to make sure they matched the aerial landscape background plates: "We've degraded the image, because the snorkel lens that the background scenes were shot with provided a less sharp image," Muren explained. "We've done everything possible to tie all of these elements together so that the result would look real."[9] The quality of the final image and its composite elements was important, but the higher goal was to make the depicted events look as if they had taken place in front of a real camera. Even the science-fictional multi-beam phaser in *The Wrath of Khan* had simulated lens flare added to its beam to achieve this look.[10]

This aim—and the strategy of refinement that lay behind it—extended to ILM's deployment of stop-motion animation, which remained an extremely useful way to bring creatures to life onscreen well into the 1980s and 1990s. While *Clash of the Titans* (Desmond Davis, 1981) looked back to an earlier era of effects work (and the old RKO and Universal "creature features" they made possible), in contrast *Empire* displayed a refinement of the technique that would permit its longevity in an increasingly computerized world. Stop-motion animation is achieved by moving an armatured model in tiny increments, exposing a still image of each individual increment onto a separate frame of film. The resulting animated sequence conveys the illusion of motion, but often with a staccato characteristic created because each frame has captured a clear *still* image rather than the motion blur that would be captured if the object were genuinely moving in real time in front of the camera. *Empire* used stop-motion to animate two-legged and four-legged armored transport vehicles nicknamed "Walkers," as well as the woolly beasts called "tauntauns" that Luke Skywalker and Han Solo use to traverse the icy planet Hoth. To create a more fluid motion, animators Phil Tippett and Jon Berg deployed a motion-control mechanism that moved the model slightly while the camera shutter was still open, thereby reintroducing motion blur into the image.[11] In addition, a judder was added to the path of the motion-control camera that was filming the armatured models, to give the impression that a camera had tried to capture the footage imperfectly in the real world.[12]

A more complex motion-control animation rig was developed by Stuart Ziff for *Dragonslayer* (Matthew Robbins, 1981), consisting of motor-driven rods attached to the puppet's body, head, neck, and each leg, which registered each movement on a computer. These movements could then be "played back" automatically so that the puppet could "perform" in real time while the camera rolled, thus generating the requisite amount of motion blur. This "Go-Motion" method was subsequently used for the flying bicycles in *E.T.* (Steven Spielberg, 1982) and the dragon in *Willow* (Ron Howard, 1988). As in *Empire*, the photorealism of the resulting smooth, lifelike movements was further enhanced by the addition of photographic imperfections to the scenes.[13]

This project, to produce "a meticulously rendered integrated photorealism," is a cornerstone of what Julie Turnock calls the "ILM aesthetic," and the huge success of many ILM films has caused not simply the proliferation of this photorealist approach, but its positioning as a benchmark of "good" special effects that persists today, as Turnock points out.[14] ILM was formed in order to accommodate all the different kinds of effects work *Star Wars* required under one roof. In subsequent years, one of the big effects houses could similarly handle all the special effects needed for a given production, ranging from miniature and stop-motion work to mechanical effects, prosthetics and makeup, optical effects, and compositing. There was a significant quality assurance aspect to this, too, with

Oscar-winning visual effects supervisors like Richard Edlund, Dennis Muren, and Ken Ralston getting involved as early as possible to ensure appropriate allocation of expertise, consistency, and complementarity of approach across all phases, thus achieving a consistent photorealist look from concept development to postproduction. The experience on *Star Trek III: The Search for Spock* (Leonard Nimoy, 1984) was fairly typical. Associate Producer Ralph Winters explained, "We started with [ILM] in December 1982, before we hired production designer Jack Tilburg. ILM started designing the effects, but they were also feeding Tilburg ideas about how the sets, props, and planets should look and feel. It was a true collaborative effort."[15]

This mode of engagement was expensive, however, and, as Winters's words unwittingly reveal, could involve a suppression of artistic input from other parts of the filmmaking team.[16] As early as *Altered States* (Ken Russell, 1980), John Dykstra and Apogee, Inc. were dropped because of escalating costs and concerns about artistic control,[17] and it became relatively common for film producers or directors to shop around for effects work when such issues arose. Thomas Smith, executive producer of *Honey, I Shrunk the Kids* (Joe Johnston, 1989) and a former ILM employee, estimated they saved about two-thirds of the costs of contracting a big effects house by identifying and coordinating a number of smaller effects vendors for the film themselves.[18] For *Beetlejuice* (1988), director Tim Burton "didn't even approach the bigger effects houses like ILM," due to budgetary constraints, but also because of the look he was going for: "We wanted to take a simple, matter-of-fact approach to the effects," he explained, adding tartly, "I like effects that have a little humanity to them."[19] David Cronenberg was equally disinclined, insisting that optical animation enhancements of the teleportation and energy-filled receiving pod shots in his film *The Fly* (1986) (supplied by Dream Quest Images) remained subtle, because he "didn't really go for the *Star Wars* or *Star Trek* look."[20] These sentiments betray the fact that while the seamless photorealism of the optically composited ILM aesthetic—and the concept-to-composite mode of engagement that enabled it—might be economically dominant, it did not penetrate all areas of popular cinema during this period.[21]

Alternatives to Big-Budget Effects

Lower-budget filmmaking was creating a space for alternative effects solutions and aesthetic possibilities. Groupings of effects practitioners were gathered for particular films, or to create small, bespoke effects houses. Roger Corman's New World Pictures special effects studio was put together for his low-budget space opera *Battle Beyond the Stars* (Jimmy T. Murakami, Roger Corman, 1980) (which had a $5 million budget compared to *Empire*'s $18 million price tag and *Return of the Jedi*'s $32.5 million). It went on to supply miniature and matte work for

Escape from New York (John Carpenter, 1981) (to which the fledgling Dream Quest Images also contributed), and creature effects, miniatures, and live compositing via a beam-splitter and a reverse-focus lens for *Mind Warp: An Infinity of Terror* (Bruce D. Clark, 1981), thereafter serving a number of New World productions, such as *Saturday the 14th* (Howard R. Cohen, 1981), *Mutant* (Allan Holzman, 1982), and *Space Raiders* (Howard R. Cohen, 1983). John Carpenter approached New World for *Escape from New York* because, with a budget of $7 million, the quotes he was receiving from other effects houses were simply too high. New World's studio specialized in finding ingenious ways to do things more cheaply, through creative experimentation and repurposing. *Escape* featured a glider flight onto the roof of the World Trade Center and a burned-out New York skyline, to which the New World team applied a creative "make do and mend" approach. Special visual effects engineer Tom Campbell explained that the required Manhattan miniature model was constructed mostly of "cardboard boxes, or whatever else we could find that was about the right size. . . . We took photographs of buildings and pasted them on the boxes, then we put in buses, docks, and tried to make it as much to scale as we could."[22] Photographs of the miniature formed the basis of some of the film's matte paintings, and one photograph was mounted on glass and placed between the camera and a San Fernando Valley live-action set to achieve a "live" composite combining the Manhattan miniature photograph with the shoot location.

While there is a gesture toward photorealism here, it is more elastic, more of a suggestion that the different elements might share the same spatio-temporality rather than a clear assertion, making way for a playful invitation to "see the seams." A similar invitation is present in the oversized sets and forced perspective tricks of a film like *Innerspace* (Joe Dante, 1987), which shows us many of its interactions between miniaturized and normal-sized characters through in-camera strategies rather than optical composites. Indeed, a strain of nostalgia for in-camera and older effects processes that explicitly differentiate themselves visually and technologically from the sophisticated, seamless optical composite of the ILM aesthetic is detectable throughout the 1980s and into the 1990s, in films such as *Honey, I Shrunk the Kids*, *Beetlejuice*, *Dracula* (Francis Ford Coppola, 1992), and *The Nightmare Before Christmas* (Henry Selick, 1993). By the mid-1990s such films were, ironically perhaps, often achieved with the assistance of computer-generated imagery, with good examples being *Death Becomes Her* (Robert Zemeckis, 1992) and *Mars Attacks!* (Tim Burton, 1996).

The move away from a seamless optical composite took a particular form in the vein of unapologetically low-budget horror and sci-fi movies popular in the period, which showcased a vivid mixture of prosthetics, makeup effects, puppetry, animatronics, and stop-motion work in films such as *The Thing* (John Carpenter, 1981), *The Evil Dead* (Sam Raimi, 1981), *An American Werewolf in London* (John Landis, 1981), *Creepshow* (George A. Romero, 1982), *Videodrome*

(David Cronenberg, 1983), *The Terminator* (James Cameron, 1984), *A Nightmare on Elm Street* (Wes Craven, 1984), *Fright Night* (Tom Holland, 1985), and *The Fly*—and their sequels and imitators. These films continued a trend for body horror and onscreen transformations that had emerged in the 1970s,[23] involving special makeup effects and creature effects artists who would find consistent work throughout the 1980s and 1990s, including established practitioners Dick Smith, Rick Baker, and Stan Winston, along with newcomers Rob Bottin (Baker's protégé), Carl Fullerton (Smith's protégé), Chris Walas, Jeff Dawn, and Tom Savini.

Innovations displayed early in the 1980s would prove influential across the period, and beyond economic and generic confines. These provided sensational spectacles of bodily mutation and gore that still managed to look like they involved living beings, described by practitioners as an attempt to generate an impression of "live-ness" through carefully designed, realistic bodies and lifelike movements (such as breathing, blinking), unfolding in real time "right before your eyes." Where photorealism seeks to emphasize the simulated "photographed-ness" of a sequence, here the emphasis is on the "perceptual realism"[24] of the body or event being filmed, sustained in spite of its fantastical nature. On *Altered States* Dick Smith and Carl Fullerton had discovered a highly elastic polyurethane compound called "Smooth-On 724" that could be molded into flexible, micro-thin bladder appliances of 1/32 of an inch, hidden under a thin layer of foam latex skin and inflated via tubes, but "adding virtually no buildup on the skin at all."[25] They used it to create William Hurt's initial body mutations, including mobile, rippling lumps under the skin of his face, chest, and arms.[26] *American Werewolf in London*'s transformation of actor Dennis Naughton into the titular werewolf involved a series of cuts from various camera angles that hid transitions between different phases of makeup, prosthetics, bladder appliances, and animatronics. The film was also renowned for presenting some parts of the transformation—such as the expanding hand and the protruding skull—in real time, in brightly lit single takes (eschewing the low lighting more usual for horror that can be useful for hiding makeup transitions). A series of "Change-O-Heads," progressive masks containing animatronic mechanisms first used by Rob Bottin on Rick Baker's suggestion on *The Howling* (Joe Dante, 1981),[27] allowed real-time skull mutations, while later in the scene a lower body puppet attached to Naughton's head and shoulders (while the rest of his body was hidden under a false floor) enabled his lupine form to bear scrutiny across extended takes. It resulted in Rick Baker's first Oscar, in the newly created category of Best Makeup, in 1982.

The Thing's subject—an alien creature that can mimic the form of living hosts, before ripping them apart to reach a new host—demanded a series of visceral transformation sequences of humans and animals, supervised by special makeup effects creator-designer Rob Bottin, with an emphasis once again on key moments developing in real time. In one scene, as a doctor (Wilford Brimley)

tries to revive an unconscious colleague, Norris (Charles Hallahan), with a defibrillator, a cavity opens up in the patient's chest and tears off the doctor's lower arms. As in *American Werewolf*, a foam latex body was used—in this case a false chest containing a hydraulic ram that controlled the opening and closing of the body cavity.[28] Double-amputee performer Joe Carone wore the doctor's life mask, and his arms were dressed with gelatin (to simulate torn flesh), dental acrylic (bones), and blood tubes (sheared arteries) for the moment when the arms are severed. Later in the scene Norris's head tears away from his body, an effect witnessed in real time thanks to a "push-rod hidden within the viscera of the inner neck," operated manually just off-camera (color plate 13).[29] Various Norris heads were constructed by Jim Cummins based on the actor's life mask, with radio-controlled expressions, and darting eyes were controlled via a cable rig designed by Bob Worthington. To escape the humans who are trying to burn it alive, the disembodied head sprouts spider-like legs and eye stalks and scuttles away. Initial extensions of the legs were radio-controlled, with walking shots achieved by attaching the legs to cam shafts on a hidden radio-controlled "car" produced by Tim Gillett, thrashing the legs as the car moved forward.

Through these various feats of sculpting, dressing, and ingenious, detailed animatronic devices, Bottin and his team generated not just the key creature actions the scene required, but the twitching, breathing, and blinking that "make it look alive,"[30] bringing perceptually realistic, "living" motion to the alien's many forms. What they also initiated was a productive (if initially controversial)[31] blurring of the previously established distinctions between mechanical and makeup disciplines, a trend for the integration of special makeup effects with prosthetics, puppetry, and mechanical effects that was highly influential, not just in horror and science fiction (*The Fly*, *A Nightmare on Elm Street*, *Batman* [Tim Burton, 1989], *Total Recall* [Paul Verhoeven, 1990], *Darkman* [Sam Raimi, 1990]), but also in fantasy and family fare (*Legend* [Ridley Scott, 1985], *Back to the Future* [Robert Zemeckis, 1985], *Willow*, *Hook* [Steven Spielberg, 1991], *Jurassic Park*, *True Lies* [James Cameron, 1994], *Babe* [Chris Noonan, 1995], and *Mighty Joe Young* [Ron Underwood, 1998]).

The above list permits a broader observation: while we might see low-budget horror and blockbuster movies as opposite ends of the spectrum in terms of their effects practices, aesthetics, and economics, many films were routinely combining effects disciplines in ways that disregarded the supposed distance between them. *Raiders of the Lost Ark* drew on physical effects, miniatures, matte paintings, and optical effects as well as the special makeup effects expertise of Chris Walas (veteran of *Scanners* [David Cronenberg, 1981]) for, among other scenes, the Ark-induced deaths of three Nazi characters: Belloq (Paul Freeman), whose head explodes, Dietrich (Wolf Kahler), whose face shrinks, and Toht (Ronald Lacey), whose head melts away. The characters' heads were constructed with gelatin skins over plastic skulls. Belloq's head was filled with blood bags and

rigged with small detonations, with pyrotechnic effects added via optical anima-
tion.[32] Toht's head was melted by heaters just off-camera, filmed with time-lapse
motion-control photography,[33] and for Dietrich's accelerated mummification,
molded bladders were inflated to approximate the actor's facial structure and
then deflated to shrink over the plastic skull.

The Terminator also combined various disciplines to create its well-known
effects sequences. Artists created a puppet head for the scene in which the Ter-
minator (Arnold Schwarzenegger) must operate on his own eye, along with
miniature models to depict (with the addition of some animated laser blasts) the
fighting vehicles in the future war scenes, and "a full-scale mechanical Termina-
tor, constructed by Stan Winston in his shop, and a stop-motion puppet built by
Doug Beswick at Fantasy II" for the film's climactic chase scene.[34] Meanwhile,
makeup and prosthetic effects—including a move in the mid-1990s from foam
latex to the more versatile translucent silicone prosthetics developed by Gordon
Smith—were used not just in science fiction and fantasy films but found appli-
cations in dramas such as Legends of the Fall (Edward Zwick, 1994) and Nixon
(Oliver Stone, 1995).[35]

If optical compositing and other special photographic effects offered the
capacity to "fix things in post" at the beginning of the 1980s, by the end of the
1990s digital visual effects and compositing seemed to fulfill the same promise.
What happened in the years in between is not the total usurpation of one set of
technologies by another, but the thinking through and testing out of the evolv-
ing capacities of this new computer technology, its risks and benefits, its cost
and time implications, and its ability to integrate with other effects technologies,
onscreen and in the image workflow.

Computer-Generated Images

Computer-generated images (CGI) had made it onto cinema screens in the 1970s,
but fleetingly, and mostly to simulate futuristic display technologies, in films like
Westworld (Michael Crichton, 1973), its sequel Futureworld (Richard T. Heffron,
1976), Star Wars, and Alien[36] (in other films, such displays were created using
optical animation or other means).[37] Processing power requirements and render
times were enormous and required the use of supercomputers, often in commer-
cial or university research labs. For example, the android's (Yul Brynner) eyeview
of a human character in Westworld is a 2D digitally pixelated image of the live-ac-
tion plate created by Gary Demos and John Whitney Jr. of Triple-I (Information
International Inc.)[38] that required eight hours per film frame to render.[39] Balk-
ing at the costs and time involved, filmmakers in the late 1970s and early 1980s
struggled to see the technology's full potential. Computer-generated images
found a more welcoming medium in television, in advertisements and corporate

logos requiring only a few seconds of lower resolution motion graphics, for companies that could afford the high price tag.[40] Such advertising and logo work frequently adopted "an aesthetic more based in 2-D animation and graphic art than photorealism,"[41] such as Robert Abel and Associates' 1982 advertisements for the Toyota Celica and the Maxfli DDH golf ball, which bring vivid colors and a movement-centered approach to computer-animated wireframes rendered both with and without surface modeling. Related electronic aesthetics were also emerging, including that of video game arcades and home consoles—which had exploded in popularity in the late 1970s and early 1980s with *Pong* (1972), *Space Invaders* (1978), *Pac-Man* (1980), and *Donkey Kong* (1981)—and that of personal and desktop computers like the Apple II (1977) and IBM PC (1981).

It is into this world—and this cluster of electronic aesthetics—that the first film to feature extensive computer-generated images was born. *TRON* (Steve Lisberger, 1982) features a combination of backlit live action rotoscoped by hand, optical effects animation of interactive light and shadow, and computer-generated 2D and 3D objects. The CG sequences were provided by two effects houses with different imaging capabilities: MAGI (Mathematic Applications Group, Inc.), whose software was "more suited to the fast-moving graphics of the battles with tanks and light cycles," and Triple-I, who "could create more dynamic shapes"[42] suitable for the more realistically rendered computer environments.[43] As effects supervisor Richard Taylor reveals, the non-CG elements were a major task, particularly the backlit compositing of the actors that gave their costumes a computer wireframe look, which involved "hand painting of hundreds of thousands of cels and as many as forty hand-flopped passes under the animation cameras per scene."[44] It is somewhat ironic that the most labor intensive aspect of the film was the non-CG element responsible for giving the actors the same electronic look that had been ascribed to the CG sequences. But this paradox reveals both the practical reality that CG was still only one of a number of effects solutions, and the extent to which this look was designed to correlate with existing trends in electronic visual culture, rather than flowing from the absolute limits of the computer imaging technology available at the time.[45] *The Last Starfighter* (Nick Castle, 1984) featured computer-generated 3D environments and spaceships with more developed surface modeling than *TRON*. While the filmmakers were bullish about *Starfighter*'s differences from the earlier film (claiming more natural colors and a more photorealistic look),[46] both films share a "technofuturist aesthetic"[47] that sought to speak to electronic visual culture and possible computer futures by presenting images which asserted themselves as distinct from the special photographic effects that had held sway up to that point.

Later in this period the focus shifted toward more direct assimilation of CG into the frame, an integrationist approach that had much in common with ILM's optical composite-based photorealism. As Stephen Prince notes, it was the "Genesis" sequence in *Star Trek II* that was "the era's great industry eye-opener . . .

cinema's first attempt to simulate properties of organic matter in a photograph-
ically convincing manner, one not intended to look like a computer graphic,"
using fractal and particle system modelers to simulate a world being brought to
life, including water, fire, and fauna.[48] Thereafter CGI that could integrate con-
vincingly into the diegesis and the film image was a key aspiration, even before
the technology had managed to develop sufficient surface modeling capability
to render complex textures like water or skin. Pixar Animation Studios, which
had started life as The Graphics Group in the Lucasfilm Computer Division,
left Lucasfilm in 1986 and shortly afterward released RenderMan, software that
"performed a comprehensive set of calculations that were needed in render-
ing—lighting, texturing, and adding other 3D effects—to wireframe models."[49] It
was this software that proved so effective in generating the CG spectacles of *The
Abyss, Terminator 2*, and *Jurassic Park*, among others.

Even computer-imaging processes that had particularly non-naturalistic
characteristics were subject to the integrationist, photorealist approach. Mor-
phing software, first used in 1988 in *Willow*, was a valuable tool in its ability
to digitally interpolate between key frames to generate a seamless transition,
but the effect could be quite uncanny.[50] Films like *The Abyss* and *Terminator
2* capitalized on this strangeness of morphing by using it to create mutating
nonhuman CG characters, but at the same time cannily gave those characters
surfaces that literally reflect the diegetic environment around them, thus inte-
grating them visually into the scene. Elsewhere morphing was being used more
subtly to smooth transitions between other effects elements so that they appeared
more photoreal, for example in *Indiana Jones and the Last Crusade* (1989), where
the villain's (Julian Glover) death, aging hundreds of years almost instantly, is
achieved with sequential shots of three motion-control puppet heads in different
states of decomposition, knitted together with computer morphs.[51]

Nevertheless, the challenge of integrating CG into image workflows would be
unwieldy for most of the 1980s and 1990s, only properly ameliorated by the arrival
of digital scanning technology advanced enough to digitize film footage so that
it could be manipulated in a computer before being printed back onto film. This
"Digital Intermediate" process, first applied to *Pleasantville* (Gary Ross, 1998),[52]
made digital compositing much more manageable. Up to this point, CGI still had
to be recorded back onto celluloid and combined with other image elements in
an optical printer, with attendant challenges—like ensuring that lighting, color,
and movement were matched across the live-action and CG elements—for which
software had to be written and continually refined. Inevitably, this meant film-
makers were always weighing CGI against alternatives, frequently reluctant to
take a risk with this relative newcomer to the effects disciplines. For the *Abyss*
"pseudopod," for example, James Cameron had been considering replacement
animation or water reflections projected onto a stop-motion animated clay
model, only changing his mind when ILM produced CG images that not only

looked the part, but could be rendered overnight on a daily basis to provide Cameron with robust opportunity for regular input.[53] Even so, data about the camera angle, position, height, focal length, and lighting on set had to be meticulously gathered for every live-action plate, to generate the correct spatial parameters for the computer model's movements in each shot.[54]

Jurassic Park illustrates that the analog/CG interface was not always wholly negative, however, and could sometimes work to sustain older effects expertise. Less than four years after *The Abyss*, CG advances enabled digital dinosaur skin textures and movements to be simulated with sufficient photorealism that such images could be intercut with live-action footage and Stan Winston's animatronic dinosaurs.[55] Like Cameron before him, Spielberg had thought the technology was not ready, and he was considering stop-motion animation until screen tests proved otherwise. Stop-motion expertise remained essential to the success of the CG dinosaurs, however, particularly once ILM realized there were not enough computer animators to manage the workload. Stop-motion animator Phil Tippett became animation supervisor on the project, and Tippett Studio's Craig Hayes co-developed with ILM a "Dinosaur Input Device" (DID), a stop-motion armature with encoders at pivot points that allowed stop-motion animators to input animation movements directly into the computer to drive the CG dinosaurs (see figure 21),[56] later used on other films including *Species* (Roger Donaldson, 1995) and *Starship Troopers* (Paul Verhoeven, 1997).

Other analog/CG interfaces allowed matte painters to continue their art in digital form, while real-world sculpted maquettes continued to be built as the basis for 3D computer models throughout much of the 1990s. Speaking in 1994,

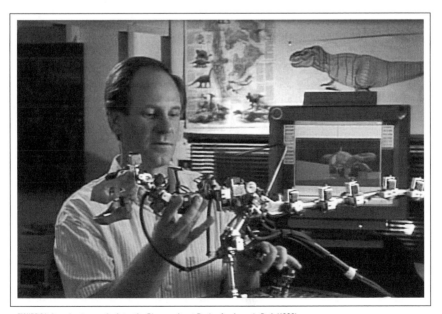

FIGURE 21: An animator manipulates the Dinosaur Input Device for *Jurassic Park* (1993).

Randal M. Dutra, animator at Tippett Studio and then ILM, was happy to enthuse about the advantages digital technologies supplied: "CGI has already made the animator's job far more labor- and time-efficient. There's no gravity to fight or possible armature pops that can ruin an otherwise good take; we can save days, weeks, even months of work by key-framing procedures; we can create detailed paths of action, review shots in progress, enjoy immediate playback capabilities, virtually lift camera and lighting constraints, and finesse a shot to a remarkable degree."[57] Render times, processing power, and costs continued to drop, and CGI was now offering unprecedented control over the image.

Such changes were also beginning to transform effects companies. New players joined the fray, not least Digital Domain, a digital visual effects house set up in 1993 by James Cameron, Stan Winston, and Scott Ross, fully funded by computer giant IBM. Anticipating a "digital revolution," Digital Domain rented rather than purchased expensive cameras and motion control equipment, and threw investment into computer technology instead.[58] They joined an increasingly crowded marketplace where smaller independent digital visual effects houses multiplied and "brutal bidding wars" gave rise to "greatly abbreviated schedules" with minimal pre- and postproduction phases.[59] These trends put severe pressure on the operating margins of even established companies, causing some—such as Boss Film Studios—to fold, and others—including Sony Picture Imageworks, Rhythm & Hues, and Digital Domain—to downsize.[60]

If the emergence of CGI heralded an increasingly hostile landscape for effects companies, it had not prompted the wholesale cessation of older effects disciplines that some had anticipated.[61] Instead, the 1990s looked much like the 1980s in their flexible combinations of older and newer effects technologies. So, for example, *Starship Troopers* married physically built miniature models of spaceship with 3D computer-generated environments, and real-world pyrotechnics and special makeup effects with computer-generated bugs in a digital composite.[62] *Dark City*, noted for its use of computer morphs to convey a metamorphosing cityscape, also featured an array of nondigital effects strategies, such as the construction of a motion-control miniature of the city floating in space,[63] and various wide shots of the city that used forced perspective and extensively reconfigurable, variously scaled miniature buildings.[64] For one scene in which buildings implode, rigid polyurethane foam structures were blown inward by air cannons located offscreen, alongside "assorted movable models on camera tracks and pneumatic rams, spiraling set pieces and a large model of a water tower, rigged to explode."[65]

Action movies, too, provided fertile ground for dynamic combinations of effects disciplines. In *Die Hard* (John McTiernan, 1988), explosions at the top of a terrorist-occupied building were realized with miniature sets, miniature remote-controlled helicopters, and some rotoscoping work to position the helicopters in appropriate relation to the fireball.[66] *Speed* (Jan de Bont, 1994) begins in an

elevator shaft, built eighth-scale and shot with motion control cameras and lights. In the scene where a speeding bus has to jump a gap in an under-construction LA freeway, live-action plates of the bus careening off a six-foot-high ramp were combined in the computer with digital matte paintings of the fictional gap in the road.[67] The showpiece climax of *Mission: Impossible* (Brian De Palma, 1996) occurs atop a speeding Eurotunnel train, and includes a helicopter following the train into the tunnel and crashing, narrowly missing the hero (Tom Cruise). Digital matte paintings of the tunnel walls and the CG train were digitally composited with bluescreen footage of Cruise, "special camera rigging, pyro effects, eight-scale model helicopters, and a like-scaled train nose section."[68] Photorealistic digital composites were the goal and were regularly achieved.

Films such as *The Matrix* and *Dark City* demonstrate the seemingly endless possibilities of CGI at the end of the 1990s. Their narratives offered fantasies (and concomitant fears) of total control that seemed to function as barely concealed metaphors for CGI's expanding impact on cinema. Yet CG was not yet a totalizing technology, and was not yet being used to control all elements of the frame. *Dark City* presented extensive, intricate miniature cityscapes alongside its morphing sequences, and *The Matrix*'s battery farms and "unplugged humans" occasioned visceral prosthetic- and puppet-work alongside its CG spectacles and digitally sutured "bullet-time" sequences. In 1999, CG elements nestled among equally state-of-the-art iterations of preexisting effects specialisms, including prosthetics, miniature work, stunt work, pyrotechnic effects, and matte painting. Two decades of invention and refinement, innovation, and continuity had left the effects landscape changed but not unrecognizable: there were, still, plenty of routes to choose from on the road to the screen.

11

THE MODERN ENTERTAINMENT MARKETPLACE, 2000-PRESENT:
Editing Meraj Dhir

For much of its history the rules of traditional Hollywood filmmaking have exalted editing that is seamless to the point of invisibility, deepening the viewer's immersion in the story without calling attention to the existence of any cuts. Over the past two decades, one sees much discussion in the trade press, popular film criticism, and even film studies scholarship bemoaning the loss of traditional craft practices in mainstream filmmaking in favor of an editing style designed to shock and awe the spectator. Critics of contemporary genre films lament that these films sacrifice spatial coherence in favor of a fragmentary sampling of some larger spectacle.[1] For some writers, this trend toward a quickened editing tempo and transgression of continuity norms signifies that contemporary editing practices constitute a significant break with filmmaking of the past. They charge that heightened rhythmic patterning and fracturing of shot-to-shot relations are privileged over the traditional subservience of editing to plot and character construction.

The views of such film scholars are echoed in the shoptalk of film editors themselves. Over the past decade, *Cinemaeditor*, the official journal of the American Cinema Editors (ACE), has presented several special roundtable discussions,

with titles such as "The Normal Rules Do Not Apply: The Evolution of MTV's Editing Style and Its Impact on Society," as an opportunity for film editors to take stock of the influence of music videos and commercials on the hyperkinetic pace of contemporary film editing.[2] Writing in the Summer 2010 edition of the journal, Edgar Burcksen, the editor-in-chief at the time, posits the possibility of wide-scale cultural shifts in viewing habits as driving what is sometimes termed the "ADHD" style of contemporary film editing: "The short attention span of today's executives is of course just a sign of the times where it seems that we have to supply the audience with a constant barrage of audio visual impulses at the danger of losing their interest because for the generation of multi-taskers there are so many other influences that vie for their attention, that the patience to let something play out is almost absent."[3]

Burcksen argues that the ubiquitous proliferation of smartphones and iPods and the practice of constantly "texting" and "twittering" have displaced the immersive reading habits that cultivated sustained attention spans. He concisely summarizes two of mainstream cinema's most important stylistic trends, the constantly moving camera and shorter cutting rates, when he writes:

There needs to be movement, and if not, there needs to be a cut. It's a little bit more forgiving in a theater where the big screen and the darkness keeps [*sic*] the audience focused for a longer time because no cell phones are allowed. . . . So we intensify the viewing experience by shortening our edits and if the edits don't supply the necessary stimuli, then the camera helps out by using handheld wobbly shots: instant audiovisual gratification without much brain activity.[4]

Some critics argue that the development of particular technologies are to blame, and that nonlinear, digitally based editing technologies such as AVID and Final Cut Pro—with the unprecedented facility they offer in storing infinite versions of a scene—also encourage a certain mindlessness and lack of forethought in postproduction.[5]

As *Variety* critic Justin Chang has observed, when Christopher Rouse won the Academy Award for Best Editing for *The Bourne Ultimatum* (2007), a film especially exemplary of this shift toward more hyperkinetic editing and fragmentary image construction, it could be read as a "significant institutional endorsement" of a vanguard style.[6] And yet a wariness concerning the excesses of this kind of editing pervades the many criticisms voiced above. Certainly one finds that many traditional genres often classified under the "prestige" label—especially those dominating awards season—still exemplify the self-effacing, unobtrusive principles of textbook classical construction. As Joel Cox, editor of nearly thirty films for Clint Eastwood, asserts: a great cut is a "cut you didn't see."[7] Indeed, point-of-view structures, analytical

editing, shot-reverse-shot schema, eyeline matching, crosscutting, and montage sequences remain central components in the toolkit of contemporary Hollywood editing, across *all* genres.

So why, then, do commentators believe that today's films look and feel so different from their predecessors of even a decade ago? Has editing undergone a fundamental change during this time period, or have we witnessed a less dramatic but still noticeable modification of editing norms? And what are the ramifications of the changes that have occurred? In order to answer these questions with some precision, I propose that we start by concentrating on two types of proximate forces—craft practices and technological developments—to help mount compelling causal explanations for the stylistic change that these shifting editing patterns typify. Certainly, the primary thrust of this chapter is aesthetic, but, as will become clear, the manner in which editors respond to technological and industrial forces translates into discernible craft practices. Accordingly, much of what follows details how the craft of editing has developed over the last fifteen or so years, both through comments by the editors themselves and analysis of representative sequences from a variety of films. Specifically, I examine how considerations of genre and shifting hierarchies of motivation and authorial expression influence and mold editing strategies, strategies that are themselves bounded and sometimes encouraged by technological and industrial developments.

Technological Change, Editing Tendencies

New technological developments in the past two decades such as video assist have given filmmakers small screens for viewing their work while shooting. We might speculate that this in turn has influenced staging and framing practices, promoting closer framing because long-scale shots register with less impact on small screens. Moreover, the expansive market for movies on television, and, more recently, online and on-demand viewing, has further increased the importance of framing for smaller and more intimate, nontheatrical contexts. The cusp of the past century also saw the universal adoption of digital, nonlinear editing systems, and these technologies have quite profoundly changed the workflow for film editors, not least of which is an exponential acceleration of the editing process and pronounced ease in the cutting and joining of shots. With such systems making cuts and optical effects as fast as tapping a key, editors can not only make cuts quickly, but they can experiment and propose many different editing possibilities for the same scene simultaneously, encouraging broader experimentation.

At the same time, the proliferation of lightweight, digital cameras has given filmmakers the ability to more easily move and experiment with different

camera angles and movements; such mobility during shooting, in turn, makes it more economical and easier to cover action from multiple angles simultaneously, leading to a change in the way filmmakers approach the issue of coverage. "Shooting for coverage" names a set of procedures through which the director and cinematographer shoot the dramatic action. According to a time-honored process, the director will begin by first blocking and then shooting a "master-shot" or long-scale shot as the entire scene is performed. Next, the director will reshoot details of the scene from different, usually closer, angles, ensuring continuity is maintained every time the scene is played out. This method of obtaining coverage is keyed to the classical continuity practice of analytical editing or decoupage, in which the editor assembles the film so as to maintain continuous and clear narrative action. Multi-camera shooting is an outgrowth of the need to shoot fast and still have a range of choices in the editing room. The practice escalated in the 1960s, as directors such as Sidney Lumet and Arthur Penn entered film from live television. And steadily, with the introduction of a generation of lighter, less expensive cameras, and more recently, cheaper digital cameras, shooting with multiple cameras to save production time has become the norm. In an interview about *Body of Lies* (2008), director Ridley Scott suggests that both shooting speed and a sense of immediacy are two of the chief benefits of multi-camera shooting: "I like to move really fast, as fast as possible because that's when you feel you're really alive. It's my job to keep the actors just slightly off-balance because then they're all paying attention and it really feels spontaneous and energized."[8]

One can note how the cutting of action scenes has been influenced by the popularization of multiple-camera shooting by contrasting the differing treatments of the same scene from a 1950s Hollywood film and its remake. Both versions of *3:10 to Yuma* feature a stagecoach hold-up, but in the 1957 original, the scene is treated almost laconically, in several alternating long to medium-scale shots, with only one close-up (see figures 22 and 23).

The hold-up is staged as a simple standoff. We receive a POV tracking shot through the eyes of the coach driver, revealing he is clearly outnumbered, and so he sensibly raises his arms in surrender. This accentuates the sense of powerlessness and defeat felt by all who fall victim to the robbers. The remake from 2007 stages the hold-up as a highly dynamic set piece. Indeed, the very introduction of the stagecoach itself is markedly different in the remake: before we have an overall view of the coach we receive several tight, tracking close-ups of its component parts as it hurtles toward its destination, plumes of dust rising all around. This succession of tight, fragmentary shots livens the rhythm and the sense of action at the film's introduction.

While the original film enlists several moving shots with the camera mounted to the stagecoach, in the remake nearly every cut is made from a tracking, arcing, or pivoting camera, and every new character is introduced by cutting to

FIGURES 22 & 23: The hold-up is constructed out of long-scale shots joined by clear eyelines in the original version of *3:10 to Yuma* (1957).

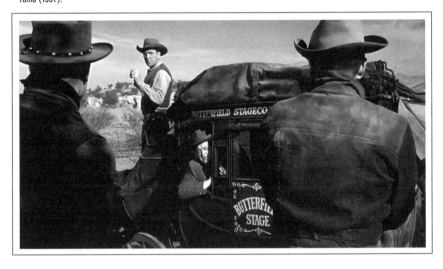

an intensifying push-in. Thus, there is a greater sense that shots are constantly interrupting one another rather than actively constructing and stitching together cinematic space. Another addition in the latter film is the use of subjective POV shots in tandem with aperture framings, which increase the spectator's sense of being viscerally situated in the midst of the action onscreen (see color plate 14). This impulse to engage the spectator kinetically is a central element of what Geoff King calls the "impact aesthetic" of contemporary action film editing.[9] Here, thrusts toward the camera, "concentration," axial cutting, a rapid editing pace, and immersive POV shots—all resources admittedly found in classical Hollywood filmmaking—are elevated to preferred status and employed to an almost exaggerated degree.

Editing and Genre: The Musical

We can examine the historical evolution of a genre such as the musical, where choreography and exact staging are essential components, to further elucidate the change in editing practices wrought by multi-camera filming. In a special roundtable discussion entitled "The Art of Editing and Musicals," Antony Gibbs explains that for films that he edited such as *Fiddler on the Roof* (1971) and *Jesus Christ Superstar* (1973), the choreography for musical numbers was carefully planned out in advance of shooting, with an eye toward the eventual shot breakdown. First the dance choreographer and cinematographer would block out the salient part of each musical number with the objective of obtaining a "real master, *master* camera. . . . It's almost single camera work but with some ancillary ones to help them along."[10] And Gibbs indicates how this pre-production organization could simplify the editor's workflow: "There might be a particular piece of choreography that has to have its own camera just for those few bars, so it will be set up for that. That makes the editing fairly easy, because when you arrive at that spot you just drop it in from your guide track."[11]

Gibbs implicates multi-camera shooting and new technologies for burdening contemporary editors with an overwhelming amount of footage to choose from, and he expresses a preference for more traditionally precise choreography requiring less cutting:

> Particularly now with musicals like *Chicago* (2002) and *Moulin Rouge!* (2001) there is enormous coverage. They've shot so much footage they can sit and play with it. They may have not started off with such a hard and fast rule like with the old fashioned numbers. They can sit at the Avid and say, "Well it could go this way or that way." The two most effective numbers I have ever seen in Musicals [*sic*] are when Gene Kelly and Leslie Caron sing 'Our Love Is Here to Stay' from *An American in Paris* (1951) and the song 'I'm Just a Lonesome Hound Dog' from *Seven Brides for Seven Brothers* (1954). There are no cuts at all in either of those songs. They've been so perfectly blocked [for the camera], so perfectly visualized and translated by the actors and the music they are perfection in themselves. I just look at them and say, "Why do we mess around?"[12]

With average shot lengths (ASLs) of 2 and 2.8 seconds, respectively, *Moulin Rouge!* and *Chicago* are evidence that contemporary musicals feature some of the most accelerated editing found in mainstream cinema. And both films received strong industry recognition for film editing, with the former receiving an Eddie and an Oscar nomination, and Martin Walsh receiving the Academy Award for Best Editing for *Chicago*. Again, multi-camera coverage shooting helps explain the rapid editing and also a certain loss of editorial and choreographic precision

in both films. The special features of the DVD version of Baz Luhrmann's film, edited by Jil Bilcock, allows at-home viewers to stream and "edit" views from the four simultaneously running cameras that were used to shoot many of the film's dance numbers. Such multi-camera shooting reveals, however, that while editors may theoretically have more creative "choices" in the editing room, there is a greater contingency involved in the expectation that such multi-camera coverage will provide the editor with the materials required to make compositionally and artistically motivated editing decisions. (This problem extends to films of all genres, as John Mathieson, the director of photography of *Gladiator* [2000], for example, explained when shooting dialogue scenes with seven cameras: "I was thinking. Someone has got to be getting something good.")[13] But instead of leading to a greater degree of creative variety, especially in genres as loose with verisimilitude as the musical, the practice of multi-camera shooting actually constricts editing practices.

Examining *Chicago* more closely, we find that the film follows a highly programmatic strategy of alternating between the staged musical numbers and the dramatic action sequences, both shot using multiple-camera coverage. Since all the musical numbers are staged as theatrical performances, the camerawork and compositions are bound to remain on one side of the "proscenium arch." And since the cameras have to be placed out of one another's view, the staging of the actors in the film's dramatic scenes remains fairly static and rigid so as not to provoke unnecessary camera movements (see color plate 15). Moreover, the editing of the dance/song numbers merely shifts shot-scale rather than providing any truly fresh perspectives on the action, as fast cutting is used instead to enliven otherwise ordinary choreography.

As a genre, the musical does allow for more narratively obtrusive forms of editing. The interweaving of the musical numbers and the dramatic story arc operates as counterpoint, as songs provide exposition or reveal character subjectivity. The character Mama, played by Queen Latifah, sings the number "Mama's Good to You," as we learn of her role as a corrupt prison warden. And editing that alternates between musical numbers and the dramatic plotline leads to other more abstract formal relations, as when Richard Gere's tap dance number, intercut with the trial, works as a sort of rhythmic barometer whose rising crescendo underscores his success at cross-examining Velma. The conventions of the musical allow for frequent deviations from verisimilitude: self-conscious shot transitions such as superimpositions and wipes are used frequently throughout the film. Nevertheless, *Chicago* is a far more conventional film than the works of Bob Fosse, from which it supposedly takes much of its inspiration. Fosse's *Sweet Charity* (1969; Stuart Gilmore, editor) and *All That Jazz* (1979; Alan Heim, editor), in comparison, were heavily influenced by European art cinema figures such as Federico Fellini (the former film is an adaptation of the director's *The Nights of Cabiria*, from 1957), and produced under the sway of the so-called

New Hollywood. Accordingly, they incorporate editing strategies that heighten narrative ambiguity and character subjectivity in ways that make *Chicago* seem formally conservative in comparison.

Accelerated Cutting Rates and Craft Specialization

Contemporary films are cut faster than at any point in the history of Hollywood. The taste for adrenalized visuals as well as changes in filmmaking practice and various technological innovations have contributed to the steady acceleration of ASLs over the past few decades. If we go back to the silent era, we find that films were cut quite fast, with many films from the 1920s having an ASL of 4 to 6 seconds. With the advent of bulky sound recording equipment at the end of the decade, cutting rates decelerated. Most films were constructed out of anywhere from 300 to 700 shots, and between the 1930s and 1960s we find that ASLs hover at around 8 to 10 seconds. Not until the 1960s do filmmakers significantly begin accelerating their cutting rates, with ASLs dropping to 6 to 8 seconds in most films, and several films falling far below the norm, such as *Goldfinger* (1964; Peter Hunt, editor), with an ASL of 4 seconds, and *Bonnie and Clyde* (1967; Dede Allen, editor), at 3.6 seconds. By the 1980s, double-digit ASLs disappeared from mass cinema and we find many genre films with ASLs below 4 seconds.[14] Today's films can use well over 2,000 shots, with ASLs between 3 and 6 seconds, regardless of genre, though one finds a few conspicuous outliers such as *Cloverfield* (2008; Kevin Stitt, editor), with an ASL of 29 seconds, and *Gravity* (2013; Alfonso Cuarón and Mark Sanger, editors), with an ASL of 29.2 seconds, and some films such as *The Bourne Ultimatum* (2007) with an ASL of 1.9 seconds below the norm. Table 1 shows the ASLs of forty films across the past thirteen years.[15]

The ASLs from this table roughly conform to the 3- to 6-second range, with only a few outside the norm, as noted above. We can also use this information to comment on several other trends. Many editors repeatedly work with the same directors, as can be seen from the frequent Andrew Weisblum/Wes Anderson, Michael Kahn/Steven Spielberg, Angus Wall/David Fincher, Thelma Schoonmaker/Martin Scorsese, Leslie Jones/Paul Thomas Anderson, Lee Smith/Christopher Nolan collaborations. While generic norms clearly affect editing pace, directorial or authorial control seems to override generic requirements. For example, all of Spielberg's films over the last decade, whether we look at the sci-fi actioner *Minority Report* (2002) or the historical drama *War Horse* (2011), hover around 6 seconds. So, too, does Steven Soderbergh's ASL remain remarkably consistent from film to film, regardless of genre: the director's dramatic thrillers such as *Ocean's Eleven* (2001; Stephen Mirrione), with an ASL of 5.8 seconds, and *Contagion* (2011) both have around the same ASL as the director's brazen foray into the action-film genre, *Haywire*, which he also edited (2011; ASL of 6.5

TABLE 1: ASLs of American Films, 2001-13

TITLE	ASL	EDITOR	DIRECTOR
The Bourne Ultimatum (2007)	1.9	Christopher Rouse	Paul Greengrass
Quantum of Solace (2007)	2	Matt Chesse and Richard Pearson	Marc Forster
Moulin Rouge! (2001)	2.1	Jill Bilcock	Baz Luhrmann
Unstoppable (2010)	2.1	Robert Duffy and Chris Lebenzon	Tony Scott
The Bourne Supremacy (2004)	2.2	Richard Pearson and Christopher Rouse	Paul Greengrass
The Expendables 2 (2012)	2.2	Todd E. Miller	Simon West
End of Watch (2012)	2.3	Dody Dorn	David Ayer
Man on Fire (2004)	2.5	Christian Wagner	Tony Scott
Resident Evil: Extinction (2007)	2.6	Niven Howie	Russell Mulcahy
Chicago (2002)	2.9	Martin Walsh	Rob Marshall
Batman Begins (2005)	3	Lee Smith	Christopher Nolan
Inception (2010)	3	Lee Smith	Christopher Nolan
Insidious (2010)	3.2	Kirk M. Morri	James Wan
The Prestige (2006)	3.3	Lee Smith	Christopher Nolan
3.10 to Yuma (2007)	3.3	Michael McCusker	James Mangold
Wreck-It Ralph (2012)	3.3	Tim Mertens	Rich Moore
The Departed (2006)	3.4	Thelma Schoonmaker	Martin Scorsese
Transformers 2: Revenge of the Fallen (2009)	3.4	Roger Barton, Tom Muldoon, Joel Negron, and Paul Rubell	Michael Bay
Skyfall (2012)	3.5	Stuart Baird	Sam Mendes
The Avengers (2012)	3.5	Jeffrey Ford and Lisa Lassek	Joss Whedon
The Girl with the Dragon Tattoo (2011)	3.7	Angus Wall and Kirk Baxter	David Fincher
The Bourne Identity (2002)	3.8	Saar Klein	Doug Liman
Wall-E (2008)	4	Stephen Schaffer	Andrew Stanton
Avatar (2009)	4.2	James Cameron, John Refoua, and Stephen E. Rivkin	James Cameron

TITLE	ASL	EDITOR	DIRECTOR
Casino Royale (2006)	4.5	Stuart Baird	Martin Campbell
American Gangster (2007)	4.5	Pietro Scalia	Ridley Scott
Zodiac (2007)	5	Angus Wall	David Fincher
Ocean's Eleven (2001)	5.8	Stephen Mirrione	Steven Soderbergh
Moonrise Kingdom (2012)	6	Andrew Weisblum	Wes Anderson
August: Osage County (2013)	6	Stephen Mirrione	John Wells
Minority Report (2002)	6.5	Michael Kahn	Steven Spielberg
Contagion (2011)	6.5	Stephen Mirrione	Steven Soderbergh
War Horse (2011)	6.5	Michael Kahn	Steven Spielberg
War of the Worlds (2005)	6.7	Michael Kahn	Steven Spielberg
The Ghost Writer (2010)	6.7	Hervé de Luze	Roman Polanski
Life of Pi (2012)	7	Tim Squyres	Ang Lee
Punch-Drunk Love (2002)	9	Leslie Jones	Paul Thomas Anderson
There Will Be Blood (2007)	13	Dylan Tichenor	Paul Thomas Anderson
The Master (2012)	14.5	Leslie Jones	Paul Thomas Anderson
Cloverfield (2008)	29	Kevin Stitt	Matt Reeves

Source: Average shot lengths calculated manually by the author.

seconds). And the Indie art-film auteur Paul Thomas Anderson is the only director from this sample to consistently feature average shot lengths over 10 seconds, although both Woody Allen and M. Night Shyamalan also frequently shoot films with ASLs well above 10 seconds. Accordingly, we can speak of something such as "authorial norms" in terms of editing pace. As expected, and despite the strong influence of a few select auteurs, action films maintain a heightened pace, with ASLs of between 2 and 4 seconds.

A significant trend characterizing the division of editorial labor in contemporary Hollywood is that editors consistently work in particular genres and specialize in certain skill sets. Competition for a limited number of jobs can encourage niche specialization and conspicuous prowess. Cultivating qualities such as efficiency and craftsmanship, but also specialization and technical and aesthetic virtuosity, can help editors secure prestigious and well-paying assignments. For example, when actor/director Jon Favreau was hired by Paramount and Marvel Studios to direct the first installment of *Iron Man* (2008), he brought along film editor Dan Lebental, with whom he had worked previously on *Elf*

(2003) and *Zathura: A Space Adventure* (2005). But after Lebental delivered a first cut to the studio, veteran action editor Michael Tronick, whose credits include Tony Scott's *Days of Thunder* (1990) and the Arnold Schwarzenegger vehicle *Eraser* (1996), was brought in to assist with the cut and the visual effects turnovers.[16] For *Iron Man 2*, a film with a much larger budget and bigger expectations than its predecessor, Lebental shared coediting credits with veteran action editor Richard Pearson, who had worked on *Men in Black II* (2002) and *The Bourne Supremacy* (2004). Of Pearson, Lebental has said: "Rick saved me. *Iron Man 2* is one of the highest expectation films of this year. The fact that he could come on and really bring it . . . he just really brought it. And I think people will find that the action in *Iron Man 2* is better than the action in *Iron Man*."[17] When director Timur Bekmambetov cited the frenetic editing of the *Bourne* franchise as exemplary of the look he wanted to obtain for his first American studio feature, *Wanted* (2008), an additional editor, Dallas Puett, who previously edited *The Fast and the Furious: Tokyo Drift* (2006) and *Lara Croft: Tomb Raider* (2001), was brought on for her specific expertise in editing action sequences.[18]

But editing specialization need not be restricted to the action genre. Patrick McMahon, editor on *A Nightmare on Elm Street* (1984) and *It's Alive* (2008), noted the greater creative opportunities found in editing horror movies in an interview regarding his work on John Carpenter's *The Ward* (2010): "You start approaching things differently. This is a very exciting genre to edit for that reason. You're creating your own reality. Each film lives within its own reality so you can try anything."[19] And before editing Paul Thomas Anderson's *There Will Be Blood* (2007), Dylan Tichenor had come off a run of revisionist westerns such as *Brokeback Mountain* (2005) and *The Assassination of Jesse James by the Coward Robert Ford* (2007). The distinctive skillsets of certain directors increases the possibility of labor mobility, facilitated by the package-unit system of contemporary Hollywood filmmaking. Editors not only migrate to projects that their favored directors are helming; they also become entrusted personnel for franchises in which studios have invested significant capital, as the next section explores.

Bond and Intensified Continuity

The James Bond franchise possesses a longevity that few film series can boast: it has been a strong box-office performer for over fifty years. It stands as a particularly compelling example of how filmmaking can reinvent itself in light of developing trends and changing tastes, as the franchise has been rebooted on numerous occasions, replacing lead actors and shifting stylistic gears with alacrity. The most recent Bond entries offer a compelling example of how contemporary action-film editing tendencies can coexist with continuity principles; they also reveal the significance of the editor's contribution to contemporary

film's deployment of cutting, in this case, the veteran editor Stuart Baird, whose film credits date back to collaborations with Ken Russell in the mid-1970s. In his work, we can see how contemporary editing can produce faster rhythms without totally sacrificing previously established formal norms. Baird's work helps to confirm David Bordwell's thesis that recent decades have witnessed a move toward what he calls "intensified continuity," wherein quicker cutting rates and a heavier reliance on closer framing render "even ordinary scenes [an urgency designed] to compel attention and sharpen emotional resonance."[20] And yet, Bordwell claims, contemporary films are still "staged, shot, and cut according to principles which crystallized in the 1910s and 1920s. Intensified continuity constitutes a selection and elaboration of options already on the classical filmmaking menu."[21] Baird's contributions to two of the three most recent installments of the Bond franchise reinforce the importance of the editor to a film's narrative coherence while also demonstrating the efficacy of Bordwell's concept.

After the critical failure of *Quantum of Solace* (2008), Baird, who had edited the much-lauded *Casino Royale* (2006), was brought back to pair with fellow countryman Sam Mendes on *Skyfall* (2012). Baird's work on *Casino Royale* reveals how quickly edited action can enhance the kinaesthetic impact on the viewer while still maintaining spatial continuity. In the film's first chase, each shot is cut at the high point of an action, and precise matching on action reinforces the directional current of dynamic onscreen movements. We see Bond leap from a ledge, followed by a centered shot of him landing on the ground and rolling, and the next shot has him burst into the middle of the frame as he finds his bearings. Here Baird uses a type of constructive editing to give the viewer the impression of a continuous action and an impressive physical feat that never actually took place.

Baird's editing displays how the conventions of continuity editing can be used to heighten visceral affect and nonetheless coherently render the film's action. Instead of covering the action from many different angles and then constructing the film in the editing room, the editing approach of *Casino Royale* depends on shots that are carefully designed with an eye for how they will be cut together, making each shot transition that much smoother. As demonstrated above, a movement in one shot is "picked up" in the next, either through a match-on-action or a similarly thrusting current of motion that continues the same screen direction. Baird's editing also displays another important tendency of intensified continuity principles: enlisted to produce the clear depiction of onscreen action, they can also influence other facets of film style. When shots are present for such brief instants onscreen, they must be compositionally distinct and centered so that viewers can comprehend the content of each shot clearly (see figures 24, 25, and 26). In *Casino Royale,* director Martin Campbell often uses internal aperture framing so that the impact of a particular shot is doubly framed and remains highly legible. In the initial chase scene, Campbell shoots characters framed through metal beams on a construction site to focus our attention.

FIGURES 24, 25 & 26: Constructive editing principles are used to render an impressive action feat in *Casino Royale* (2006).

Indeed, this conception of the frame in geometric terms facilitates the viewer's clear comprehension of rapidly passing images, while the treatment of movement further aids in reducing confusion. While the fight on the large moving crane is rendered with mostly close-ups and medium scale shots, the editing frequently switches to smoothly moving long-scale shots that provide the viewer with a

comprehensive view of the fight. Note, as well, that a compositional movement, such as a figure running, will continue in an oblique or perpendicular direction to the frame as Bond hurls forward through the shot and a series of matched cuts carries his movement from back to foreground; additionally, editing and framing combine to have beams, vehicles, and other elements move at increasingly dynamic angles while always being compositionally centered. Moreover, at a more abstract or graphic level, this concatenation of diagonal or oblique motion, repeated across the film's editing, compounds the sense of visual dynamism. Baird's smooth and assured use of continuity principles demonstrates that action film editing need not be abrasive or intentionally disjunctive in order to be visually impactful.

Baird's expertise would prove crucial when the producers of *Skyfall* took the risk of employing Sam Mendes, a director known mostly for dramatic and independent filmmaking, such as *American Beauty* and *Revolutionary Road*. (This move seemed all the more risky because the unorthodox choice of Marc Forster for *Casino Royale*'s successor, *Quantum of Solace,* resulted in considerable critical derision and fan displeasure.) To offset that risk, the producers paired Mendes with two world-class industry professionals: nine-time Academy Award nominee Roger Deakins, the film's cinematographer, arguably the most sophisticated and experienced director of photography working today, and Baird. The latter's approach to editing *Skyfall* is highly indicative of his respect for the traditional norms of continuity editing practices and the Hollywood editing ideal of invisible artistry.

Baird's interview with *Cinemaeditor* reveals several crucial facts about his editing process. First, he reinforces the contemporary practice of modulating the rhythm and tone of a film through the idea of an overall stylistic arc or "expressive program." This is reflected in his thinking about the film in terms of different types of generic "beats." He says: "We have a big action beat at the beginning and another big one at the end. The nature of the sequences determines the need for visual effects but also the tidying up [of shots] after the fact."[22] The two big action sequences that bookend the film contribute to its low but normative ASL of 3.5, even while the film's various dialogue sequences are cut much slower.

Second, Baird reasserts the ideal of unobtrusive, invisible artistry, and this is affirmed in the following section of the interview where he says: "I hope it won't look like a heavy effects show. The goal is to be invisible." Reflecting on the editor's remarks, interviewer Matthew Klekner asserts: "Film editing is often referred to as the 'invisible art' and Baird has obviously taken this to heart. A good editor is not one that calls attention to himself, or to his edit, but rather is someone at the service of the story." And Baird reemphasizes this when he says: "Everything is story for me, even inside the action." He also reveals that Mendes's directorial style centered on performance and that the director lacked experience in directing action sequences: "Sam is a theater

director so everything he does is about performance—it's not kinetic, it's very classical. He's comfortable with the actors and getting the performances. The material was new to him, the action scenes are very complicated and it took intricate planning to get them right."[23] In the interview he blames digital editing machines for encouraging editors to cut faster, alternating too quickly and without sufficient motivation among the choices offered by the extensive coverage that today's shooting methods provide.

Finally, Baird disparages filmmakers who attempt to mimic the *Bourne* franchise style of "hyper-kinetic" editing. He says: "Chris Rouse is a friend of mine, and he's a very fine editor, and if Chris cuts it, it tends to work, but I don't think it works the same way in everybody's hands. You have to have a certain skill and sensibility for it. It isn't my style. I've done many action pictures over the years and I was known for fast cutting but, once again, my cutting was always based on storytelling. Some of these pictures that have the *Bourne Identity* style, not so much the *Bourne* pictures themselves, but some of the other pictures that try to mimic them. . . . Let's just say it isn't my taste."[24] Here Baird could easily be speaking of *Quantum of Solace* and the comparisons between it and *Bourne* made in the critical press. His remarks also suggest that editors think of their work and that of their peers in terms of authorial style. Baird's work on both the Bond films proves that the "cinema of chaos" actually contains within it much that still borrows from traditional cinematic storytelling.

Editing into the Future

Based on our knowledge of film history and analysis, can we make any predictions about future trends in mainstream film editing? It is unlikely that the underlying principles informing classical continuity editing in mainstream cinema are likely to change in any radical or fundamental way. The norms of continuity editing have proven to be remarkably resilient, and while the techniques developed to support them have undergone some changes, overall we can observe remarkable consistency. These techniques are so efficient that they constitute the basis for directing audience attention and telling stories in most filmed narratives, even in animated films, where there is no inherent need to utilize analytical editing at all. Animated films could organize spatial and temporal relations in a myriad of other ways including long takes, but so far continuity editing prevails.

As the worlds of animated and live-action films converge, mise-en-scène and how it is shaped through editing will achieve ever greater degrees of plasticity. Technologies such as rotoscoping, which allow filmmakers to stitch together different parts of a performance into a single take, eliminate the need to cut between different takes—they may even elide the need to cut altogether. Recently such technologies were used in *Gravity* to merge the performances of the actors into

photorealistic long-take CGI sequences. In *Birdman* (2014; Douglas Crise and Stephen Mirrione, editors), rotoscoping technology was used to "stitch" together over 100 different parts of performances into what appeared in the film as seamless long takes.[25] As such technologies become cheaper and faster we can be assured that they will make a significant impact on how films are edited in the future. Nevertheless, "traditionalists" such as Paul Thomas Anderson, Sam Mendes, and Christopher Nolan insist on the almost Bazinian authenticity achieved through maintaining the coherence of the shot.[26] In her approach to working on Anderson's *The Master* (2012), editor Leslie Jones relays, "In editing you spend so much time on a typical movie manufacturing performances using different takes, using a sentence from here and a sentence from there, and [Anderson] doesn't do that. His performances are already there. You can play out a whole take and you're completely sucked in. If you have to manufacture something then for him it's not authentic."[27] It is ironic, then, that at a moment when cinema once again is seeking to distinguish itself from other media, that both approaches—the "manufactured" effacement of the cut found in effects-laden films such as *Gravity* and *Birdman,* and the resistance to cutting found in *The Master*—may, in the end, appear indistinguishable.[28]

12

THE MODERN ENTERTAINMENT MARKETPLACE, 2000–PRESENT:
Special/Visual Effects Tanine Allison

Visual effects in the twenty-first century continued the shift toward digital imaging that started in the 1980s and reached mainstream attention in the 1990s with high-profile films such as *Jurassic Park* (Steven Spielberg, 1993) and *Titanic* (James Cameron, 1997). Although some films in this period were conspicuous in advancing and celebrating nondigital effects—most visibly, perhaps, the stop-motion animation in films like *Chicken Run* (Peter Lord and Nick Park, 2000), *Corpse Bride* (Mike Johnson and Tim Burton, 2005), and *Coraline* (Henry Selick, 2009)—even these films typically were aided by digital techniques. Indeed, filmmaking in the last decade and a half has been characterized by the ubiquity of computer-generated visual effects and the profusion of digital technologies into all parts of the industry. In the 1990s, digital visual effects shots in any given "effects-driven" Hollywood film might number in the dozens, but since the turn of the millennium, it is common for hundreds or even thousands of shots to be altered by digital effects.[1] Moreover, the accelerated adoption of techniques including the Digital Intermediate (DI), nonlinear editing, and digital color grading means that all or nearly all of a film might be modified in postproduction, challenging how we conceptualize visual effects in the first place.

Since 2000, visual effects have gained prominence not only through the progressive innovation of digital technologies, but also through the predominant business paradigm of Hollywood. Seduced by the profits promised by "tent-pole" films, studios now routinely spend $100 million or more on high-concept "event" pictures in the hopes of grossing $1 billion worldwide. To mitigate risk, studios invest in "presold" properties, such as bestsellers or sequels, that bring in pre-existing fan bases and appeal to global audiences. Beneficiaries of this strategy have included the fantasy and science fiction genres and, most recently, the comic book-derived superhero film. Visual effects are largely responsible for creating the magical worlds and imaginary creatures that bring these fantastic scenarios to life, and therefore they are a key component to the current industrial landscape.

Tino Balio writes in *Hollywood in the New Millennium* that the acquisition of movie studios by multinational media conglomerates has motivated the creation of "more and bigger franchises that are instantly recognizable and exploitable across all platforms and all divisions of the company."[2] A list of these franchises is nearly identical to a list of the most prominent visual-effects films since the turn of the millennium (including the *Star Wars* saga, the *Matrix* trilogy, the *X-Men* films, the *Harry Potter* series, the *Lord of the Rings* films, and the Marvel *Avengers* series). Other properties have been the recipients of multiple franchise "reboots" in a decade or less, including *Planet of the Apes* (2001 and 2011), *Spider-Man* (2002 and 2012), *The Incredible Hulk* (2003 and 2008), and *Superman* (2008 and 2013). Of the thirty highest grossing films worldwide, twenty-five of them are part of current or planned franchises.[3] Setting aside the animated films (a distinction that has less and less meaning nowadays), nearly all of them can be considered "effects driven."

Looking back over the last twenty years, George Lucas's second trilogy of *Star Wars* films, starting with 1999's *Star Wars: Episode I—The Phantom Menace* (George Lucas), stands out as an early exemplar of the move toward extreme and ever-growing media franchises. These films also represent the effort to maximize the use of computers in all aspects of filmmaking, including the very first digital projection of a full-length narrative film.[4] Although Lucas was not able to shoot all of *The Phantom Menace* on digital video, as he had originally hoped, by the second film, *Star Wars: Episode II—Attack of the Clones* (2002), Lucas had a custom-built HD camera, Sony's CineAlta HDW-F900. To complement these cameras, the films embraced the "digital backlot," in which actors are filmed performing scenes against a bluescreen or greenscreen and inserted later into computer-generated settings. Backgrounds, props, and even scene partners, such as Jar Jar Binks and Yoda, were created digitally by Industrial Light and Magic (ILM), using a full slate of state-of-the-art software, including Softimage, Maya, and RenderMan. Although parts of the films were shot on location in Italy, Spain, and Tunisia and many settings were constructed with miniature models, almost every shot of *The Phantom Menace* and the subsequent sequels involved

some amount of digital adjustment. Following common practice, Lucas's team numbered the effects shots in *The Phantom Menace* before they were sent to ILM and additional effects houses—in this case, there were nearly 2,000—but, in fact, they numbered every single shot in the movie because they predicted that all would be digitally manipulated in some way before being scanned back onto film for distribution.[5]

A number of other films followed suit in adopting the digital backlot in the years following *The Phantom Menace*. One of the first U.S. films to gain mainstream attention for its espousal of bluescreen filming was *Sky Captain and the World of Tomorrow* (Kerry Conran, 2004). Director Conran built no practical sets for the film, instead relying entirely on minimal bluescreen soundstages at Elstree Studios in England (see figure 27). After 2D storyboards and 3D animatics, principal photography comprised a busy six weeks before moving on to 3D animation and final compositing. The computer-generated settings were designed to mimic the black-and-white photography and visual style of 1930s serials; some backgrounds were created from old photographs.[6] Subsequent films to exploit the digital backlot also adopted extremely stylized imagery to evoke other media forms. *Sin City* (Frank Miller and Robert Rodriguez, 2005), *300* (Zach Snyder, 2006), and *Speed Racer* (Andy and Larry Wachowski, 2008) all invented exaggerated CG settings to emulate the comic-book aesthetics of graphic novels or anime.

The *Lord of the Rings* films, beginning with 2001's *The Lord of the Rings: The Fellowship of the Ring*, departed from this trend of creating all-digital environments; instead, they emphasized real locations and practical special effects, more in line with director Peter Jackson's early films that featured gore effects,

FIGURE 27: Actors performed on minimal bluescreen-covered sets, and backgrounds were replaced with computer-generated imagery, in *Sky Captain and the World of Tomorrow* (2004).

special-effects makeup, and puppets (*Bad Taste*, 1987; *Meet the Feebles*, 1989). The trilogy was shot back-to-back-to-back, utilizing a complex mix of actual locations (in Jackson's native New Zealand), practical sets, miniature models, and digital set extensions. Digital imaging technologies were still used extensively—particularly in compositing these disparate visuals together in a seamless fashion—but the filmmakers also reinvigorated older effects techniques, such as model-building and on-set special effects. Director Peter Jackson explained, "We wanted to create a feeling that we'd gone to Middle-Earth and were able to shoot on authentic locations. . . . The mantra of our design work became 'Make it real.'"[7]

To achieve this look, they attempted to create a real Middle-Earth in New Zealand (that one can now visit as a tourist). The construction of Hobbiton, Frodo Baggins's hometown, in Matamata, New Zealand, began more than a year before shooting started so that there would be enough time for the 5,000 cubic feet of grass, flowers, and vegetable gardens they planted to grow to the desired maturity.[8] Their emphasis on actual environments also extended to miniature models. Jackson's Weta Workshop built sixty-eight miniature environments for the trilogy, including the Elven city of Rivendell, the fortress of Isengard, and the Mines of Moria. They coined the term "bigatures" to describe these practical models because, despite their fractional scale, they were extremely large—Saruman's tower of Barad-dur, built at 1/166 scale, was still three stories tall. The production's commitment to model-building was such that the engineers made a number of technical innovations in the practice, including custom-built motion-control rigs, a novel smoke density sensor and controller, and an interface to match lighting changes with the movement of motion-control cameras. The production also minimized the use of digital matte paintings, preferring to create background plates made from still photographs of remarkable vistas around New Zealand.[9]

The production's commitment to practical effects led to the creation of 1,800 Orc suits padded out with foam latex, made complete with massive weapons and special-effects makeup.[10] However, the most significant application of digital imaging in *The Lord of the Rings* trilogy was in the creation of digital characters and fantastical creatures, including Orcs, Wargs, Trolls, Ents, and enormous spiders. It is in this arena that Jackson's digital effects arm, Weta Digital, made its revolutionary contributions. Although 1,800 extras in Orc costumes would be an impressive horde, Jackson envisioned in the Uruk-hai of Isengard tens of thousands of Orcs collected as a colossal army. Existing trick photography, digital compositing, or computer animation could not create for Jackson the appropriate mix of uniformity and individuality, creating a fairly indistinguishable mass of soldiers that would still look and move in a lifelike way.

Previous methods usually involved repetition of movements or a limited crowd repeated over and over, and this repetition often stood out as artificial. To combat this problem, Weta's Stephen Regelous developed a new software program called MASSIVE (an acronym for Multiple Agent Simulation System in

Virtual Environment), which employs a form of artificial intelligence based on fuzzy logic to create digital hordes, masses, and background characters that can number to the tens or hundreds of thousands. MASSIVE replaces the prohibitively labor-intensive process of animating 10,000 individual Orcs by hand with a system that programs individual "agents" to react to their environment and other agents; once given parameters and goals, the agents then "choose" among various options, drawing upon a vast library of movements, many created by motion capture. The result is an impressive multitude that mimics the unpredictability of crowds, lending greater perceptual realism.[11] MASSIVE has since spawned legions of robots in *I, Robot* (Alex Proyas, 2004), penguins in *Happy Feet* (George Miller, 2006), and zombies in *World War Z* (Marc Forster, 2013). With the ease of use and increasingly accessible price of MASSIVE and other programs, crowd simulation has become a standard, if not clichéd, aspect of spectacular effects in contemporary cinema.[12] In *The Lord of the Rings* films, MASSIVE's autonomously warring Orcs contributed to the franchise's signature visual style (color plate 16), which Dan North has named an "aesthetic of surplus."[13]

The Lord of the Rings trilogy also stands as a significant achievement in digital effects due to its pioneering approach to motion capture, particularly in its creation of Gollum. In *The Two Towers* (2002) and *The Return of the King* (2003), Jackson's team created Gollum—a slender, slimy, devolved Hobbit—as a digital model whose animation was driven by actor Andy Serkis's performance via motion capture. While motion-capture technology was first developed in the 1980s and was utilized in films like *Titanic* for the animation of digital doubles and background extras, Gollum, a major character with extensive interaction with the live-action characters, marks an audacious step forward. In the optical motion-capture system employed by *The Lord of the Rings* films, dozens of CCD (charge-coupled device) cameras track the movement of reflective dots attached to a performer, and specialized software interprets these dots as data that is then applied to a digital character. In the case of a nonhuman, stylized, and exaggerated character like Gollum, typical key frame animation was initially judged to be adequate (and it was used in *The Fellowship of the Ring* to create a brief scene with Gollum). But to accomplish their goal of creating "the most emotionally truthful, complex and interactive CG character that had been seen in a live action film,"[14] Jackson's team decided to apply the voice, movements, and visual appearance (for design reference) of the accomplished actor Serkis to the digital manifestation of Gollum.

The remarkable performance of Gollum was due to a combination of state-of-the-art strategies and techniques: first, a design team visualized the character and constructed the virtual model (based in part on Serkis's appearance); second, the actor provided pieces of the performance (in this case, voice, motion captured bodily movements, and visual references for the movement of the face and interaction with the other cast members); and finally, an animation team

implemented the motion-capture data and completed the performance with key frame animation. In addition to Serkis's impressive performance, credit for this believable character is also due to advances in character animation, such as the rigging of the digital model with a skeletal and muscular system as well as skin that appears to slide, stretch, and fold. Digital painting techniques also emulated the subsurface scattering of light under the skin, avoiding the blocky, painted appearance of characters from films like *Final Fantasy: The Spirits Within* (Hironobu Sakaguchi and Motonori Sakakibara, 2001). Since no facial performance data was captured from Andy Serkis (except for some reference footage), all of Gollum's face was created digitally using blend-shape animation, which uses a series of set facial poses to act as key frames and animates various blended poses in between. Facial animation was also adjusted with sixty-four controls for minute lip, brow, or nose movements.[15]

In the years following *The Lord of the Rings* trilogy, *King Kong* (Peter Jackson, 2005), *The Curious Case of Benjamin Button* (David Fincher, 2008), and *Avatar* further advanced the technology of motion capture to create perceptually realistic digital characters, particularly in the animation of their faces. For *King Kong*, Andy Serkis again played a major CG character—the gorilla-like Kong, arguably the protagonist of the film—via motion capture. To animate Kong, the production again used optical motion capture, and included facial capture this time; the combination of facial and body motion capture allowed for a more unified and consistent performance from the actor.[16] In contrast, *Avatar* and *Benjamin Button* employed performance-capture systems built specifically for faces and ultimately separated facial and bodily performances. For *Avatar*, instead of using optical tracking marks on faces, small cameras attached to head rigs captured minute facial expressions, which guided the facial animation process for the Na'vi. Inspired by Automated Dialogue Replacement (ADR), Cameron created a system called Facial Performance Replacement (FPR), which allowed the actors to redo their facial performances after the principal motion capture had been completed. Cameron explained that they were "uncoupling the facial performance from the physical performance, but in a way that the actors embraced. It actually freed them up to perfect their performance without having to worry about how they were jumping or rolling around."[17]

Unlike these films, which espoused motion capture to create imaginary, nonhuman characters, *The Curious Case of Benjamin Button* confronted the additional challenge of realistically animating a human face after previous attempts, such as *Final Fantasy* and *The Polar Express* (Robert Zemeckis, 2004), had been criticized for falling into the "uncanny valley."[18] *Benjamin Button* employed digital head replacements to create the impression that the title character is aging in reverse. Brad Pitt plays Button throughout the film, but his face is variously aged or "youthened"; the techniques employed for these processes varied from digitally enhanced age makeup to CG heads driven by motion capture. For the latter,

Pitt provided facial performances while being filmed by four video cameras; no tracking marks or specialized head rigs were necessary. Software then applied advanced image analysis, branded "e-motion capture," to map Pitt's performance onto a digital head designed to depict Pitt as an old man. The CG heads depicting Button at various ages were then tracked onto the live-action performances of appropriately aged stand-in performers who wore blue hoods while filming on set (see figures 28 and 29). As with *Avatar*, the facial performance was separated from the bodily acting—and in this case, distributed among different actors. Again, motion capture provided only part of the final performance. Pitt's facial movements were modified by digital animation, attached to another performer's body, and applied to a CG head that used advanced skin shaders and ray-traced displacement maps to create lifelike skin.[19]

As these examples make plain, the line between visual effects and film performance—never totally clear—is rapidly breaking down. "In films like *Benjamin Button* and *Avatar*," observes Stephen Prince, "there is no clear boundary between domains that we might call acting and those that we would term visual effects. Actors become effects and effects derive from actors."[20] *The Lord of the Rings*, *Avatar*, and even *Benjamin Button* all displayed digitally enhanced performance in a very visible way, both textually and extra-textually. In the films themselves, the CG or digitally enhanced characters are acknowledged as fantastical—a devolved Hobbit, blue-skinned aliens, a magically de-aging man. In paratexts, including behind-the-scenes promotional materials, the motion-capture process has been exposed and celebrated as a new kind of acting. Andy Serkis published a book about the creation and performance of Gollum, and Peter Jackson released a series of online "production diaries" detailing the creation of *King Kong*. However, digitally modified performances are often far less visible. In *Benjamin Button*, effects artists utilized facial replacement—compositing an actor's face onto another person's body using sophisticated tracking and match moving techniques—to create the impression that Benjamin's friend Daisy (Cate Blanchett)

FIGURES 28 & 29: In *The Curious Case of Benjamin Button* (2008), computer-generated heads, driven by Brad Pitt's facial performance capture, replaced the heads of appropriately aged stand-ins.

was an accomplished ballerina. Director David Fincher later used this same technique to create the Winklevoss twins in *The Social Network* (2010). While the actor Josh Pence provided the bodily presence for character Tyler Winklevoss in live-action shooting, his face in postproduction was swapped for that of Armie Hammer, who played Tyler's twin Cameron Winklevoss in live-action shooting.[21]

Darren Aronofsky's *Black Swan* (2010) also used facial replacement to put actress Natalie Portman's face onto the body of a professional ballerina, creating the illusion—perpetuated by interviews and behind-the-scenes featurettes—that Portman had done all the dancing for the role herself.[22] This caused some controversy after Portman was nominated for the Academy Award for Best Actress. After an official video explaining the film's visual effects was modified to obscure her contribution, dance double Sarah Lane complained to the press that she did not get the acknowledgment she deserved (she was credited for "stunts" and was not mentioned in Portman's Oscar acceptance speech).[23] As this controversy shows, our notions of acting have still not been substantially updated to account for the radical modifications digital technology can have on film performance.

Actors' performances can also be altered in the editing room; while this has always been the case for film acting, digital technologies increase the amount of control that the director or editor can have over performances after they have already been recorded. In postproduction for *The Phantom Menace*, for example, editor Paul Martin Smith worked closely with Lucas and visual effects personnel to modify actors' performances as the film was put together. Some single shots were constructed out of multiple takes to create an ideal ensemble performance from all of the actors; they separated out the best performance of each actor across the various takes and then composited them together in a fresh plate, creating an impression of a spatial and temporal coherence where there was none. Although continuity editing has long created illusory unities across various cuts, digital compositing makes minute changes within the shot both easier and more seamless, without the need to keep actors available for reshoots. Smith and Lucas

were also able to add actors to shots in which they did not originally appear and modify lip movements to accommodate lines of dialogue added later. If an actor did so much as turn his head a moment too soon, such action could be taken out and added a fraction of a second later. For these "patching" tricks and his ability to edit both within the shot and between the shots, *American Cinematographer* called Smith "the prototype editor of the future."[24]

As this example demonstrates, digital visual effects have transformed not only film performance, but many other aspects of film production and postproduction, to the point that it is now difficult to distinguish between visual effects and other practices. Editing, once an activity that could not properly begin until the production phase had wrapped, has now become part of pre-production. For *The Phantom Menace*, the editing process started with Lucas and his team creating storyboards and full-motion animatics of the entire film, a full year before Paul Martin Smith even came on board. Many films today, especially those that are effects heavy, employ CG previsualization to fix shots in place before any cameras roll.[25] Previsualization renders the entire film (or select sequences) in low-resolution digital animation so that directors, visual-effects supervisors, and other members of the production can see each shot and plan accordingly for each of the elements that will go into it—practical camera movements, virtual camera movements, CG elements, digital matte paintings, miniature models, live-action elements, and so on. In a reversal of conventional practice, editing and visual effects therefore often precede the production phase, determining how the shots will be filmed/constructed beforehand rather than manipulating them afterward. In the form of CG previsualization, visual effects now stand at the very origin of the editing process.

Cinematography has also been profoundly altered by digital visual effects. The integration of CG and live-action elements means that cinematographers and visual effects directors often collaborate throughout the filmmaking process. Tim Burke, visual-effects supervisor for *Harry Potter and the Order of the Phoenix* (David Yates, 2007), explained, "With the complexity of visual effects these days, it's vital for effects supervisors to work closely with cinematographers. Everyone needs to have the same aim and goal, and dialogue is very important."[26] Different lighting choices need to be made on set if CG elements will be added to the shot. The use of filters and gels tends to be minimized, both to create a clean slate for the digital elements and because colors and shading can be adjusted later on the computer.

Previsualization has meant that many aspects of lighting, framing, and camera movement are planned out in advance—not by the cinematographer but by visual-effects personnel. Randy Cook, animation director for *The Lord of the Rings* films, worked alongside director Peter Jackson to design cinematographic, editing, and performance elements while completing the pre-visualization: "Peter and I worked very closely to choose camera angles and choreograph the

chase down the stairs [in the Stairway of Khazad-Dum sequence], which became a rather elaborate, 140-shot Puppetoon[27] staged entirely with CG characters and CG sets. Peter cut that down to 80 shots, and then the second-unit director, who shot the live-action elements, followed it. The final sequence is extraordinarily close to the pre-vis as far as composition, pace and cutting, even down to the rudimentary gestures I gave the little figures."[28] Significantly, here the live-action shooting is relegated to the second-unit director, while the majority of camera movements and scene elements were designed digitally with virtual cameras and CG sets. Even aspects of the performance were determined in this early stage, designed not by actors or even animators, but by the previsualization team.

Between 2009 and 2013, the Academy Award winners for Visual Effects (*Avatar* [2009], *Inception* [Christopher Nolan, 2010], *Hugo* [Martin Scorsese, 2011], *Life of Pi* [Ang Lee, 2012], and *Gravity* [Alfonso Cuarón, 2013]) also won the Academy Award for Cinematography. Noting this, Steven Shaviro questions whether films such as these that rely heavily on CG and the digital backlot even contain cinematography as it is classically conceived. He suggests that, "in terms of visual effects and cinematography, . . . the former is not destroying the latter, but merging with it and merging into it."[29] As digital imaging technologies become more and more powerful, the decision to "fix it in post" has increasing applicability to aspects of the setting, cinematography, and performance that a film director would like to control. With the rapid adoption since 2000 of the DI—in which a celluloid film is scanned into the computer and modified with color grading and other image adjustments—many aspects of the cinematographer's job in determining the lighting, color, and overall look of the film have now shifted to postproduction.[30] As more and more films, especially effects-heavy ones, adopt HD video as their primary capture method, this process is even more streamlined, creating a series of new workflows in which images are recorded, adjusted, composited, and edited in a continuous, fully digital procession.[31]

The digital workflow allows the director to have more precision and greater control over all aspects of the image. On his embrace of digital video for *Benjamin Button*, director David Fincher remarked, "With HD, we could up-rez material and look at it, and say, 'Hmm, that needs a little bit of work'—and we could go back in very easily and soften hair lines, wig lines, et cetera. We had instant control over little areas of the frame. I can't imagine having shot this movie on film, just because of the amount of material that needed to be massaged."[32] The target of the "massage" included not only the overall look and color of the film, but also virtual camerawork. For *The Girl with the Dragon Tattoo* (2011), Fincher shot HD video "in 5K with a 2.1 aspect ratio but finished in 4k with a 2.4 aspect ratio. Only 70% of each shot frame was used in the finished film; this meant that Fincher could revise every shot—reframing, altering the speed of camera movements, adding zooms—during editing without any loss of image quality."[33] Visual effects, cinematography, and editing all blend into

one another here, blurring the boundaries between previously distinct film-making practices. With their ability to seamlessly create, modify, and combine images, digital visual effects therefore exemplify contemporary digital filmmaking practice. Instead of simply creating moments of wonder—special-effects sequences—visual effects now subtend all aspects of the image, introducing a new model for how films are imagined and conceived.

As the films discussed above attest, digital visual effects have become essential parts of many films that do not fit the typical model of spectacular, effects-driven films. With the increasing sophistication and decreasing cost of computing hardware and software, digital effects have become nearly ubiquitous, transforming formerly "special" effects into commonplace tools. Although the aging effects of *Benjamin Button* were visibly impressive, they were not meant to distract spectators from the narrative. Visual effects supervisor Eric Barba explains that the goal was "to bring this character to life so that when someone is watching the movie, all they are thinking about is the story and the character. We didn't want anyone to be taken out of the story by some kind of obvious effects technique."[34] Clint Eastwood's 2008 film *Changeling* provides a good example of how methods created for large-scale, effects-driven fantasy films like *The Lord of the Rings* or *Avatar* can create historical realism rather than a pageant of effects. In *Changeling*, digital visual effects take a secondary role, instead of a starring one. Techniques like 3D character animation,[35] motion capture, MASSIVE, and digital set extensions were used here to re-create a historical world—the Los Angeles of the 1920s and 1930s. These effects are likely to be "invisible," in that they are not obvious fabrications like the CG dinosaurs or magical settings of *Jurassic Park* or *Harry Potter*. Rather, they allow directors to create simulations of the past or to achieve realistic imagery for whatever they have imagined, without the constraints of physical locations.

Visual effects supervisor Michael Owens, a long-time collaborator with Eastwood, notes that the director has "gradually come to rely on visual effects even for his movies that are not at all visual effects movies. By the time we got to *Changeling*, Clint was very comfortable with visual effects as just another filmmaking tool."[36] Much of *Changeling* was shot on the Universal Studios backlot, a familiar street corner that has appeared in hundreds of films. However, Eastwood and his crew hung bluescreens on each end of the street and generated digital matte paintings and 3D set extensions to modify the setting. This process not only disguised the familiar backlot, but also effectively re-created the look of Los Angeles from eighty years before. Although the production had one somewhat operational trolley car from the period to use on set, digital artists added a number of others, as well as all of the trolley cables and many other period vehicles. MASSIVE created background crowds for many scenes and, in the last two-and-a-half-minute long take that plays under the final credits, digital extras walk around the town alongside actual extras. Even more "invisibly," digital

artists cleaned up various images, removing anachronous elements like modern street signs, road markings, and electricity wires, as well as any production errors (such as continuity discrepancies or a drooping boom mic).

With the advanced technologies and decreasing costs of visual effects, even art-house and low-budget independent films take advantage of digital techniques to create unique impressions. Many of the stunning images in the cosmic creation sequence in Terrence Malick's *The Tree of Life* (2011) were created with practical means—water tanks, dry ice, and flashlights—and spearheaded by special-effects pioneer Douglas Trumbull. However, digital tools allowed the filmmakers to composite these individual pieces together and add elements that could not be recorded, such as computer-generated dinosaurs. The visual-effects team also used CGI to enhance scientific illustrations and Hubble telescope photographs, adding movement and depth.[37] Despite its meager $5 million budget, *The Dallas Buyers Club* (Jean-Marc Vallée, 2013) used digital effects to create key elements of two important scenes with star Matthew McConaughey: in one scene, he is surrounded by tens of thousands of computer-generated butterflies in a Mexican research lab; for another scene, a flashback that was shot after principal photography had already wrapped, artists at Montreal-based FAKE Digital Entertainment constructed a digital mustache for McConaughey, since he had already shaved his off.[38] These more modest additions and fixes demonstrate how universal digital effects have become. Outside tent-pole pictures and science fiction blockbusters, visual effects may not be as visible, but they still play an important role in shaping the ultimate look of the film.

Despite the increasing reliance on visual effects in all stages of the filmmaking process and in all kinds of films, the visual effects industry has faced severe challenges in recent years. Two of the biggest and oldest visual effects houses, Digital Domain and Rhythm and Hues, declared bankruptcy in 2012 and 2013. In the ten years prior, more than twenty additional effects companies closed or went bankrupt.[39] After many years of financial instability, Digital Domain— founded by director James Cameron, makeup and special effects master Stan Winston, and visual effects executive Scott Ross in 1993—was ultimately auctioned off to the Chinese media company Beijing Galloping Horse Group. Rhythm and Hues, founded in 1987, went bankrupt and laid off hundreds of employees less than two weeks before the company won the Academy Award for Visual Effects for *Life of Pi*, prompting a protest of visual effects professionals outside the Oscar ceremony.[40]

Technological and industrial changes to filmmaking have had an enormous impact not only on the aesthetics, but also the business model of visual effects. The current fixed-bid model of contracting visual effects work rewards companies that can promise the lowest overall price for a total number of shots, but this system places the risk with the effects company, which must absorb costs that exceed the set price. With the rising adoption of digital effects for all kinds of

visual fixes and image "massage," the work guaranteed for the agreed upon price can balloon. Without a profit participation agreement, the effects companies do not immediately benefit when their films do well at the box office or win an Academy Award.[41]

The increasing pressure to maximize profit that has driven the franchise model in contemporary Hollywood also has reduced time frames for completing films. This is particularly significant for effects-heavy films that often need months, if not years, of research and development time to further develop the technical processes necessary to advance the art form. Whereas in previous decades, a film's visual effects would likely be created by one effects house, now tighter production schedules mean that effects are more likely to be divvied up among a number of effects companies, with each providing specialized services. This creates intense competition and less of the sustained support necessary to invest in new technologies independent of a current film project. Much of the expense of visual effects is due to the fact that it is extremely labor intensive. A common strategy now is to outsource visual effects to India, where labor costs can be as little as one-tenth that of Southern California, or Canada, which offers studios tax subsidies, reducing the overall cost.[42] *Life of Pi* credited nearly 1,000 visual effects artists, many of them located in India and elsewhere around the world. Current visual effects artists often describe themselves as "migrant film workers," having to move internationally to chase the latest tax subsidy. Without a union, they work long hours, often with unpaid overtime, and also complain of lack of job security and benefits like continuous health insurance.[43]

Although visual effects companies continue to struggle, Hollywood's reliance upon them to create imaginary worlds and incredible vistas seems unlikely to change any time soon. Visual effects have become a core part of contemporary blockbuster filmmaking, despite the fact that the effects houses themselves are not benefiting from the demand for the specialized work they do. With the lowering cost of software and hardware, visual effects now can be done all over the world, frequently on high-end personal computers, meaning that there will continue to be rivals to the major effects companies. This technological advancement has also meant that filmmakers do not feel limited in their imagination, believing that visual effects can bring their dreams to life. As visual effects have evolved over time to solve successive problems of realistic imagery—cloth simulation, realistic skin, believable hair and fur, crowd simulation, facial animation, and so on—they have become pervasive and often invisible to spectators. Visual effects underlie much of contemporary filmmaking, rather than just fantastical special-effects sequences. Moreover, with the increased exploitation of digital means at every stage, the lines between visual effects and other categories of production have rapidly broken down. Digital techniques manipulate lighting and color, build virtual sets and virtual cameras, and adjust costumes and makeup, while also radically transforming film acting.

Instead of being tied to just one aspect of film practice, the logic of visual effects extends throughout the contemporary filmmaking process, from pre- to postproduction. Visual effects emblematize the way that digital technologies have made film images malleable, customizable, and infinitely changeable, rather than being tied indexically to recorded reality. Since digital technology revolutionized filmmaking in the last decades of the twentieth century, visual effects have never been more important; rather than being an afterthought, an extraneous or inessential piece of the puzzle, they are at the very heart of contemporary visuality. As Stephen Prince notes, visual effects "are not a peripheral element of cinema but a core feature, essential to its operation as a narrative medium."[44] Instead of being "special," effects now shape how films are conceived, written, shot, edited, and composed. They are major drivers of film style as well as industrial models. The ubiquity of contemporary visual effects reminds us that special and visual effects have always played a crucial role in filmmaking, never more so than now.

ACADEMY AWARDS FOR EDITING

1934 Conrad A. Nervig, *Eskimo*

1935 Ralph Dawson, *A Midsummer Night's Dream*

1936 Ralph Dawson, *Anthony Adverse*

1937 Gene Havlick, Gene Milford, *Lost Horizon*

1938 Ralph Dawson, *The Adventures of Robin Hood*

1939 Hal C. Kern, James E. Newcom, *Gone with the Wind*

1940 Anne Bauchens, *North West Mounted Police*

1941 William Holmes, *Sergeant York*

1942 Daniel Mandell, *The Pride of the Yankees*

1943 George Amy, *Air Force*

1944 Barbara McLean, *Wilson*

1945 Robert J. Kern, *National Velvet*

1946 Daniel Mandell, *The Best Years of Our Lives*

1947 Francis Lyon, Robert Parrish, *Body and Soul*

1948 Paul Weatherwax, *The Naked City*

1949 Harry Gerstad, *Champion*

1950 Ralph E. Winters, Conrad A. Nervig, *King Solomon's Mines*

1951 William Hornbeck, *A Place in the Sun*

1952 Elmo Williams, Harry Gerstad, *High Noon*

1953 William A. Lyon, *From Here to Eternity*

1954 Gene Milford, *On the Waterfront*

1955 Charles Nelson, William A. Lyon, *Picnic*

1956 Gene Ruggiero, Paul Weatherwax, *Around the World in 80 Days*

1957 Peter Taylor, *The Bridge on the River Kwai*

1958 Adrienne Fazan, *Gigi*

1959 Ralph E. Winters, John D. Dunning, *Ben-Hur*

1960 Daniel Mandell, *The Apartment*

1961 Thomas Stanford, *West Side Story*

1962 Anne V. Coates, *Lawrence of Arabia*

1963 Harold F. Kress, *How the West Was Won*

1964 Cotton Warburton, *Mary Poppins*

1965 William H. Reynolds, *The Sound of Music*

1966 Fredric Steinkamp, Henry Berman, Stewart Linder, Frank Santillo, *Grand Prix*

1967 Hal Ashby, *In the Heat of the Night*

1968 Frank P. Keller, *Bullitt*

1969 Françoise Bonnot, *Z*

1970 Hugh S. Fowler, *Patton*

1971 Gerald B. Greenberg, *The French Connection*

1972 David Bretherton, *Cabaret*

1973 William H. Reynolds, *The Sting*

1974 Harold F. Kress, Carl Kress, *The Towering Inferno*

1975 Verna Fields, *Jaws*

1976 Richard Halsey, Scott Conrad, *Rocky*

1977 Paul Hirsch, Marcia Lucas, Richard Chew, *Star Wars*

1978 Peter Zinner, *The Deer Hunter*

1979 Alan Heim, *All That Jazz*

1980 Thelma Schoonmaker, *Raging Bull*

1981 Michael Kahn, *Raiders of the Lost Ark*

1982 John Bloom, *Gandhi*

1983 Glenn Farr, Lisa Fruchtman, Stephen A. Rotter, Douglas Stewart, Tom Rolf, *The Right Stuff*

1984 Jim Clark, *The Killing Fields*

1985 Thom Noble, *Witness*

1986 Claire Simpson, *Platoon*

1987 Gabriella Cristiani, *The Last Emperor*

1988 Arthur Schmidt, *Who Framed Roger Rabbit*

1989 David Brenner, Joe Hutshing, *Born on the Fourth of July*

1990 Neil Travis, *Dances with Wolves*

1991 Joe Hutshing, Pietro Scalia, *JFK*

1992 Joel Cox, *Unforgiven*

1993 Michael Kahn, *Schindler's List*

1994 Arthur Schmidt, *Forrest Gump*

1995 Mike Hill, Daniel P. Hanley, *Apollo 13*

1996 Walter Murch, *The English Patient*

1997 Conrad Buff, James Cameron, Richard A. Harris, *Titanic*

1998 Michael Kahn, *Saving Private Ryan*

1999 Zach Staenberg, *The Matrix*

2000 Stephen Mirrione, *Traffic*

2001 Pietro Scalia, *Black Hawk Down*

2002 Martin Walsh, *Chicago*

2003 Jamie Selkirk, *The Lord of the Rings: The Return of the King*

2004 Thelma Schoonmaker, *The Aviator*

2005 Hughes Winborne, *Crash*

2006 Thelma Schoonmaker, *The Departed*

2007 Christopher Rouse, *The Bourne Ultimatum*

2008 Chris Dickens, *Slumdog Millionaire*

2009 Chris Innis, Bob Murawski, *The Hurt Locker*

2010 Angus Wall, Kirk Baxter, *The Social Network*

2011 Angus Wall, Kirk Baxter, *The Girl with the Dragon Tattoo*

2012 William Goldenberg, *Argo*

2013 Alfonso Cuarón, Mark Sanger, *Gravity*

2014 Tom Cross, *Whiplash*

2015 Margaret Sixel, *Mad Max: Fury Road*

ACADEMY AWARDS FOR SPECIAL/VISUAL EFFECTS

SPECIAL EFFECTS

1939 Fred Sersen, *The Rains Came*

1940 Lawrence Butler, *The Thief of Bagdad*

1941 Farciot Edouart, Gordon Jennings, *I Wanted Wings*

1942 Gordon Jennings, Farciot Edouart, William L. Pereira, *Reap the Wild Wind*

1943 Fred Sersen, *Crash Dive*

1944 A. Arnold Gillespie, Donald Jahraus, Warren Newcombe, *Thirty Seconds over Tokyo*

1945 John Fulton, *Wonder Man*

1946 Thomas Howard, *Blithe Spirit*

1947 A. Arnold Gillespie, Warren Newcombe, *Green Dolphin Street*

1948 Paul Eagler, J. McMillan Johnson, Russell Shearman, Clarence Slifer, *Portrait of Jennie*

1949 ARKO Productions, *Mighty Joe Young*

1950 George Pal Productions, *Destination Moon*

1951 Paramount, *When Worlds Collide*

1952 Metro-Goldwyn-Mayer, *Plymouth Adventure*

1953 Paramount, *The War of the Worlds*

1954 Walt Disney Studios, *20,000 Leagues under the Sea*

1955 Paramount Studio, *The Bridges at Toko-Ri*

1956 John Fulton, *The Ten Commandments*

1958 Tom Howard, *tom thumb*

1959 A. Arnold Gillespie, Robert MacDonald, *Ben Hur*

1960 Gene Warren, Tim Baar, *The Time Machine*

1961 Bill Warrington, *The Guns of Navarone*

1962 Robert MacDonald, *The Longest Day*

1963 Emil Kosa Jr., *Cleopatra*

SPECIAL VISUAL EFFECTS

1964 Peter Ellenshaw, Eustace Lycett, Hamilton Luske, *Mary Poppins*

1965 John Stears, *Thunderball*

1966 Art Cruickshank, *Fantastic Voyage*

1967 L. B. Abbott, *Dr. Dolittle*

1968 Stanley Kubrick, *2001: A Space Odyssey*

1969 Robbie Robertson, *Marooned*

1970 A. D. Flowers, L. B. Abbott, *Tora! Tora! Tora!*

VISUAL EFFECTS

1971 (SPECIAL ACHIEVEMENT AWARD) Alan Maley, Eustace Lycett, Danny Lee, *Bedknobs and Broomsticks*

1972 (SPECIAL ACHIEVEMENT AWARD) L. B. Abbott, A. D. Flowers, *The Poseidon Adventure*

1974 (SPECIAL ACHIEVEMENT AWARD) Frank Brendel, Glen Robinson, Albert Whitlock, *Earthquake*

1975 (SPECIAL ACHIEVEMENT AWARD) Albert Whitlock, Glen Robinson, *The Hindenburg*

1976 (SPECIAL ACHIEVEMENT AWARD) Carlo Rambaldi, Glen Robinson, Frank Van der Veer, *King Kong*; L. B. Abbott, Glen Robinson, Matthew Yuricich, *Logan's Run*

1977 John Stears, John Dykstra, Richard Edlund, Grant McCune, Robert Blalack, *Star Wars*

1978 (SPECIAL ACHIEVEMENT AWARD) Les Bowie, Colin Chilvers, Denys Coop, Roy Field, Derek Meddings, Zoran Perisic, *Superman*

1979 H. R. Giger, Carlo Rambaldi, Brian Johnson, Nick Allder, Dennis Ayling, *Alien*

1980 (SPECIAL ACHIEVEMENT AWARD) Brian Johnson, Richard Edlund, Dennis Muren, Bruce Nicholson, *The Empire Strikes Back*

1981 Richard Edlund, Kit West, Bruce Nicholson, Joe Johnston, *Raiders of the Lost Ark*

1982 Carlo Rambaldi, Dennis Muren, Kenneth F. Smith, *E.T. The Extra-Terrestrial*

1983 (SPECIAL ACHIEVEMENT AWARD) Richard Edlund, Dennis Muren, Ken Ralston, Phil Tippett, *Return of the Jedi*

1984 Dennis Muren, Michael McAlister, Lorne Peterson, George Gibbs, *Indiana Jones and the Temple of Doom*

1985 Ken Ralston, Ralph McQuarrie, Scott Farrar, David Berry, *Cocoon*

1986 Robert Skotak, Stan Winston, John Richardson, Suzanne Benson, *Aliens*

1987 Dennis Muren, William George, Harley Jessup, Kenneth F. Smith, *Innerspace*

1988 Ken Ralston, Richard Williams, Edward Jones, George Gibbs, *Who Framed Roger Rabbit*

1989 John Bruno, Dennis Muren, Hoyt Yeatman, Dennis Skotak, *The Abyss*

1990 (SPECIAL ACHIEVEMENT AWARD) Eric Brevig, Rob Bottin, Tim McGovern, Alex Funke, *Total Recall*

1991 Dennis Muren, Stan Winston, Gene Warren Jr., Robert Skotak, *Terminator 2: Judgment Day*

1992 Ken Ralston, Doug Chiang, Doug Smythe, Tom Woodruff Jr., *Death Becomes Her*

1993 Dennis Muren, Stan Winston, Phil Tippett, Michael Lantieri, *Jurassic Park*

1994 Ken Ralston, George Murphy, Stephen Rosenbaum, Allen Hall, *Forrest Gump*

1995 Scott E. Anderson, Charles Gibson, Neal Scanlan, John Cox, *Babe*

1996 Volker Engel, Douglas Smith, Clay Pinney, Joseph Viskocil, *Independence Day*

1997 Robert Legato, Mark Lasoff, Thomas L. Fisher, Michael Kanfer, *Titanic*

1998 Joel Hynek, Nicholas Brooks, Stuart Robertson, Kevin Mack, *What Dreams May Come*

1999 John Gaeta, Janek Sirrs, Steve Courtley, and Jon Thum, *The Matrix*

2000 John Nelson, Neil Corbould, Tim Burke, Rob Harvey, *Gladiator*

2001 Jim Rygiel, Randall William Cook, Richard Taylor, Mark Stetson, *The Lord of the Rings: The Fellowship of the Ring*

2002 Jim Rygiel, Joe Letteri, Randall William Cook, Alex Funke, *The Lord of the Rings: The Two Towers*

2003 Jim Rygiel, Joe Letteri, Randall William Cook, Alex Funke, *The Lord of the Rings: The Return of the King*

2004 John Dykstra, Scott Stokdyk, Anthony LaMolinara, John Frazier, *Spider-Man 2*

2005 Joe Letteri, Brian Van't Hul, Christian Rivers, Richard Taylor, *King Kong*

2006 John Knoll, Hal Hickel, Charles Gibson, Allen Hall, *Pirates of the Caribbean: Dead Man's Chest*

2007 Michael Fink, Bill Westenhofer, Ben Morris, Trevor Wood, *The Golden Compass*

2008 Eric Barba, Steve Preeg, Burt Dalton, Craig Barron, *The Curious Case of Benjamin Button*

2009 Joe Letteri, Stephen Rosenbaum, Richard Baneham, Andrew R. Jones, *Avatar*

2010 Paul Franklin, Chris Corbould, Andrew Lockley, Peter Bebb, *Inception*

2011 Rob Legato, Joss Williams, Ben Grossmann, Alex Henning, *Hugo*

2012 Bill Westenhofer, Guillaume Rocheron, Erik-Jan De Boer, Donald R. Elliott, *Life of Pi*

2013 Tim Webber, Chris Lawrence, David Shirk, Neil Corbould, *Gravity*

2014 Paul Franklin, Andrew Lockley, Ian Hunter, Scott Fisher, *Interstellar*

2015 Mark Williams Addington, Sara Bennett, Paul Norris, Andrew Whitehurst, *Ex Machina*

NOTES

Introduction

1 Tom Gunning, "Non-Continuity, Continuity, Discontinuity: A Theory of Genres in Early Film" [1984], in *Early Cinema: Space, Frame, Narrative*, ed. Thomas Elsaesser (London: British Film Institute, 1990), 89.

2 Charlie Keil, *Early American Cinema in Transition: Story, Style, and Filmmaking, 1907–1913* (Madison: University of Wisconsin Press, 2001).

3 Barry Salt, *Film Style and Technology: History and Analysis* (London: Starword, 1983), 211.

4 Interview with Ralph Winters, in *Selected Takes: Film Editors on Editing*, ed. Vincent LoBrotto (Westport, CT: Praeger, 1991), 44.

5 Interview with John D. Dunning ("'Good Stuff' Never Changes"), in *First Cut: Conversations with Film Editors*, ed. Gabriella Oldham (Berkeley: University of California Press, 1992), 260.

6 Interview with Donn Cambern ("Keeping the Beat"), in *First Cut*, 206.

7 Interview with Evan Lottman ("Seeing the Invisible"), in *First Cut*, 232.

8 Interview with Richard Marks ("Creating a Legacy"), in *First Cut*, 364.

9 Interview with Harold F. Kress and Carl Kress ("Flashback, Flashforward"), in *First Cut*, 95.

10 For one such example, see interview with Ralph Winters, in *Selected Takes*, 42.

11 Interview with William Reynolds, in *Selected Takes*, 19.

12 Quoted by Overpeck; originally found in Steven Pizello, "Avid Helps Cameron Cut to the

Chase," *American Cinematographer* (September 1994): 55.

13 Interview with William Reynolds, in *Selected Takes*, 16.

14 Michael Fink, "Introduction," *The VES Handbook of Visual Effects: Industry Standard VFX Practices and Procedures*, 2nd ed., ed. Jeffrey A. Okun and Susan Zwerman (New York: Focal Press, 2015), 3.

15 For a discussion of the historical change in terminology used by the Academy as well as the stakes of prioritizing one term over another, see Stephen Prince, *Digital Visual Effects in Cinema: The Seduction of Reality* (New Brunswick, NJ: Rutgers University Press, 2012), and Julie Turnock, *Plastic Reality: Special Effects, Technology, and the Emergence of 1970s Blockbuster Aesthetics* (New York: Columbia University Press, 2015). A list of Academy Awards can be found at the Academy of Motion Picture Arts and Sciences (AMPAS) Official Academy Awards database: awardsdatabase.oscars.org/ampas_awards/BasicSearchInput.jsp.

16 Fink, *The VES Handbook*, 1.

17 Rick Rickitt, *Special Effects: The History and Technique* (New York: Billboard Books, 2007), 373.

18 Ibid.

19 On the use of splicing in creating the trick film's appearances and disappearances, see Tom Gunning, "'Primitive' Cinema: A Frame-Up? or, The Trick's on Us," in Elsaesser, *Early Cinema: Space, Frame, Narrative*, 95–103.

20 Stephen Heath, *Questions of Cinema* (Bloomington: Indiana University Press, 1981), 221.

21 See Tom Gunning's two groundbreaking essays, "The Cinema of Attractions: Early Film, Its Spectator, and the Avant-Garde," *Wide Angle* 8, nos. 3–4 (Fall 1986): 63–70, and "An Aesthetic of Astonishment: Early Film and the (In)Credulous Spectator," *Art & Text* (Fall 1989): 31–45.

22 Gunning, "An Aesthetic of Astonishment," 31–45.

23 On special/visual effects and the sublime, see Scott Bukatman, *Matters of Gravity: Special Effects and Supermen in the 20th Century* (Durham, NC: Duke University Press, 2003), 81–109. On the relationship between wonder and special effects, see Michele Pierson, *Special Effects: Still in Search of Wonder* (New York: Columbia University Press, 2002).

24 For recent examples, see Kristen Whissel, *Spectacular Digital Effects: CGI and Contemporary Cinema* (Durham, NC: Duke University Press, 2014); Prince, *Digital Visual Effects*; Geoff King, *Spectacular Narratives: Hollywood in the Age of the Blockbuster* (New York: I. B. Tauris, 2000); and Jason McGrath, "Heroic Human Pixels: Mass Ornaments and Digital Multitudes in Zhang Yimou's Spectacles," *Modern Chinese Literature* 25, no. 2 (Spring 2013): 51–79.

25 See, for example, North, *Performing Illusions*.

26 Prince, *Digital Visual Effects*, 4–5.

27 Joe Fordham, "*Children of Men*: The Human Project," *Cinefex* 110 (July 2007): 33–37.

1 The Silent Screen, 1895–1927: Editing

1 Thomas Elsaesser, "Afterward," in *Early Cinema: Space, Frame, Narrative*, ed. Thomas Elsaesser and Adam Barker (London: British Film Institute, 1990), 408.

2 Stephen Bottomore, "Shots in the Dark—The Real Origins of Film Editing," in *Early Cinema: Space, Frame, Narrative*, 105.

3 Ibid., 106.

4 Charles Musser, *The Emergence of Cinema: The American Screen to 1907* (Berkeley:

University of California Press, 1994), 193–223.

5 Tom Gunning, "'Primitive' Cinema: A Frame-Up? or, The Trick's on Us," in Elsaesser and Barker, *Early Cinema: Space, Frame, Narrative*, 99.

6 André Gaudreault, "Detours in Film Narrative: the Development of Cross-Cutting," in Elsaesser and Barker, *Early Cinema: Space, Frame, Narrative*, 140–141.

7 Gunning, "The Cinema of Attractions: Early Film, Its Spectator, and the Avant-Garde," in Elsaesser and Barker, *Early Cinema: Space, Frame, Narrative*, 66.

8 Barry Salt points out that the erotic close-up derives from point-of-view films like G. A. Smith's *As Seen Through a Telescope* (1901), in which a lecherous man uses his telescope to spy a female cyclist's leg. Porter's use of an unmediated cut-in, not framed as a point-of-view, derives from another Smith film, *The Little Doctor* (1901), that cuts from long shot to a close-up of a girl administering medicine to her kitten. Barry Salt, *Film Style and Technology: History and Analysis*, 2nd ed. (London: Starword, 1992), 49–50.

9 Musser, *The Emergence of Cinema*, 337–369.

10 Ibid., 376–377.

11 Charlie Keil, *Early American Cinema in Transition: Story, Style and Filmmaking, 1907–1913* (Madison: University of Wisconsin Press, 2001), 47. Keil recognizes a lingering autonomy of each obstacle-laden scene, but explains that "by introducing the possibility of multiple spaces, the chase film initiates a disintegration of the principle of unity [that] the single shot ensured" (86).

12 Ibid., 108–109.

13 Tom Gunning, *D. W. Griffith and the Origins of American Narrative Film: The Early Years at Biograph* (Urbana: University of Illinois Press, 1991), 105.

14 Salt, *Film Style and Technology*, 93.

15 Keil, *Early American Cinema*, 168–169.

16 Salt, *Film Style and Technology*, 92.

17 Noel Burch, *Life to Those Shadows*, trans. Ben Brewster (Berkeley: University of California Press, 1990), 225; Salt, *Film Style and Technology*, 55–56.

18 Keil, *Early American Cinema*, 84–85.

19 Eileen Bowser, *The Transformation of Cinema: 1907–1915* (Berkeley: University of California Press, 1990), 261.

20 Keil, *Early American Cinema*, 111.

21 Kristin Thompson, "Part Three: The Formulation of the Classical Style, 1919–1928," in David Bordwell, Janet Staiger, and Kristin Thompson, *The Classical Hollywood Cinema: Film Style and Mode of Production to 1960* (New York: Columbia University Press, 1985), 202, 210.

22 Bowser, *The Transformation of Cinema*, 261; Salt, *Film Style and Technology*, 93.

23 Gunning, *D. W. Griffith*, 169.

24 Salt, *Film Style and Technology*, 92; Keil, *Early American Cinema*, 110.

25 Salt, *Film Style and Technology*, 93–94; Keil, *Early American Cinema*, 110–118. Keil notes Edison's 1911 *A Stage Romance* as an exception (114–115). Here, the backstage setting encouraged the director to cut between camera positions to depict action in the wings and behind the set. Salt points out that reverse angle cutting could incorporate interior sets if at least one of the shots was taken on an exterior, for instance through a window or door (93).

26 Ben Brewster, "A Scene at the 'Movies,'" in Elsaesser and Barker, *Early Cinema, Space, Frame, Narrative*, 324.

27 For a discussion of *The Loafer* see Thompson, "Part Three," 203; and Salt, *Film Style and Technology*, 94.

28 Thompson, "Part Three," 201.

29 Ibid.

30 Bowser, *The Transformation of Cinema*, 260.

31 Salt, *Film Style and Technology*, 137, 138.

32 For a discussion of DeMille's lighting techniques, see Lea Jacobs, "Belasco, DeMille, and the Development of Lasky Lighting," *Film History* 5 no. 4 (December 1993): 405–418.

33 Burch, *Life to Those Shadows*, 218.

34 Thompson, "Part Three," 201.

35 Ibid., 202; Salt, *Film Style and Technology*, 170.

36 Thompson, "Initial Standardization of the Basic Technology," in Bordwell et al., *The Classical Hollywood Cinema*, 278.

37 Ibid.

38 Salt, *Film Style and Technology*, 138.

39 Ibid., 170.

40 David Bordwell, "Part Six: Film Style and Technology, 1930–1960," in Bordwell et al., *The Classical Hollywood Cinema*, 306.

41 Ibid., 308.

2 The Silent Screen, 1895–1927: Special/Visual Effects

1 Tom Gunning, "The Cinema of Attractions: Early Film, Its Spectator, and the Avant-Garde," in *Early Cinema: Space Frame Narrative*, ed. Thomas Elsaesser (London: British Film Institute, 1990), 56–62.

2 See Charlie Keil and Shelley Stamp, ed., *American Cinema's Transitional Era: Audiences, Institutions, Practices* (Berkeley: University of California Press, 2004).

3 See Kristin Thompson, "The Formulation of the Classical Style, 1909–28," in *The Classical Hollywood Cinema: Film Style and Mode of Production to 1960*, by David Bordwell, Janet Staiger, and Kristin Thompson (New York: Columbia University Press, 1985), 245–329.

4 See Tom Gunning, "An Aesthetic of Astonishment: Early Film and the (In)credulous Spectator," in *Viewing Positions: Ways of Seeing Film*, ed. Linda Williams (New Brunswick, NJ: Rutgers University Press, 1995), 114–133; Tom Gunning, "The Cinema of Attractions: Early Film, Its Spectator, and the Avant-Garde," in *Early Cinema: Space Frame Narrative*, ed. Thomas Elsaesser (London: British Film Institute, 1990), 56–62.

5 Charles Musser, *The Emergence of Cinema: The American Screen to 1907* (Berkeley: University of California Press, 1990), 21.

6 André Gaudreault, "Movies and Chasing the Missing Link(s)," in *American Cinema, 1890—1909: Themes and Variations*, ed. Andre Gaudreault (New Brunswick, NJ: Rutgers University Press, 2009), 135.

7 Frank Kessler, "Trick Films," in *The Encyclopedia of Early Cinema*, ed. Richard Abel (New York: Routledge, 2004), 643.

8 Stephen Heath, *Questions of Cinema* (Bloomington: Indiana University Press, 1981), 221.

9 Charlie Keil, "Integrated Attractions: Style and Spectatorship in Transitional Cinema," in *The Cinema of Attractions Reloaded*, ed. Wanda Strauven (Amsterdam: Amsterdam University Press), 199.

10 Musser, *The Emergence of Cinema*, 86–87.

11 The camera's diaphragm controls how much light enters the lens, and could thus be used to

fade in or out an apparition. See R. W. Baremore, "Tales Told Out of School," *Picture-Play*, February 1919, 177–182.

12 Jonathan Auerbach, *Body Shots: Early Cinema's Incarnations* (Berkeley: University of California Press, 2007), 96.

13 André Gaudreault, *Film and Attraction: From Kinematography to Cinema* (Urbana: University of Illinois Press, 2011), 50.

14 Luke McKernan, "Frederick S. Armitage," *Who's Who of Victorian Cinema*, accessed June 2, 2014, victorian-cinema.net/armitage.

15 L. Gardette, "Some Tricks of the Moving Picture Maker," *The Nickelodeon* 2, no. 2 (1909): 53.

16 Frederick S. Talbot, *Moving Pictures: How They Are Made and Worked* (London: William Heinemann, 1912), 21.

17 Keil, "Integrated Attractions," 197.

18 Eileen Bowser, *The Transformation of Cinema 1907–1915* (New York: Simon & Schuster, 1990), 87.

19 Gardette, "Some Tricks of the Moving Picture Maker," 56.

20 Technically, double exposure refers to when the two shots are made on the same film, and it is a "split aperture" when masks are used to separate zones of action within the frame. "Double exposure" entered common parlance in the entertainment press for any shots where split screens or superimpositions were deployed. See Herbert C. McKay, *Handbook of Motion Picture Photography* (New York: Falk, 1927), 220.

21 H. D. Hineline, "Composite Photographic Processes," *Journal of the Society of Motion Picture Engineers*, April 1933, 283.

22 Earl Theisen, "In the Realm of Tricks and Illusions," *International Photographer*, June 1934, 8.

23 Maureen Turim, *Flashbacks in Film: Memory and History* (London: Routledge, 1989), 24.

24 Bowser, *The Transformation of Cinema*, 64.

25 Ibid.

26 Charlie Keil, "Narration in the Transitional Cinema: The Historiographical Claims of the Unauthored Text," *CiNéMAS* (Spring 2011): 121.

27 Charlie Keil, *Early American Cinema in Transition: Story, Style, and Filmmaking, 1907–1913* (Madison: University of Wisconsin Press, 2001), 195.

28 E. E. Bennett, "Seeing Double," *Pictures and the Picturegoer*, March 1925, 41.

29 "The Corsican Brothers," *Moving Picture World*, January 20, 1912, 192.

30 Bennett, "Seeing Double," 40.

31 Barry Salt, *Film Style and Technology: History and Analysis* (London: Starword, 1983).

32 "Striking Effects Produced by Ingenious Devices," *Motion Picture News*, May 1916, 2762.

33 "Press Praises 'Fauntleroy,'" *Exhibitors Trade Review*, October 1, 1921, 1243.

34 J.S.S., "'Little Lord Fauntleroy' Triumph," *Exhibitors Herald*, October 1, 1921, 54.

35 "Press Praises 'Fauntleroy,'" 1243.

36 Jeffrey A. Okun and Susan Zwerman, eds., *The VES Handbook of Visual Effects: Industry Standard VFX Practices and Procedures* (Burlington, MA: Focal Press, 2010), 2–3.

37 See A. J. Mitchell, *Visual Effects for Film and Television* (Oxford: Focal Press, 2004), 73–80.

38 Jeffrey Vance, *Douglas Fairbanks* (Berkeley: University of California Press, 2008), 133.

39 "Loud Speaker Directs Mob Scene of 'The Hunchback,'" *Radio Digest*, May 26, 1923, 3.

40 Gregory, "Trick Photography Summarized," *American Cinematographer*, June 1926, 21.

41 "Progress in the Motion Picture Industry: 1924 Report of the Progress Committee," *Transactions of the Society of Motion Picture Engineers*, November 1924, 18.

42 Gregory, "Trick Photography Summarized," 16.

43 Theisen, "In the Realm of Tricks and Illusions," 9.

44 For a detailed description of the Williams Process, see Hineline, "Composite Photographic Processes," 285–286.

45 "Williams Process," *Film Daily*, August 27, 1923, 1–2.

46 Dick Hylan, "Risking Life and Limb for $25," *Photoplay*, November 1927, 31.

47 Musser, *The Emergence of Cinema*, 241.

48 Richard Rickitt, *Special Effects: The History and Technique* (New York: Billboard Books, 2007); Raymond Fielding, *Special Effects Cinematography*, 4th ed. (Oxford: Focal Press, 1985), 15.

49 Charles Musser, "The American Vitagraph 1897–1901: Survival and Success in a Competitive Industry," in *Film before Griffith*, ed. John L. Fell (Berkeley: University of California Press, 1983), 49.

50 For the best histories of animation in the silent period, see Donald Crafton, *Before Mickey: The Animated Film 1898–1928* (Chicago: University of Chicago Press, 1993); Scott Bukatman, *The Poetics of Slumberland: Animated Spirits and the Animating Spirit* (Berkeley: University of California Press, 2012).

51 David Shepherd, *The Bible on Silent Film: Spectacle, Story, and Scripture in the Early Cinema* (Cambridge: Cambridge University Press, 2013), 253–254.

52 Cal York, "How They Do It!" *Photoplay*, April 1926, 28–31, 114–115.

53 Cecil B. DeMille, "Mechanical Perfection at Hand, Subtlety in Direction Next, Says De Mille," *Film Daily*, August 30, 1925, 10.

3 Classical Hollywood, 1928 –1946: Editing

1 See, for example, "Death on the Cutting Room Floor," *Hollywood* (December 1936), 32, 63–64. The only instances of editors registering in the publicity materials for a film that I have been able to identify highlight this aspect of the editor's work. See advertisement for *Captain Blood*, captioned "Cutting with Tears in My Eyes," in *Motion Picture Daily*, December 9, 1935, 3.

2 Auteurist biographers celebrate John Ford's refusal to shoot a close-up of the forlorn rector in *How Green Was My Valley*'s wedding scene, and the violence done to *The Magnificent Ambersons* includes, among other things, interrupting Welles's elaborately choreographed long takes with close-ups of the film's stars.

3 David Bordwell, "Part One: The Classical Hollywood Style, 1917–60," in David Bordwell, Janet Staiger, Kristin Thompson, *The Classical Hollywood Cinema: Film Style and Mode of Production to 1960* (New York: Columbia University Press, 1985), 60.

4 Jean Mitry, *Esthétique et psychologie du cinéma*, vol. 2, *Les Formes* (Paris: Éditions universitaires, 1965), trans. Timothy Barnard, in *Découpage* (Montréal: caboose, 2014), 17.

5 Barbara McLean is quoted in "Film Editors Forum," *Film Comment* (March-April 1977), rpt. in *Editors Guild Magazine* 27, no. 3 (May-June 2006); www.editorsguild.com/v2/magazine/archives/0507/features_article04.htm, accessed July 14, 2014.

6 The Neumade Synchronizer became available in August 1930; see Donald Crafton, *The Talkies: American Cinema's Transition to Sound, 1926–1931* (Berkeley: University of California Press, 1997), 239.

7 Barry Salt, *Film Style and Technology: History and Analysis*, 2nd ed. (London: Starword,

1992), 236; Maurice Pivar, "Sound Film Editing," *Projection Engineering* (May 1932): 16.

8 Salt, *Film Style and Technology*, 235–236; W. C. Harcus, "Finishing a Motion Picture," *Journal of the Society of Motion Picture Engineers* 19, no. 6 (December 1932): 553–560.

9 Earl Theisen, "Story of the Moviola," *International Photographer* (November 1935): 4; Edward Dmytryk, *It's a Hell of a Life, But Not a Bad Living: A Hollywood Memoir* (New York: New York Times Books, 1978), 20.

10 Lea Jacobs, "The Innovation of Re-recording in the Hollywood Studios," *Film History* 24, no. 1 (2012): 17–18. The movement of sound cutters to re-recording departments occurred, at least at RKO, sometime after 1933. This was necessitated by the need to build more extensive and complex tracks for dubbing.

11 "'Preview' Moviola Ready for Use," *International Photographer* (June 1937): 28–29.

12 David Bordwell, "The Introduction of Sound," in Bordwell et al., *Classical Hollywood Cinema*, 299–300.

13 "Special Equipment for Cutting Sound Films," *Film Daily*, August 22, 1928, 4; Arthur W. Eddy, "Talker Cutting Device Developed for Pathé," *Film Daily*, November 16, 1928, 11; "The Magic of the Cutting Room," *The International Photographer* (August 1929): 20–21; "Spring Convention S.M.P.E. 1930," *The International Photographer* (June 1930): 158.

14 Kristin Thompson, "Initial Standardization of the Basic Technology," in Bordwell et al., *Classical Hollywood Cinema*, 278.

15 Bordwell, "Introduction of Sound," 305.

16 To edit sound, Vitaphone discs needed to be recut. In the Movietone system, sound and image were on the same negative; however, there was a twenty-frame separation between the image and sound. See Ted Kent, interview with Richard Koszarski, Universal Pictures Project, American Film Institute/Louis B. Mayer Oral History Collection, box 56, vol. 10 (1973): 24.

17 Aided, of course, by improvements in sound recording and actors' acclimating.

18 Barry Salt, "Film Style and Technology in the 1930s," *Film Quarterly* 30, no. 1 (Fall 1976): 20; for varying tempo see Dmytryk, *It's a Hell of a Life*, 23.

19 Bordwell, "Introduction of Sound," 308. William Hornbeck describes Frank Capra shooting master shots of entire scenes, often utilizing multiple cameras, in the 1920s: "It wasn't for matching purposes, it was just to save time. . . . He would always try, the last thing of the day, to shoot the master scene for the next day. And that way he could see that scene the next morning . . . [and] know exactly where I wanted to make his shots, his close shots." Quoted in David Bordwell and Kristin Thompson, "From Sennett to Stevens: An Interview with William Hornbeck," *Velvet Light Trap* no. 20 (Summer 1983), 37.

20 *An Oral History with Margaret Booth,* interviewed by Rudy Behlmer, Academy Oral History Program, Margaret Herrick Library, AMPAS (Academy Foundation, 1990), 303.

21 Harcus, "Finishing a Motion Picture," 556–558.

22 Kent, interview with Koszarski, 4–6.

23 *An Oral History with Ralph Winters,* interviewed by Jennifer Peterson, Academy Oral History Program, Margaret Herrick Library, AMPAS (Academy Foundation, 2000), 89–90. On McLean directing close-ups of Colleen Moore, see Barbara McLean, interview with Thomas Stempel, Darryl F. Zanuck Research Project, American Film Institute/Louis B. Mayer Oral History Collection, box 27, vol. 4 (1970): 14. Similarly, Hal Kern shot additional inserts and second-unit material for *Gone with the Wind* (1939) among other Selznick productions.

24 The additional edits that producers required were often eliminations of material extraneous to the narrative, which were thought inessential atmosphere. Hal Wallis's cutting notes, for example, are famous for excising footage to quicken the pace. His notes on the climax of *Angels with Dirty Faces* (1938) are excerpted in Richard Maltby, *Hollywood Cinema*, 2nd ed. (Malden, MA: Blackwell Publishing, 2003), 334–335.

25 *An Oral History with Gene Fowler, Jr., and Marjorie Fowler,* interviewed by Douglas Bell,

Academy Oral History Program, Margaret Herrick Library, AMPAS (Academy Foundation, 1990), 113.

26 Grant Whytock, interview with Richard Koszarski, Universal Pictures Project, American Film Institute/Louis B. Mayer Oral History Collection, box 56, vol. 15 (1970): 5–6.

27 On Warner Bros. and MGM's practice of assigning editors to the sets of first-time directors' films, see *An Oral History with Rudi Fehr,* interviewed by Douglas Bell, Academy Oral History Program, Margaret Herrick Library, AMPAS (Academy Foundation, 1992–93), 124–126; and *An Oral History with Margaret Booth,* 46–47.

28 Interview with William Reynolds in *Selected Takes: Film Editors on Editing,* ed. Vincent LoBrutto (Westport, CT: Praeger, 1991), 16.

29 Ralph Dawson, "How *Anthony Adverse* Was Cut," *American Cinematographer* (hereafter *AC*) (August 1935): 345.

30 Ralph E. Winters is quoted in Kevin Lewis, "The Moviola Mavens and the Moguls," *Editors Guild Magazine* 27, no. 2 (March-April 2006); www.editorsguild.com/magazine.cfm?ArticleID=207, accessed July 14, 2014.

31 Margaret Booth, "The Cutter," in *Behind the Screen,* ed. Stephen Watts (London: A. Barker, 1938), 153.

32 D.W.C., "Shears for the Ladies," *New York Times,* August 2, 1936, X4.

33 Elmo Williams and Dann Cahn mention these qualities. They are quoted in "The Great Society: Highlights from the Early Years of the Editor's Guild," *Editors Guild Magazine* 28, no. 3 (May-June 2007); www.editorsguild.com/magazine.cfm?ArticleID=325, accessed July 14, 2014.

34 Karen Ward Maher, *Women Filmmakers in Early Hollywood* (Baltimore: Johns Hopkins University Press, 2006), 200–202.

35 In her oral history interview, Marjorie Fowler disputed that the profession was particularly open to women when her career began: "When I came along [in the early 1940s] there were, I'd say offhand, a half-dozen or so. Each studio had one ... that's all, and they didn't seem to *want* to come in." See *Oral History with Gene Fowler, Jr., and Marjorie Fowler,* 19–20.

36 Dmytryk, *It's a Hell of a Life,* 17.

37 Notable women editors of the silent era, such as Hettie Gray Baker and Katherine Hilliker, simultaneously worked as scenario editors, title writers, and editors. See Kristen Hatch, "Cutting Women: Margaret Booth and Hollywood's Pioneering Female Film Editors," in *Women Film Pioneers Project,* ed. Jane Gaines, Radha Vatsal, and Monica Dall'Asta, Center for Digital Research and Scholarship (New York: Columbia University Libraries, 2013); wfpp.cdrs.columbia.edu/essay/cutting-women/, accessed July 14, 2014. On the flexibility of work and women's careers during the silent era, see Maher, *Women Filmmakers in Early Hollywood,* 29–76.

38 Dmytryk started as a projectionist, and Don Siegel began in the film library.

39 Philip K. Sheuer, "Lady Film Cutters: a Vanishing Profession," *Los Angeles Times,* April 21, 1940, C3.

40 See, for example, Blanche Sewell, "Editing is Easy When ... ," *AC* (December 1932): 26, 42; and Dawson, "Cutting *Anthony Adverse.*"

41 "Film Editors Organizing Own Section in Academy," *Film Daily,* October 25, 1932, 8; and "Film Editors Propose Annual Merit Award," *Film Daily,* December 22, 1934, 1.

42 *An Oral History with Fredrick Y. Smith,* interviewed by Douglas Bell, Academy Oral History Program, Margaret Herrick Library, AMPAS (Academy Foundation, 1994), 182–190; and *Oral History with Rudi Fehr,* 118–119.

43 *SMPFE Dinner-Dance Commemorative Program, September 20, 1940* (Los Angeles: SMPFE,

1940), 33.

44 Ibid., 57.

45 Cecil B. DeMille is quoted in Anne Bauchens, "How We Use These Devices to Increase Production Value," in "Transitions and Time Lapses: Fades, Wipes, and Dissolves, Their Use and Value to the Production," *AMPAS Academy Technical Branch Technical Bulletin*, no. 10 (September 28, 1934): 8.

46 Ibid.

47 Lloyd Knechtel, "Optical Printing," *International Photographer* (July 1930): 12.

48 See Margaret Booth interview in Kevin Brownlow, *The Parade's Gone By* (New York: Alfred A. Knopf, 1968), 305.

49 Bordwell, "Part One: The Classical Hollywood Style," 47.

50 *Oral History with Gene Fowler, Jr., and Marjorie Fowler*, 16. The Fowlers go on to attribute the eventual move away from dissolves to the influence of television (45).

51 Bordwell, "Part One: The Classical Hollywood Style," 57.

52 I. James Wilkinson and W. H. Hamilton, "Motion Picture Editing," *Journal of the Society of Motion Picture Engineers* 36 (January 1941): 103.

53 Oral history interviewer Douglas Bell drew editor Frederick Y. Smith's attention to mismatched action and character positions in a dialogue sequence from *The Libeled Lady*. Smith didn't perceive the violation as a flaw: "Those are beautifully balanced close-ups. . . . It couldn't look any better!" *An Oral History with Fredrick Y. Smith*, 212.

54 Bordwell, "Part One: The Classical Hollywood Style," 13.

55 Kent, interview with Koszarski, 38.

56 *Oral History with Ralph Winters*, 72.

57 On genre/scene conventions, see Patrick Keating, *Hollywood Lighting: From the Silent Era to Film Noir* (New York: Columbia University Press, 2013), 71–81, 91–99.

58 Kent, interview with Koszarski, 38.

59 Bordwell, "Part One: The Classical Hollywood Style," 62; and Salt, *Film Style and Technology*, 237–238.

60 Harcus, "Finishing a Motion Picture," 554.

61 Selznick, quoted in Alan David Vertrees, *Selznick's Vision: "Gone with the Wind" and Hollywood Filmmaking* (Austin: University of Texas Press, 1997), 60.

62 For a survey of Menzies's career and contributions to studio-era filmmaking, see David Bordwell, "William Cameron Menzies: One Forceful, Impressive Idea" (March 2010), www.davidbordwell.net/essays/menzies.php, accessed July 12, 2015.

63 Robert L. Carringer, *The Making of "Citizen Kane"* (Berkeley: University of California Press, 1996), 110.

64 Kristin Thompson, *Herr Lubitsch Goes to Hollywood: German and American Film after World War I* (Amsterdam: Amsterdam University Press, 2005), 121–123.

65 Ed Gibbons, "Montage Marches In," *International Photographer* (October 1937): 25.

66 Karl Freund goes so far as to claim montage theories were just descriptions of Hollywood's editing practices, confused by "characteristic, Russian introspectiveness." Karl Freund, "Just What Is 'Montage'?," *AC* (September 1934): 210.

67 Gibbons, "Montage Marches In," 26.

68 "Montage—A Look into the Future with Slavko Vorkapich," *Cinema Progress* (December 1937–January 1938): 18.

4 Classical Hollywood, 1928 –1946: Special/Visual Effects

Thanks to Kristen Whissel, Julie Turnock, Katharina Loew, Sarah Keller, and audiences at Northwestern University and Princeton University for feedback and advice pertaining to this research.

1 For overviews of effects in the classical era see David Bordwell and Kristin Thompson, "Technological Change and Classical Film Style," in *Grand Design: Hollywood as a Modern Business Enterprise, 1930–1939*, ed. Tino Balio (Berkeley: University of California Press, 1993), 130–135; and Barry Salt, *Film Style and Technology: History and Analysis*, 2nd ed. (London: Starword, 1992), 186–187, 209–210, 235–236. For more in-depth non-academic discussions see Richard Rickitt, *Special Effects: The History and Technique* (New York: Billboard Books, 2007); and Raymond Fielding, *Special Effects Cinematography*, 4th ed. (Oxford: Focal Press, 1985). Versions of several of the technical articles referenced below are reprinted in George E. Turner, ed., *The ASC Treasury of Visual Effects* (Hollywood, CA: American Society of Cinematographers, 1983).

2 The notion that effects enhance production value is prominent in industry discourse. For example, G. A. Chambers points out those effects shots that, "unrecognized as 'trick' shots, are inserted in a picture to lend production value." G. A. Chambers, "Process Photography," *Journal of the Society of Motion Picture Engineers* (hereafter *JSMPE*) 18, no. 6 (June 1932): 782.

3 Farciot Edouart, "Paramount Transparency Process Projection Equipment," *JSMPE* 40, no. 6 (June 1943): 369.

4 Carroll Dunning, "Typical Problems in Process Photography," *Transactions of the Society of Motion Picture Engineers* (hereafter *TSMPE*) 13, no. 38 (May 1929): 298. See also Frank Williams, "Trick Photography," *TSMPE* 12, no. 34 (April 1928): 537; and Bordwell and Thompson, "Technological Change and Classical Film Style," 131.

5 Charles Loring, "The Cinema Workshop (For Semi-Professional and Amateur Production): 12. Special Effects," *American Cinematographer* (hereafter *AC*) (June 1947): 208.

6 "Biggest Stage on Earth Devoted Entirely to Special Process Work," *AC* (April 1929): 20.

7 Fred M. Sersen, "Special Photographic Effects," *JSMPE* 40, no. 6 (June 1943): 376; David Bordwell, "The Classical Hollywood Style, 1917–60," in David Bordwell, Janet Staiger, and Kristin Thompson, *The Classical Hollywood Cinema: Film Style and Mode of Production to 1960* (New York: Columbia University Press, 1985), 59.

8 Bordwell and Thompson, "Technological Change and Classical Film Style," 131.

9 A particularly nuanced example can be found in Scott Bukatman, "The Artificial Infinite: On Special Effects and the Sublime," *Matters of Gravity* (Durham, NC: Duke University Press, 2003), 90. For a discussion of contemporary spectacular effects that addresses their continuity with effects in the classical era see Kristen Whissel, *Spectacular Digital Effects: CGI and Contemporary Cinema* (Durham, NC: Duke University Press, 2014).

10 Lev Manovich, *The Language of New Media* (Cambridge, MA: MIT Press, 2001), 301. Manovich's observation that earlier effects techniques such as rear projection and matte painting "were pushed to the periphery by its practitioners, historians, and critics" does not seem to justify identifying the cinema of the classical era, but not ours, with "indexicality" (299). For an argument against this distinction see Stephen Prince, *Digital Visual Effects in Cinema: The Seduction of Reality* (New Brunswick, NJ: Rutgers University Press, 2012).

11 See David O. Selznick to Jack Cosgrove, October 10, 1939, folder 45: *Gone with the Wind* (misc.), Vertical File Collection, Margaret Herrick Library, Academy of Motion Picture Arts and Sciences, Beverly Hills (hereafter MHL).

12 See Haidee Wasson's introduction to "In Focus: Screen Technologies," *Cinema Journal* 51, no. 2 (Winter 2012): 141–144.

13 On the heterogeneous spatialities and temporalities in rear projection see Dominique Païni, "The Wandering Gaze: Hitchcock's Use of Transparencies," in Dominique Païni and Guy Cogeval, *Hitchcock and Art: Fatal Coincidences* (Montreal: Montreal Museum of Fine Arts, 2000), 51–78; and Laura Mulvey, "A Clumsy Sublime," *Film Quarterly* 60, no. 3 (Spring 2007): 3.

14 A. Arnold Gillespie, "Big Ones Out of Little Ones," 10 vols., 5:9–12, folders 1–3 (manuscript undated), A. Arnold Gillespie Manuscript Collection, MHL.

15 Hans Dreier, "Motion Picture Sets," *JSMPE* 17, no. 5 (November 1931): 790.

16 Vincent Korda, "Why Overlook the Set-Miniature?" *AC* (December 1941): 561.

17 Ibid., 588.

18 Don Jahraus, "Making Miniatures," *AC* (November 1931): 9.

19 Edwin G. Lindin, "Destroying Pompeii—in Miniature," *AC* (December 1935): 519, 522–523; Fred M. Sersen, "Special Photographic Effects," *JSMPE* 40, no. 6 (June 1943): 376.

20 See Gordon Jennings, "A Boom for Operating Miniature Airplanes," *AC* (July 1942): 297.

21 Gillespie, "Big Ones Out of Little Ones," 7:5–8; "*Mrs. Miniver* Process Shots" (February 10, 1942), folder 131: *Mrs. Miniver*—production, Andrew Marton Papers, MHL.

22 G. F. Hutchins, "Dimensional Analysis as an Aid to Miniature Cinematography," *JSMPE* 14, no. 4 (April 1930): 377–383; Sersen, "Special Photographic Effects," 378.

23 Carl Louis Gregory, "Trick Photography," *TSMPE* 9, no. 25 (September 1926): 104–105.

24 Orville Goldner and George E. Turner, "The Making of the Original *King Kong*," *AC* (January 1977): 102.

25 Chambers, "Process Photography," 783; J. A. Norling, "Trick and Process Cinematography," *JSMPE* 28, no. 2 (February 1937): 151; Salt, *Film Style and Technology*, 180, 194.

26 Arthur J. Campbell, "Making Matte-Shots," *AC* (December 1934): 347.

27 Frank Williams, "Trick Photography," *TSMPE* 12, no. 34 (April 1928): 537; Carroll Dunning, "Composite Photography," *TSMPE* 12, no. 36 (September 1928): 975–979; Dunning, "Typical Problems in Process Photography," 298–302.

28 John P. Fulton, "How We Made the Invisible Man," *AC* (September 1934): 200–201, 214.

29 Ralph G. Fear, "Projected Background Anematography," *AC* (January 1932): 11–12, 26; Vern Walker, "Special Process Technic," *JSMPE* 18, no. 5 (May 1932): 663–664; Chambers, "Process Photography," 786–787; Farciot Edouart, "The Transparency Projection Process," *AC* (July 1932): 15, 39; H. G. Tasker, "Current Developments in Production Methods in Hollywood," *JSMPE* 24, no. 1 (January 1935): 3–11; G. G. Popovici, "Background Projection for Process Cinematography," *JSMPE* 24, no. 2 (February 1935): 102–109; Julie Turnock, "The Screen on the Set: The Problem of Classical-Studio Rear Projection," *Cinema Journal* 51, no. 2 (Winter 2012): 157–162.

30 Farciot Edouart, "Paramount Transparency Process Projection Equipment," *JSMPE* 40, no. 6 (June 1943): 368–369.

31 Walker, "Special Process Technic," 664; Vernon Walker, "Saunders Cellulose Screen Reduces 'Hot Spot,'" *AC* (October 1932): 11; William Stull, "The Dieterich Process for Composite Photography," *AC* (March 1933): 9; H. D. Hineline, "Composite Photographic Processes," *JSMPE* 20, no. 4 (April 1933): 293–294; Popovici, "Background Projection," 102–109; H. Griffin, "New Background Projector for Process Cinematography," *JSMPE* 27, no. 1 (July 1936): 96; A. F. Edouart, "Paramount Triple-Head Transparency Process Projector," *JSMPE* 33, no. 2 (August 1939): 180, 172.

32 Edouart, "Transparency Projection Process," 15.

33 Walter Blanchard, "Production Economies with Process Photography," *AC* (July 1934): 110–111, 118–119. Although the studio goes unnamed in Blanchard's article, a comparison with the writing of Farciot Edouart of Paramount suggests that his was the studio in question. See Edouart, "Paramount Transparency Process Projection Equipment," 369.

34 Blanchard, "Production Economies," 110.

35 Edouart, "Paramount Transparency Process Projection Equipment," 369–370.

36 Edouart, "Paramount Triple-Head," 180.

37 Salt, *Film Style and Technology,* 209; Linwood G. Dunn, "Creating Film Magic for the Original *King Kong*," *AC* (January 1977): 96.

38 Edouart, "Paramount Triple-Head," 180. Also see Byron Haskin, "Development and Practical Application of the Triple-Head Background Projector," *JSMPE* 34, no. 3 (March 1940): 252–258.

39 A. F. Edouart, "Work of the Process Projection Equipment Committee of the Research Council," *JSMPE* 33, no. 3 (September 1939): 252.

40 William Stull, "Process Shots Aided by Triple Projector," *AC* (August 1939): 364. Also see F. W. Jackman, "Evolution of Special-Effects Cinematography from an Engineering Viewpoint," *JSMPE* 29, no. 3 (September 1937): 302.

41 Stull, "Process Shots Aided by Triple Projector," 376.

42 Edouart, "Paramount Transparency Process Projection Equipment," 371.

43 Ibid., 372–373. Also see William Hoch, "Cinematography in the Hollywood Studios (1942): Technicolor Cinematography," *JSMPE* 39, no. 2 (August 1942): 101–102.

44 Rickitt, *Special Effects,* 61.

45 Alfred B. Hitchins, "Duplex Optical Printers," *TSMPE* 11, no. 32 (September 1927): 771–774; Herford Tynes Cowling, "For Trick Work," *AC* (March 1928): 7, 22–23; Carl Louis Gregory, "An Optical Printer for Trick Work," *TSMPE* 12, no. 34 (April 1928): 419–426; L. Dunn, "Optical Printing and Technic," *JSMPE* 26, no. 1 (January 1936): 54–66; Linwood Dunn, "New Acme-Dunn Optical Printer," *JSMPE* 42, no. 4 (April 1944): 204–210.

46 As of October 1926 Eastman Duplicating Film had been available "for a number of years" but there had not yet been instructions for its use. J. G. Capstaff and M. W. Seymour, "The Duplication of Motion Picture Negatives," *TSMPE* 10, no. 28 (February 1927): 229; Salt, *Film Style and Technology,* 180, 195.

47 Gregory, "An Optical Printer for Trick Work," 419.

48 R. Seawright and W. V. Draper, "Photographic Effects in the Feature Production 'Topper,'" *JSMPE* 32, no. 1 (January 1939): 60–72.

49 Lynn Dunn, "Tricks by Optical Printing," *AC* (April 1934): 496.

50 Fred W. Jackman, "The Special-Effects Cinematographer," *AC* (October 1932): 42; Dunn, "Optical Printing and Technic," 55.

51 Gillespie, "Big Ones Out of Little Ones," 1:2.

52 See Turnock, "The Screen on the Set," 159–162.

53 "Recommendations on Process Projection Equipment," *JSMPE* 32, no. 6 (June 1939): 608; "Report of the Projection Practice Committee," *JSMPE* 30, no. 6 (June 1938): 644.

54 John Belton, *Widescreen Cinema* (Cambridge, MA: Harvard University Press, 1992), 34–38; Amir H. Ameri, "The Architecture of the Illusive Distance," *Screen* 54, no. 4 (Winter 2013): 439–462.

55 B. Schlanger, "Reversing the Form and Inclination of the Motion Picture Theater Floor for Improving Vision," *JSMPE* 17, no. 2 (August 1931): 167.

56 C. Francis Jenkins, "Pantomime Pictures by Radio for Home Entertainment," *TSMPE* 12, no. 33 (April 1928): 116; C. Francis Jenkins, "The Transmission of Movies by Radio," *TSMPE*

12, no. 36 (September 1928): 915–920; H. R. Lubcke, "The Theatrical Possibilities of Television," *JSMPE* 25, no. 1 (July 1935): 46–49; "Television from the Standpoint of the Motion Picture Industry," *JSMPE* 29, no. 2 (August 1937): 144–148; D. W. Epstein and I. G. Maloff, "Projection Television," *JSMPE* 44, no. 6 (June 1945): 443–455.

57 Cecil DeMille, "A Director Looks at 'Process-Shots'" *AC* (November 1936): 458–459.

58 Clarence W. D. Slifer, "Creating Visual Effects for G.W.T.W.," *AC* (August 1982): 788–791, 833–848; Rickitt, *Special Effects*, 26.

59 Slifer, "Creating Visual Effects for G.W.T.W.," 838–839, 841; "*Gone with the Wind*: Schedule of Cosgrove Shots" (May 27, 1939), folder 2: Special Effects: *Gone with the Wind* file, Ronald Haver Collection, MHL; Alan David Vertrees, *Selznick's Vision: "Gone with the Wind" and Hollywood Filmmaking* (Austin: University of Texas Press, 1997), 69–124.

60 David O. Selznick to William Paley, July 16, 1941, folder 2: Special Effects: *Gone with the Wind* file, Ronald Haver Collection, MHL.

61 David O. Selznick to Mr. Klune, May 4, 1939, folder 45: *Gone with the Wind* (misc.), Vertical File Collection, MHL; R. A. Klune to Mr. Selznick, May 12, 1939, folder 2: Special Effects: *Gone with the Wind* file, Ronald Haver Collection, MHL.

62 "Concerning the Presentation of *Gone with the Wind*," folder 45: *Gone with the Wind* (misc.), Vertical File Collection, MHL.

63 "Explanation of Transparency Process Prepared by Raymond A. Klune for Mr. William Paley, at Request of Mr. Selznick," July 3, 1941, folder 2: Special Effects: *Gone with the Wind* file, Ronald Haver Collection, MHL. On optical printing in *Citizen Kane* see David Bordwell, "Film Style and Technology, 1930–60," in Bordwell, Staiger, and Thompson, *The Classical Hollywood Cinema*, 349.

64 Edouart, "Paramount Triple-Head," 180–181.

65 Goldner and Turner, "Making of the Original *King Kong*," 62, 81; Rickitt, *Special Effects*, 184–186.

66 R. Riley, Natalie Kalmus, W. E. Pohl, "Report for Special Effects Department Committee: Painting Matte Shots," 2–3, folder 2: Special Effects: *Gone with the Wind* file, Ronald Haver Collection, MHL.

67 Vernon L. Walker, "Use of Miniatures in Process Backgrounds," *AC* (August 1934): 162.

68 J. A. Norling, "Three-Dimensional Motion Pictures," *JSMPE* 33, no. 6 (December 1939): 617; W. E. Garity and W. C. McFadden, "Multiplane Camera Crane for Animation Photography," *JSMPE* 31, no. 2 (August 1938): 144–156. William Paul makes the connection between deep-focus cinematography, 3D, and the multiplane camera in William Paul, "The Aesthetics of Emergence," *Film History* 5, no. 3 (1993): 333.

69 Garity and McFadden, "Multiplane Camera Crane," 147.

70 David O. Selznick to Mr. Klune, April 14, 1939, folder 2: Special Effects: *Gone with the Wind* file, Ronald Haver Collection, MHL.

71 "*Dr. Cyclops* in Two Counts in Hall of Fame," *AC* (May 1940): 220.

72 Also see Païni, "The Wandering Gaze," 69, 77. For the suggestion, in early 1932, that rear-projected images be made in widescreen, see Fear, "Projected Background Anematography," 12.

5 Postwar Hollywood, 1947–1967: Editing

1 Arthur L. Gaskill and David A. Englander, *Pictorial Continuity: How to Shoot a Movie Story* (New York: Duell, Sloan and Pearce, 1947), vi.

2 Ibid., 3, 4–5, 6, 8.

3 Ibid., 6.

4 Patrick Keating, *Hollywood Lighting from the Silent Era to Film Noir* (New York: Columbia University Press, 2009).

5 David Bordwell discusses Selznick's push against "cuttiness" in films in "A Dose of DOS: Trade Secrets from Selznick," a blog entry of December 17, 2012, at www.davidbordwell. net/blog/2012/12/17/a-dose-of-dos-trade-secrets-from-selznick/.

6 Barry Salt, *Film Style and Technology: History and Analysis*, 3rd ed. (London: Starwood, 2009), 236.

7 Ibid., 256.

8 For one contemporaneous ode to the crab dolly, see cinematographer Lee Garmes's "New 'All Direction' Baby Camera Dolly," *American Cinematographer* (hereafter *AC*) (September 1950): 307, 321–322. For the filming of *Rope*, see Virginia Yates, "'Rope' Sets a Precedent," *AC* (July 1948): 230–231, 246.

9 Guy Stockwell, quoted from "The Face on the Cutting Room Floor," *Cinemeditor* 15, no. 1 (Winter 1965): 15 (emphasis in original).

10 Arthur G. Clarke, "CinemaScope Photographic Techniques," *AC* (June 1955): 362.

11 See Lisa Dombrowski, "Cheap but Wide: The Stylistic Exploitation of CinemaScope in Black-and-White Low-Budget American Films," in *Widescreen Worldwide*, ed. John Belton, Sheldon Hall, and Steve Neale (Herts, UK: John Libbey Publishing, 2010), 63–70; Ariel Rogers, "*East of Eden* in CinemaScope: Intimacy Writ Large," in *Cinematic Appeal: The Experience of New Movie Technologies* (New York: Columbia University Press, 2013), 63–90. Such studies take inspiration from David Bordwell's pioneering "CinemaScope: *The Modern Miracle You See Without Glasses*," in his *Poetics of Cinema* (New York: Routledge, 2008), 281–325.

12 Salt, *Film Style and Technology*, 277.

13 Barry Salt, "The Shape of 1959," *New Review of Film and Television Studies* 7 no. 4 (December 2009): 393–409.

14 Frederick Y. Smith, "A Controversial Evening (1st A.C.E. Symposium)," *Cinemeditor* 13, no. 2 (Summer 1963): 13.

15 See Leonard A. Herzig, "Film Splicing without Cement or Adhesives," *Journal of the Society of Motion Picture and Television Engineers* 60, no. 2 (February 1953): 181–188.

16 Irving Lerner, "The Butt Splicer: Editor's Aid or Gimmick?," *Cinemeditor* 14, no. 2 (Summer 1964): 17.

17 As *Easy Rider*'s editor Donn Cambern puts it, "The KEM system removed all that searching [for alternate takes or out-takes] because whatever was not in the film was on rolls in sync that you could play on another picture head on the same machine." See his interview in *First Cut: Conversations with Film Editors*, Twentieth Anniversary Edition, ed. Gabrielle Oldham (Berkeley: University of California Press, 2012), 203. To come even remotely near that with the Moviola, editors, such as Dede Allen, had to work with two Moviolas and go back and forth between machines. See Allen's interview in *Selected Takes: Film Editors on Editing*, ed. Vincent LoBrutto (Westport, CT: Praeger, 1991), 77.

18 Salt, "The Shape of 1959," 407.

19 On the editing in *The Pawnbroker*, see Ralph Rosenblum's own account of his efforts: Rosenblum with Robert Karen, *When the Shooting Stops . . . The Cutting Begins: A Film Editor's Story* (New York: Da Capo, 1979), 139–166.

20 Bradley Schauer provides sharp discussion of split-screen in his contribution to the volume on cinematography in this series. See Schauer, "The Auteur Renaissance, 1968–1980," in *Cinematography*, ed. Patrick Keating (New Brunswick, NJ: Rutgers University Press, 2014), 97–100.

21 Jan-Christopher Horak, *Saul Bass: Anatomy of Film Design* (Lexington: University Press of Kentucky, 2014). Crowther's review, from the *New York Times* for December 22, 1966, is quoted on p. 239 of Horak's book.

22 Stanley Frazen, "'Monkees' in the Cutting Room," *Cinemeditor* 17, no. 1 (Spring 1967): 24–25. In like fashion, the psychedelic TV comedy *Laugh-In*, debuting in 1967, was predicated on quick cuts, even as it resuscitated vaudeville. Just how widespread the idea of visual overload or surround was can be seen in the benign example of *Mad* magazine. True, there were cartoon panels that adhered to the logic of sequentiality: for instance, Dave Berg's whimsical looks at American mores, "The Lighter Side," requires reading to a punch-line final panel. Yet *Mad* frequently fractures the coherent, logical page layout by little disconnected gags in the margin ("Spy vs. Spy" is perhaps the most notorious) or by panels overloaded with extra jokes and details extraneous to the story at hand. When, in 1964's *A Hard Day's Night*, an abrupt straight cut takes us to one of the Beatles' handlers reading *Son of Mad*, it seems an homage to one irreverent media form by another.

23 For an account of editor Sam O'Steen's efforts on this scene, see the summary by his spouse, Bobbie, in the oral interview she published after his death: Sam O'Steen as told to Bobbie O'Steen, *Cut to the Chase: Forty-Five Years of Editing America's Favorite Movies* (Studio City, CA: Michael Wiese Productions, 2001), ix–x.

6 Postwar Hollywood, 1947–1967: Special/Visual Effects

1 Scott Higgins, *Harnessing the Technicolor Rainbow: Color Design in the 1930s* (Austin: University of Texas Press, 2007); John Belton, *Widescreen Cinema* (Cambridge, MA: Harvard University Press, 1992); Ariel Rogers, *Cinematic Appeals: The Experience of New Movie Technologies* (New York: Columbia University Press, 2013).

2 Julie Turnock, "The Screen on the Set: The Problem of Classical Studio Rear Projection," *Cinema Journal* 51, no. 2 (2012): 157–162.

3 Although used interchangeably with many kinds of compositing techniques in the 1920s and 1930s, in the postwar era the term "process" exclusively came to mean projection techniques. Another projection technique, front projection, used powerful lights and the precise alignment of angled mirror and light-sensitive screens to "trick" the camera into seeing projected and live-action material as part of the same space (and registering them as such). See L. F. Rider, "The Alekan-Gerard Process of Composite Technology," *American Cinematographer* (hereafter *AC*) (July 1962): 428.

4 "Cinematic Process during 1933: A Technical Review," *AC* (April 1934): 491. Effects artists experimented with color rear projection in the 1930s, but black-and-white rear projection was much more the norm. William Stull, "Process Shots Aided by Triple Projector," *AC* (August 1939): 363–364.

5 Although Hollywood did not lack technicians trained in optical printing techniques, most prominently Linwood Dunn at RKO, John Fulton and Paul Lerpae at Paramount, and Irving G. Ries at MGM, it was generally believed that there were very few who were true masters of the technique. "George Stevens Makes a Pitch: From Lerpae to Jackman," *AC* (December 1952): 538. For an account of Dunn and Cecil Love's development of "off the shelf" optical printers for the U.S. Army, see George Turner, "Cinemasters: Linwood Dunn, ASC," *AC* (December 1985): 34.

6 Herb Lightman, "*Decision Before Dawn*: Photographed Entirely on Location in Germany, in Actual Locales," *AC* (February 1952): 62.

7 As was typical in discussions of color rear projection, color distortion was only acknowledged publicly as a problem well after the fact, with the public introduction of an "improvement." Herb Lightman, "MGM's 'Tri Lace Process' Rear Projection System," *AC* (August 1964): 456.

8 Farciot Edouart, ASC, "The Evolution of Transparency Process Photography," *AC* (October 1943): 359; Charles Anderson, "Background Projection Photography," *AC* (August 1952): 360–361; Lightman, "MGM's 'Tri Laced,'" 456.

9 Lightman, "MGM's 'Tri Laced,'" 456.

10 Ibid., 466.

11 According to Paramount records, the shooting schedule for first unit: 24 days in France, 53 on lot; for the second unit, 25 days in France. "Production Costs ([period ending 12–29–1956])," "Miscellaneous" folder 663 [55-f.663], *To Catch a Thief* files, Alfred Hitchcock Papers, Margaret Herrick Library, Academy of Motion Picture Arts and Sciences, Beverly Hills, CA (hereafter MHL).

12 Herb Lightman, "Matching Footage with Studio Shots," *AC* (June 1950): 197.

13 Ibid.

14 "Frank Caffey Letter," "Production—1954–1955" Folder 215-f. 20, *To Catch a Thief* files [Paramount Production Papers], MHL.

15 Ray Kellogg and L. B. Abbott, "Special Photographic Effects in Motion Pictures," *AC* (October 1957): 662–665.

16 Arthur Rowan, "Photography Unsurpassed: *The 10 Commandments*," *AC* (November 1956): 658; Paul Mandell, "Parting the Red Sea (and Other Miracles)," *AC* (April 1983): 46–47.

17 Rowan, "Photography Unsurpassed," 660.

18 Mandell, "Parting the Red Sea," 50.

19 Ibid., 51.

20 Ibid., 47–50.

21 Darrin Scot, "Photographing 'Mutiny on the Bounty,'" *AC* (February 1963): 114.

22 Ibid., 90.

23 Qtd. in Arther Gavin, "'South Pacific': New Concept in Color Photography," *AC* (May, 1958), 319.

24 Ibid., 296.

25 Ibid. While such strategies were not unexpected in a musical, Logan and Shamroy likewise had put forward their "emotional" color theories on the more naturalistic romance *Sayonara* (1957), lighting the female lead Miiko Taka dramatically and (in Logan's words) "unrealistically" with the goal of creating a passionate response in the (heterosexual male) viewer. Logan: "I want Miiko's beauty to be so electrifying in this scene that the pulse of every man in the audience will skip a beat or two!" Ellsworth Fredricks, "The Photography of *Sayonara*," *AC* (November 1957): 742.

26 Sidney Gottlieb, ed., *Hitchcock on Hitchcock: Selected Writings and Interviews* (Berkeley: University of California Press, 1997), 51–52, 97–98, 102, 148, 151, 173–174, 202.

27 H. G. Scott, *Hitchcock-Truffaut*, rev. ed. (New York: Simon & Schuster, 1985), 65, 165.

28 "Letter from John Ferren, August 27, 1957," and "Memo to Frank Caffey from Charles West, December 11, 1957," ["Production—1956–1958" 225-f.11], *Vertigo* files [Paramount Production Papers], MHL.

29 "List of Second Unit Work in San Francisco, November 13, 1956," ["Production—1956–1958" 225-f.11], *Vertigo* files [Paramount Production Papers], MHL.

30 Hitchcock only refers to importance of the close-up of Marnie's face, which will necessitate "plates," as he puts it, in a meeting with production designer Robert Boyle. But Hitchcock does not discuss the background specifically. "Transcript, Story Outline Meeting for Production Design, February 4, 1963," "Production" folder 490, *Marnie* files, Hitchcock Papers, MHL. Though in his oral history Boyle states that he was "embarrassed" by the matte shots in *Marnie* (68), he never discusses the rear projection. Interview with Robert F. Boyle, by George Turner, 1998, Oral History Program, MHL. Even the famous example of *Foreign Correspondent* (1940), where rear projection is used to simulate the effect of a plane crashing into water (complete with the physical effect of water breaking through the windshield), is a spectacular "realistic" effect, not an expressive one.

31 When the Schufftan process became known outside of Germany, Hitchcock was quick to use it in Britain, as in *Blackmail*. When rear projection became dominant in the 1930s, he tried it in *The Lady Vanishes* and *Foreign Correspondent*. As color started to dominate production, he used VistaVision and 65mm film for better quality rear screen plates in *To Catch a Thief* and *North by Northwest*. Likewise, when optical printing and rotoscoping started to reenter the marketplace in the early 1960s, it was used in *The Birds* and *Marnie*.

32 See Ronnie D. Lipschutz, *Cold War Fantasies: Film, Fiction, and Foreign Policy* (Lanham, MD: Rowman & Littlefield, 2001), 1–14.

33 Harryhausen is best known for his stop-motion animation work on legend-based fantasy films such as *Jason and the Argonauts* (Don Chaffey, 1963), *The 7th Voyage of Sinbad* (Nathan Juran, 1963), and *Clash of the Titans* (Desmond Davis, 1981).

34 David Bordwell, Janet Staiger, and Kristin Thompson, *The Classical Hollywood Cinema: Film Style and Mode of Production to 1960* (New York: Columbia University Press, 1985); Tino Balio, *Grand Design: Hollywood as a Modern Business Enterprise, 1930–1939* (Berkeley: University of California Press, 1995).

35 For example, Williams process patent holder Frank Williams, and Dunning process inventors, father and son Carroll H. and C. Dodge Dunning, set up independent effects houses based on maintaining exclusive rights to their inventions.

7 The Auteur Renaissance, 1968-1980: Editing

Special thanks to Vickie Sampson and Monica Champagne for their help in writing this essay.

1 Howard S. Becker, "Art as Collective Action," *American Sociological Review* 39, no. 6 (December 1974): 768.

2 Robert R. Faulkner, *Music on Demand: Composers and Careers in the Hollywood Film Industry* (New Brunswick, NJ: Transaction, 1983); Robert R. Faulkner, "Swimming with Sharks: Occupational Mandate and the Film Composer in Hollywood," *Qualitative Sociology* 1, no. 2 (September 1978): 99–129; Robert R. Faulkner, *Hollywood Studio Musicians: Their Work and Careers in the Recording Industry* (New Brunswick, NJ: Transaction, 1971).

3 Faulkner, "Swimming with Sharks," 126.

4 Thomas Porcello, "Speaking of Sound: Language and the Professionalization of Sound-Recording Engineers," *Social Studies of Science* 34, no. 5 (Special Issue on Sound Studies: New Technologies and Music) (October 2004): 733–758.

5 Peter Rainer, "Do Film Critics Know What Editors Do?" *Motion Picture Editors Guild Newsletter* 16, no. 1 (January–February 1995): 4.

6 Jerry Greenberg, quoted in *Selected Takes: Film Editors on Editing*, ed. Vincent LoBrutto (Westport, CT: Praeger, 1991), 120; Carol Littleton, quoted in *First Cut: Conversations with Film Editors*, 20th Anniversary Edition, ed. Gabriella Oldham (Berkeley: University of California Press, 2012), 66; Alan Heim, quoted in Oldham, *First Cut*, 381.

7 Murch, quoted in "Walter Murch Interviews Anne Coates," *Editors Net*, www.norman-hollyn.com/class/handouts/coates.html, accessed May 24, 2014.

8 Quoted in Ric Gentry, "Dede Allen: An Interview," *Post Script* 19, no. 3 (Summer 2000): 14.

9 Quoted during "Dede Allen in Conversation" at the Los Angeles Creative Pro User Group (April 19, 2006), www.youtube.com/watch?v=RR2UKWeGmOo, accessed on May 24, 2014.

10 Quoted in Oldham, *First Cut*, 204.

11 In 1971, CMX Systems developed the first non-linear video editing system that stored audiovisual content on Memorex disk cartridges that could provide instant random access to video content.

12 Susan Christopherson and Michael Storper, "The Effects of Flexible Specialization on Industrial Politics and the Labor Market: The Motion Picture Industry," *Industrial & Labor Relations Review* 42, no. 3 (1989): 331–348.

13 Don Fairservice, *Film Editing: History, Theory, and Practice* (Manchester: Manchester University Press, 2001), 258.

14 Faulkner, "Swimming with Sharks," 100.

15 Quoted in Oldham, *First Cut*, 206.

16 Ibid., 207.

17 Ibid., 164.

18 "Walter Murch Interviews Anne Coates."

19 Heim, quoted in Oldham, *First Cut*, 391.

20 Peter Biskind, *Easy Riders, Raging Bulls: How the Sex-Drugs-and-Rock 'n' Roll Generation Saved Hollywood* (New York: Simon & Schuster, 1998), 108.

21 Quoted in LoBrutto, *Selected Takes*, 136.

22 Ibid.

23 These linguistic resources are evident in the many interview compendiums available on film editing. See, for instance, *First Cut 2: More Conversations with Film Editors*, ed. Gabriella Oldham (Berkeley: University of California Press, 2012); LoBrutto, *Selected Takes*; Roger Crittenden, *Fine Cuts: The Art of European Film Editing* (Oxford: Focal Press, 2006).

24 "Hollywood: The Shock of Freedom in Films," *Time*, December 8, 1968, www.time.com/time/magazine/article/0,9171,844256,00.html.

25 Quoted in Ric Gentry, "Dede Allen," in *Interviews from Post Script*, ed. Gerald Duchovnay (New York: State University of New York Press, 2004), 288.

26 Quoted in Gary Crowdus and Richard Porton, "The Importance of a Singular, Guiding Vision: An Interview with Arthur Penn," *Cineaste* 20, no. 2 (December 1993), www.cineaste.com/articles/the-importance-of-a-singular-guiding-vision-an-interview-with-arthur-penn-web-exclusive, accessed May 24, 2014.

27 Quoted during "Dede Allen in Conversation."

28 Claudia Luther, "Dede Allen Dies at 86; Editor Revolutionized Imaging, Sound and Pace in U.S. Films," *Los Angeles Times*, April 18, 2010, articles.latimes.com/2010/apr/18/local/la-me-dede-allen18-2010apr18.

29 Quoted in Paul Rosenfield, "Women in Hollywood," *Los Angeles Times*, July 13, 1982, G1.

30 L. Hill, "Verna Fields Never Wanted a Career," *Cinema* 35 (1976): 31.

31 Interviewed in *The Cutting Edge: The Magic of Movie Editing* (Wendy Apple, director; Warner Home Video, 2005).

32 Quoted in Mary Murphy, "Fields: Up from the Cutting Room Floor," *Los Angeles Times*, July 24, 1975, E1.

33 Hill, "Verna Fields," 31.

34 Quoted in Michael Ondaatje, *The Conversations: Walter Murch and the Art of Editing Film* (London: Bloomsbury, 2002), 13.

8 The Auteur Renaissance, 1968–1980: Special/Visual Effects

1 Terminology surrounding effects technology can be historically inconsistent and confusing, not least of all around the term "special effects" itself. The 1970s marks an era of particular terminological inconsistency. Since the mid-1960s (when the Academy Award

categories changed from special effects and split into visual effects and sound effects), movie credits for "special effects" have meant physical and mechanical effects, such as stunts, gun shot squibs, makeup prosthetics, or pyrotechnics. However, in the 1970s, in both casual and professional usage, "special effects" continues to be in frequent use, even as the techniques begin to separate in practice. For my polemical reasons for wishing to preserve the term "special" visual effects, see Julie Turnock, *Plastic Reality: Special Effects, Technology, and the Emergence of 1970s Blockbuster Aesthetics* (New York: Columbia University Press, 2015).

2 *Vérité* styles are associated with, for example, filmmakers such as Robert Altman, Hal Ashby, and Peter Bogdanovich.

3 Many diverse international filmmakers of the 1960s and 1970s explored the possibilities in science fiction and special effects, including Nicolas Roeg, David Lynch, John Boorman, Donald Cammell, John Carpenter, Andrei Tarkovsky, Louis Malle, Jean-Luc Godard, and Rainer Werner Fassbinder.

4 See David Cook, *Lost Illusions: American Cinema in the Shadow of Watergate and Vietnam, 1970–79* (Berkeley: University of California Press, 2000), xvi–xvii; Robin Wood, *Hollywood from Vietnam to Reagan* (New York: Columbia University Press, 1986), 144–155; and Richard Maltby, "Nobody Knows Everything," in *Contemporary Hollywood Cinema*, ed. Steve Neale and Murray Smith (London: Routledge, 1998), 34.

5 The evaluative notion of auteurism in the U.S. context is most closely associated with critic Andrew Sarris. On the terms "American auteurs," "New Hollywood," and others, see Thomas Elsaesser, Alexander Horwath, and Noel King, eds., *The Last Great American Picture Show* (Amsterdam: University of Amsterdam Press, 2004).

6 Thomas Schatz, "The New Hollywood," in *Film Theory Goes to the Movies*, ed. Jim Collins, Hilary Radner, and Ava Preacher Collins (New York: Routledge, 1993), 20–21; and Peter Krämer, "Post Classical Hollywood," in *Oxford Guide to Film Studies* (Oxford: Oxford University Press 1998), 289–309.

7 "John Dykstra," *Fantastic Films*, August 1978, 45; Brad Dunning, "Lights, Camera . . . Praxis!," *Los Angeles Weekly*, August 10–16, 1984; Jack Kroll, "The Wizard of Special Effects," *Newsweek*, November 21, 1977, 24; and David Hutchison, "The Incredible World of Douglas Trumbull," *Future Magazine* 1, April 1978, 62.

8 Herb Lightman, "Filming *2001: A Space Odyssey*," *American Cinematographer* (hereafter *AC*) (June 1968): 412–413.

9 For a more extensive discussion of photorealism, see Turnock, *Plastic Reality*. Although *2001*'s production and release predate the famous "Earthrise at Christmas" picture taken by the *Apollo 8* crew in 1968, Kubrick's visual aesthetic is remarkably similar to the photographic style and resolution of those images.

10 Information on retakes from the Kubrick Archive in University of the Arts archives and Special Collections at the London College of Communication at Elephant and Castle, conducted October 2007.

11 Lightman, "Filming *2001*," 442.

12 Don Shay and Jody Duncan, "*2001*: A Time Capsule," *Cinefex* 85 (April 2001): 81.

13 Douglas Trumbull, "The Slit Scan Process as Used in *2001*," *AC* (October 1969): 1026.

14 Ibid., 998.

15 Dick Smith, "Special Effects Looming Larger with Gotham's Wizards of Ahs!," *Variety*, December 12, 1984, 80.

16 Herb Lightman "Filming *2001*," 442; John Dykstra, "Miniature and Mechanical Special Effects for *Star Wars*," *AC* (July 1977): 704.

17 Rear projection was reimagined after the 1960s to display data on computer screens (as in *2001* or *Alien*), or as "miniature rear projection" to insert moving image footage into a matte painting.

18 While *Star Wars* had one sequence that included computer-generated imagery (the sche- matics of the Death Star, produced by Larry Cuba and Gary Imhoff), the motion-control rigs were computer-assisted, meaning conventional live-action cameras were attached to the computers. For more on Cuba and Imhoff, see Larry Cuba, Alternative Projections Oral Histories, Interviewer Andrew Johnston, July 23, 2010, www.alternativeprojections.com/ oral-histories/.

19 Interview with Richard Winn Taylor, Marina del Rey, July 18, 2007.

20 Douglas Trumbull, "Creating the Photographic Special Effects for *Close Encounters of the Third Kind*," *AC* (January 1978): 72.

21 See interviews collected in *George Lucas: Interviews*, ed. Sally Kline (Jackson: University Press of Mississippi, 1999), 32, 44, 50, 81.

22 Ibid., 32.

23 "Behind the Scenes of *Star Wars*," *AC* (July 1977): 701.

24 For a discussion of Lucas's attention to ancillaries, see Michael Pye and Lynda Myles, *The Movie Brats* (New York: Holt, Rinehart, and Winston, 1979), 131–132.

25 Moreover, as in the Martin Scorsese or Brian De Palma approach, self-conscious camera stylistics additionally allowed the filmmaker to align himself with an auteurist tradition and history, whether referencing Alfred Hitchcock, Roberto Rossellini, Michelangelo Antonioni, William Wyler, or Akira Kurosawa.

26 See Julie Turnock, "The ILM Version: Recent Digital Effects and the Aesthetics of 1970s Cinematography," *Film History* 24, no. 2 (2012): 158–168.

27 Trumbull formed a number of independent effects companies under different names in his post-*2001* career, starting with Trumbull-Shourt in 1970. This company eventually became Future General by 1976 and then Entertainment Effects Group in 1981. In 1984, Trumbull sold EEG to Richard Edlund, who renamed it Boss Films, and Trumbull shifted his atten- tion toward theme park ride films and his high-frame-rate image capture, projection, and exhibition processes, under the name Showscan.

28 Trumbull needed financing to develop Showscan. Trumbull, "Creating the Photographic," 72.

29 Ibid.; Lightman, "Spielberg Speaks about 'Close Encounters,'" *AC* (January 1978): 58.

30 Trumbull, "Creating the Photographic," 83.

31 Between 1967 and 1970, Paramount, Fox, and MGM all either shut down or cut to the bone their effects departments, after the retirement (forced or voluntary) of long-time heads Far- ciot Edouart, L. B. Abbot, and Arnold Gillespie, respectively, each of whom had been in place for at least forty years.

32 This is a popular critical position most influentially forwarded by Peter Biskind in *Easy Rid- ers, Raging Bulls: How the Sex-Drugs-and Rock 'n' Roll Generation Saved Hollywood* (New York: Simon & Schuster, 1998), 343–344.

33 James Harwood, "Film Effects Men Turn Trick at BO: *Star Wars* Spotlights a New Breed of Wizard," *Daily Variety*, July 27, 1977, 1.

9 The New Hollywood, 1981–1999: Editing

1 David Bordwell, "Intensified Continuity: Visual Style in Contemporary American Film," *Film Quarterly* 55, no. 3 (Spring 2002): 16–28. Bordwell also discusses shifts toward the use of long lenses and an increased reliance on tight framings as part of this intensified continuity.

2 Mike Jaye, "Electronic Editing for Motion Pictures," *American Cinematographer* (hereafter *AC*) (March 1981): 257.

3 The system is discussed in Jon Lewis, *Whom God Wishes to Destroy... Francis Coppola and the New Hollywood* (Durham, NC: Duke University Press, 1995), 59–62.

4 "Mating Film with Video for 'One from the Heart,'" *AC* (January 1981): 94.

5 Quoted in Lewis, *Whom God Wishes to Destroy*, 59.

6 "Computer-assisted Filmmaking: Coppola's Electronic Cinema," *AC* (August 1982): 777.

7 Jaye, "Electronic Editing for Motion Pictures," 256.

8 "Montage Editing: Vital Component in 'Electronic Lab,'" *Millimeter*, December 1984, 217.

9 Diana Weynand, "An Editing Alternative," *Videography*, April 1984, 33. Although *Videography* was devoted primarily to video production, the systems that Weynand wrote about, including the Montage and the EditDroid, were also being offered to film producers. As such, her arguments help illuminate the general discourse about the possibilities of these systems.

10 Joseph Rooney, "Film and Videotape Editing: The Process of Conformation," *SMPTE Journal* (February 1984): 166.

11 Ibid., 168.

12 James Verniere, "The Art of Film Editing: An Interview with Paul Hirsch," *Filmmakers Monthly* 14 (September 1981): 34.

13 Rex Weiner, "The Cutting Edge Finds Converts," *Variety*, June 27, 1994, 26.

14 Quoted in Ric Gentry, "Dede Allen," in *Interviews from Post Script*, ed. Gerald Duchovnay (Albany: State University of New York Press, 2004), 291. Allen describes the system as a Sony Beta video recorder connected to a Moviola.

15 "I wish it would come in my time; I am afraid it won't," she told the interviewer. Joyce Sunila, "Cutters' Way: Slaving over a Hot Steenbeck with Dede Allen and Richard Marks," *American Film* 11 (November 1985): 46. Allen would not use an electronic editing system until she cut Barry Sonnenfeld's *The Addams Family* (1991) on an Avid.

16 Ibid.

17 Ibid.

18 Jaye, "Electronic Editing for Motion Pictures," 257; Robert Duffy and Joseph Roizen, "A New Approach to Film Editing," *SMPTE Journal* (February 1982): 203 (see also "Computer-Assisted Filmmaking: Coppola's Electronic Cinema," 781); "The Non-linear Future," *Millimeter* (October 1987): 144.

19 "Computer-Assisted Filmmaking: Computer Research and Development at Lucasfilm," *AC* (August 1982): 775; "Montage Editing," 217; "Computer-Assisted Filmmaking: Coppola's Electronic Cinema," 777.

20 Michael J. Stanton, "EdiFlex, An Electronic Editing System," *AC* (July 1987): 102.

21 Bruce Stockler, "The Return of EditDroid," *Millimeter* (January 1990): 158–159. A documentary detailing the system's promise and collapse—*The EditDroid, Rise and Fall*—was released in mid-2014.

22 Stanton, "EdiFlex, An Electronic Editing System," 101.

23 Steven Pizello, "Avid Helps Cameron Cut to the Chase," *AC* (September 1994): 55.

24 Ibid.; Ron Resnick, "Film Editors Cut to the Digital Chase," *Variety*, February 24, 1997, A26; Gregory Solman, "Editors Spliced in Two: Rivalry Splits Biz into Avid, Final Pro Camps," *Daily Variety*, January 19, 2011, 10.

25 Ron Magid, "Edit-suite Filmmaking," *AC* (September 1999): 118–124.

26 Justin Wyatt, *High Concept: Movies and Marketing in Hollywood* (Austin: University of Texas Press, 1994).

27 Ibid., 17.

28 *"Flashdance,"* *Variety,* April 20, 1983, 12. For other contemporary examples of films being described as influenced by MTV and/or music videos, see also Janet Maslin, "'Footloose,' Story of Dancing on the Farm," *New York Times,* February 17, 1984, C12; Roger Ebert, *"Staying Alive,"* http://www.rogerebert.com/reviews/staying-alive-1983; Sheila Benson, "Throw in the Towel on 'Rocky IV,'" *Los Angeles Times,* November 27, 1985, http://articles.latimes.com/1985-11-27/entertainment/ca-4688_1_rocky-iv; Gregory Solman, "At Home on the Range: Walter Hill," *Film Comment* 30, no. 2 (1994): 75. Recent scholarly examples include Chris Jordan, *Movies and the Reagan Presidency: Success and Ethics* (Santa Barbara, CA: Greenwood Publishing, 2003), 113; and David Neumeyer, *The Oxford Handbook of Film Music Studies* (New York: Oxford University Press, 2013), 305.

29 Marco Calavita, "'MTV Aesthetics' at the Movies: Interrogating a Film Criticism Fallacy," *Journal of Film and Video* 59, no. 3 (Fall 2007): 15–31. See also R. Serge Denisoff and George Plasketes, "Synergy in 1980s Film and Music: Formula for Success or Industry Mythology?," *Film History* 4, no. 3 (1990): 257–276.

30 Calavita, " 'MTV Aesthetics' at the Movies," 18.

31 Saul Austerlitz, *Money for Nothing: A History of the Music Video from the Beatles to the White Stripes* (New York: Continuum, 2007), 22–30.

32 It is worth noting that established Hollywood directors began making music videos early in the 1980s. Perhaps the most famous example of this is John Landis's clip for the Michael Jackson song "Thriller," which debuted in December 1983. Other examples include William Friedkin's video for "Self Control" by Laura Branigan (1984) and Brian De Palma's work with Frankie Goes to Hollywood ("Relax," 1984) and Bruce Springsteen ("Dancing in the Dark," 1985).

33 Richard Gold, "'Flashdance' Film, LP Feeding Off Each Other; Companies Hope for Repeat of 'SNF' Syndrome," *Variety,* May 11, 1983, 3, 46; Stephen Holden, "Music Video Leaves Its Mark on the Film 'Footloose,'" *New York Times,* March 4, 1984, H21; Richard Gold, "'Purple Rain' Sells Rock at Box Office," *Variety,* August 1, 1984, 5, 29. See also R. Serge Denisoff, *Inside MTV* (New Brunswick, NJ: Transaction, 1988), 246–248.

34 Rick Altman, *The American Film Musical* (Bloomington: Indiana University Press, 1987).

35 Ibid., 62–64.

36 Marcia Pally, "Dancing for Their Lives," *Film Comment* 20, no. 6 (1984): 53.

37 Bordwell, "Intensified Continuity," 17.

38 Ibid., 23.

39 Ibid., 17. Another example from the same year is Scott's *The Last Boy Scout.* Still, *JFK's* running time is a modifying factor: at three hours long, its ASL remains in the four- to five-second range.

40 Ric Gentry and Robin Wallace, "Film Editor Pietro Scalia: An Interview," *Post-Script: Essays in Film and Humanities* 13, no. 3 (1994): 26.

41 The phrase is from a conference paper delivered by political scientist Robert S. Robins and psychiatrist Jerrold Post, and quoted in Michael Kurtz, "Oliver Stone, *JFK*, and History," in *Oliver Stone's USA: Film, History and Controversy,* ed. Robert Brent Toplin (Lawrence: University Press of Kansas, 2000), 170.

42 Gavin Smith, "A Question of Control," *Film Comment* 28, no. 1 (January 1992): 36.

10 The New Hollywood, 1981–1999: Special/Visual Effects

1 Jordan R. Fox, "Roy Arbogast," *Cinefex* 5 (July 1981): 43.

2 The *Star Trek* films had various directors: *Star Trek II: The Wrath of Khan* (Nicholas Meyer, 1982), *Star Trek III: The Search for Spock* (Leonard Nimoy, 1984), *Star Trek IV: The Voyage Home* (Leonard Nimoy, 1986), and *Star Trek V: The Final Frontier* (William Shatner, 1989).

3 Richard Edlund, "Special Visual Effects for *Star Wars: The Empire Strikes Back*," *American Cinematographer* (hereafter AC) (June 1980): 553, 564. Although the system was not finished in time for location shooting, it was used for the film's stop-motion work and would be invaluable to subsequent ILM shows.

4 Richard Rickitt, *Special Effects: The History and Technique* (London: Aurum Press, 2006), 78.

5 Don Shay, "Jedi Journal," *Cinefex* 13 (July 1983): 19.

6 Don Shay, "The Wrath of God . . . and Other Illusions," *Cinefex* 6 (October 1981): 64, 67.

7 Quoted in Shay, "Jedi," 8.

8 Kay Anderson, "*Star Trek: The Wrath of Khan*," *Cinefantastique* 12, nos. 5–6 (July–August 1982): 67.

9 "Effects Photography for *Star Wars: The Empire Strikes Back*," *AC* (June 1980): 592.

10 Anderson, "*Star Trek*," 62.

11 Rickitt, *Special Effects*, 192–193.

12 Julie Turnock, "The ILM Version: Recent Digital Effects and the Aesthetics of 1970s Cinematography," *Film History* 24, no. 2 (2012): 162.

13 S. S. Wilson, "*Dragonslayer*," *Cinefex* 6 (October 1981): 59.

14 Julie Turnock, "Before Industrial Light and Magic: The Independent Hollywood Special Effects Business, 1968–1975," *New Review of Film and Television Studies* 7, no. 2 (2009): 134. See also Turnock, "The ILM Version."

15 Kay Anderson, "*Star Trek III: The Search for Spock*," *Cinefantastique* 14, nos. 4–5 (September 1984): 8–9.

16 Large effects houses could also become overstretched, because they were constantly working on several significant projects at a time. In her 1982 article on the making of *Star Trek II* Anderson notes that "half the facility was working on other films, including *E.T.* and *Poltergeist*" (67).

17 David Bartholomew et al., "The Filming of *Altered States*," *Cinefantastique* 11, no. 2 (Fall 1981): 23.

18 Dennis Fischer, "*Honey, I Shrunk the Kids* Special Effects," *Cinefantastique* 20, nos. 1–2 (November 1989): 113.

19 Don Shay, "Cheap and Cheesy and Off-the-Cuff," *Cinefex* 34 (May 1988): 6.

20 Visual effects supervisor Hoyt Yeatman quoted in Ron Magid, "More about *The Fly*," *AC* (September 1986): 74.

21 Indeed, optical compositing itself seemed already to be falling out of fashion in some quarters, with the "just sort it all in post" capacity of optical compositing a butt of the joke in a cartoon accompanying a preview article on *TRON* (*Cinefantastique* 12, no. 2 [March 1982]: 12), and unsatisfactory optical composites heavily pilloried (of the bluescreen composite work in *Superman II* [Richard Lester, 1980] Michael Kaplan remarks, "You probably still won't believe a man can fly" [1981, 9]). Ubiquity was already dampening the appeal of the process before the decade had properly begun.

22 Bob Villard, "Corman's Cut-Rate FX," *Cinefantastique* 11, no. 3 (September 1981): 10.

23 I am thinking here of films like *The Exorcist* (William Friedkin, 1973) and early Cronenberg movies like *They Came from Within* (1975), *Rabid* (1977), and *The Brood* (1979).

24 Pointing out that, in the era of digital images, "indexical referencing" is no longer necessary to the appearance of photographic realism, Stephen Prince suggests we should instead

discuss moving images in terms of "perceptual realism," the "structured correspondences between the audiovisual display and a viewer's extra-filmic visual and social experience." Prince, "True Lies: Perceptual Realism, Digital Images, and Film Theory," *Film Quarterly* 49, no. 3 (Spring 1996): 27–37, 32.

25 Fullerton in Paul Mandell, "The Altered States of *Altered States*," *Cinefex* 4 (April 1981): 37.

26 David Bartholomew, "*Altered States*," *Cinefantastique* 11, no. 1 (Summer 1981): 18.

27 Jordan R. Fox and Adam Eisenberg, "*The Howling*," *Cinefantastique* 10, no. 3 (Winter 1980): 22.

28 David J. Hogan, "The Making of *The Thing*, and Rob Bottin's Eye-popping, Razzle-dazzle Makeup Effects," *Cinefantastique* 13, nos. 2–3 (November–December 1982): 67.

29 Ibid., 68.

30 Bottin in Hogan, "The Making of *The Thing*," 68.

31 The Makeup and Hair Stylists Local 706 union fined Universal Studios $10,000 because Bottin's work in *The Thing* was credited as "special makeup effects" when instead they felt he had provided "mechanical devices, mannequins, and non-living things" (Tim Lucas, review of "*The Thing*," *Cinefantastique* 13, no. 1 (September/October 1982): 49), while mechanical effects specialist Roy Arbogast was reportedly uncomfortable with the crossover of work between his team and Bottin's on the film (Hogan, "The Making of *The Thing*," 57).

32 Don Shay, "The Wrath of God . . . and Other Illusions," *Cinefex* 6 (October 1981): 71.

33 Ibid., 72.

34 Martin Perlman, "*The Terminator*: Special Effects by Fantasy II," *Cinefantastique* 15, no. 2 (May 1985): 47.

35 Christine Sandoval, "Gordon Smith: Seeking Silicone Solutions," *Cinefex* 64 (December 1995): 20.

36 In 1976 *Futureworld* used a scan and 4,000 polygon wireframe model of Peter Fonda's face by Triple-I; in 1977 *Star Wars* featured CG wireframe models for its fighter ships' targeting diagram screens by Larry Cuba; and *Alien* featured a wireframe model of a terrain flyover by Systems Simulation Ltd. for a computer display in the film (Tom Sito, *Moving Innovation: A History of Computer Animation* [Cambridge, MA: MIT Press, 2013], 153–155).

37 One of the more ingenious examples is *Escape from New York*, which features a wire-frame flight approach display constructed by adding reflective tape to all the building edges of a miniature city model painted black, and then shot with black light.

38 Both Demos and Whitney Jr. had both previously worked in computer artist John Whitney's company Motion Graphics.

39 Sito, *Moving Innovation*, 153.

40 Stephen Prince, *Digital Visual Effects in Cinema: The Seduction of Reality* (New Brunswick, NJ: Rutgers University Press, 2012), 13.

41 Julie Turnock, "Before Industrial Light and Magic: The Independent Hollywood Special Effects Business, 1968–1975," *New Review of Film and Television Studies* 7, no. 2 (2009): 146.

42 Dan North, *Performing Illusions: Cinema, Special Effects and the Virtual Actor* (London: Wallflower Press, 2008), 131.

43 Glenn Lovell, "*TRON*," *Cinefantastique* 12, no. 2 (March 1982): 12.

44 In Peter Sørensen, "Tronic Imagery," *Cinefex* 8 (April 1982): 4.

45 Ibid., 8.

46 Dennis Fischer, "*The Last Starfighter*," *Cinefantastique* 15, no. 1 (January 1985): 24–25.

47 Michele Pierson, *Special Effects: Still in Search of Wonder* (New York: Columbia University Press, 2002), 129–130.

48 Prince, *Digital Visual Effects in Cinema*, 21–22.

49 Ibid., 20.

50 See Vivian Sobchack, ed., *Metamorphing: Visual Transformation and the Culture of Quick-Change* (Minneapolis: University of Minnesota Press, 2000).

51 David Heuring, "Effects Maestros Put Buckle in Indy's Swash," *AC* (December 1989): 72–73.

52 See Matthew MacDonald, "*Pleasantville*: Color My World," *Cinefex* 76 (January 1999): 13, 16, 21–22.

53 Don Shay, "Dancing on the Edge of the Abyss," *Cinefex* 39 (August 1989): 41.

54 Ibid., 42.

55 See Ron Magid, "Effects Team Brings Dinosaurs Back from Extinction," *AC* (June 1993): 46–52.

56 Jody Duncan, "The Beauty in the Beasts," *Cinefex* 55 (August 1993): 56. The image is reproduced under Creative Commons license (CC BY-NC-SA 3.0) from Oliver Gaycken, "Jurassic Park, Animation, and Scientific Visualization," the new everyday: a media commons project, June 14, 2012, mediacommons.futureofthebook.org/tne/pieces/jurassic -park-animation-and-scientific-visualization, accessed July 1, 2012.

57 Estelle Shay, "Profile: Randal M. Dutra," *Cinefex* 59 (September 1994): 118.

58 Don Shay, "Effects Scene: In the Digital Domain," *Cinefex* 55 (August 1993): 112.

59 Jody Duncan, "A Look Back," *Cinefex* 80 (January 2000): 162.

60 Mark Cotta Vaz, "Boss Film Studios: End of an Era," *Cinefex* 73 (April 1998): 61.

61 Prince, *Digital Visual Effects*, 26.

62 Dan Persons, "*Starship Troopers*," *Cinefantastique* 29, no. 8 (December 1997): 24.

63 Estelle Shay, "*Dark City*: Masters of the Dark," *Cinefex* 74 (July 1998): 145.

64 Ibid., 78.

65 Ibid., 145.

66 George Turner, "Sophisticated Visuals on a Grand Scale for *Die Hard*," *AC* (December 1988): 61, 64.

67 Jody Duncan, "Maximum Speed," *Cinefex* 59 (September 1994): 89, 90.

68 Mark Cotta Vaz, "Cruising the Digital Backlot," *Cinefex* 67 (September 1996): 98.

11 The Modern Entertainment Marketplace, 2000–Present: Editing

1 The bibliography on post-classical cinema is vast. For a representative example that argues for the collapse of narrative and stylistic fragmentation, see Wheeler Winston Dixon, "Twenty-Five Reasons Why It's All Over," in *The End of Cinema as We Know It: American Film in the Nineties*, ed. Jon Lewis (New York: New York University Press, 2001), 356–366. Also relevant is Elizabeth Cowie, "Storytelling: Classical Hollywood Cinema and Classical Narrative," in *Contemporary Hollywood Cinema*, ed. Steve Neale and Murray Smith (London: Routledge, 1998), 178–190. Richard Maltby provides a useful overview in "'Nobody Knows Everything': Post-Classical Historiographies and Consolidated Entertainment," in Neale and Smith, *Contemporary Hollywood Cinema*, 21–44. Many film journalists have also weighed in on the debate. For the argument that modern action films are edited incomprehensibly, see Anne Bilson, "Action Sequences Should Stir, Not Just Shake," www. theguardian.com, November 5, 2008, accessed April 3, 2015. The idea that contemporary genre films are edited in a fundamentally chaotic fashion was advanced in a series of video blogs produced by Matthias Stork: "VIDEO ESSAY: CHAOS CINEMA: The Decline and Fall of Action Filmmaking," www.indiewire.com. August 22, 2011, accessed April 3, 2015.

2 Michael Ornstein, "The Evolution of MTV's Editing Style and Its Impact on Society," *Cinemaeditor* 53, no. 4 (2003): 4. Note that the organization originally used some variation on *"Cinemeditor"* for its publications until 2001, at which time it switched to *Cinemaeditor*.

3 Edgar Burcksen, "Aspects of Editing," *Cinemaeditor* 60, no. 2 (2010): 34.

4 Ibid.

5 The pros and cons of digital editing receive particular emphasis in the interviews with editors Michael Kahn and Anne Coates in Justin Chang, *FilmCraft: Editing* (London: Ilex Press/Ivy Press, 2012).

6 Ibid., 9.

7 Ibid., 10.

8 Emanuel Levy, *"Body of Lies*: How Ridley Scott Shoots a Thriller," *Emanuel Levy Cinema 24/7*, September 26, 2008, emanuellevy.com/comment/body-of-lies-how-master-ridley-scott-shoots-a-political-thriller-6/, accessed April 3, 2015.

9 Geoff King, *Spectacular Narratives: Hollywood in the Age of the Blockbuster* (London: I. B. Tauris, 2000), 91–116.

10 Edgar Burcksen and Vincent LoBrutto, "The Art of Editing and Musicals: Four Editors Tell You What Happens When You Add Music, Singing, and Dancing to a Project," *Cinemaeditor* 53, no. 4 (2003): 28.

11 Ibid., 28–29.

12 Ibid., 29.

13 Quoted in David Bordwell, *The Way Hollywood Tells It: Story and Style in Modern Movies* (Berkeley: University of California Press, 2006), 154.

14 The ASL averages by decade are estimated by Bordwell, ibid., 121.

15 The average shot lengths for films cited in this chapter were all calculated manually by the author. A useful resource for ASLs as well as an online tool for shot counting and statistical analysis can be found at cinemetrics.lv/database.php.

16 Nanci Jundi, *"Iron Man*: Dan Lebental, A.C.E. Takes Us Behind the Mask," *Cinemaeditor* 58, no. 2 (2008): 32.

17 Ellen Galvin, *"Iron Man 2*: An Interview with Dan Lebental, A.C.E.," *Cinemaeditor* 60, no. 2 (2010): 27.

18 Walter Fernandez Jr., *"Wanted*: From Russia with Blood," *Cinemaeditor* 58, no. 2 (2008): 27.

19 Peter Tonguette, "John Carpenter's Cutting Room *Ward*," *Cinemaeditor* 60, no. 2 (2010): 26.

20 David Bordwell, "Intensified Continuity: Visual Style in Contemporary American Film," *Film Quarterly* 55, no. 3 (Spring 2002): 16–28.

21 Ibid., 24.

22 Quoted in Matthew Klekner, "The Sky Never Falls for Stuart Baird, A.C.E.," *Cinemaeditor* 62, no. 4 (2012): 73.

23 Ibid., 73, 74.

24 Ibid.

25 Carolyn Giardina, "VFX Secrets Behind 'Birdman' Finally Revealed," *Hollywood Reporter*, February 24, 2015, www.hollywoodreporter.com/behind-screen/vfx-secrets-behind-birdman-finally-777258, accessed April 3, 2015.

26 Film theorist Andre Bazin famously championed the use of the long take and related techniques to uphold a sense of temporal and spatial integrity. Such a stylistic approach created what Bazin labeled a "realist aesthetic." See André Bazin, *What Is Cinema?*, trans. Timothy Bernard (Montreal: Caboose, 2009).

27 Quoted in Nathan Cole, "Processing *The Master*," *Cinemaeditor* 62, no. 4 (2012): 65.

28 Writing about the Hollywood industry event CinemaCon, *Variety* writer Brent Lang suggests that the "cinematic quality" of much high-end television programming such as *Breaking Bad* and *Mad Men* has encouraged big-screen auteurs such as Alejandro González Iñárritu, Robert Zemekis, Ang Lee, and others to enlist techniques that "redefine cinema." Specifically, he suggests that cinematographer Emmanuel Lubezki's long-take work in *Gravity* and *Birdman* and his purported use of only natural lighting conditions in Iñárritu's *The Revenant* (2015) are exemplary of this differentiation through film style. See Brent Lang, "How Movies Like Leonardo DiCaprio's 'The Revenant' Could Revolutionize the Industry," *Variety*, April 24, 2015, variety.com/2015/film/news/leonardo-di-caprio-the-revenant-the-walk-billy-lynns-last-walk-cinemacon-1201479372/, accessed April 27, 2015.

12 The Modern Entertainment Marketplace, 2000–Present: Special/Visual Effects

1 *Jurassic Park*, for instance, only had fifty-seven computer-generated dinosaur shots.

2 Tino Balio, *Hollywood in the New Millennium* (London: BFI/Palgrave Macmillan, 2013), 25.

3 "All Time Box Office," *Box Office Mojo*, accessed April 14, 2014, boxofficemojo.com/alltime/world/ .

4 "In a First, 'Phantom Menace' to Be Screened in Digital," *Los Angeles Times*, June 4, 1999, articles.latimes.com/1999/jun/04/business/fi-44024.

5 Ron Magid, "Edit-Suite Filmmaking," *American Cinematographer* (hereafter *AC*) (September 1999): 123–124.

6 Joe Fordham, "Brave New World," *Cinefex* 98 (2004): 15–33.

7 Quoted in Ron Magid, "Imagining Middle-Earth," *AC* (December 2001): 61.

8 Simon Gray, "Ring Bearers," *AC* (December 2001): 42.

9 Magid, "Imagining Middle-Earth," 66–68.

10 Ibid., 67.

11 "Perceptual realism" is Stephen Prince's term for computer-generated elements that are referentially false (such as dinosaurs or dragons) but correspond to our expectations about how objects and animals look and behave in the world. See Prince, "True Lies: Perceptual Realism, Digital Images, and Film Theory," *Film Quarterly* 49, no. 3 (1996): 27–37.

12 Kristen Whissel explores how the prevalence of the "digital multitude" in contemporary Hollywood films reflects current anxieties about historical change, power relations, and collective action. See Whissel, *Spectacular Digital Effects: CGI and Contemporary Cinema* (Durham, NC: Duke University Press, 2014), especially chapter 2, "The Digital Multitude as Effects Emblem," 59–89.

13 Dan North, *Performing Illusions: Cinema, Special Effects, and the Virtual Actor* (London: Wallflower Press, 2008), 174.

14 Andy Serkis, *The Lord of the Rings: Gollum, How We Made Movie Magic* (London: Collins, 2003), 7.

15 Stephen Prince, *Digital Visual Effects in Cinema: The Seduction of Reality* (New Brunswick, NJ: Rutgers University Press), 128–129. For more on the creation of Gollum, see Joe Fordham, "Middle-Earth Strikes Back," *Cinefex* 92 (2003): 74–92.

16 The performance-capture setup employed by *King Kong* is described in Joe Fordham, "Return of the King," *Cinefex* 104 (2006): 49–50.

17 Quoted in Jody Duncan, "The Seduction of Reality," *Cinefex* 120 (2010): 119.

18 In 1970, Japanese roboticist Masahiro Mori first invented the concept of the uncanny valley, which describes the eeriness of representations of humans as they approach lifelikeness. See Mori, "The Uncanny Valley," trans. K. F. Macdorman and Takashi Minato, *Energy* 7, no. 4 (1970): 33–35.

19 Jody Duncan, "The Unusual Birth of Benjamin Button," *Cinefex* 116 (2009): 71–118.

20 Prince, *Digital Visual Effects*, 143.

21 Michael Goldman, "With Friends Like These," *AC* (October 2010): 38–40.

22 The facial replacement process is described in Joe Fordham, "Metamorphosis," *Cinefex* 125 (2011): 20.

23 Christopher John Farley, "Natalie Portman's '*Black Swan*' Dance Double Says She Deserves More Credit," *Wall Street Journal* Speakeasy blog, March 26, 2011, blogs.wsj.com/speakeasy/2011/03/26/natalie-portman%E2%80%99s-black-swan-dance-double-says-she-deserves-more-credit/.

24 Magid, "Edit-Suite Filmmaking," 118.

25 P. J. Huffstutter, "What's a Movie Before It's a Movie? It's 'Previsualization,'" *Los Angeles Times*, July 6, 2003, C1.

26 Iain Stasukevich, "Post Focus: Adding Hocus-Pocus to *Harry Potter*," *AC* (August 2007): 78.

27 Cook here compares his previsualized animation to George Pal's "Puppetoons," stop-motion animations from the 1930s and 1940s created with wooden puppets.

28 Magid, "Imagining Middle-Earth," 66–67.

29 Steven Shaviro, "The New Cinematography," *The Pinocchio Theory* blog, posted March 4, 2014, www.shaviro.com/Blog/?p=1196.

30 For more on the history of and technologies behind the digital intermediate, see Douglas Bankston, "The Color-Space Conundrum, Part Two: Digital Workflow," *AC* (April 2005): 76–107.

31 The rapid rise of digital image capture and corresponding shifts to workflow are discussed in Christopher Probst, "Go with the Flow," *AC* (January 2012): 74–87.

32 Duncan, "Benjamin Button," 90.

33 Ignatiy Vishnevetsky, "What Is the 21st Century? Revising the Dictionary," *Notebook*, posted February 1, 2013, mubi.com/notebook/posts/what-is-the-21st-century-revising-the-dictionary, cited in Shaviro, "The New Cinematography."

34 Duncan, "Benjamin Button," 72.

35 By 3D here, I am referring to the design of digital objects that include three-dimensional data within the computer, not stereoscopic projection that creates the illusion of depth.

36 Jody Duncan, "Urban Renewal," *Cinefex* 117 (2009): 12.

37 Benjamin B, "Big Bang Theory," *AC* (August 2011): 34–35.

38 FAKE Digital Entertainment released a visual-effects featurette on their Vimeo page detailing the creation of these scenes. Marc Côté, "*Dallas Buyers Club*: The Technology and Creative Effects Behind the Movie," *Vimeo.com*, accessed June 23, 2014, vimeo.com/87962280.

39 The challenges faced by visual effects studios, particularly Rhythm and Hues, are documented in Scott Leberecht's short film *Life after Pi* (2014).

40 David S. Cohen, "Visual Effects Artists Protest Near Oscars," *Variety*, February 24, 2013, variety.com/2013/film/news/visual-effects-artists-protest-near-oscars-817905/.

41 Richard Verrier, "The Newest Trick in Special Effects: Disappearing Jobs," *Los Angeles Times*, March 24, 2013, A1.

25

42 Carolyn Giardina, "The Global Forces Behind a VFX Bankruptcy," *Hollywood Reporter,* March 1, 2013, 26; Shashank Bengali, "Digital Artists in India Make U.S. Films Pop," *Los Angeles Times,* March 28, 2014, www.latimes.com/entertainment/envelope/cotown/la-et-ct-hollywood-outsource-india-20140329-story.html.

43 Bob Strauss, "Movie Visual Effects Business in Turmoil, Artists Consider Union," *Los Angeles Daily News,* March 23, 2013, www.dailynews.com/arts-and-entertainment/20130324/movie-visual-effects-business-in-turmoil-artists-consider-union.

44 Prince, *Digital Visual Effects,* 2.

GLOSSARY

ACE: Acronym designating American Cinema Editors, an honorary society founded in 1950. After being voted in as members, editors can use the designation "A.C.E." after their name.

analytical editing/continuity editing: Within the practices of the classical Hollywood cinema, analytical editing refers to editing patterns that, typically, move from overall establishment of a scene and then to closer views of parts of the scene. Often, shifts in the focus of the scene are effected through various cues that maintain continuity, such as shot/reverse shot, or a shot of a character looking, followed by a cut to the object of the character's glance.

answer print: During the studio era, the answer print was struck from the negative after studio management approved the final cut for release. In the silent period, the answer print was made after the negative was cut to match the completed working (or cutting) print, but, with the coming of sound, additional stages were introduced. Feeler prints were made from the cut negative and sent to technical departments, which outlined and produced the necessary sound effects, music, titles, and so forth, on dubbing prints. Once completed, the work of these several departments was brought together in the answer print.

average shot length (ASL): The average length in seconds of individual shots from films, typically calculated to demonstrate tendencies within a given period of time. According to David Bordwell, the ASL of American films dropped throughout the 1980s and 1990s, to the point that many films had ASLs of less than 2 seconds, a development he attributes to the influence of music videos. See also intensified continuity.

Avid: A nonlinear editing system introduced in 1989, the Avid Film Composer would become the primary video-assisted editing system in the American film industry by the mid-1990s.

axial cutting: Editing between camera positions that are progressively closer to or farther from the subject, without a change in angle. Each shot moves along an axis, or an imaginary straight line between the camera and subject.

butt-splice: A method of editing pieces of film together that was perfected in the 1950s. Where the previous dominant practice, glue splicing, required stripping away a bit of the emulsion on two strips of film, putting glue on the exposed celluloid, and then overlapping the stripped areas, butt-splicing put the two strips end to end and then found the means (typically, transparent tape) to attach them. Combined with tape in this manner, butt-splicing entailed no loss of visual material on the attached frames and enabled edits to be taken apart and recombined anew as the filmmakers sought the best editing patterns for their film.

CMX Systems: One of the first nonlinear editing platforms, developed by CBS and Memorex in 1971.

compositing: The process of combining filmic elements taken from separate pro-filmic sources into a single frame. Compositing can be achieved by a range of methods, both analog and digital.

coverage: Coverage typically entails, first, filming the entirety of a scene with one camera set far enough away to capture everything that transpires within the scene (the master shot), and then filming salient closer views (for example, characters talking or reacting) that can, in editing, be cut into the master shot to give the scene visual variety.

digital backlot: A motion picture set where actors are filmed performing scenes against a bluescreen or greenscreen. Their performances are later composited into computer-generated settings.

digital intermediate (DI): The process of scanning celluloid film into a computer program in order to color correct and modify the image.

double (or multiple) exposure: A compositing technique whereby film is run through the camera more than once, with different portions of the frame masked or exposed for each pass. It is used for compositing separate elements inside the same frame. Technically, double exposure refers to the overlaying of two shots on the same frame (the term "split aperture" is used when masks are used to separate zones of action within the frame).

double-printing/superimposition: When two or more images are printed together, one is superimposed onto the other. This technique could be used for ghostly effects, where a performer shot against a black background is printed onto a separately shot scene.

Dunning-Pomeroy Process: A process for creating traveling mattes patented in 1927 by C. Dodge and Carroll Dunning with assistance from Roy Pomeroy. It uses color separation to "self-matte" the action footage onto pre-filmed background footage at the time of shooting.

edge numbering: Also known as rubber numbering, numbers stamped at one-foot internals on the frame edges of both image and sound tracks became standard throughout the industry by 1932. Edge numbering permitted perfect synchronization of image and sound and relieved the editor of having to constantly check his or her work on the multiple synchronizer, thereby increasing the efficiency of the physical process of editing image and dialogue tracks and, according to some scholars, encouraging a greater number of edits and more rapid cutting.

glass shots/glass painting: This technique is a form of virtual set extension that involves shooting a scene (including live action) through a pane of glass onto which scenery has been painted.

Go-Motion: An animation technique co-developed by Phil Tippett and ILM in order to give animated elements "motion blur." To create motion blur the animator moves a three-dimensional puppet in tiny increments while the camera's shutter is open. This eliminates stop motion animation's staccato or stuttered movement.

intensified continuity: Analytical term developed by David Bordwell to describe the emphasis on visual sensation over spatial and narrative continuity in American films beginning in the 1980s. Although traditional Hollywood continuity

principles were more or less preserved, films featured more shots and thus more cuts within a given sequence.

joiners: Workers (usually women) who assembled final release prints that were shipped to exhibitors. They were responsible for inserting tinted or toned sequences into each copy of the print and for splicing reels into standard lengths.

KEM/Steenbeck: Two table-top editing systems developed in Germany that came into increased usage in the 1960s. Unlike the more mechanical, upright Moviolas of the classical studio period, the KEM (Keller-Elektro-Mechanik) and Steenbeck allowed variable speed so that editing could be done faster. They also allowed multiple visual and audio tracks to be run simultaneously so that various combinations of images and sounds could be tried.

linear editing systems: A form of video-assisted editing that transferred film footage to high quality videotape, which was then used to assemble workprints; time codes were assigned to each frame to facilitate assembly. Footage was stored sequentially (linearly) on the videotapes, requiring editors to rewind or fast forward to find a specific shot.

matte: A mask used in the creation of composites that prevents part of the film from being exposed to light while allowing the unmasked parts to receive an image. The term "counter-matte" is used to refer to a matte that covers the already-exposed parts of the film.

matte painting: Paintings (often of background scenery) that are composited with separately filmed footage. They allow artists to create settings that are different from locations captured during principal photography. Matte paintings are also used to extend or complete built sets, and compositing can take place in the camera or in postproduction.

montage sequences: Montage sequences were imported to Hollywood from Germany in the mid-1920s and were widely used throughout the 1930s. Eccentric framings, rapid cutting, and complex superimpositions characterized these sequences, which were often created by dedicated departments within studios. Though stylistically experimental, montage sequences soon came to perform codified narrative tasks and were thought useful for two purposes. First, montages could efficiently compress the passage of time and indicate what narrative developments had been elided. Second, these could also economically depict narrative events that would be prohibitively expensive to film more conventionally.

morph: The seamless transition between one image or object (called the "source image") and another (called the "target image") through the phased distortion of the first image so that it gradually appears to resemble the second, usually using algorithm-based digital animation. The smoothness of the transition relies on the sophistication of the morphing algorithms used, and the points of correspondence and vectors for distortion selected in the two images. This process has become increasingly automated since its widespread adoption in the early 1990s.

motion capture: The process of recording the movements of a performer, usually by placing markers or patterns on his or her body that are tracked by an array of cameras, and then applying those movements to a digital character.

motion control: An apparatus that permits camera movements to be exactly repeated a number of times, so that the different takes can later be combined in a composite shot. Motion control allows for camera movements in composites. Early systems were mechanically based; later computer-controlled motion-control camera rigs became widespread as a favored technique for creating composites.

Moviola: The trade name for a film-viewer/editing device invented by Iwan Serrurier and first marketed in 1924. The device allowed editors to view an enlarged film image through a magnifying glass for more precise cutting.

nonlinear editing systems: A form of video-assisted editing that transferred film footage to videodiscs. These systems allowed random access to raw footage through the use of timecoded video playback. Because footage was stored on videodisc rather than on videotape, individual shots could be more easily referenced and different variations of a scene more easily compared.

optical printing: A technique used to re-photograph existing footage or, often, carefully controlled portions thereof, using the optical printer. Optical printing has been used most prominently to create composites, and its applications include transitions (such as fades, dissolves, and wipes), matte shots, and split-screen effects.

photorealism: A visual aesthetic that results from the attempt to make an image look as if it has been recorded by the photochemical processes of photography.

pre-editing: A process that eschewed "master scene" coverage in order to plan a precise visual design in advance of shooting. In the early sound period, this practice was utilized for sequences in which images needed to follow a previously

recorded sound track. While the practice could be used in a more thorough-going fashion—anticipating the practice of storyboarding—pre-editing was an extreme deviation from studio-era production practices and thus remained a minority practice explored in atypical outliers such as *Citizen Kane* (1941) and the films designed by William Cameron Menzies.

previsualization: The rendering of film sequences in low-resolution digital animation before the production phase so that filmmakers can accurately imagine each shot and plan for the practical and digital elements that will comprise it.

rear projection: Previously photographed background imagery is projected, from behind, onto a translucent screen on the set. Actors perform in front of the screen, so that the composite camera can capture their action and the projected background simultaneously.

SMPFE: Formed shortly after the U.S. Supreme Court upheld the National Labor Relations Act in the spring of 1937, the Society of Motion Picture Film Editors represented picture and sound editors, assistants, apprentices, and librarians, and ratified its first contract with producers that fall. The editors' industry-wide association focused on labor issues and, in contrast to the American Society of Cinematographers, did little to fashion an occupational identity in order to stake its claim to a distinct self-image within the studio-era production system. In 1944, the SMPFE's membership voted to affiliate with IATSE, after which it became the Motion Picture Film Editors, Local 776. A guild devoted to advancing the profession's status was not formed until 1950.

stop-motion animation: An animation technique in which an armatured model is moved in tiny increments, with each position photographed onto a separate frame of film.

stop-motion substitution: A simple effect commonly used before 1907 to create trick effects. Filming begins, then the camera is stopped and an adjustment is made to the scene in front of the camera, and shooting recommences. Stop motion creates the illusion of instantaneous transformations, appearances, or disappearances within the frame.

Telecine: Equipment used to transfer images recorded on celluloid film to video formats, including videotape and videodiscs. In transferring from film to video, a beam of light is projected through the filmstrip and recorded in a special photo-electric cell. Various techniques are used to account for the different frame-rates of film and video so that the transfer remains in synch.

traveling mattes: A technique that uses mattes to composite a moving figure with a background that has been filmed separately. They are produced by re-photographing the composite elements into negative and positive areas through high-contrast reversal stock. With traveling (as opposed to still) mattes, the matted area shifts from frame to frame, making it possible to display the varying portions of the background exposed as the figure moves. Hand-drawn traveling mattes are created through a process similar to animation and are more labor intensive than traditional mattes. An artist creates male and female matte elements by hand blackening the composite area frame by frame.

Tri-Lace rear projection system: A rear projection technique developed by MGM in the early 1960s that simultaneously projected images from three projectors onto an ultra-wide screen to create a blended composite. This approach was designed to improve color balance and saturation (to blend with the foreground) in color rear projection, especially in larger screen formats.

video-assisted editing: Also known as electronic editing, these editing systems used videotape or videodiscs to store and edit film footage. Once a final cut had been approved, the footage was transferred back to film for distribution and exhibition. Over the course of the 1980s and 1990s, these systems would gradually replace traditional flatbed film-editing systems.

VistaVision: Paramount's proprietary widescreen format, which debuted in 1954. Rather than widening the conventional 1.37:1 Academy ratio (like Cinemascope), VistaVision stretched the exposure area taller, with a 1.5:1 ratio. VistaVision used conventional 35mm film, but oriented the film horizontally, creating a larger, eight-perforation filming area.

Williams process: A type of traveling matte process that involved photographing foreground action against a black background using a Bi-Pack that gives a transparent negative along with the foreground action.

wireframe model: An abstract geometric model of an object in three dimensions, in which the shape and underlying structure of the object is rendered by intersecting lines, before any textures are added. Wireframe models are used in 3D computer graphics.

workprint: Editors created workprints by cutting together positive shots made from the original negative. The workprint, or cutting copy, served as the basis for "conforming" or cutting the negative, from which release prints were made.

z-axis: In special effects, this usually refers to the feeling of moving into the depth of the picture plane.

SELECTED BIBLIOGRAPHY

Allison, Tanine. "More than a Man in Monkey Suit: Andy Serkis, Motion Capture, and Digital Realism." *Quarterly Review of Film and Video* 28, no. 4 (July 2011): 325–341.

Altman, Rick. *The American Film Musical.* Bloomington: Indiana University Press, 1987.

Balcerzak, Scott. "Andy Serkis as Actor, Body, and Gorilla: Motion Capture and the Presence of Performance." In *Cinephilia in the Age of Digital Reproduction: Film, Pleasure, and Digital Culture*, edited by Scott Balcerzak and Jason Sperb, 195–213. London: Wallflower, 2009.

Barnard, Timothy. *Découpage.* Montreal: Caboose, 2014.

Bode, Lisa. "No Longer Themselves? Framing Digitally Enabled Posthumous 'Performance.'" *Cinema Journal* 49, no. 4 (Summer 2010): 46–70.

Bordwell, David. "Intensified Continuity: Visual Style in Contemporary American Film." *Film Quarterly* 55, no. 3 (Spring 2002): 16–28.

———. *On the History of Film Style.* Cambridge, MA: Harvard University Press, 1998.

———. *The Way Hollywood Tells It: Story and Style in Modern Movies.* Berkeley: University of California Press, 2006.

Bordwell, David, Janet Staiger, and Kristin Thompson. *The Classical Hollywood Cinema: Film Style and Mode of Production to 1960.* New York: Columbia University Press, 1985.

Bowser, Eileen. *The Transformation of Cinema: 1907–1915.* Berkeley: University of California Press, 1994.

Bukatman, Scott. *Matters of Gravity: Special Effects and Supermen in the 20th Century.* Durham, NC: Duke University Press, 2003.

Calavita, Marco. "'MTV Aesthetics' at the Movies: Interrogating a Film Criticism Fallacy." *Journal of Film and Video* 59, no. 3 (Fall 2007): 15–31.

Carringer, Robert L. *The Making of "Citizen Kane."* Berkeley: University of California Press, 1996.

Chang, Justin. *FilmCraft: Editing.* London: Ilex, 2012.

Clarke, Frederick. "The Making of *The Birds.*" *Cinefantastique* 10, no. 2 (1980): 14–35.

Crafton, Donald. *The Talkies: American Cinema's Transition to Sound, 1926–1931.* Berkeley: University of California Press, 1999.

Crittenden, Roger. *Fine Cuts: The Art of European Film Editing.* Waltham, MA: Focal Press, 2005.

Cubbitt, Sean. "Digital Filming and Special Effects." In *The New Media Book,* edited by Dan Harries, 17–29. London: Palgrave Macmillan, 2002.

Dancyger, Ken. *The Technique of Film and Video Editing: History, Theory, and Practice.* 4th ed. Waltham, MA: Focal Press, 2006.

Dmytryk, Edward. *It's a Hell of a Life, But Not a Bad Living: A Hollywood Memoir.* New York: New York Times Books, 1978.

———. *On Film Editing: An Introduction to the Art of Film Construction.* Waltham, MA: Focal Press, 1984.

Dykstra, John. "Miniature and Mechanical Special Effects for *Star Wars.*" *American Cinematographer* (July 1977).

Edlund, Richard. "Special Visual Effects for *Star Wars: The Empire Strikes Back.*" *American Cinematographer* (June 1980).

Edouart, Farciot. "The Evolution of Transparency Process Photography." *American Cinematographer* (October 1943).

———. "The Transparency Projection Process." *American Cinematographer* (July 1932).

Fielding, Raymond. *Special Effects Cinematography.* 4th ed. Oxford: Focal Press, 1985.

Fulton, John P. "How We Made *The Invisible Man.*" *American Cinematographer* (September 1934).

Gaskill, Arthur L., and David A. Englander. *Pictorial Continuity: How to Shoot a Movie Story.* New York: Duell, Sloan, and Pearce, 1947.

Gunning, Tom. *D. W. Griffith and the Origins of American Narrative Film: The Early Years at Biograph.* Urbana: University of Illinois Press, 1991.

———. "Now You See It, Now You Don't: The Temporality of the Cinema of Attractions." In *The Silent Cinema Reader,* edited by Lee Grieveson and Peter Kramer, 41–50. London: Routledge, 2004.

Keating, Patrick. *Hollywood Lighting from the Silent Era to Film Noir.* New York: Columbia University Press, 2010.

Keating, Patrick, ed. *Cinematography.* New Brunswick, NJ: Rutgers University Press, 2014.

Keil, Charlie. *Early American Cinema in Transition: Story, Style, and Filmmaking, 1907–1913.* Madison: University of Wisconsin Press, 2001.

Kellogg, Ray, and L. B. Abbott. "Special Photographic Effects in Motion Pictures." *American Cinematographer* (October 1957).

King, Geoff. *New Hollywood Cinema: An Introduction.* New York: Columbia University Press, 2002.

———. *Spectacular Narratives: Hollywood in the Age of the Blockbuster.* New York: I. B. Tauris, 2000.

La Valley, Albert J. "Traditions of Trickery: The Role of Special Effects in the Science Fiction Film." In *Shadows of the Magic Lamp,* edited by George Slusser and Eric S. Rabkin, 141–158. Carbondale: Southern Illinois University Press, 1985.

Lewis, Jon. *Whom God Wishes to Destroy . . . Francis Coppola and the New Hollywood.* Durham, NC: Duke University Press, 1995.

LoBrutto, Vincent Anthony, ed. *Selected Takes: Film Editors on Editing.* Westport, CT: Praeger Publishing, 1991.

Magid, Ron. "Effects Team Brings Dinosaurs Back from the Dead." *American Cinematographer* (June 1993).

Maher, Karen Ward. *Women Filmmakers in Early Hollywood.* Baltimore: Johns Hopkins University Press, 2006.

Mandell, Paul. "Parting the Red Sea (and other Miracles)." *American Cinematographer* (April 1983).

Manovich, Lev. *The Language of New Media.* Cambridge, MA: MIT Press, 2002.

Mathijs, Ernest, and Murray Pomerance, eds. *From Hobbits to Hollywood: Essays on Peter Jackson's "Lord of the Rings."* Amsterdam: Rodopi, 2006.

Metz, Christian. "Trucage and the Film." *Critical Inquiry* 3, no. 4 (Summer 1977): 657–675.

Murch, Walter. *In the Blink of an Eye: A Perspective on Film Editing.* 2nd ed. Los Angeles: Silman-James Press, 2001.

Musser, Charles. *The Emergence of Cinema: The American Screen to 1907.* Berkeley: University of California Press, 1994.

Ndalianis, Angela. *Neo-baroque Aesthetics and Contemporary Entertainment.* Cambridge, MA: MIT Press, 2005.

Neale, Steve, and Murray Smith, eds. *Contemporary Hollywood Cinema.* London: Routledge, 1998.

North, Dan. *Performing Illusions: Cinema, Special Effects, and the Virtual Actor.* London: Wallflower, 2008.

Okun, Jeffrey A., and Susan Zwerman. *The VES Handbook of Visual Effects: Industry Standard VFX Practices and Procedures.* 2nd ed. Burlington, MA, and London: Focal Press, 2015.

Oldham, Gabriella, ed. *First Cut: Conversations with Film Editors.* Berkeley: University of California Press, 1995.

———. *First Cut 2: More Conversations with Film Editors.* Berkeley: University of California Press, 2012.

Ondaatje, Michael. *The Conversations: Walter Murch and the Art of Editing Film.* New York: Knopf, 2004.

O'Steen, Bobbie. *The Invisible Cut: How Editors Make Movie Magic.* Studio City, CA: Michael Wiese Productions, 2009.

O'Steen, Sam, and Bobbie O'Steen. *Cut to the Chase: Forty-five Years of Editing America's Favorite Movies.* Studio City, CA: Michael Wiese Productions, 2002.

Pierson, Michele. *Special Effects: Still in Search of Wonder.* New York: Columbia University Press, 2002.

Prince, Stephen. *Digital Visual Effects in Cinema: The Seduction of Reality.* New Brunswick, NJ: Rutgers University Press, 2012.

———. "The Emergence of Filmic Artifacts: Cinema and Cinematography in the Digital Era." *Film Quarterly* 57, no. 3 (2004): 24–33.

———. "True Lies: Perceptual Realism, Digital Images, and Film Theory." *Film Quarterly* 49, no. 3 (Spring 1996): 27–37.

Purse, Lisa. *Digital Imaging in Popular Cinema.* Edinburgh: Edinburgh University Press, 2013.

Rehak, Bob, Dan North, and Michael S. Duffy, eds. *Special Effects: New Histories, Theories, Contexts.* London: Palgrave, 2015.

Reisz, Karel. *Technique of Film Editing.* 2nd ed. Waltham, MA: Focal Press, 2009.

Rickett, Richard. *Special Effects: History and Technique.* New York: Billboard Books, 2007.

Rosenblum, Ralph. *When the Shooting Stops . . . The Cutting Begins: A Film Editor's Story.* New York: Da Capo Press, 1986.

Salt, Barry. *Film Style and Technology: History and Analysis.* 3rd ed. London: Starword, 2009.

Sersen, Fred M. "Special Photographic Effects." *Journal of the Society of Motion Picture Engineers* 40, no. 6 (June 1943): 376.

Sobchack, Vivian, ed. *Meta-morphing: Visual Transformation and the Culture of Quick Change.* Minneapolis: University of Minnesota Press, 2000.

Strauven, Wanda, ed. *The Cinema of Attractions Reloaded.* Amsterdam: Amsterdam University Press, 2006.

Trumbull, Douglas. "Creating the Photographic Special Effects for *Close Encounters of the Third Kind*." *American Cinematographer* (January 1978).

———. "The Slit Scan Process As Used in *2001*." *American Cinematographer* (October 1969).

Turner, George E., ed. *The ASC Treasury of Visual Effects.* Hollywood, CA: American Society of Cinematographers, 1983.

Turnock, Julie. *Plastic Reality: Special Effects, Technology, and the Emergence of 1970s Blockbuster Aesthetics.* New York: Columbia University Press, 2015.

———. "The Screen on the Set: The Problem of Classical Studio Rear Projection." *Cinema Journal* 51, no. 2 (2012): 157–162.

Whissel, Kristen. *Spectacular Digital Effects: CGI and Contemporary Cinema.* Durham, NC: Duke University Press, 2014.

Wyatt, Justin. *High Concept: Movies and Marketing in Hollywood.* Austin: University of Texas Press, 1994.

NOTES ON CONTRIBUTORS

Tanine Allison is an assistant professor of film and media studies at Emory University, where she teaches courses on film, video games, and digital media. She has published essays on motion capture, digital realism, and war video games in the *Quarterly Review of Film and Video, Critical Quarterly,* and *Literature/Film Quarterly*; her essays on race in digital animation and military science-fiction films have appeared in edited collections. She is currently completing a book on the aesthetics of combat in American films and video games set during World War II. Her website is www.tanineallison.com.

Meraj Dhir is a Ph.D. candidate in the History of Art and Architecture Department at Harvard University. His principal interests include film style and aesthetics, and his past publications have appeared in *The Velvet Light Trap* and *Arnheim for Film and Media Studies.*

Scott Higgins is professor and chair of the College of Film and the Moving Image at Wesleyan University. His books include *Harnessing the Technicolor Rainbow: Color Design in the 1930s, Arnheim for Film and Media Studies,* and *Matinee Melodrama: Playing with Formula in the Sound Serial.*

Charlie Keil is the principal of Innis College and a professor in the Cinema Studies Institute and the History Department at the University of Toronto. He has published extensively on the topic of early cinema, especially the pivotal "transitional era" of the early 1910s, in such books as *Early American Cinema in Transition, American Cinema's Transitional Era* (coedited with Shelley Stamp), and *American Cinema of the 1910s* (coedited with Ben Singer). He is currently editing an anthology on D. W. Griffith.

Paul Monticone is a Ph.D. candidate in the Department of Radio-Television-Film at the University of Texas at Austin, where he is a coordinating editor of *The Velvet Light Trap*. His dissertation is an institutional and cultural history of the MPPDA during the studio era. His work has appeared in *Cinema Journal* and the *Quarterly Review of Film and Video*. In 2014 he won the SCMS Student Writing award for a study of public relations films made by the electric utility industry in the 1920s.

Dan North is an independent scholar based in China. For more than ten years, he taught film studies at the University of Exeter, UK, followed by teaching posts at Leiden University and Webster University in the Netherlands. Now teaching film history, theory, and practice at Qingdao Amerasia International School, he continues to write and research actively, with particular interest in histories of filmic special effects, animation, and puppetry. He is the author of *Performing Illusions: Cinema, Special Effects, and the Virtual Actor* and coeditor, with Bob Rehak and Michael S. Duffy, of *Special Effects: New Histories, Theories, Contexts*. Some of his writing can also be found at *Spectacular Attractions* (drnorth.wordpress.com).

Deron Overpeck is an assistant professor in the Department of Communication, Media and Theatre Arts at Eastern Michigan University. His scholarship has appeared in *Film History: An International Journal, Historical Journal of Film, Radio and Television,* and *Moving Image,* as well as the anthologies *American Cinema of the 1980s: Themes and Variations* and *Explorations in New Cinema History: Approaches and Case Studies.*

Dana Polan is a professor of cinema studies at New York University and author of eight books in film and media, including *Scenes of Instruction: The Beginnings of the U.S. Study of Film, 1915–1930.* He is currently at work on a project on Hollywood and the range of its films in 1939.

Lisa Purse is an associate professor of film in the Department of Film, Theatre, and Television at the University of Reading. She is the author of *Contemporary Action Cinema* and *Digital Imaging in Popular Cinema*, and has published widely on digital visual effects technologies, genre cinema, and the politics of representations of the body on film.

Ariel Rogers is an assistant professor in the Department of Radio/Television/Film at Northwestern University. Her research and teaching focus on movie technologies, spectatorship, and new media. She is the author of *Cinematic Appeals: The Experience of New Movie Technologies*, as well as articles on widescreen cinema, digital cinema, and screens. She is currently working on a new book about screen technologies.

Julie Turnock is an assistant professor of media and cinema studies in the College of Media at the University of Illinois, Urbana/Champaign. She is the author of *Plastic Reality: Special Effects, Technology, and the Emergence of 1970s Blockbuster Aesthetics* and has published articles on special effects, spectacle, and technology of the silent and studio era, the 1970s, and recent digital cinema in *Cinema Journal, Film History, Film Criticism*, and *New Review of Film and Television Studies*.

Kristen Whissel is a professor of film and media at the University of California, Berkeley. She is the author of *Spectacular Digital Effects: CGI and Contemporary Cinema* and *Picturing American Modernity: Traffic, Technology, and the Silent Cinema*. She is the guest editor of two special issues of *Film Criticism*, one on digital effects and another on 3D. She is currently writing a book on stereoscopic 3D cinema and media.

Benjamin Wright is a lecturer in cinema studies at the University of Toronto. He received his Ph.D. from the Institute for Comparative Studies in Literature, Art, and Culture at Carleton University and was previously the Provost Postdoctoral Fellow in the School of Cinematic Arts at the University of Southern California. His work on industry studies, film sound and music, and film technology has appeared in numerous journals and book collections, and he is currently completing a monograph that examines the production culture and professional practices of sound and music professionals in the American film industry.

INDEX

Absent-Minded Professor, The (1961), 87

Abyss, The (1989), 142, 152–153, 195

Academy of Motion Picture Arts and Sciences: awards for editing, 10, 59–60, 187–191, 200n15; awards for special/visual effects, 181, 183, 193–197; category terminology, 13, 216n1; sound transition and, 53

Ace of Aces (1933), 73

action sequences: camera shots, 159–160; combined effects in, 154–155; continuity and, 166–170; miniatures used in, 70; rapid cutting of, 6, 21, 137–138, 141, *plate 10*

Adventures of Robin Hood, The (1938), 72, 187

advertisements, 120, 134, 150–151

aerial photography, 98

aesthetics, 1–2; of "astonishment," 15; impact of, 160, *plate 14*; Kubrick's sense of, 117–118, 217n9; music video, 133–134; norms, 54–56, 64; presentationalism as,

38; of *Star Wars*, 120–122; of "surplus," 176; technofuturist, 151

Alien (1979), 127, 222n36

aliens, 101–102; UFO special effects, 124–125, 127, *plate 9*

Allen, Dede, 11, 85, 105, 139; partnership with Penn, 85, 88, 110–112, *111*, 163; on video-assisted systems, 132, 219nn14–15

Allen, Woody, 165; *Zelig* (1983), 139

Allison, Tanine, 16, 19–21

All That Jazz (1979), 108–109, 162, 189

Altered States (1980), 146, 148

Altman, Rick, 135

Altman, Robert, 117, 130; *McCabe and Mrs. Miller* (1971), 109, 110

Americana, 78–80

American Cinema Editors (ACE), 7, 82. See also *Cinemaeditor* (*Cinemeditor*)

American Cinematographer, 15, 69, 72, 93, 180; on electronic editing, 131, 133

American Graffiti (1973), 112–113, 121

American Werewolf in London, An (1981), 147–148

American Zoetrope, 114

analog effects, 12, 18; combined with digital effects, 9, 143, 153, *153*, 225n1

analytical/continuity editing: action films, 166–170; devices, 62, 67; Fields's view of, 113–114; growth of, 27; long takes and, 82; multiple-camera shooting and, 54–55; narrative film and, 15–16; principles or rules, 6, 10, 63, 137, *plate 10*; shooting for coverage and, 159; space and, 4, 27, 62, 167; spectatorship and, 34; studio-era, 67, 80. *See also* scene dissection

Anderson, Paul Thomas, 140–141, 165, 171

animation: computer, 143, 175; continuity in, 170; facial, 177–178; Go-Motion technique, 145; montage sequences, 141; in *Star Wars* series, 122, *123*; 3D, 174, 182. *See also* stop-motion animation

animatronics, 21, 127; in horror films, 148–149; in *Jurassic Park* (1993), 19, 153, *153*

answer print, 9, 55

Apocalypse Now (1979), 6, 114–115, *plate 7*

Armitage, Frederick S., 40, 41

artistry, 14, 16, 19, 59, 63; DeMille on, 60; invisible, 169

As Seen Through a Telescope (1901), 201n8

Atomic Café, The (1982), 139

attractions: cinema of, 15, 37; close-ups as, 24, 27; spectacular effects as, 40, 45; trick effects as, 39–40

audiences: emotional reactions of, 38, 101; preferences, 125; special/visual effects and, 14–15, 60

Auntie's Affinity (1913), 28–31, *30*

Auteur Renaissance, 102, 103; directors in, 116–117; editing in, 109, 113, 115; special/visual effects in, 117

Avatar (2009), 17, 19, 177–178

average shot length (ASL): 1940s and 1950s trends, 5, 81, 83; 1960s trends, 163; 1980s and 1990s trends, 6, 129, 138, 140, 163; 2001–2013 rates, 163–165; between genres, 64; for musicals, 161; in silent era, 163

Avid, 9, 133, 157

Baird, Stuart, 164–165, 167, 169–170

Balio, Tino, 173

Barba, Eric, 182

Barrymore, John, *43*, 43–44

Bass, Saul, 88

Battle Beyond the Stars (1980), 146

Battle of Santiago Bay, The (1898), 48

Bauchens, Anne, 58, 60, 187

Bay, Michael, 141, 164

Bazin, André, 224n26

Beatty, Warren, 110, 139

Beau Brummel (1924), *43*, 43–44

Becker, Howard S., 104

Beetlejuice (1988), 146, 147

Ben Hur (1959), 95, 194

Bennett, E. E., 43–44

Beyond the Rocks (1922), 47

Biograph, 24–25, 27, 40

Birdman (2014), 2, 171, 225n28

Birth of a Nation, The (1915), 48

Biskind, Peter, 109

Blackmail (1929), 99, 214n30

Black Swan (2010), 179

Blackton, James Stuart, 48

Black Widow, The (1954), 86

Blalack, Robert, 117, 126, 195

bluescreen or greenscreen, 18, 96, 122, 155, *174*, 221n21; digital backlot and, 173–174, 181

Body of Lies (2008), 159

Bond series. *See* James Bond series

Bonnie and Clyde (1967), 85, 88, 110–112, *111*, 163

Boogie Nights (1997), 140

Booth, Margaret, 10, *57*, 57–58

Bordwell, David, 36, 52, 69; on intensified continuity, 129, 137–138, 167, 218n1

Boss Film Studios, 143–144, 154, 218n27

Bottin, Rob, 148–149, 195, 222n31

Bottomore, Stephen, 23

Bourne series: *Identity* (2002), 164, 170; *Supremacy* (2004), 164; *Ultimatum* (2007), 157, 163, 164, 190

Bowie, Les, 118, 195

Bowser, Eileen, 27, 28, 42

Brando, Marlon, 82

Brown, Clarence: *The Flesh and the Devil*

(1926), 35–36; *The Rains Came* (1939), 70
Brown, David, 113
Buckland, Wilfred, 46
Buff, Conrad, 9, 133, 190
Burch, Noel, 27, 32
Burcksen, Edgar, 157
Burke, Tim, 180, 196
Burks, Ivyl, 96
Burton, Tim, 146, 147, 149, 172, 173
Burtt, Ben, 117, 133

Calavita, Marco, 134
Cambern, Donn, 5–6, 89, 106–108, 212n17
camera shots: angles, 26–27, 29; continuous, 23–24; deep focus, 81; insert and emblematic, 26; "master" or long, 4, 36, 54–55, 64, 80–81, 205n19; midway/medium, 79; moving, 6, 159; POV, 159–160, 201n8, *plate 14*; shot/reverse-shot pattern, 30, *30*, 80, 83, *plate 3*; successive, 24–25; transitions, 4, 34, 85–86, 162. *See also* average shot length (ASL); close-ups; multiple-camera shooting
Cameron, James, 154, 177, 183; *The Abyss* (1989), 142, 152–153, 195; *Avatar* (2009), 17, 19, 177–178; *Titanic* (1997), 143, 172, 176, 190, 196
Campbell, Martin, 167
Campbell, Tom, 147
Capra, Frank, 60, 205n19
car chases, 106, 113
Carousel (1956), 83, *plate 3*
Carpenter, John: *Escape from New York* (1981), 147, 222n37; *The Thing* (1981), 19, 127, 148–149, 222n31, *plate 13*; *The Ward* (2010), 166
Carringer, Robert, 65
Casino Royale (2006), 165, 167–169, *169*
CGI. *See* computer-generated images
Chang, Justin, 157
Changeling (2008), 17, 182
Chaplin, Charlie, 47
chase films, 24–25, 201n11
Cheat, The (1915), 31–34, *32–33*
Chicago (2002), 161–163, 164, 190, *plate 15*
Children of Men (2006), 21
choreography, 161–162

Christopherson, Susan, 106
Cineaste, 111
Cinefex, 15, 143
cine-genres, 3
Cinemaeditor (Cinemeditor), 84–85, 156–157, 169
CinemaScope, 17, 82, 121
cinematic space, 4, 23, 35, 161; screens and, 74–76, *76*; viewers and, 29, 77. *See also* space and time
cinematography: deep-focus, 69, 81–82, 211n68; digital visual effects and, 19–20, 180–181; expressive effects in, 98–99; live-action, 121; for musicals, 161; postwar, 91, 97; studio, 94, 97
Citizen Kane (1941), 65, 75, 81
Clark, Alfred, 39
Clarke, Arthur, 82
Clash by Night (1952), 81
Clash of the Titans (1981), 128, 145
classical era: defining features of, 37; sound transition in, 4; special effects techniques of, 15, 16, 69, 208n10; studio editing in, 20, 51–52, 91
Cleopatra (1934), 66
Close Encounters of the Third Kind (1977), 11, 120; special effects, 123–125, 128, *plate 9*
close-ups: as an attraction, 24, 27; of children *vs.* adults, 27; continuous, 23–24; erotic, 201n8; extreme, 79, 87; of faces, 31, 33–34, 79; shot scale and, 63; of stars, 52, 204n2
CMX Systems, 215n11
Coates, Anne V., 108
color filters, 98–99, 180
comic book adaptations, 141, 173, 174
compositing: bluescreen, 92, 221n21; digital, 14, 92, 152, 154, 179; early technology, 44; narrative and, 41–42; refinements to, 48; Schüfftan process, 99, 214n30; seamless, 147; in silent-era films, 41–43; in *Star Wars*, 121–122, 143–144. *See also* optical printing; rear projection; traveling matte process
computer-generated images (CGI): bluescreen use, 174, *174*; in body/facial capture, 177–178, *178–179*; combined with older effects, 154–155; evolution of,

computer-generated images (CGI) (continued) 150–151; integration challenges, 18, 151–153; previsualization process, 21, 180–181; proliferation of, 12, 20, 142–143; software, 152, 173, 175–176, 183, plate 16

contact printing, 118

continuity: aural, 5, 87; classical, 85, 115, 159, 170; of framing, 23; genre of, 3; intensified, 129, 138, 166–170, 218n1; narrative/storytelling, 3, 78–79, 134; norms, 156; over-the-shoulder, 83, plate 3; script, 52, 60; spatial, 111, 137, 167; on stage, 82. See also analytical/continuity editing

Cook, Randy, 180–181, 226n27

Coppola, Francis Ford, 10, 103, 117; Apocalypse Now (1979), 6, 114–115, plate 7; video-assisted editing use, 130–131

Corman, Roger, 88, 146

Corsican Brothers, The (1912), 44

court scenes, 31–34, 61

coverage, shooting for, 4, 80, 159

Cox, Joel, 11, 157; awards, 190, 196

crab dolly, 8, 81–82

creature effects artists, 148

Cronenberg, David, 11, 221n23; The Fly (1986), 146, 148

Crowther, Bosley, 88–89

Curious Case of Benjamin Button, The (2008), 177–178, 178–179, 181–182, 196

cutting: action scenes, 64, 138, 170; angle/reverse angle, 4, 26, 29–30, 32, 201n25; axial, 29, 79, 160; craft of, 104–105; experimentation and innovation in, 87, 106; pre-cutting, 64–65, 67; rapid, 82–83, 137–138; sound recording and, 52–55; between spaces, 24–25; straight, 5, 85–88, 108, 110, 213n22; technical process of, 51. See also editing

Dallas Buyers Club, The (2013), 183

Dark City (1998), 142, 154–155

Dark Knight Rises, The (2012), 141

Dead End (1937), 63–64

Deakins, Roger, 169

Death of a Salesman (play, Miller), 79

death scenes, 43–44

DeMille, Cecil B., 58; The Cheat (1915), 31–34, 32, 33; Manslaughter (1922), 47; The Plainsman (1936), 74; The Ten Commandments (1923 and 1956), 48–49, 66, 92, 96–97, 194, plate 5

Demolishing and Building Up the Star Theatre (1901), 40

De Palma, Brian, 117, 134, 155, 218n25, 220n32

Dhir, Meraj, 6, 11

dialogue scenes, 31, 44, 68, 95, 162; editing, 54–55, 63–64; shot scale of, 63

Die Hard (1988), 154

Digital Domain, 154, 183

Digital Intermediate (DI), 16, 172, 181

digital visual effects: actor performance and, 19–21, 178–181; combined with older effects, 19, 154–155; companies, 151, 154; painting techniques, 177; proliferation, 172–173, 182–185; technologies, 16, 21, 142, 157. See also computer-generated images (CGI)

disaster films, 125–126

Disney, 87

dissolves: demise of, 8; function and usage, 61, 73, 85–86; visual and audio, 135

Divorce, American Style (1967), 80

Dombrowski, Lisa, 83

Domela, Jan, 96

double or multiple exposure: in action scenes, 42–43; of apparitions, 43, 43–44; definition, 203n20; for dual roles, 44–45, 45; in Porter films, 39, 43

Dragonslayer (1981), 145

Dr. Cyclops (1940), 72, 77, plate 2

Dr. Dolittle (1967), 126, 194

dream sequences, 99–101, 100

Dreier, Hans, 70

Drive, He Said (1971), 108

Dr. Jekyll and Mr. Hyde (1931), 20, 61, 62

Drugstore Cowboy (1989), 140

Drunkard's Reformation, A (1909), 27–28, 31

Dunn, Linwood, 73, 102, 213n5

Dunning, Carroll, 68–69, 71, 92

Dunning, Jack, 5

Dutra, Randal M., 154

Dykstra, John, 117, 119–120, 142; Apogee effects house, 126, 143, 146
Earth vs. the Flying Saucers (1956), 92, 101, 124
East of Eden (1955), 83
Eastwood, Clint, 11, 157; Changeling (2008), 17, 182
Easy Rider (1969), 125–126; editing in, 5–6, 88; LSD sequence, 89, 107–108, plate 6
edge numbering, 53
EdiFlex, 9, 132
Edison, Thomas, 39
editing: 1960s experimentation, 5, 83, 87–80; awards for, 10, 59–60, 187–191; continuity, 23, 25, 26; as a craft practice, 1, 9–12, 11, 52, 104–105, 114–115; creative, 66, 166; criticism of, 156–158; découpage as term for, 52; devices, 60–62, 85; intra-scene, 62–63; in/visibility of, 3, 58, 156; kinetic and hyperkinetic, 6, 157, 170; production process, 9–10, 55–56, 69; and special/visual effects relationship, 1–2, 20; stylistic trends, 3–6, 54, 134. See also analytical/continuity editing; cutting; freelance editors; women editors
editing technology: 1930s techniques, 70–73; 1950s and 1960s innovations, 84–85; early developments, 34–35; flatbed vs. upright systems, 85, 105–106; historical overview of, 6–9. See also electronic editing; video-assisted editing
editor-director relationship, 9–11, 55–56, 58; client management, 107–110; notable partnerships, 110–115, 163–165
Edlund, Richard, 117, 119, 146; Boss Film Studios, 143–144, 218n27
Edouart, Farciot, 68, 72, 100, 193, 210n33, 218n31
effects houses. See independent effects houses
Eisenstein, Sergei, 140
electronic editing: adoption of, 132–133, 219n15; emergence of, 8, 10; systems, 130–133, 138
Elephant Man, The (1980), 108
Elsaesser, Thomas, 22
Englander, David A., 78–80

English Patient, The (1996), 133, 190
Escaped Lunatic, The (1904), 40
Escape from New York (1981), 147, 222n37
E.T. (1982), 127, 145
European art cinema, 83, 103, 129, 162
Execution of Mary, Queen of Scots, The (1895), 1, 21, 23, 39
exhibition, 37, 40, 74–75
Exhibitors Herald, 45

fades, 61, 73, 85
Fairservice, Don, 107
FAKE Digital Entertainment, 183, 226n38
Faulkner, Robert R., 104, 107
Favreau, Jon, 165
feature-length narrative film, 15–16, 17
Fiddler on the Roof (1971), 161
Fields, Verna, 11; editing background, 112; work on Spielberg films, 112–114
film critics, 156–157
Fincher, David, 163–165, 179, 181
Fink, Michael, 13–14, 196
Flaming Gold (1933), 73
flashback sequences, 86, 88
Flashdance (1983): dance sequence, 135–136; soundtrack, 6, 134
flatbed systems, 114; compared to upright systems, 105–106; features, 8, 85
Flesh and the Devil, The (1926), 35–36
flexible specialization, 10, 104, 106, 114
Flying Down to Rio (1933), 73
Footloose (1984), 134–135
forced perspective, 40, 147, 154
Forest Rangers, The (1942), 73
Forty Guns (1957), 83
Fosse, Bob, 108–109, 162; Sweet Charity (1969), 162
Fowler, Gene, 61
Fowler, Marjorie, 206n35
Fox, Jordan, 143
franchises, 173
Frankenheimer, John, 79, 89
freelance editors: client management, 107–109; creativity and artistry, 109–110, 114–115; editing technology and, 106; notable partnerships, 110–115
French Connection, The (1971), 106, 189

Freund, Karl, 96, 207n66
Fugitive Kind, The (1960), 82
Fullerton, Carl, 148
Fulton, John, 71, 99–100, 213n5; awards, 193–194; *The Ten Commandments* (1956), 96–97
Futureworld (1976), 150, 222n36

Gaskill, Arthur, 78–80
Gaudreault, André, 38
Gay Shoe Clerk, The (1903), 24, 27
Gibbs, Antony, 161
Gigi (1958), 98, 188
Gillespie, A. Arnold, 70, 73–74, 193–194, 218n31
Girl with the Dragon Tattoo, The (2011), 164, 181, 191
Gladiator (2000), 162, 196
glass shots: function of, 46, 70–71; in silent-era films, 46–47
Gone with the Wind (1939), 91, 187, 205n23; rear projection in, 75–77, *plate 1*
Graduate, The (1967), *86–87*, 87, 90, 110
Grandpa's Reading Glass (1902), 24
Grand Prix (1966), 88, *88–89*, 189
Grant, Cary, *76*, 77, 94, *plate 4*
Gravity (2013), 163, 170–171; awards, 181, 191, 197
Great Train Robbery, The (1903), 39, 41
Greenberg, Jerry, 106, 111, 189
greenscreen. *See* bluescreen or greenscreen
Gregory, Carl Louis, 46–47, 73
Griffith, D. W.: *The Birth of A Nation* (1915), 48; *A Drunkard's Reformation* (1909), 27–28, 31; *Intolerance* (1916), 46; *The Lady and the Mouse* (1913), 29–30; *An Unseen Enemy* (1912), 25
guilds, 10, 59–60; Motion Picture Editors Guild, 112, 115
Gunning, Tom, 14, 23, 25, 28; on cine-genres, 3; on cinema of attractions, 15, 24

Hall, Walter, 46
Hard Day's Night, A (1964), 90, 213n22
Harryhausen, Ray, 101, 215n32
Heath, Stephen, 15, 38
Heim, Alan, 108–109, 110, 162, 189

Higgins, Scott, 4
high-concept filmmaking, 134
Hirsch, Paul, 132, 134, 189
Hitchcock, Alfred: *The Birds* (1963), 99, 215n30; *Blackmail* (1929), 99, 214n30; creative use of effects, 98–100; *Marnie* (1964), 92, 214n29; *Notorious* (1946), *76*, 77; *Rope* (1948), 81–82; *Spellbound* (1945), 99; *To Catch a Thief* (1955), 93–95, 96, 99, 213n5, *plate 4*; *Vertigo* (1958), 92, 96, 99–101, *100*
Hollywood: conglomeration and consolidation, 133; editing, 52, 54, 158, 169; growth of, 46; profits, 173, 184; Renaissance or New, 103–105, 107, 109, 114, 121, 130; star acting, 80–81; stylistic conventions, 2, 62–63, 69, 129
Honey, I Shrunk the Kids (1989), 146, 147
Hopper, Dennis, 5, 108, 121
Horak, Jan-Christopher, 88
horror: creative editing in, 166; low-budget films, 149–150; special effects, 147–148, *plate 13*
Howard, Tom, 118, 193–194
Howling, The (1981), 148
Hunchback of Notre Dame, The (1923), 46–47
Hunger, The (1983), 136
Hylan, Dick, 47

identity: commodity, 117; occupational, 59–60, 104–105, 115
image quality, 97, 118, 122, 181; color rear projection, 93–94
independent effects houses: CGI, 151, 154; costs, 146; formation of, 102, 106, 126, 215n34, 218n27; for low-budget films, 146–147; project bid system, 20, 126–127, 183; struggles and closures, 183–184, 221n16. *See also* Industrial Light and Magic (ILM); Robert Abel and Associates
independent film, 58, 129; influences of, 141; intellectual montages of, 130, 139–140
Indiana Jones and the Last Crusade (1989), 152
Industrial Light and Magic (ILM), 119, 123, 125; aesthetics, 145–146, 147; CGI, 152–154; Dinosaur Input Device (DID),

153; formation of, 126–127; innovations, 143, 145; software usage, 173
Innerspace (1987), 147, 195
Intolerance (1916), 46
Invisible Man, The (1933), 71, 96
Iron Man series, 165–166

Jackman, Fred, 73
Jackson, Peter, 19, 174–178, 180–181
James Bond series, 167–170, *168*
Jaws (1975): editing, 6, 113–114, 189; special effects, 123, 125, 127
Jennings, Gordon, 96, 193
Jesus Christ Superstar (1973), 161
JFK (1991), 138–139, 190, 220n39, *plate 11*
Johnson, Nunnally, 86
joiners, 7, 34
Jones, Leslie, 163, 165, 171
Jungle Book, The (1942), 70
Jurassic Park (1993), 21, 172, 196; analog/ CG effects in, 19, 143, 153, *153*, 182, 225n1

Kahn, Michael: awards, 189–190; work on Spielberg films, 11, 163, *165*
Kaplan, Michael, 221n21
Keating, Patrick, 63, 80
Keaton, Buster, 45–46
Keil, Charlie, 27, 38, 40, 42, 201n25; on chase films, 24, 201n11
Kelly, Grace, 94, *plate 4*
KEM system, 8, 85, 105–106, 114, 212n17
Kent, Ted, 63
Kessler, Frank, 38
Kinetoscope Company, 39
King, Geoff, 160
King, Henry, 58
King Kong (1933), 71, 76–77, 91
King Kong (1976), 125
King Kong (2005), 19, 177
Klekner, Matthew, 169
Korda, Vincent, 70
Kovacs, Laszlo, 121
Kress, Carl, 8, 189
Kronos: Ravager of Planets (1957), 83
Kubrick, Stanley: aesthetics, 116, 117–118, 217n9; *The Shining* (1980), 132. See also *2001: A Space Odyssey* (1968)

labor: conditions, 11, 20, 184; division of, 7, 34, 55, 59, 165; outsourcing, 102, 184; specialization, 165–166; unemployment, 103. *See also* freelance editors; women editors
Ladies' Skirts Nailed to a Fence (1900), 26–27
Lady and the Mouse, The (1913), 29–30
Lane, Sarah, 179
Lang, Brent, 225n28
Lang, Fritz, 112; *Clash by Night* (1952), 81
Last Days of Pompeii, The (1935), 70
Last Picture Show, The (1971), 108
Last Starfighter, The (1984), 151
Laugh-In (TV show), 213n22
Lawrence, Viola, 58
Lawrence of Arabia (1962), 95, 108, 188
Lebental, Dan, 165–166
Lerner, Irving, 84
Lerpae, Paul, 96, 213n5
Lessley, Elgin, 46
Lester, Richard, 90
Libeled Lady (1936), 61, 207n53
Life of an American Fireman (1903), 24
Life of Pi (2012), 165, 181, 183–184, 197
lighting schemes, 54
Little Doctor, The (1901), 201n8
Little Lord Fauntleroy (1921), 45, *45*
Loafer, The (1912), 30
location shooting, 91; of major productions, 96–98, 175; rear projection and, 93–95
Logan, Joshua, 95, 98, 214n24
Lombardo, Louis, 109, 110
Lord of the Rings trilogy: digital characters, 175–178, *plate 16*; effects techniques, 19, 174–175; previsualization team, 180–181
Los Angeles Times, 59
Lost World, The (1925), 48
Lottman, Evan, 6
Lovejoy, Ray, 87, 132
low-budget filmmaking: digital techniques in, 183; effects houses for, 146–147; horror films, 149–150
Lubitsch, Ernst, 65
Lucas, George, 103, 116–117, 133; on aesthetics of *Star Wars*, 120–121; *American Graffiti* (1973), 112–113, 121. See also *Star Wars* series

Lucasfilm, 121, 126–127, 152; EditDroid, 132–133, 219n9. *See also* Industrial Light and Magic (ILM)
Luhrmann, Baz, 162, 164
Lumet, Sidney, 159; *The Fugitive Kind* (1960), 82; *The Pawnbroker* (1965), 86, 88
Lynch, David, 117; *The Elephant Man* (1980), 108

Mackley, Arthur, 30
MAD magazine, 213n22
MAGI (Mathematic Applications Group, Inc.), 151
Magnolia (1999), 140–141
Mahar, Karen Ward, 59
makeup effects, 148–149, 154, 222n31
Malick, Terrence, 117, 134; *The Tree of Life* (2011), 183
Malkin, Barry, 85
Man in the Gray Flannel Suit, The (1956), 86
Manovich, Lev, 208n10
Manslaughter (1922), 47
marketing, 6, 134, 137
Marks, Richard, 7, 132
Marnie (1964), 92, 214n29
Marshall, Frank, 112
masculinization, 59
MASSIVE, 175–176, 182
Master, The (2012), 171
Mathieson, John, 162
Matrix, The (1999), 142–143, 155, 173, 190, 196
matte paintings, 17–18, 208n10; digital, 153, 155, 175, 182; Hitchcock's use of, 99; miniatures *vs.*, 70; rear projection and, 76–77
matte processes. *See* traveling matte process
Mayer, Louis B., 58
Maytime (1937), 66
Mazursky, Paul, 106
McConaughey, Matthew, 183
McLean, Barbara "Bobby," 10, 58, 61, 188
media conglomerates, 133, 173
Medium Cool (1968), 112
Méliès, Georges, 23, 39
Mendes, Sam, 164, 167, 169, 171
Menzies, William Cameron, 64–65, 67
Method acting, 82

MGM, 65, 218n31; editing operations, 10, 57–58; major productions, 58, 97; Tri-Lace system, 17, 93, 95, 97
Millimeter, 131
miniatures: CGI and, 154–155; for creation of settings, 70, 175; in early films, 40, 47–49; "hanging," 46; image planes and, 76; low-budget, 147; Red Sea (*The Ten Commandments*), 96; in sci-fi and horror films, 19, 98, 120, 124, 144; for staging action, 70–71
Minnelli, Vincente, 95, 98, 100–101
Mission: Impossible (1996), 155
Monkees, The (TV show), 89
Montage (electronic editing system), 131–133, 219n9
montages: in 1920s and 1930s films, 5, 65–67, 66; in 1980s and 1990s films, 130; Freudian, 100; Hitchcock's use of, 99; intellectual, 139–140; Lynch's use of, 108; music video, 129, 134–137; rapid or intense, 88, 90, 138–139, 190, *plate 11*; Soviet, 65–66, 140; theories, 66, 207n66
Monticone, Paul, 5, 9, 36; on shot lengths, 7–8; on the transition to sound, 4, 7, 9
Mori, Masahiro, 226n18
morphing: sequences in films, 14, 142–143, 154; uses of, 152
motion-capture technology, 19, 176–178
motion-control camera technology: functionality, 119–120; innovations, 143–144, 175; in *Star Wars*, 122, 145, 218n18
Moulin Rouge! (2001), 161, 164
"Movie Brats," 112
Movietone system, 53, 55, 205n16
Moviola: editors' preferences for, 8, 85, 105–106; innovations to, 7, 53
Mrs. Miniver (1942), 70
MTV, 133–134, 137, 141, 157
multiple-camera shooting: cutting rates, 6, 161; of musicals, 161–162; purpose and benefits of, 159–160; sound recording and, 4, 54–55; stacked planes and, 76–77
multiple synchronizer, 7, 53
Murawski, Bob, 141, 190
Murch, Walter, 10, 105, 112, 117, 133, 190; work on Coppola films, 114

Muren, Dennis, 119, 124, 144, 146; awards, 195–196

Murnau, F. W., 49, 65

Murphy, Peter, 136

musicals, 108, 161–163, *plate 15*

music videos: by Hollywood directors, 220n32; influence on films, 6, 135–136, 157; montage sequences, 129, 134–137, 141

Musser, Charles, 24, 38

Mutiny on the Bounty (1963), 92, 97

Napoleon, The Man of Destiny (1909), 27

narrative: compositing and, 41–42; continuity, 3, 83, 134; digital effects and, 182; editing devices and, 61–62; montage and, 66–67, 136–137; scene dissection and, 33, 62; spectacle, 13, 15–16, 24; vision scenes and, 42

National Amusements, 133

negative cutting: digital technology and, 9, 130; process, 7, 34; women's roles in, 59

News Corporation, 133

New World Pictures, 146–147

New York Times, 58

Nicholson, Bruce, 144, 195

North, Dan, 15, 16, 176

Nosler, Loyd, 35

Notorious (1946), 76, 77

Nymph of the Waves (1900), 41, 49

One Hour with You (1932), 64

O'Neill, Barry, *Auntie's Affinity* (1913), 28–31, *30*, 32

optical effects, 20, 41, 158; animation, 151; definition, 14; Hitchcock's use of, 99. *See also* special/visual effects

optical printing: 1970s revival, 119, 125; problems with, 18; refinements and innovations, 143–144; space and time and, 69, 74; techniques and usage, 17, 61, 73, 75, 213n5

Oscars. *See* Academy of Motion Picture Arts and Sciences: awards

Our Town (1940), 62, 65

Overpeck, Deron, 6, 8–9, 10

Owens, Michael, 182

Pajama Game, The (1957), 87

Paramount: adoption of rear projection, 72–73, 100; decree on studio monopolies, 92, 102; editing operations, 10; effects department, 96, 218n31

Pearson, Richard, 164, 166

Peckinpah, Sam, 109

Pederson, Con, 118, 123

Penn, Arthur, 159; *Bonnie and Clyde* (1967), 85, 88, 110–112, *111*, 163

Personal (1904), 24

Phantom Lady (1944), 61

photorealism, 122, 221n24; CGI and, 152–153; ILM's, 145–146, 151; Kubrick's, 118–119; in low-budget films, 147–148

Pickford, Mary, 16

Pictorial Continuity (Gaskill and Englander), 78–80

Pitt, Brad, 177–178, *178–179*

Pixar Animation Studios, 152

Playhouse (1921), 45–46

Pleasantville (1998), 152

Polan, Dana, 5, 8

Pomeroy, Roy, 49

Porcello, Thomas, 104

Porter, Edwin S.: *Fireside Reminiscences* (1908), 42; *The Gay Shoe Clerk* (1903), 24, 27; *The Great Train Robbery* (1903), 39, 41; *Jack and the Beanstalk* (1903), 39; *Life of an American Fireman* (1903), 24, 41–42; *Uncle Tom's Cabin* (1903), 43, 48

postproduction process, 119, 126; digital effects editing in, 172, 181; early editing, 55, 57, 67; technological shifts in, 130–131, 157

pre-editing, 64–65, 131

Prince, Stephen, 19, 151–152, 178, 185; on perceptual realism, 221n24, 225n11

Princess Nicotine (1909), 40

projectionists, 23, 40

promotional films, 135

prosthetics, 127, 147–150

psychedelic sequences, 88–89, 107–108, *plate 6*

Puett, Dallas, 166

puppetry, 128, 145, 148–150, 226n27

Purse, Lisa, 19

Quantum of Solace (2007), 164, 167, 169–170

Raiders of the Lost Ark (1981), 127, 189, 195; special effects, 143–144, 149–150, *plate 12*
Rains Came, The (1939), 13, 70, 193
Ralston, Ken, 146, 195–196
realism, 69, 123, 126; historical, 182; perceptual, 148, 176, 222n24, 225n11. *See also* photorealism
rear projection: audience reaction to, 14; color, 92–95, 213n4, 213n7; equipment, 72–73; in Hitchcock films, 93–95, 99–101, 214n30, *plate 4*; problems with, 18, 71–72; production value of, 68; screen size and, 74–76; space and time and, 69; stacked planes and, 76, 76–77; techniques and usage, 17, 71, 92, 119, 213n3, 217n17
Reds (1981), 132, 139
Reservoir Dogs (1992), 140
Revenant, The (2015), 225n28
Reynolds, William, 8, 10, 83, 188–189
Rhythm and Hues, 183, 226n39
Rickitt, Richard, 14
Right Stuff, The (1983), 132, 139, 189
RKO, 70, 96, 205n10
road shows, 95–98, 126, *plate 5*
Robert Abel and Associates, 120, 123, 127, 151
Robin Hood (1922), 46
Rogers, Ariel, 14, 17, 83
Rolf, Tom, 132, 139, 189
Rooney, Joseph, 131
Rope (1948), 81
Rosenblum, Ralph, 86, 88
rotoscoping, 122, 154, 170–171, 215n30
Rouse, Christopher, 157, 164, 170, 190
Running, Jumping, and Standing Still Film, The (1959), 90

Salt, Barry, 28, 29, 201n8; on angle shots, 4, 26–27, 31, 34, 201n25; on average shot lengths, 81, 83, 85
Sanders, Ronald, 11
San Francisco (1936), 70
Sayonara (1957), 95, 97, 214n24
Scalia, Pietro, 138, 165, 190

scene dissection: narrative and, 33, 62; principles, 62; shot length and, 83; in silent-era films, 30–31; technique, 22–23, 36; viewer and, 35
scene transitions, 60–61
Schlanger, Benjamin, 74
Schoonmaker, Thelma, 11, 110, 137, 163–164; awards, 189–190
science fiction: 1950s films, 101, 124; 1970s blockbusters, 116, 117–119; low-budget films, 147–148
Scorsese, Martin, 11, 130
Scott, Ridley, 117, 125, 127, 142, 165; *Alien* (1979), 127, 222n36; *Body of Lies* (2008), 159
Scott, Tony, 164, 166, 220n39; *Top Gun* (1986), 6, 134, 137–138, 141, *plate 10*
screen size, changes in, 72, 74–76
Seconds (1966), 79–80, 89
Selznick, David O., 80, 107. See also *Gone with the Wind* (1939)
Serkis, Andy, 176–178
Sersen, Fred M., 13, 16, 69, 193
set design, 46, 70, 175
Seven-Ups, The (1973), 106
Sewell, Blanche, 58
sex, lies and videotape (1989), 139–140
Shamroy, Leon, 98, 214n24
Shaviro, Steven, 181
shot scale, 34, 53, 54; dialogue and, 63; extreme changes in, 63, 65
Showgirl in Hollywood (1929), 54, 54–55
Shyamalan, M. Night, 165
Siegel, Don, 65, 66, 101
silent era: defined periods of, 37–38; editing technology in, 52–53; spectacle and narrative in, 15–16, 22
Sirk, Douglas, 95, 98, 101
Sky Captain and the World of Tomorrow (2004), 174, *174*
Skyfall (2012), 167, 169
slit-scan technique, 118, *plate 8*
Smith, Albert, 48
Smith, Bud, 134
Smith, Dick, 148
Smith, Frederick, Y., 84, 207n53
Smith, G. A., 201n8

Smith, Paul Martin, 133, 179–180
Smith, Thomas, 146
Social Network, The (2010), 179, 191
Society of Motion Picture Film Editors (SMPFE), 10, 59–60
Soderbergh, Steven: ASL of films, 163, 165; *sex, lies and videotape* (1989), 139–140
sound tracks: continuity editing and, 36; cutting, 7, 53–55, 205n16; introduction of, 4, 7, 9; marketing, 6, 134, 137; recording, 17, 64, 95
South Pacific (1958), 98, 101
Soviet filmmakers, 65–66
space and time: constructing, 3, 22; continuity and, 4, 27, 62, 167; control of, 23, 27; master shot and, 36; montage sequences and, 66–67, 137; progression of, 25–26; in sixties films, 90
Spawn of the North (1938), 72
special/visual effects: awards for, 181, 183, 193–197; in defining eras, 37–38, 116–117, 217n3; and disaster cycle, 125–126; and editing relationship, 1–2, 20; expressive use of, 98–102; narrative and, 16, 38; previsualization process, 21, 180–181; production value of, 68, 208n2; refining of, 49–50; scale and, 37–38; self-branding aspect of, 117; terminology, 12–14, 216n1; transparency goal of, 14–15, 20; ubiquity of, 184–185. *See also* analog effects; computer-generated images (CGI); digital visual effects; optical effects
special/visual effects technologies: 1970s techniques, 91, 119–120, 127–128; historical overview, 17–19
spectacle: early cinema, 69; narrative/non-narrative, 13, 15–16, 24, 37; ostentatious, 12; road show, 95
spectacular effects, 12, 16–17, 24, 176
spectator sequences, 28
Speed (1994), 154–155
Spencer, Dorothy, 58, 86
Spider-Man films, 141
Spielberg, Steven, 11, 103, 116–117, 153; ASL of films, 163–165; partnership with Fields, 112–114. *See also titles of films*
splicing: butt, 8, 84; negative, 7, 34

split screens, *88*, 88–89, 96, 203n20
stacked planes, 74–77, *76*
Stage Romance, A (1911), 201n25
Star! (1968), 126
Starship Troopers (1997), 153–154
Star Trek series: directors, 221n2; *The Motion Picture* (1979), 118, 126; *The Search for Spock* (1984), 146; *The Wrath of Khan* (1982), 144, 151
Star Wars series, 91, 125, 127; budget, 146; effects team, 126; *The Empire Strikes Back* (1980), 122, 126, 143–145, 195; motion-control cameras, 122, 143, 145, 218n18; *The Phantom Menace* (1999), 133, 173–174, 179–180; *Return of the Jedi* (1983), 126, 143, 146, 195; special effects, 120–123, *123*, 128, 143–144; stop-motion animation, 145, 221n2; total effects shots, 119, 174
Steenbeck, 8, 85, 105
Stella Maris (1918), 44
stereoscopic 3D, 69, 76
Stevens, George, 92
Stockwell, Guy, 82
stop-motion animation, 119, 226n27; CGI and, 153; in notable films, 127–128, 172; technique and refinement, 145
stop-motion substitution, 16; definition, 14; effects in early films, 1, 39–40
Storper, Michael, 106
story films, 3, 24–25, 40
storytelling technique, 78, 120
Story the Biograph Told, The (1904), 27, 28
Strategic Air Command (1955), 98
Struss, Karl, 49
studio system: editorial departments, 56–59; effects departments, 20, 68, 91–92, 95–98; montage units, 65–66; outsourcing, 92, 102, 106; rehiring practice, 125–126; role of editor in, 9–10, 51–52
stunt work, 126, 179
Sugarland Express, The (1974), 110, 112–113, 121
Sunrise: A Song of Two Humans (1927), 49
superimpositions, 41, 65, 114, 162, 203n20, *plate 7*
Superman (1978), 118, 195

Suspense (1913), *42*, 42–43

Taylor, Richard, 151, 196
Technicolor, 17, 69; rear projection and, 72–73
television, 8, 74, 83, 225n28; advertisements, 120, 150–151; cable system, 133–134
Ten Commandments, The (1923 and 1956), 66, 194; special effects, 48–49, 92, 96–97, *plate 5*
Terminator 2: Judgment Day (1991), 14, 19, 150
Thalberg, Irving, 57
theater design, 74–75
Theisen, Earl, 47
Thief of Bagdad, The (1940), 73, 193
Thing, The (1981), 19, 127, 148–149, 222n31, *plate 13*
Thirty Seconds over Tokyo (1944), 70
Thompson, Kristin, 31, 34, 54, 69
3:10 to Yuma (1957 and 2007), 95, 159–160, *160, plate 14*
Tichenor, Dylan, 140, 165–166
Tilburg, Jack, 146
time codes, 8, 130
time-lapse photography, 40, 150
Time magazine, 110
Tippett, Phil, 145, 153, 195–196
Tippett Studio, 153–154
Titanic (1997), 143, 172, 176, 190, 196
To Catch a Thief (1955), 93–95, 96, 99, 214n11, *plate 4*
Toland, Gregg, 65, 81
Top Gun (1986), 6, 134, 137–138, 141, *plate 10*
Topper (1937), 73
To the Moon and Beyond (1964), 118
TouchVision, 11, 132
Transactions of the Society of Motion Picture Engineers (*TSMPE*), 47
transformation scenes, 148–149; of Jekyll to Hyde, 20; magic in, 39
transitional era: defining features of, 37; space and narrative of, 3, 28, 34, 46; visions scenes in, 42
traveling matte process: bluescreen, 101;

"clean," 18, 120; in Hitchcock films, 99, *100*; rear projection and, 73; Williams and Dunning process, 19, 47, 71, 92, 215n34
Tree of Life, The (2011), 183
trick film, 16, 20, 37; definition, 3, 38; early effects, 23, 39–40; forced perspective in, 40, 147; glass shots, 47. *See also* double or multiple exposure
trick photography, 47, 49, 68–69, 175
Tri-Lace system, 17, 93, 95, 97
Trip, The (1967), 88
TRON (1982), 142, 151
Tronick, Michael, 166
Trumbull, Douglas, 118, 120, 126, 218n27
Turnock, Julie, 14, 17–18, 145
Twentieth Century–Fox, 10, 57, 218n31
2001: A Space Odyssey (1968), 87, 89; Lucas on, 120–121; special effects, 117–119, 126, 128, 194, *plate 8*; total effects shots, 119

Uncle Tom's Cabin (1903), 43, 48
unions, 60, 114, 222n31
Universal Studios, 182, 222n31
Unseen Enemy, An (1912), 25

Van der Veer, Frank, 102, 126
Vanishing Lady, The (1896), 23
Variety, 115, 134, 157
Veevers, Wally, 118
Vertigo (1958), 92, 96, 99–101, *100*
video-assisted editing: cost benefits of, 130–131; linear and nonlinear systems, 130–133, 138, 215n11
video games, 151
videotape, 8, 130–131
vision scenes, 42
VistaVision, 17, 94–95, 98, 121–122, 143
visual effects. *See* special/visual effects
Vitagraph, 27, 48
Vitaphone discs, 55, 205n16
Vorkapich, Slavko, 5, 65, 67

Walas, Chris, 148, 149
Walker, Vernon, 76
Wallis, Hal, 205n24
Walsh, Martin, 161, 164, 190
Wanger, Walter, 58

Warburton, Cotton, 87, 188
war films, 70
Warner, Jack, 85, 110
Warner Bros., 57, 65
Warner Communications, 133
War of the Worlds (1953), 92, 101–102, 124, 194
Weber, Billy, 134, 137
Welles, Orson, 67, 80, 204n2; *Citizen Kane* (1941), 65, 75, 81
Wendkos, Paul, 95
Westworld (1973), 150
Weta Workshop, 175
Weynand, Diana, 219n9
Whale, James, 63
What Price Hollywood? (1932), 66
Whissel, Kristen, 225n12
Whytock, Grant, 56
widescreen formats: color in, 93; cutting rates for, 83; editing for, 8, 82; emergence of, 17, 82
Wild Bunch, The (1969), 109
Willow (1988), 145, 149, 152
Wilson (1945), 58, 188

Windsor Hotel Fire, The (1899), 48
Wings (1927), 13
Winston, Stan, 19, 117, 148, 150, 154, 183; awards, 195–196
Winters, Ralph, 5, 58, 63, 146, 188
wipes, 73; diagonal, 61, *62*; function of, 5, 61
wireframe models, 151–152, 222nn36–37
Wise, Robert, 65, 81, 118, 126
women editors, 206n35; career advancement, 59; notable, 10–11, 52, *57*, 57–58, 206n37
workprints, 7, 34, 54, 130
Worsley, Wallace, 46
Wright, Benjamin, 6, 8, 10–11, 85, 88
Wyatt, Justin, 134

Zanuck, Darryl F., 58, 107
Zanuck, Richard, 113
z-axis, 122
Zelig (1983), 139
Ziegler, William, 81, 87
Ziff, Stuart, 145
Zoetrope. *See* American Zoetrope
Zsigmond, Vilmos, 117, 121, 124